Coming to our senses

Coming to our senses

The significance
of the Arts
for American
education

The Arts, Education and Americans Panel

McGraw-Hill Book Company

New York St. Louis San Francisco Düsseldorf London Mexico Sydney Toronto

This book was set in Janson
with display lines in Pistilli Roman
by University Graphics, Inc.
It was printed and bound
by R. R. Donnelly & Sons Company.

The designer was Jan White.

The editors were Thomas Quinn
and Cheryl Hanks.

Milton Heiberg supervised the production.

The photo editor was Donald L. Spencer.

Library of Congress Cataloging in Publication Data
American Council for the Arts in Education.
Arts, Education and Americans Panel.

 Coming to our senses.
 Bibliography: p.
 Includes index.
 I. Arts—Study and teaching—United States. I. Title.
NX503.A52 1977 700'.7'1073 77-6401 √
ISBN 0-07-002360-3
ISBN 0-07-002361-1 pbk.

3456789 RRDRRD 7654321098

Acknowledgments

Martin Engel, "The Future of Aesthetic Education," *Art Education*, vol. 29, no. 3, Journal of the National Art Education Association, Reston, Va., March 1976.

J. T. Howard and G. K. Bellows, *A Short History of Music in America*, Thomas Y. Crowell Company, New York, 1967, pp. 24, 25, 33, 95, 165, 346.

Gordon Parks, "Jazz," from the book *Mom, The Flag and Apple Pie*, by the editors of Esquire, Doubleday & Company, Inc., Garden City, N.Y. © 1976 by Esquire, Inc. Reprinted by permission of the author.

Mel Gussow, *The New York Times*, Oct. 15, 1976. © 1976 by The New York Times Company. Reprinted by permission.

Judith Cummings, "Annual Survey Finds Few Adults Are Grading Their Schools A for Excellence," *The New York Times*, Dec. 17, 1975. © 1975 by The New York Times Company. Reprinted by permission.

Iver Peterson, "The Newest Innovation: Back to Basics," *The New York Times*, Jan. 15, 1975. © 1975 by The New York Times Company. Reprinted by permission.

Definitions on pages 57 and 59 from *Webster's New Collegiate Dictionary*, G. & C. Merriam Co., Springfield, Mass. © 1977 by G. & C. Merriam Co., Publishers of the Merriam-Webster Dictionaries.

Beatrice and Ronald Gross, "A Little Bit of Chaos," *Saturday Review*, May 16, 1970, pp. 71–75. Copyright © 1970 Saturday Review.

Letter from Kerry Stutzman, *Denver Post*, Nov. 15, 1976. Reprinted by permission.

Sharon Abercrombie, "Arts Have Impact," *Columbus-Citizen Journal*, May 9, 1975. Reprinted by permission.

Herbert A. Otto, "The Personal and Family Strength Research Projects—Some Implications for the Therapist," *Mental Hygiene*, vol. 48, no. 3, pp. 439–450, July 1964.

Shirley Ririe, "A Quality Program on Dance on the High School Level," an unpublished paper. Used with the permission of Institute for Development of Educational Activities, Inc. (| I | D | E | A |).

"Contract for Students of High School of Performing and Visual Arts," reprinted courtesy of Houston Independent School District, Area II Administrative Division, and the High School for the Performing and Visual Arts.

"Youth Fifteen, Wins Olympiad with a Perfect Score," *The New York Times*, May 20, 1976. © 1976 by The New York Times Company. Reprinted by permission.

John Clark Donahue, *Minneapolis Sun*, Oct. 27, 1976. Reprinted by permission.

1976 American Artist Art School Directory, Billboard Publications, Inc., New York, 1976, pp. D2–D29. Copyright © 1976 by Billboard Publications, Inc.

Henry Rosovsky, *The New York Times*, Nov. 10, 1976. © 1976 by The New York Times Company. Reprinted by permission.

Robert Brustein, "Theatre and the University," *The Culture Watch*, Alfred A. Knopf, Inc., New York, 1975. Copyright © 1975 by Robert Brustein and reprinted by his permission..

Edwin Wilson, the chart "Separation and Clarification of Goals in Teaching the Arts," prepared for The Arts, Education and Americans Panel by Edwin Wilson, Hunter College, CUNY, and reprinted by his permission.

Margaret Mahoney, "Opportunities and Constraints," *Arts in Society*, vol. 10, no. 1, p. 121, Spring 1976. Reprinted by permission of *Arts in Society*.

Calvin W. Taylor, "Developing Effectively Functioning People," *Education*, vol. 94, no. 2, pp. 99–110, November–December 1973, and "Increasing Creative Minds and Creative Mind Power Producers in the Creativity Movement," a paper prepared for the UNESCO Conference *Creativity in Education*, held at Valencia University, Valencia, Spain, Nov. 19, 1976.

Micki Seltzer, "'Arts IMPACT' Impact, Test Score Leap at Eastgate School Examined," *Columbus Call & Post*, Aug. 24, 1974. Reprinted by permission.

The remarks made by John Biguenet are reprinted by his permission.

Edward Kamarck, "A Prefatory Note, The Surge of Community Arts," *Arts in Society*, vol. 13, Spring–Summer 1975. Reprinted by permission of *Arts in Society*.

Hilton Kramer, "Curators Seek Wider Museum Roles," *The New York Times*, June 25, 1975. © 1975 by The New York Times Company. Reprinted by permission.

Max Kaplan, "The Arts and Recreation—Not-So-Strange Bedfellows," *Parks and Recreation*, vol. 9, p. 27, June 1974. Reprinted by permission.

Junius Eddy, "Beyond Enrichment: Developing a Comprehensive School-Community Arts Curriculum," in Jerome J. Hausman (ed.), *Issues and Options in Arts Education* (tentative title), McGraw-Hill Book Company, New York, forthcoming. Copyright by Institute for Development of Educational Activities, Inc. Used by permission of Institute for Development of Educational Activities, Inc. (| I | D | E | A |).

Newton N. Minow and Nell Minow, "What Are We Learning from Television?" *Change Magazine*, vol. 8, no. 9, October 1976. Reprinted by permission of *Change Magazine*.

George W. Bonham, "Educational Media: A Mixed Bag," *Change Magazine*, vol. 8, no. 3, April 1976. Reprinted by permission of *Change Magazine*.

Editorial, *The New York Times*, Sept. 27, 1976. © 1976 by The New York Times Company. Reprinted by permission.

The closing quotation on page 265 is from the Introduction by Katherine Anne Porter to *Flowering Judas and Other Stories*, Random House, Inc., New York, 1940. Reprinted by permission of the publisher.

Contents

Chairman's introduction viii

Members of the panel xii

The crisis and the hope 1

Roots and branches of learning and the arts: a review of traditions 13

The arts: a better primer for our children 49

Creative energy and the adolescent 89

The arts at home in college 119

Powers behind the curriculum: teachers, artists, administrators 137

Beyond the schools 171

The promise and the problems of the media 197

Analyzing the present, mapping the future 211

Recommendations 247

Appendix 267

 Plan of research 268
 Research staff 269
 Research locations (map) 270
 Notes on methodology 272
 Summary of questionnaire responses: sixteen school districts 278
 Research reports prepared for the project 294
 Resource persons 295

Notes 303

Selected bibliography 312

Index 324

Chairman's introduction

The seeds of this Report were planted long before the first shoots appeared.

The Panel's corporate parent, the American Council for the Arts in Education (ACAE), was founded in 1959, and soon recognized the importance of a national statement on arts education. But it was not until fifteen years later, following the efforts of two ACAE presidents, Joseph C. Sloane and Norris Houghton, that this study came into bloom.

It is a recent notion in America that "education" and "arts" are important partners, but the idea is clearly gaining support and is even demonstrated by the mix of organizations which financed this Report. In an unusual collaborative gesture, the United States Office of Education and the National Endowment for the Arts, both federal agencies, became important early contributors.

The twenty-five Panel members were selected, not for their professional experience in the field of arts education, but for their concern about the arts, their concern about education, and their concern for the way Americans live. Thus, the study originally bore the title "Arts, Education and Americans."

It would be difficult to make other generalizations about the panelists. They hail from Maine to Hawaii, from Texas to Minnesota. They are representatives of the arts, education, mass communications, labor, arts patronage, government, and other fields.

With a staff created especially for the study and with the help of an Advisory Committee (see the Appendix, page 302),

the preliminary work was completed by June of 1975. Recognizing that arts education could mean anything from a tuba lesson in a church basement to a graduate lecture course on Romanesque architecture, the Panel agreed to concentrate its efforts. Although it would try to draw an outline of the entire world of arts education, it would agree from the start to leave some of the terrain unsurveyed. With this in mind, the Panel decided where it would put greater or lesser emphasis. The following graph was developed:

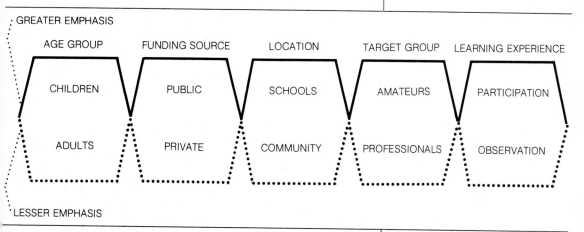

The Panel received information from three principal sources: the testimony of witnesses and staff at Panel meetings; selected works already published; and materials specially generated by staff, consultants, and witnesses (see the Appendix, pages 295–301).

The Panel meetings—fifteen days of them—were held in metropolitan New York, Memphis, Los Angeles, and Minneapolis.

When they were not in formal session, the Panel members were treated to a dance demonstration by the Mary Anthony Dance Theatre; an improvisational theatre presentation by Studio Arts Productions; a visit to Nelson Rockefeller's sculpture garden; blues by Grandma Dixie Davis, Furry Lewis, and Harry Godwin; a mime performance by Rick Shope; a song recital by Janelle Robison; and theatre and dance performances by Teatro Chicano, the Aztec Danzas Indigenes, and the Folklorico Dancers of UCLA.

To counteract the inevitable dominance of the written and spoken word, meetings were held in environments nota-

ble for their natural or artistic beauty. Thus, the Panel not only could gaze from its meeting room at the high west banks of the Hudson and Mississippi Rivers in Tarrytown and Memphis, it also deliberated at tables in Minneapolis' Walker Art Center and Institute of Arts, in Los Angeles' Plaza de la Raza and Junior Arts Center in Barnsdall Park, and Southwestern University at Memphis.

The fifteen recommendations which follow, like the text which precedes them, have been reviewed and approved by the Panel. While not every Panelist has subscribed to every recommendation in its entirety, there has been a strong consensus of support in every case.

Ever since I joined the project in 1974, what has been most remarkable and personally gratifying is the widespread interest in arts education and people's deep commitment to it. Such enthusiasm causes me to be very hopeful for the Report's success, but humble in the face of expectations for it.

As with the cathedrals of Europe, there were many who labored to build this Report whose names will not be recorded in it. There are a few, however, who must not be allowed behind the anonymous veil. I am indebted particularly to Norris Houghton for his patience, insight, wit, and creative pen. He not only got us started but was a reliable mentor throughout and an invaluable editor in the closing days.

The project would surely have run off the tracks without the equanimity, industry, and sure managerial hand of Margaret Howard, the Project Director. She brought, as well human concern to a superhuman task.

Three others were on the staff throughout the project Donald Spencer, Gina Morea, and Janelle Robison. All three were remarkable for being able to perform jobs requiring administrative, clerical, or creative skills. Like a group of repertory actors, they played all roles with equal ease and polish.

The research team was directed by Cynthia Hettinger who skillfully planned the capture of an elusive prey and calmed our fears that we might be hunting the snark.

A special word of thanks must go to the many kind people who welcomed the Panel in Memphis, Los Angeles and Minneapolis. Whether providing sustenance, space, or entertainment, they did so with taste and grace.

The meetings, the research, and the publication were made possible by grants from government and private sources around the country. With many thanks, we list them here:

Ahmanson Foundation
Atlantic Richfield Foundation
Brown Foundation
Disney Foundation
Exxon Corporation
Ford Foundation
The JDR 3rd Fund
Jerome Foundation
National Endowment for the Arts
Northwest Area Foundation
Rockefeller Brothers Fund
Rockefeller Foundation
Rubinstein (Helena) Foundation
United States Office of Education
Zellerbach Family Fund

The Panel's findings and conclusions do not necessarily reflect the views of these funding agencies.

Many persons are responsible for the initiation of this study, but I wish to thank two in particular. Kathryn Bloom (director, Arts in Education Program, The JDR 3rd Fund) and Nancy Hanks (chairman, National Endowment for the Arts) were early advocates of a national study and have been invaluable advisors throughout.

I must also express my abundant gratitude to the twenty-four other Panel members who devoted more hours to the preparation of this Report than they ever anticipated and did so with good nature. I have never shared a table with such a remarkable group, and their own utterances, frequently cited within the Report, are good evidence of their dedication and intelligence.

Finally, my thanks to a dozen wonderful friends who consented to read early drafts and took the risk of being honest critics. Most of them are artists or teachers and will find their lives affected by the future health of education in the arts. To them I dedicate my one twenty-fifth share of this rewarding collaborative venture.

David Rockefeller, Jr.

Members of the panel

David Rockefeller, Jr., Chairman
Cambridge, Massachusetts

Executive Vice President, *The Real Paper;* former Chairman, Associated Councils of the Arts; Chairman, performer, The Cantata Singers

Norris Houghton, Vice Chairman
New York, New York

Dean Emeritus and Professor of Theatre Arts, State University of New York, College at Purchase; co-founder, Phoenix Theatre, New York

Thomas P. Bergin
South Bend, Indiana

Dean, Center for Continuing Education at Notre Dame; Chairman, Artists-in-Schools Advisory Panel, National Endowment for the Arts

Barry Bingham, Sr.
Louisville, Kentucky

Chairman of the Board, Louisville *Courier-Journal*

Donald M. Carroll, Jr.
Harrisburg, Pennsylvania

Vice President for School Services, Richard A. Gibboney Associates, Inc.; former Commissioner for Basic Education, State of Pennsylvania

Peggy Cooper
Washington, D.C.

Special Assistant to the President, Post-Newsweek Stations, Inc.; founder, Workshops for Careers in the Arts, Washington, D.C.

John B. Davis, Jr.
St. Paul, Minnesota

President, Macalester College, St. Paul, Minnesota; former Superintendent of Schools, Minneapolis, Minnesota

Walter G. Davis
Washington, D.C.

Director of Education, AFL-CIO

Enrique Durán
Los Angeles, California

Actor, Educator

Ray Eames
Venice, California

Artist, Designer and Filmmaker

O'Neil Ford
San Antonio, Texas

Architect; former member, National Council on the Arts

Bernice Frieder
Cleveland, Ohio

Executive Director, United Parents Association, Inc.; former Vice Chair, Colorado State Board of Education

Edward K. Hamilton
San Francisco, California

President, Griffenhagen-Kroeger, Inc., public management consultants, San Francisco, California; former Deputy Mayor, New York City

Melissa Hayden
Seattle, Washington

Artistic Director, Pacific Northwest Dance Company; former Artist-in-Residence, Skidmore College

Lorin Hollander
Stockton Springs, Maine

Concert Pianist

Flora H. Hurschler
Pasadena, California

Board member, California Institute of the Arts; past President, Young Audiences Council of California

John Jay Iselin
New York, New York

President, Educational Broadcasting Corporation, Channel 13 WNET

Coming to our senses

The crisis and the hope

Imagine two people in conversation using a Teletype machine instead of speaking to each other directly. The words, all in upper-case letters, are a stammered outpouring from a mindless mouth. No gesture. No facial expression. No vocal rhythm or pitch. No emotion. Simply a procession of sterile symbols on a paper tongue.

This Report asserts that American education exaggerates the importance of words as transmitters of information. The fact is we send and receive a torrent of other information through our eyes, our ears, our skin, and our palate. We use all our senses to interpret and convey the complexities of daily life. Is a job interview settled on a written résumé alone? What of the handshake, the style of dress, the mannerisms of speech and gesture?

Verbal and written language is essential, but all our sensory languages need to be developed as well if words are to fulfill their deeper function and deliver both subtle and vivid messages.

Perception and communication—both fundamental learning skills—require much more than verbal training. And since the arts (painting, dancing, singing, acting, and so forth) can send important nonverbal messages from a creator or performer to an observer, they are ideal vehicles for training our senses, for enriching our emotional selves, and for organizing our environment.

Panel witness John Culkin, director of media studies at the New School for Social Research, New York, writes:

> Today the case for the arts is based less on the great things we see happening in the classroom than on the great need imposed by the environment. The buzzing confusion of media and messages of all kinds threaten to overpower and stultify our senses and our psyches. We must develop powers of discrimination, selectivity, and expression to control and counter the one-way spate of images and sounds which constitute our communications ecology—the environment of our senses, our emotions, our minds.

Our environment is what we make it. And how we shape it depends upon how we perceive it. Through the arts we can

3

learn to see our environment more clearly; to sense its color, song, and dance; and to preserve its life and quality.

Many of our schools and most of our cities and towns, however, bear testimony to our general "senselessness." All schools could be galleries or supermarkets of wonderful information, but too many have become fearful, gray fortresses.

Our cities could be monuments to the creative interplay

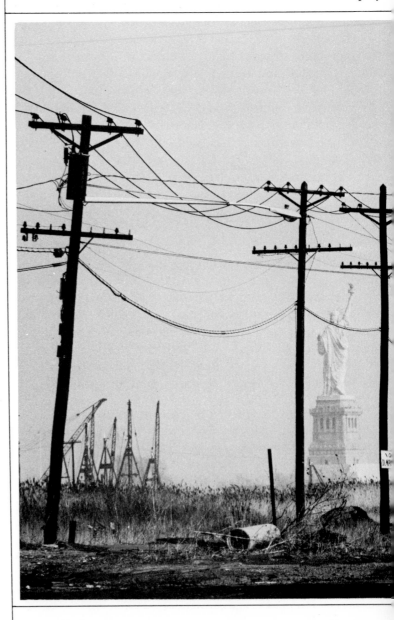

between nature and man, but they have become a gridwork of dismal frontage and automotive clamor. Yet most of us live in cities and all of us go to school.

Grayness and tension. Do we accept these as conditions of life? Must our surroundings homogenize our thoughts? Must cultural differences stimulate more suspicion than celebration?

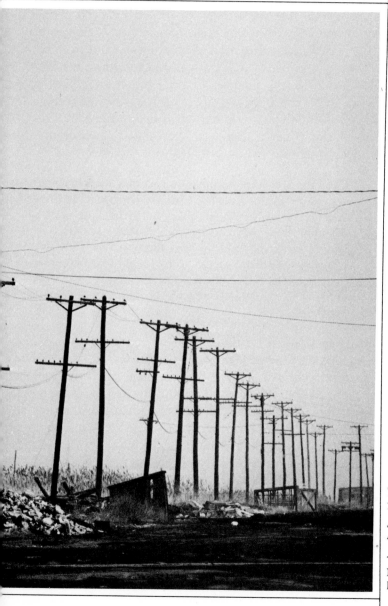

Give me your tired, your poor,
Your huddled masses yearning to breathe free,
The wretched refuse of your teeming shore.
Send these, the homeless, tempest-tost to me,
I lift my lamp beside the golden door!
　　—Emma Lazarus, *The New Colossus*
The Statue of Liberty as viewed from the New Jersey flatlands.
Photograph by David Plowden. © 1971.

5

The public schools have to establish in the minds of children the real role of the arts in American society. They must come to see the importance of design in the development of the American culture, design meaning all the visual aspects of our communities, from the objects we eat out of to the trash cans on the street corners. [RAY PIEROTTI, assistant to the president of the American Crafts Council, in staff interview]

Education, of course, is not primarily a cause but a reflection of social gloom and distress. Our formal schooling cannot be expected to provide a cure for what ails the nation. Parents are accountable too; and television producers; and Congress; governors and mayors as well; all of us, in fact.

The roots of grayness and tension run deeper than this Report, which does not pretend to be a blueprint for schools or for society. We address ourselves to just one symptom of the problem: that the arts in America are viewed neither as part of everyday living nor as a legitimate part of education.

The official segregation of art from life and from education has a long history in America, although this is not the case in other cultures, such as France, Indonesia, Nigeria, or Japan. It is the Panel's conviction that this segregation is unnatural and that art is indivisible from life and education.

Martin Engel, arts and humanities advisor to the National Institute of Education, says it forcefully:

> Once the arts were an intrinsic part of the mythology—the system of beliefs—and filled the waking hours, as it did the dreams, through religion, magic and the host of symbols which reflected meanings and the knowledge of ourselves. But now. . .technology has usurped that function. The fine arts will play more than a superficial role in our lives only when our lives become more like art. The Balinese have a common saying: "We do not have any art. We do everything as well as possible."[1]

This Panel supports the concept of "basic education," but maintains that the arts, properly taught, are basic to individual development since they more than any other subject awaken all the senses—the learning pores. We endorse a curriculum which puts "basics" first, because the arts are basic, right at the heart of the matter. And we suggest not that reading be replaced by art but that the concept of literacy be expanded beyond word skills.

The arts provide unique ways of knowing about the world and should be central to learning for this reason alone. But it is also significant that arts education can influence two elements of human behavior which concern every teacher: discipline and motivation.

Artists are often accused of being undisciplined, but quite the reverse is true. Art requires tremendous discipline—

the dancer at the exercise barre, the pianist playing endless finger exercises, the meticulous editing of the filmmaker, the centering of the potter. Learning an art is learning to care passionately about tiny details as well as overall excellence.

On the other hand, the arts can bring enormous pleasure, and all of us are motivated to do what brings us pleasure. Think of schoolchildren completing a mural on the playground wall, producing a musical in the gymnasium, or videotaping a parade: these are arts experiences which can energize an entire school population, and which can teach principles of design, geometry, speech, carpentry, political science, electricity, and more. A successful art experience motivates the child to look further and deeper.

The educators are missing the most important link in this whole business, and that is to try and think of ways to motivate the child to want to learn, and to become a master of the instruments of its survival. This is where I think arts education fits in. [PATSY T. MINK, Panel member]

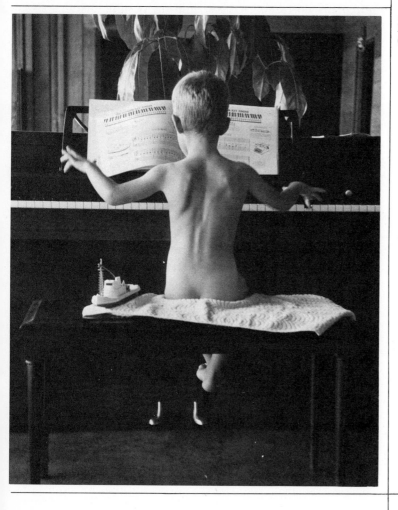

Boy at the Piano. Photograph by Wayne Miller, from *The World Is Young.* (Magnum Photos, Inc.)

Panelist Ray Eames, designer and filmmaker, emphasizes that "the real task is to develop programs affecting *all* the teaching in the school (science, history, phys. ed.)—to raise the level of awareness, discipline, elegance, rigor, pleasure, appropriateness; and to establish a consistent concern for quality in the life of the student—in such a way that the question of art never comes up."

When we speak of "arts education," do we mean something broader than looking at art or listening to music? Yes. We mean making art, knowing artists, and using art as a general tool of learning. To give an example, theatre education can occur when a person writes a play; performs in one; rehearses for one; studies stage movement and voice production; plans costume, set, or lighting design; takes a social studies course in which historical events are acted out by the students; reads a play or attends a performance. We call this learning in, through, and about the arts.

This Report, then, seeks to demonstrate that direct creative and re-creative experience—learning *in* the arts—is of unique educational value. It asserts that learning *about* the arts is learning about the rich world of sensation, emotion, and personal expression surrounding us each day. It claims that

The Commonwealth of Massachusetts
Board of Education
September 1971

Physical and emotional well-being

Education should contribute to the learner's physical and emotional well-being, especially to a sense of personal worth and to a capacity for influencing one's own destiny.

Basic communication skills

Education should develop in each learner the basic skills needed for communication, perception, evaluation, and conceptualization of ideas. Among the most important are reading, writing, speaking, listening, visual and computational skills.

Effective uses of knowledge

Education should provide for each learner access t[o] man's cultural heritage, stimulate intellectual cur[i]osity and promote intellectual development.

Capacity and desire for lifelong learning

Education should foster and stimulate in eac[h] learner the natural desire for lifelong learning an[d] should develop the skills necessary to fulfill th[e] desire.

Citizenship in a democratic society

Education should provide each learner with knowledge and understanding of how our societ[y] functions in theory and in practice; education mu[st] also foster individual commitment to exercise th[e] rights and responsibilities of citizenship and to pr[o]tect the rights of others.

learning *through* the arts has the potential to enhance one's general motivation to learn and to develop one's respect for a disciplined approach to learning.

These are not new ideas. They are present throughout educational literature. They are even present in educational policy documents, for example, in the Massachusetts Board of Education's most recent statement of educational goals (see below). Compare the flavor of these goals to those of the seventeenth century (see page 18.)

It is noteworthy that most of the titles for these ten goals relate to themes of this present Report. Moreover, the same document restates our central thesis:

> Without the basic learning skills—the capacity to receive information through the senses and to interpret and respond to that information in various ways, the process of learning cannot take place.

There is clearly a need for fundamental change in education. And the opportunities lie within walking distance of the school. Suppose we said "the city and its neighborhoods are curriculum; the school is laboratory: let us look at our environment first as work of art, then as work of history, work of

> I think you can teach ecology by studying the city; you can learn about sewerage, about marine biology. I think anything you want to do can occur within the structure of the city. [DOREEN NELSON, Panel witness]

spect for the community of man

ucation should provide each learner with knowl-
ge and experience which contribute to an under-
nding of human similarities and differences and
ich advance mutual respect for humanity and
the dignity of the individual.

cupational competence

ucation should provide the learner with the
lls, experience and attitudes, and the guidance
initial job placement; it is equally important for
learner to develop a capacity to adapt to chang-
conditions.

derstanding of the environment

ucation should provide each learner with knowl-
ge and understanding of the social, physical, and

biological worlds and the balance between man and his environment and should develop attitudes and behavior leading to intelligent use of the environment.

Individual values and attitudes

Education should expand and advance the humane dimensions of all learners, especially by helping them to identify and cultivate their own spiritual, moral, and ethical values and attitudes.

Creative interests and talents

Education should provide each learner with varied opportunities to nurture interests, to discover and to develop natural talents, and to express values and feelings through various media.

science, work of nature, of physical labor, of government." For, in fact, it is all of these, and this approach can succeed in the supermarket schools, but not in the fortresses.

This Report begins by describing the crosscurrents which formed the culture and the educational goals of America and then goes on to describe arts education today. It is concerned not only with schools, but with institutions of higher learning and arts education programs run by community groups, city agencies, arts institutions, and other social institutions. The Report does focus on public schools, because that is where most young people are. And as such, it emphasizes the education of children while recognizing that education is a lifelong process and does not end with graduation.

We describe a variety of successful experiments, emphasizing that there is no single model which works for all, and recognizing the existence of many schools which already have excellent programs in the arts.

Finally, we suggest changes for the field of arts education, including philosophical, substantive, and structural changes.

This Report appears at a time of contradictory trends. On the one hand, the arts are flourishing as never before in America. For example, according to estimates by the National Endowment for the Arts, between 1965 and 1975, the number of professional orchestras doubled; resident professional thea-

tres quadrupled; arts councils quintupled; and resident professional dance companies increased sevenfold![2]

On the other hand, arts education is struggling for its life. Music and art teachers are losing their jobs on a wholesale basis in some cities. Why? Because we have not made the connection between our desire for art and our need for art. Yet the resources are there, right next door. We have a profusion of superb artists, arts institutions, technology, and manifold cultural traditions: all the ingredients. The schools and their neighboring arts resources must be intertwined.

Panel witness John Edward Ryor, president of the National Education Association, makes this case for the arts as part of the fabric of education:

> Quality education in its most fundamental sense cannot be separated from the culture of a society. The quality of the culture is expressed in its arts and its humanities. Those who say they can be removed from the curriculum are calling for the rape of education, for a return to "training" at the expense of "learning."

In the fifties, with a nudge from Sputnik, America recognized the central importance of science education.

In the sixties, with a lateral pass from the Kennedy clan, the nation reaffirmed that physical education was essential.

Now, in the seventies, it is time to acknowledge the power and urgency of arts education.

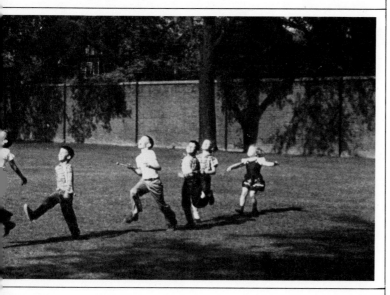

Children united in the spirit of play and the joy of a parade dance to the beat of their own drum. Photograph by Alfred Eisenstaedt. (Time-Life Picture Agency. © Time Inc.)

Roots and branches of learning and the arts: a review of traditions

Preliminary perspectives

In 1835—which was quite a long time before our child psychologists got to work in earnest on the subject of infancy—Alexis de Tocqueville wrote in an early chapter of his epochal *Democracy in America:*

> We must watch the infant in his mothers's arms; . . . we must hear the first words which awaken the sleeping powers of thought. . . . The entire man is, so to speak, to be seen in the cradle of the child.[1]

The great French observer then went on to make his point:

> The growth of nations presents something analogous to this: they all bear some marks of their origin. . . . If we carefully examine the social and political state of America, after having studied its history, we shall remain perfectly convinced that not an opinion, not a custom, not a law, I may even say not an event is upon record which the origin of the people will not explain.[2]

If Tocqueville is right, this is something to take into account as we begin our look at the past and present state of America's education and the role of the arts in it.

Everybody knows that the Pilgrim Fathers landed at Plymouth Rock in 1620, and everybody knows (though people are more likely to forget) that earlier an English colony led by Captain John Smith had been set up at Jamestown in Virginia in 1607 and that the Dutch under Henry Hudson had discovered in 1609 the river which bears his name. But Jamestown got off to a bad start and New Amsterdam soon became New York and was absorbed by the British; so Massachusetts is the likeliest place for Americans to examine the "marks of their origin." As Tocqueville himself remarks, "The civilization of New England has been like a beacon lit upon a hill, which after it has diffused its warmth immediately around it, also tinges the distant horizon with its glow."[3]

Let us speculate for a moment. Suppose that our first colonists in the opening decades of the seventeenth century had *not* been Puritans from England. What if they had set

forth from Rome or Florence or Venice bringing the culture of the Italian Renaissance to our shores? Brought up in the golden glow of the Vatican or of the Medicis and doges who surrounded themselves with the greatest painters, sculptors, and artificers of the day, suppose they had watched princes pass by to participate in dazzling entertainments in courtyards lighted by a thousand torches; suppose they had listened to strains of Monteverdi, jammed a sunlit square to laugh at the commedia dell'arte's latest horseplay, lapped up amazing rumors concerning the most recent findings of Galileo.

Or suppose that from the courts of James I or Charles I had come a band of settlers who recalled the sumptuous masques in Whitehall fashioned by the great architect Inigo Jones, with texts by the poet Ben Jonson, and their ears still rang with Christopher Marlowe's "mighty line" and Shakespeare's "If music be the food of love, play on." What if these high-spirited achievements had been the marks of our origin?

The Historical Monument of the American Republic, c. 1876, by Erastus Salisbury Field, was painted as a tribute to the classical roots of American democracy, art, and the important figures and events of the nation's past. Field maintained a dream of grandeur for America's future, hoping that the impressive buildings he depicted would someday be built. (Springfield, Massachusetts, Museum of Fine Arts, Morgan Wesson Memorial Collection.)

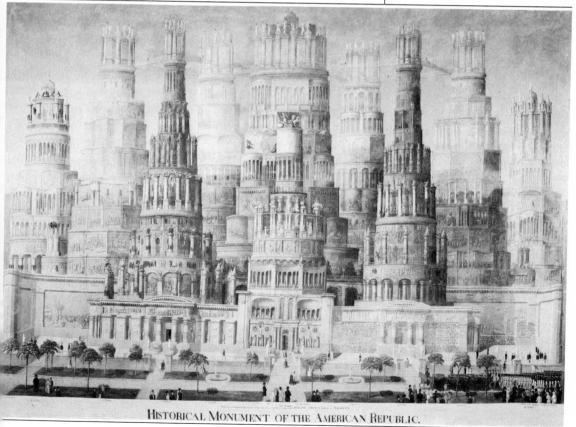

HISTORICAL MONUMENT OF THE AMERICAN REPUBLIC.

This line of speculation, however, need not detain us much longer. For, of course, the fact is that among the traditionally accepted "marks of their origin," Americans find no traces of masques at court, of dance or theatre, no strains of poetry or music (save that in the psalmbook). Massachusetts in the 1620s and the 1630s was colonized by no band of lively and cultivated adventurers but by folk who had fled their native land to get away from just these elements of life; by men and women for whom sweet strains of music, dance, and the stage, the works of the painter and the jeweler and the maker of tapestries were an abomination. They brought to these shores the Reformation, not the Renaissance, and the gray shadow of John Calvin stretched across their stern and rockbound coast.

While we are still considering "what ifs" and "might-have-beens," let us not forget that during the early years of New England other expressions of art and life were also represented elsewhere on this continent. The Spanish conquistadores and priests, the French traders and missionaries, along with an extensive variety of native Indian tribes to the west and south of New England, shared virtually none of the same presuppositions about art and religion. Different still from those explorers and native-born inhabitants were those who came from West Africa, not freely but shackled and sold against their will.

Suppose the values of any of *those* native or imported cultures had dominated? What would the subsequent history of American artistic expression be like? And how would the priorities of American education have been ordered? If Tocqueville's is a useful hypothesis, then we must acknowledge that had folk other than those relentless English purifiers and pursuers of holiness managed to dominate two centuries of American thinking, this nation might well be far different today. But the domination did occur, and neither French nor Spanish became our common language.

To imagine how different our nation might have been is not to denigrate our Puritan heritage. Rather, it encourages us to think more objectively, perhaps even more sympathetically, about our origins. By understanding our past we are both better able to profit by it and better able, when necessary, to be freed from it. So back to early New England we must go.

Our minds' eyes have cherished the image of that coast and that intrepid band of Pilgrims since our earliest school days. We need not dwell here, therefore, upon the rigors of those beginning years when wilderness must be tamed, cold and storms endured, loneliness and hardships suffered. Our forefathers were indeed made of sternest stuff.

What is more, they had not come seeking mines of gold and silver nor as traders who would set up their trading posts and carry back furs and other wealth from the New World to the places that still remained "home." These people had come to stay, and from the start they looked toward permanence. Recognizing this, you should not be surprised that a scant thirteen years later one John Eliot (who was subsequently to accomplish the prodigious task of translating the entire Bible into the Algonquian language) wrote the first recorded appeal for a college and that three years after that (1636), when the young community numbered barely 10,000, Harvard came into being.

You can see how it happened by a look at the first sentences of a pamphlet called *New England's First Fruits*, which appeared in 1643:

> After God had carried us safe to *New England*, and wee had builded our houses, provided necessaries for our livelihood, rear'd convenient places for Gods worship, and settled the Civill Government: One of the next things we longed for, and looked after was to advance *Learning* and perpetuate it to Posterity; dreading to leave an illiterate Ministery to the Churches, when our present Ministers shall lie in the dust. And as wee were thinking and consulting how to effect this great Work, it pleased God to stir up the heart of one Mr. *Harvard* . . . to give the one halfe of his Estate . . . toward the erecting of a Colledge: . . . appointed to be at Cambridge . . . and . . . called (according to the name of the first founder) *Harvard Colledge.* [4]

The very first sentence is important, for it summarizes the Puritan priorities: first, to conquer the environment; second,

In Adam's Fall
We sinned all.

Thy Life to mend,
God's Book attend.

The Cat doth play,
And after slay.

A Dog will bite
A Thief at Night.

The Eagle's Flight
Is out of Sight.

The idle Fool
Is whipt at School

The New England Primer, designed "to put the fear of God into colonial youngsters" along with teaching the A, B, C's, exemplified the tone and character of learning sources during the late seventeenth century. (Washington, D.C., The National Museum of History and Technology.)

to build churches; third, to compose a government; fourth, to provide education. And the reason for the last? To see to it that there would be a knowledgeable and literate clergy! In the light of that, no wonder that the second of the nineteen Harvard Regulations promulgated in 1642 read: "Everyone shall consider the mayne End of his life and studyes, to know God and Jesus Christ which is eternal life."[5]

In the years before 1636 schooling was of course provided for children below college age. We don't know exactly when the first edition of the *New England Primer* appeared, but it must have been fairly early in the century, for we know it was widely disseminated by 1660. It was first and foremost designed to put the fear of God into colonial youngsters. In addition to the *Primer* their sources of learning were almost entirely the Bible, psalmbooks, and testaments—a far cry from "Sesame Street."

The history books make much of the famous Massachusetts Bay Colony Education Law of 1642. They hail it as the foundation of our school system, but in fact it contains not one mention of schools. It was aimed rather at parents and the masters to whom youngsters were indentured under a widely practiced "apprentice" system to ensure that children's "ability to read and understand the principles of religion and the capital laws of the country"[6] would not be neglected.

By 1650, however, clauses appeared in the codes of Connecticut and Massachusetts establishing schools in every township and obliging citizens, under pain of fines, to support them. In consequence, town schools and Latin grammar schools were set up, not only in New England but in Virginia and the other colonies. The emphasis was on learning to read, both in the native tongue and in the classical language. But especially in New England the smell of fire and brimstone still hovered heavily in the air outside the early classrooms.

Mention of "the capital laws of the country" draws us to an insightful passage of Tocqueville. "Puritanism was not merely a religious doctrine," he observes, "but corresponded in many points with the most absolute democratic and republican theories."[7] No sooner, then, had the Pilgrims landed in 1620 than they drew up the Mayflower Compact:

We . . . solemnly and mutually, in the presence of God and one another, covenant and combine ourselves into a civil body politick for our better ordering and preservation; . . ."[8]

So the pieces of the mosaic that constitutes the American personality begin to come together before the seventeenth century is over: the solid foundation stones of religion—Protestant (Calvinist) in New England and Catholic further south in Maryland; the assertion of civic responsibility and the voice of democracy; and the concern for education at lower and higher levels.

Puritan prejudices regarding money and art

Two other pieces are needed to complete the American mosaic: Tocqueville proffers one with his usual candor. "One sees them," he writes, referring to the settlers of New England, "seeking with almost equal eagerness material wealth and moral satisfaction; heaven in the world beyond and well-being and liberty in this one."[9]

What might appear as a contradiction, in fact arises from the very nature of the Puritans' faith, which is characterized in the familiar phrase "The Protestant Work Ethic" and expressed in the familiar admonition "Satan finds work for idle hands." This American ambiguity between God and wealth remains enshrined in our currency. Do you realize that every time money changes hands in our country today—three hundred years later—from the penny to the largest greenback, it is accompanied by the reminder "In God We Trust"? Thus do we declare our allegiance to our forefathers' paradoxical spirit—a tribute to the Lord Almighty embossed on the face of every almighty dollar.

It is worth a moment's pause to see how it came about that God and mammon thus joined hands, so to speak, so early in our country's developing personality, for this bond will have its effect on America's attitude toward art.

The phrase "The Protestant Ethic" is part of the title of a landmark study by the nineteenth-century German scholar Max Weber, *The Protestant Ethic and the Spirit of Capitalism.* Weber's book traces the Protestant tendency to regard material well-being and economic success as indications of God's favor. An austere life of work and worship became the surest path to salvation, testifying to the Protestant notion of "voca-

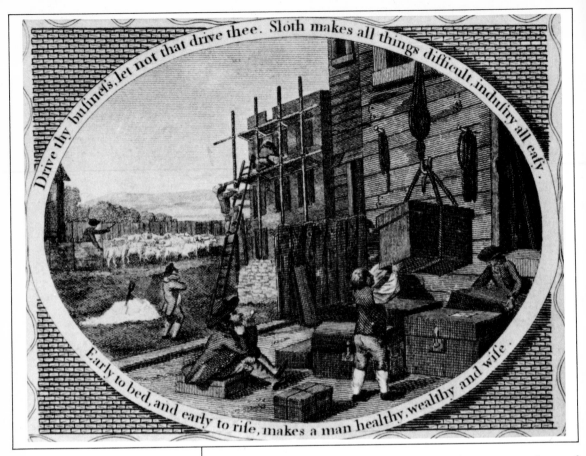

Drive thy business, let not that drive thee. Sloth makes all things difficult, industry all easy. Early to bed, and early to rise, makes a man healthy, wealthy and wise.

Bowles' Moral Pictures or *Poor Richard Illustrated, Lessons for Young and Old on Industry,* are engravers Bowles' and Carver's depiction of the Protestant work ethic. From an illustration in *Poor Richard's Almanac.* (New Haven, Connecticut, Yale University Art Gallery, the Mabel Brady Garvan Collection.)

tion," the belief that God called each person to some form of work. Thus, the successful manipulation of money and the acquisition of what it could buy served to proclaim the Protestant's hard-working, hard-praying status among the "elect," those most likely to get ahead not only in this world but the next.

The last piece of the American mosaic, the arts, must remain missing, and the more noticeable by its absence. It is necessary to keep in mind, as has already been pointed out, that the arts—as they were formally understood in our formative years as a people—were nonexistent. In the statement concerning the curricula of Harvard College and the College of William and Mary (founded in 1691), the word "arts," by which we mean the fine, visual, or performing arts, is never mentioned. We have had a long way to come from the seventeenth century.

The first three-quarters of the American eighteenth century can be viewed as prelude to the great event: the American Revolution with its Declaration of Independence and the establishment of the nation. During those seven and one-half decades, education moved forward. Yale and Princeton, Dartmouth and King's College (which was to become Columbia) were founded. Academies to prepare the sons of the wealthier colonists for admission to these colleges multiplied. Elementary and secondary schools expanded their curricula and their number. And the appearance of "private masters" to fill in the gaps with such subjects as bookkeeping, shorthand, navigation, modern languages, fencing, and needlework reminds us of our "continuing education" instruction of today. Among these supplementary offerings appeared the first announcements of the arts in or out of education.

As early as 1716 the following advertisement appeared in the *Boston News Letter* of April 16–23:

> This is to give notice that there is lately sent over from London a choice Collection of Musickal Instruments, consisting of Flageolets, Flutes, Haut-Boys, Bass-Viols, Violins, Bows, Strings, Reads for Haut-Boys, Books of Instruction for all the Instruments, Books of ruled Paper. To be Sold at the Dancing School of Mr. Enstone in Sudbury Street near the Orange Tree, Boston.
>
> NOTE: Any person may have all Instruments of Musick mended, or Virginalls and Spinnets Strung and Tuned at a reasonable Rate, and likewise may be taught to Play on any of these Instruments abovemention'd: dancing taught by a true and easier method than has been heretofore.[10]

The advertisement of another of these private masters takes us to South Carolina:

> This is to give Notice, to all young Gentlemen and Ladies inclinable to be taught the Art of DRAWING, that an Evening School for that purpose will be open'd on the first of November next, at my house on Friend Street, where every Branch of that Art will be taught with the greatest Exactness by
>
> Jeremiah Theus[11]

21

As the eighteenth century moved forward, a successful mercantile establishment emerged in New England, the Middle Atlantic colonies, and the South. With success came some slight ease in the workload along with a desire for civilizing accomplishments. The new entrepreneurs looked to England as their cultural mentor. In dress, in literary fashion, in the arts, the mother country—as was natural—was the arbiter of taste. American artistic talent largely expressed itself in endeavors of utilitarian and decorative purpose—preeminently in architecture but also in the creation of furniture, silver and pewter, and wallpaper, as well as in artistry with thread for crewel and quilted coverlets. This primitive and provincial work by largely untutored and anonymous artists can, from our perspective, be called "folk art," though such a term for utilitarian objects would have dismayed our ancestors.

Painting appears to have been the first fine art, along with architecture, that was significantly established in our pre-Revolutionary culture. Its development reveals a tie to Europe on the one hand and to the wealthy patron on the other.

The first significant American painter in our history was Benjamin West. Ironically, he gained his fame and lived most of his life in England. He was born in Pennsylvania in 1738, where his talent and eagerness to perfect it called him to the attention of wealthy patrons who enabled him to go to Italy to study for three years. Thence he went to England, where he became prominent and successful, a member of King George III's household, and for twenty-eight years president of the Royal Academy.

More important for the history of American art, however, he became a sort of "one-man academy." In the fifty years after 1764, West's studio in London drew to it dozens of his young fellow countrymen who went abroad to study art, among them Charles Willson Peale, Gilbert Stuart, John Trumbull, Thomas Sully, Samuel F. B. Morse. These men came home to become, along with John Singleton Copley, America's first artist-teachers, and from them would emerge our first academies of art.

The focus of this early American painting was on portraiture, and as a consequence art became associated with the well-to-do. It is easy to see why. Artists live by commissions, and portraitists by the persons who sit for them. Since it was mostly wealthy people who had the leisure time to pose and

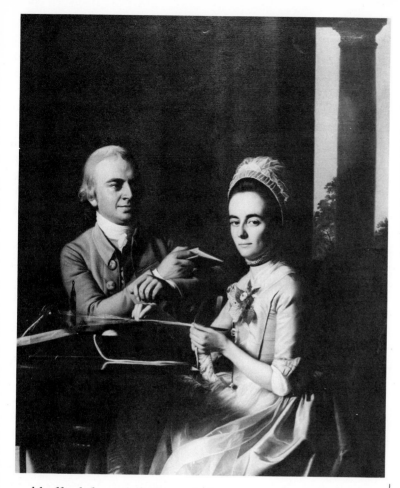

Mr. and Mrs. Thomas Mifflin, 1774, by John Singleton Copley. The portrait was an accepted art form in colonial America as pointed out by historian Jules Prown who has written that Copley understood colonial America to be "a pragmatic society wedded to the facts of life, more concerned with the material realities of this world than the spiritual potentialities of the next. For this society, portraiture was the one acceptable art form because it had a practical social application. A portrait could be sent of a family far away as a token of the physical presence of a loved one, or it could descend to a family distant in time, providing a kind of material immortality."* (The Historical Society of Pennsylvania, gift of Dr. Mifflin Vistar.)

*Jules D. Prown, *American Painting from Its Beginnings to the Armory Show,* Cleveland, Ohio, 1970, p. 53.

could afford the artist's fee, painting as a status symbol linked to wealth and breeding existed in America before the Republic was born.

At the same time other artistic experiences began to be offered to the American elite. The first playhouse on record opened its doors in 1716 in Williamsburg, Virginia. On December 30, 1731, Boston's first public concert was held. In 1732 the *South Carolina Gazette* announced the performance of a "Consort of Musick," and in 1735 the same paper advertised the first recorded performance of opera in America:

> On Tuesday the 18th Inst. will be performed at the Court-room the opera of *Flora, or Hob in the Well*, with the dance of the two Pierrots, and a new Pantomine entertainment called the Adventures of Harlequin Scaramouch. . . . [12]

Singing societies were to play a notable role in the musical life of our country up to and indeed into our present century. It was the Moravians, who immigrated to Pennsylvania, whom we have to thank for leading the way: the first *Singstunde* was formed in Bethlehem in 1742.

The cultural center of the Colonies before the Revolution was Philadelphia, probably because it was then the largest city in America. There an acting company, the Kean-Murray, performed as early as 1749. The following year that company showed up in New York with a repertory of seven works, one of which was John Gay's newly created play, *The Beggar's Opera*. It was also New York, rather than Philadelphia, that witnessed the first performance of our first native comedy, *The Contrast*, by Royall Tyler. But by that time the Revolution had already been fought and won, for the year was 1787. Washington was still President when New Orleans began to present opera; by 1810 it had three theatres and was the first American city to have a permanent opera company.

Reason opposed to the senses

Let us now look from art to education to see if we can find some more than coincidental connection (for good or bad) between the two. What we find is the Enlightenment, certainly one of the major influences upon the American mind and character in the eighteenth century. Abroad, the Enlightenment was most often known as the Age of Reason. Its effect upon the political, religious, literary, educational, and artistic life of the Western world was immense.

"Reason" is a word we are apt to put up in opposition to the senses, associating the former with the activity of the mind, the latter with the feelings and emotions. We might speculate, then, that the fact that our nation was born in an age of reason directed our national attention away from things of the spirit and the senses at a critical moment in our history. To some extent this is probably true. But insofar as the Enlightenment turned our eyes toward the past of Greece and Rome, it was bound to make us more appreciative of a need for balance between mind and spirit—that being the essence

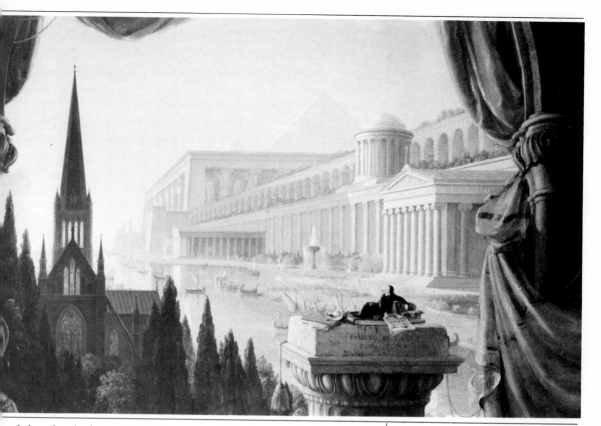

of the classical world. This appreciation in turn had its effect on contemporary expression in the arts and especially in architecture and in a basic style of living.

One of the best ways to approach this "Age of Enlightenment" is through John Locke's *Essay concerning Human Understanding*, published in 1690. His theory of the tabula rasa—that a child's mind is a blank at birth, open to receive through his senses the impressions of experience—was revolutionary. It seemed to imply that the influence of environment and education was the essential factor in making one creature "better" than another—that the aristocrat was made, not born.

In Locke's essay are statements relevant to our investigation, and one in particular stands out:

> First, our senses conversant about particular sensible objects, do convey into the mind several distinct perceptions of things; . . . and thus we come by those ideas we have of yellow, white, heat, cold, soft, hard, bitter, sweet, and all those which

The Architect's Dream, 1840, painting by Thomas Cole. Cole was one of many who saw America as a new Athens. He looked to a time "when the waters shall reflect temple, and tower, and dome, in every variety of picturesqueness and magnificence."* (The Toledo Museum of Art, gift of Florence Scott Libbey.)
*From Thomas Cole, "Essay on American Scenery," 1836.

we call sensible qualities; . . . This great source of most of the ideas we have, depending wholly upon our senses, and derived by them to the understanding I call *sensation*.[13]

Locke is worth paying attention to not only because he seemed to perceive the nature of the problem of "coming to our senses" in a world dominated by reason, but because his thinking very much influenced our founding fathers, especially Benjamin Franklin and Thomas Jefferson, the latter being to many persons the American epitome of the Age of Enlightenment. Indeed, the whole position that "all men are created equal" leads us directly to the idea of the perfectibility of man, which of course underpins the Declaration of Independence. (It was in contradistinction to the Puritan position that while man had a capacity for good, he had an inherent tendency to evil. The tension generated between these two philosophical positions—the first held by Jefferson, the second by Adams—contributes much to the intellectual excitement attendant upon our national birth.)

All the leaders of our Revolution, whatever divergence of opinion or faith they may have had, seem to have been united, however, in the conviction that ignorance is the enemy of liberty and that education is essential to the effective working of a free, democratic society. The quotations pile one upon another:

Preach, my dear sir, a crusade against ignorance; establish and improve the law for educating the common people.[14]

Thomas Jefferson

Laws for the liberal education of youth, especially of the lower classes of people, are so extremely wise and useful that to a humane and generous mind no expense for their purpose would be thought extravagant.[15]

John Adams

Knowledge is in every country the surest basis of public happiness. In one in which the measures of government receive their impression so immediately from the sense of the community as in ours, it is proportionately essential.[16]

George Washington

Nothing can more effectually contribute to the Cultivation and Improvement of a country, the Wisdom, Riches and Strength, Virtue and Piety, the Welfare and Happiness of a People, than a proper Education of Youth. . . . [17]

Benjamin Franklin

To the historian of education, all this is most heartening. To the art historian, it is considerably less so: One looks in vain for quotations of the founding fathers concerning the liberating influence or the cultural enrichment provided by the arts. Among the great figures quoted above, Jefferson is the only one of whom it could be said that the arts were truly a part of his life, the only one who officially acknowledged the values of the senses. It was Jefferson—architect, draftsman, violinist—who when writing in 1800 of his plans for the new University of Virginia made the first recommendation that "Arts and Finearts" should be included in the curriculum of an institution of higher learning.[18]

The young democracy: paradise or paradox?

The nineteenth century was not very old (the year was 1835) when the Frenchman with whom we introduced this chapter of our Report published his *Democracy in America*. Tocqueville's work was the result of a year's travel in our new Republic, which was still in the glow of its adolescence. What is remarkable is how provocative the work is 140 years later. Indeed, early nineteenth-century America can be examined no more fruitfully than through his eyes and mind.

About halfway through Volume I, Tocqueville came to some challenging and possibly "challengeable" conclusions.

> We must first understand what is wanted of society and its government. Is it your object to refine the habits, embellish the manners, and cultivate the arts, to promote the love of poetry, beauty, and glory? . . . If you believe such to be the principal object of society, avoid the government of a democracy, for it would not lead you with certainty to the goal.
>
> But if you hold it expedient to divert the moral and intellectual activity of man to the production of comfort and the promotion of general well being; if a clear understanding be more profitable to man than genius; . . . if instead of living in the midst of a brilliant society, you are contented to have prosperity around you; . . . if such be your desire, then equalize the conditions of men and establish democratic institutions.[19]

27

Committed as America was to the idea of democracy, it is clear which alternative it chose. The object of our society and its government was *not*, as we have already seen, to sustain the cultural embellishments but to attend to "the production of comfort and the promotion of general well being."

Reviewing the marks of our origin, we have already come to this conclusion. We are a nation which seems to "prefer the useful to the beautiful."[20] Tocqueville recapitulates:

> In America everyone finds facilities unknown elsewhere for making or increasing his fortune. . . .His passions, his wants, his education, and everything about him seem to unite in drawing the native of the United States earthward; his religion alone bids him turn, from time to time, a transient and distracted glance to heaven. . . . [21]

The image of American society as inhospitable to things of the spirit and the arts was, then, evident in 1835. It is not hard to conclude that education—which, as we have seen, was firmly supported by that time—would reflect that inhospitality, and perhaps be (almost too paradoxical to contemplate) actually anti-intellectual.

In his chapter entitled "In What Spirit the Americans Cultivate the Arts," Tocqueville goes on to contrast democracies with aristocracies.

> In an aristocracy the artisan would seek to sell his workmanship at a high price to the few; he now conceives that the more expeditious way of getting rich is to sell them at a low price to all. . . . When none but the wealthy had watches, they were almost all very good ones; few are now made that are worth much, but everybody has one in his pocket.[22]

In a democracy, on the other hand, he comments that:

> The productions of artists are more numerous, but the merit of each production is diminished. No longer able to soar to what is great, they cultivate what is pretty and elegant, and appearance is more attended to than reality . . . ; in a word, they put the real in the place of the ideal.[23]

Thus was identified 140 years ago one of the basic problems we have been seeking to solve in America ever since: *How in the arts as elsewhere can we reconcile the demands for quality with the necessity for quantity?* Is it wise to contend that a *little* art (or education, *or* arts education) provided for everyone who would have it is better for society than an in-depth experience

for the few whose talent and brains can best profit from it and thereby most benefit their fellow men? "All the arts for every child," says The JDR 3rd Fund (a private foundation established by John D. Rockefeller 3rd). "Can we be equal and excellent too?" queries John W. Gardner. Tocqueville thought not. This was one of the most critical issues this Panel had to deal with 140 years later, for the intervening decades have not resolved it.

Toward new frontiers: land, mind, arts

Creativity in nineteenth-century America developed principally along four lines, only two of them to do with the arts as we define them in this Report. One line was pursued by our philosophers beginning with Emerson and the Concord group, who wrestled with transcendentalism and with another aspect of Tocqueville's statement last quoted, the real versus the ideal. The second and third lines produced truly creative arts, namely, the literature of gifted authors such as Melville, Whitman, Thoreau, and Hawthorne, and a wealth of painting that expanded the horizons of American art after the somewhat limited delights of the portraitists. The new breed of painters caught the grandeur of America in magnificent landscapes, as exemplified by the Hudson River School, and the flavor of everyday life in cities, villages, and farms.

The fourth line of development was a massive surge of energy, which united the American people in their greatest enterprise, the making of a nation. This creative impulse to settle the land was spurred anew by the Louisiana Purchase of 1803, which called Americans westward with a shout, "Look, the land is bright!" In ever increasing numbers, the pioneers pushed into Kentucky and Ohio and Indiana, to Illinois and Missouri and the Great Plains, across the Rockies to Oregon and California, then to Louisiana itself and Texas.

The westward migrations, the search for new land, for silver and gold, challenged the imagination both before and after the Civil War. To open up a continent, to lay out cities, to build bridges and roads, canals and railroads, to wrest iron

Kindred Spirits, 1849, by Asher B. Durand, was painted as a tribute to Thomas Cole and the Hudson River School painters. Cole is pointing out to his friend, the poet William Cullen Bryant, nature's uplifting beauties in the Catskills. (New York Public Library.)

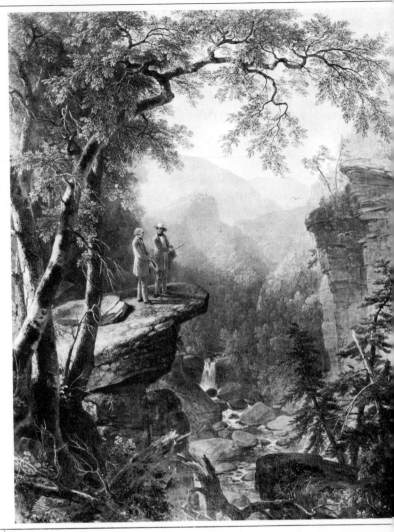

This early advertisement of the newly invented McCormick Reaper (opposite), dramatizes the indispensability of energy, and of course the reaper, to the cultivation of America westward. (Chicago Historical Society.)

from the earth and gold from the streams—what could call forth more creative energy? True, it called for the talents of the engineer rather than of the artist, but it was nonetheless creative in the full sense of the word. If the United States in the nineteenth century produced no great music, drama, painting, or sculpture, it did produce America in all its broad majesty.

In the process, to be sure, the ax became mightier than the pen. The frontiersman, intent on clearing land and opening up new vistas of another sort, could—and presumably did—scoff at the fellows who wielded nothing heavier than

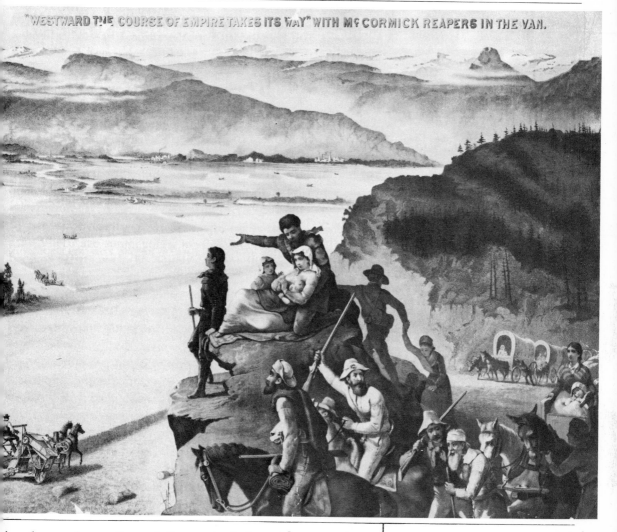

"WESTWARD THE COURSE OF EMPIRE TAKES ITS WAY" WITH McCORMICK REAPERS IN THE VAN.

brushes and pencils and flutes. And that did not increase respect for the arts. Indeed, right then and there (if it had not already happened) an American misconception was given substance: the arts were effete and their pursuit was unmanly.

But if the arts moved westward haltingly, education went as fast as the frontier expanded. The great ordinances of 1785 and 1787, granting free land for public school building, ensured that as the nation expanded, schools at both lower and higher levels would prosper. The Ordinance of 1787 devoted only one sentence to education, but it was enough: "Religion, morality and education being necessary to good government

and the happiness of mankind, schools and the means of education shall be encouraged."[24] "I doubt," said Daniel Webster, "whether one single law of any law-giver, ancient or modern, has produced more distinct, marked and lasting character than the Ordinance of 1787."[25]

Horace Mann is a name to revere in the history of American education. Between 1837 and 1848 he was the chief school officer of Massachusetts. During his incumbency he issued twelve annual reports. His seventh, published in 1844, contained a recommendation that concerns us here. It calls for an enrichment of the curriculum through "the introduction of music, drawing and the study of natural objects."[26]

Mann's proposal may well have come in response to the voice of another pioneer in American public education, this one in the arts, specifically music: Lowell Mason. (You may recall him as the composer of "Nearer, My God, to Thee" and "From Greenland's Icy Mountains.") In 1838, Mason was made the world's first superintendent of public school music. The city was Boston. Two years earlier the Boston School Committee had received a memorial, "praying that instruction in vocal Music be introduced into the Public schools of this City." In it is the following paragraph, which summed up 141 years ago this Panel's case:

> Now, the defect of our present system, admirable as that system is, is this, that it aims to develop the intellectual part of man's nature solely when for all the true purposes of life, it is of more importance, a hundredfold, to feel rightly than to think profoundly. . . . Through vocal music you set in motion a mighty power which silently, but surely, in the end, will humanize, refine and elevate a whole community.[27]

Through midcentury shocks to the first centennial

We must be careful not to go overboard in considering early sporadic developments. For while artistic life in our country began to acquire a national identity during the nineteenth century, the fact is that these developments took place outside our educational establishment. The spirituals and plantation songs of the black man, the cowboy songs out of the

West, Appalachian ballads out of the East, and French Creole dance-songs out of the South joined with the gospel hymns from all four corners of the land to enrich our native musical expression. But our schools took no notice. It took a European, Anton Dvořák, the great Czech composer who came to America toward the end of the century, to recognize the worth of both native American Indian and Negro music from the perspective of formal European composition. "In the Negro melodies of America," he said in a press statement in 1894, "I discover all that is needed for a great and noble school of music."[28]

Even then, the educational establishments took no notice. The music they taught, like the instruction in drawing that they offered (and these were the only art subjects acceptable in the curriculum), was tamely and safely academic.

This state of affairs was not, to be sure, so remarkable. For nineteenth-century Americans had other priorities and were being assaulted by other influences that turned them away from both the learning and practice of the arts. The great land grant universities and colleges held the focus on utilitarian goals of learning: cows and crops and what were called "applied sciences."

Other pressures were building up too, pressures that in the long range of our cultural history were perhaps even more powerful than the socioeconomic ones and that had more effect upon our educational, intellectual, and artistic life.

Probably the most important of these pressures were of foreign origin. They came to America through the works of four authors: the early-nineteenth-century German philosopher Hegel, the English natural scientist Charles Darwin, the political scientist Karl Marx, and the Viennese psychologist Sigmund Freud. Together they wreaked havoc with the religious, philosophical, political, and social beliefs that Americans and everybody everywhere in the Western world had pinned their faith to as long as anyone could remember. These four men and their revolutionary ideas provided the watershed between the eighteenth century and our own day.

The fact that three of the four were scientists, in various meanings of that word, leads inexorably to the conclusion that the new age will be one in which science is enthroned and "cognitive learning" becomes primary. The case for the feelings, for the senses, for the arts, if you please, is going to

suffer as thoughtful men and women become preoccupied with the implications of evolution, socialism versus capitalism, and psychology. To be sure, the arts will respond to these revolutionary concepts and express them in various forms, but that will not happen until the twentieth century.

Other pressures generated at home were building up. These too had their effect on the two worlds of our concern— education and the arts. The industrial revolution had swept across the Atlantic with hurricane force, compelling us to deal with the rising power of labor, the consolidation of business, the expanse of commerce and trade, the management of money and wealth.

The American genius asserted itself in all these fields, but at no small cost to things of the spirit. John Adams had long before said:

> I must study politics and war so that my sons may have liberty—liberty to study mathematics and philosophy, geog-

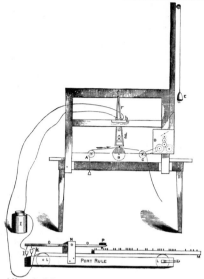

Allegorical Landscape Showing New York University, 1836, by Samuel F. B. Morse, indicated how institutions of higher learning were often idealized in the nineteenth century. When the public's interest in Morse's flamboyant style of painting declined, he shifted his attention to science. He pioneered still photographs and as illustrated above, through the ingenious use of a wooden painting stretcher, he formed a support to house a series of wires and marking instruments which led to his invention of the telegraph. (The New York Historical Society.)

George Eastman with his Kodak No. 1 aboard ship in 1890. (George Eastman House, Rochester, New York.)

raphy, natural history, naval architecture, navigation, commerce and agriculture; in order to give their children a right to study painting, poetry, music, architecture. . . . [29]

A brave vision, not invalidated by the fact that Adams' sons kept right on with their studies for a good 100 years before some of them felt it was time for *their* children to fulfill the last part of the old man's dream.

The American genius also asserted itself, as we all know, in scientific discoveries and inventions. Samuel F. B. Morse was mentioned earlier as an early-nineteenth-century American painter. His name is more familiar to almost all of us, however, as the inventor of the telegraph. He, Robert Fulton, and Eli Whitney of the cotton gin were but the vanguard of a great procession of nineteenth-century inventors and inventions. There were Edison and his incandescent light and his phonograph, Bell and his telephone, Eastman and his Kodak, followed by the trolley car and the subway, the motion

picture, later mechanizations in farming, and a thousand other contributions to America's new identity as the great technological society. No scientific or technical problem was too tough to tackle. Some of the scientific advances, what's more, could affect greatly the cultural and artistic life of the country.

Turn-of-the-century changes

Before the end of the nineteenth century, it was clear that the United States was sure to become a great world power. Only tsars and mogul potentates could challenge the wealth that began to accumulate in the coffers of men who bore names like Morgan, Vanderbilt, Rockefeller, Carnegie, Astor, Huntington, Hill, Stanford, Crocker.

All this, one is happy to note, was good for both education and culture. It appeared that at long last the materialistic nation we had been becoming, in fulfillment of Tocqueville's prophecy, might right the imbalance between matter and spirit. Now a generation of Americans existed who accepted the responsibilities for culture that wealth carried with it. Most of the men just mentioned saw to it that their names were emblazoned on the facades of art museums and libraries or the gates to university and college campuses. Their purses paid for the deficits of opera companies and academies of music, even as those of the princes of Europe had done for centuries.

The highly touted art patron, of course, tended to perpetuate the popular notion that the arts are playthings of the rich. Still, if the patrons had not been there at that particular moment, one wonders whether in later decades we would have had any art to democratize. For it is a fact that the great orchestras of a dozen cities; the Metropolitan Opera; museums including Chicago's Art Institute, the Boston Museum of Fine Arts, the Metropolitan in New York, and the National Gallery in Washington; the University of Chicago and Stanford University all came into being and in some instances are still perpetuated through the largesse of individual donors bearing the names of Frick, Mellon, Kress, and dozens of others.

I

n the context of this Report, two of the most significant developments in twentieth-century America are first, the broadening of truly American arts—American music, painting, sculpture, architecture, theatre, dance, photography, graphic design, film—and second, the awakening of our peo-

Arithmetic, 1911, by Maxfield Parrish, graced the cover of "Collier's" for a back-to-school edition. Through their wit, insight, and artistic skills, illustrators like Parrish, Norman Rockwell, Walt Disney, and Charles Schulz have done much more than stimulate the sales of magazines, newspapers, and films; they have touched the pulse of our culture. (Vose Galleries, Boston, Massachusetts.)

Ruth St. Denis in "Angkor Vat," one of her original compositions about 1930, helped to cultivate an appreciation for unfamiliar and exotic ethnic art. (New York Public Library at Lincoln Center for the Performing Arts, Dance Collection.)

ple to a realization that these American arts exist. It did not happen overnight, and as far as the second point is concerned, a large number of our citizenry still do not realize the vast range of American arts (or if they do, couldn't care less).

The most popular of these arts, the movies, came into its own, paradoxically perhaps, through our aptitude for the applied sciences. Early in the century nobody acclaimed the cinema as an art form. It first attracted attention (as had its parent, still photography) as a fascinating new invention. But by the turn of the century, Alfred Stieglitz had won acceptance for the still photographer as an artist, and by 1915–16, when D. W. Griffith released *The Birth of A Nation* and *Intolerance*, it was clear that America possessed a second new art form—film.

It is no exaggeration to say that American movies have been our most heavily exported art, indeed (even in their inferior manifestations) the principal touchstone by which our culture is universally judged. That American movies acquired this dominance surely derives from the unique necessity of this medium to ally the inventor with the artist. "The artist has no control over the inventor nor over the technological advances that come into his medium," Arthur Knight, the film historian, has reminded us. "Indeed," he adds, "the history of film is largely an account of directors the world over who, experimenting with the machinery of inventors, found ways to create. . . ."[30]

Dance, another art form which has attained phenomenal acceptance, also began to stir in America in that first decade of the new century. Following the tradition of her pioneer ancestry, Californian Isadora Duncan indirectly revolutionized the face of the dance world, affecting both the ballet and modern dance as we know it. Certainly through her work and personality and the schools she established in Europe and at home, she demands acknowledgment in the history of American arts. She and Ruth St. Denis, whose first composition dates from 1906, put the world on notice that American dance would not be a slavish imitation of European classical ballet models. Martha Graham herself started her study of dance under Ruth St. Denis. Miss Graham, whose career has spanned more than half a century, has lived to hear herself hailed as the "oracle" of American art.[31]

Equally remote from the applied sciences but close to the

heart of the people was popular music. It is time to pick up the motif we heard earlier. Virgil Thomson once remarked, "The United States is the one country in all the world that produces all kinds of music that there are. Only here do composers write in every possible style and does the public have access to every style."[32]

So after we have bowed before the talents of such a diverse company as Edward MacDowell, Rubin Goldmark, Aaron Copland, Charles Ives, Roger Sessions, and Mr. Thomson himself, we must salute Victor Herbert, Jerome Kern, Irving Berlin, Cole Porter, and Richard Rodgers, who have joined forces with their colleagues in the theatre to make the American musical theatre one of our unique gifts to the world. Finally, we salute the masters of ragtime, the blues, jazz, and "swing": Scott Joplin, W. C. Handy, Jelly Roll Morton, Paul Whiteman, George Gershwin, Benny Goodman, Duke Ellington, Louis Armstrong—among a host of others.

The greatest contribution that any one ethnic group within the American population has yet made to American arts is that of blacks to music. Long before this century—150 years or more —blacks began to blend their African rhythmic and melodic heritage with European harmonies (mostly from "folk" rather than "classical" origins) to create the Negro spiritual, and finally jazz itself. But it was not until our own century, "around 1900 . . . when the overall direction switched from European elements dominating African elements to European elements being influenced by a new combination dominated by African elements,"[33] that the magnitude of the accomplishment began to be properly appreciated. Indeed it was 1947 before John and Alan Lomax announced belatedly—but not too late:

> . . . there can be no question in the minds and hearts of those who have heard them that in the Negro spirituals American folk art reaches its highest point. Indeed, we assert that these songs form the most impressive body of music so far produced by America, ranking with the best music anywhere on this earth.[34]

Whereas "spirituals . . . present the Negro as a thoughtful human being, and reveal some of his aspirations . . . ,"[35] the blues rise out of a deep emotional yearning felt by blacks for

Irving Berlin's cascade of popular songs, both words and music, celebrated fifty years of American history and social culture, and reflected the enriching influence of blacks, Jews, Germans, Austrians, Irish, Italians, and Hispanic people. (Photograph by Arthur Rothstein.)

JAZZ

Jazz. (according to The
Oxford Universal Dictionary
 on
Historical Principles)
Is a kind of music
In syncopated time
 as played
By Negro bands in the U.S.
 and
Music. Is a fine art concerned
With the beauty of form
And the expression of thought
 and feeling.
Negro. (also nigger, esp. a male)
Is one distinguished by
Black skin
Woolly hair
Flat nose
 and
Thick protruding lips.
 [Thus defined in
This same eminent tome
Edited by C. T. Onions C.B.E.,
F.B.A.
 and
Other corresponding fellows
Of the Mediaeval Academy
 of America.]
Well,
Question not these lettered
Fellows of Oxford.
 Jazz,
The meaning of it,
Is as evasive as silence.
Name one who could
Accurately define this
Passional art that slices
And churns one's senses
Into so many delicate
 barbarous
And uncountable patterns.
But alas for me
One definition would suffice.

Jazz (n). Edward Kennedy
Ellington
Also known as Duke, Big Red,
Monster
 duc, duk, ducem.

 Gordon Parks

many centuries. So when Scott Joplin's ragtime began to wane around the time of World War I, the blues came into their own, to be succeeded in turn by jazz. One of its most eminent historians and critics, Marshall W. Stearns, asserts that "more people in the United States listen to and enjoy jazz or near-jazz than any other music . . . jazz has played a part, for better or worse, in forming the American character."[36] He defines it—correctly, we believe—as "the result of a three-hundred-years' blending in the United States of the European and West African musical traditions."[37]

The significant component is, of course, the West African, which has waited long to receive proper acknowledgment from chroniclers of our American culture. The schools took no academic interest in these native American musical developments until the 1960s when pressure forced their belated recognition and subsequent study within the curriculum. On the other hand, John Philip Sousa quickly became the patron saint of high school music: The military marching band was the justification for money spent on musical instruments and instruction in their use. Ironically, the enthusiasm for the martial strains of band music was generated by the demands of organized sports and their public relations needs.

No history of American education during the first twenty-five years of the twentieth century can avoid mention of "progressive education" and the writings of John Dewey on the twin concerns of this Panel—art and education. We now have a little better perspective on the much debated movement itself. From our vantage point we can perceive that out of it emerged, whatever else, the first real concern for children's natural interest and talents, with an obvious corollary that self-expression could lead to an opening-up of receptivity to all forms of artistic creation.

In the first quarter of our century came increasing evidence that the United States took seriously the education of its professional artists. True, the Art Students League had existed since 1875 in New York City and George Pierce Baker had been teaching creative dramatic writing at Harvard since 1905 (although under the guise of an English course). And it was 1914 (the year Eugene O'Neill went to study with Baker) before the Carnegie Theatre of the Carnegie Institute of Technology gave its first production, and 1921 before the first

major conservatory of music opened—the Eastman School in Rochester, New York. In 1923, the second great music school opened, the Juilliard in New York City. A year later the Curtis Institute of Music came into being in Philadelphia. Thereafter the pace quickened and other training schools in the arts appeared. One of the most significant was the School of American Ballet founded by Lincoln Kirstein and George Balanchine in 1933, heralding the arrival of native classical ballet to take its place alongside modern dance forms.

During the thirties and early forties America benefited by an influx of refugees from Germany and other European countries, endowing our nation with some of the most creative minds and important teachers of this century. Among them were the musicians Stravinsky, Serkin, and Hindemith; authors Mann and Brecht; painters Léger, Chagall, Mondrian, and Albers; architects Gropius and van der Rohe; choreographer Balanchine; and photographer Eisenstaedt.

These paragraphs on the changing arts scene in twentieth-century America must be interrupted to note an event of major importance: the Great Depression with its economic

At the Time of the Louisville Flood, 1937, by Margaret Bourke-White. The grim realities of the Depression years are brought to life against a striking backdrop of the optimism and prosperity that ushered in the 1930s. (Time-Life Picture Agency.)

41

The "Quiz Kids," 1938 radio program with Joe Kelley as Schoolmaster. Radio in the thirties and forties popularized symphony concerts and the big band sound of Tommy and Jimmy Dorsey, Glenn Miller, Count Basie, and Paul Whiteman, to name only a few. People sat riveted to their radios, listening to the President's fireside chats and such exciting broadcasts as Orson Welles' "War of the Worlds." (Time-Life Picture Agency.)

A schedule from the week of June 5, 1938, on NBC radio represents the varied bill of fare that emphasized music and educational programs. (Courtesy of NBC, Inc.)

NBC-*Red*:	ONE MAN'S FAMILY—sketch
NBC-*Blue*:	ROY SHIELD'S REVUE
CBS:	CAVALCADE OF AMERICA—guests, Voorhees' orchestra
MBS:	ORCHESTRA
NBC-*Red*:	RALEIGH AND KOOL SHOW—Tommy Dorsey's orchestra, Edythe Wright, Jack Leonard, Paul Stewart
NBC-*Blue*:	HARRIET PARSONS—Hollywood commentator
CBS:	BEN BERNIE—Lew Lehr, Buddy Clark
MBS:	LET'S VISIT—Dave Driscoll, Jerry Danzig
NBC-*Red*:	TOWN HALL TONIGHT—Fred Allen, Portland Hoffa, Van Steeden's orchestra
NBC-*Blue*:	ANDRE KOSTELANETZ—Deems Taylor, guests
CBS:	ANDRE KOSTELANETZ—Deems Taylor, guests
MBS:	ORCHESTRA
MBS:	JOHNSON FAMILY (9:15)—sketch, with Jimmy Scribner
NBC-*Blue*:	BOSTON "POP" CONCERT
CBS:	THE WORD GAME—Max Eastman
MBS:	JAZZ NOCTURNE—Helene Daniels, Stanley's orchestra
NBC-*Red*:	KAY KYSER'S MUSICAL CLASS AND DANCE
NBC-*Blue*:	CHOIR SYMPHONETTE
CBS:	GANGBUSTERS—crime dramatizations, Col. H. Norman Schwartzkopf
MBS:	ORCHESTRA
NBC-*Blue*:	NBC MINSTREL SHOW—Gene Arnold, orchestra
CBS:	EDGAR GUEST IN "IT CAN BE DONE"— Marion Francis Masters' orchestra
MBS:	MELODIES FROM THE SKY
NBC-*Red*:	DANCE MUSIC
NBC-*Blue*:	DANCE MUSIC
CBS:	DANCE MUSIC
MBS:	ORCHESTRA

dislocations, its social realignments, its spiritual reorientations. The reverberations of the Wall Street crash of 1929 thundered across America, shattering its long-held faith in the "get-rich-quick" philosophy. Forcing us to question our basic belief in a materialistic society, it made us wonder possibly for the first time whether money was, after all, the answer to all our needs.

Simultaneously we were exposed to a new liberalism and a new materialism—dialectical—which beckoned for our attention from Russia as we began to absorb and adjust to the first shock of its Bolshevik upheaval. The 1930s was the decade of an arising social consciousness reflected in our attitudes toward many of our institutions, not least our cultural and educational ones. The support of the arts by the federal government's Works Progress Administration (WPA), although intended to alleviate unemployment, more significantly gave a tremendous impetus to native artists. It provided them with all sorts of challenging commissions, to which murals still visible in public buildings bear witness. It created too a new audience for the arts, as anyone who attended Federal Theatre performances in the thirties can testify.

The idea of arts for the people was a dynamic one, in fact, so dynamic that Congress abolished the WPA's Federal Theatre Project. Once uncorked, however, it could not be rebottled.

There is no knowing how far we might have gone toward exploding the myth that the arts belong principally to the rich and the privileged had World War II not come along.

But the conflagration did occur, and so it was the mid-forties before accelerated academic programs and our emergency wartime priorities could be relaxed and the country could think again about the arts and about education. Those postwar years presented both educators and artists with new prospects and problems: the population explosion and the rising gross national product with hitherto unheard-of resources to create whatever kind of social and cultural environment we wanted. As television emerged, it began to alter our relation to the world and present incredible new opportunities to our arts and to the dissemination of information.

Then came Sputnik. It is scarcely necessary to remind Americans of the shock created by its launching in 1957. It meant that our priorities in education must be reordered. Once again concern for the arts yielded precedence to science. A year later the National Defense Education Act was passed; arts and humanities activities received little support under the Act until the late 1960s.

Senator Joseph McCarthy was one of the first political figures to use television as a medium of persuasion. In stirring latent fears of communism, he helped create an atmosphere that placed a stigma on many educators and artists. (United Press International, 1954.)

Conscious pursuit of American culture

Thrown off balance by the Russians, we failed to realize until the mid-sixties that we had to go on living in this new nuclear age and that living meant exploring all the world about us, not just the physical. When we recovered our balance, we found new interest in the arts. We found ourselves taking a new look at our own films, for instance. We found a renewed appreciation of dance in all its forms; new literary and poetic voices to listen to; new architects fashioning new buildings to inhabit; new urban planners to show us how to alter our cities. We found ourselves making new demands on television,

One of television's first gestures toward education in the 1950s came in the form of Miss Frances at "Ding Dong School." (Courtesy of NBC, Inc.)

beginning to take a new look at our theatre with an eye to making it nationwide (regional, we called it). By that time we were well into the 1960s.

In the years that preceded, these new explorations had begun to attract the attention of the great foundations, which by that time had superseded the early philanthropists to whom we bowed at the turn of the century. Of course, many of the foundations bore the old familiar names: Rockefeller, Carnegie, Ford, Mellon. It was the foundations that in the forties and fifties fed educational research and encouraged new programs; for example, aiding television pioneers who wanted to treat the medium as a cultural asset. They also began to underwrite the arts.

Unquestionably, however, the entrance of the government at all levels into the world of the arts was the big news of the sixties for the cultural community. In fact, so important is it that we have given it a chapter to itself.

In the private sector, as the decade advanced, new activities germinated: The Associated Councils of the Arts (ACA) came into being to correlate and aid the work of newly created arts councils. A Business Committee for the Arts was set up to encourage and direct a new flow of corporate support for them.

In the early 1960s, one also confronts a renewal of the black arts movement, which first emerged in Harlem in the 1920s. In its recent manifestation, according to the black essayist Larry Neal, the movement tends to avoid "racial protest" directed against the whites. "It speaks directly to Black people," says Neal, "and a main tenet is the necessity for Black people to define the world in their own terms. . . .to speak to the cultural needs of Black people."[38]

As weekend playgoers are discovering, Broadway is burgeoning with black theater. There is so much black talent working there—actors, singers, writers, directors—and such a lively black audience that the theater district could almost be retagged the Great Black Way. At the same time, white audiences are discovering black theater. This is not an insular variety of entertainment, but very much part of the mainstream. [MEL GUSSOW, *The New York Times*, Oct. 15, 1976]

Years of irony and promise

As we look at the next decade—in effect the past ten years (1967–1977)—we face a panorama so familiar as scarcely to require recounting. We face in the nation's life the cruel realities of the Vietnam war, the deepest recession since the

1930s, and the prospect of imminent zero growth in our population. We face changing life-styles that give shape to a new morality; changing attitudes toward sex and toward the role of women in our society; accelerating problems relating to our inner cities and their suburbs; the crisis in public confidence stemming from Watergate; increasing concern for the environment and for consumer rights.

During the troubled period of the recession, education budgets were cut almost as drastically as those of arts institutions. Private colleges and state universities alike underwent belt tightening; school boards, superintendents, and principals were forced to reevaluate their priorities. As the last subjects to be added to elementary and secondary curricula, the arts usually were the first to suffer. The situation was not much better in institutions of higher learning. As early as 1970, Columbia announced it was cutting back its School of the Arts. The State University of New York in 1967 created a new four-year college at Purchase, whose mandate was to institute a professional training program in the visual and performing arts. But before its first four-year class had graduated, its budget had been so tightened that it seemed questionable, once the four-theatre multimillion-dollar center had been completed, that the university could afford to finance its ambitious teaching and stage-production programs. With the prospect of a declining population and reduced enrollments, the cuts that were made at every level seemed likely to be permanent ones, unless pressure was brought to bear or the economy soared skyward again.

The decade saw a rise in public concern for the reemphasis on "basic education." Troubled by statistics that indicated a deterioration in the school population's ability to read and write, the public lined up enthusiastically behind a "back to basics" movement that boded no good for arts educators unless they could prove that their subjects qualified as basic to learning.

Lest this chapter appear to conclude on too bleak a note, it must be recorded that during the past decade many constructive and affirmative steps were taken to bring the arts into the mainstream of American education. The list is long. It includes the strengthening of the Central Midwestern Regional Educational Laboratory (CEMREL), which was already providing leadership in helping train classroom teach-

ers to become arts educators; The JDR 3rd Fund's Arts in Education Program; the creation in 1973 of a major national enterprise, the Alliance for Arts Education, in order to fulfill the mandate of the John F. Kennedy Center that it concern itself with arts education on a national basis; the Artists-in-Schools program of the National Endowment for the Arts, which got under way in 1969; and finally and perhaps immodestly mentioned, the creation of this public Panel.

Forecasting with an eagle eye toward our past

What's to be learned, in summation, from this bird's-eye view of our past three hundred years?

First, a confirmation of the suspicion that in our infancy as a people, we were denied the satisfactions and inspiration that art can provide.

Second, that as our educational life was formed it looked toward the triple aim of imbuing us with religious fervor, the civic virtues, the importance of material well-being.

Third, that as our nation became a nation, the arts found growing acceptance, but as an ornament to life, rather than as a necessity.

Fourth, as we trace today the cultural history of America, we are forced to pursue two parallel lines: one of education, strong and straight; the other of the arts, wavering and uncertain.

Fifth, that not until the last thirty of the three hundred years do we see sure signs of the two lines converging, of a conscious effort to move the study, practice, and appreciation of the arts from the periphery of the educational experience toward its center.

The evidence that such signs are now apparent will be placed before you in the chapters that follow. The distance we have yet to travel will also become evident. Much has happened to alter the quality of American life since 1620. Much remains to happen if we are to acquire those enduring values by which our civilization will finally be judged. So let us turn from the past and look now at the present—and beyond.

. . . art means more than the resuscitation of the past: it means the free and unconfined search for new ways of expressing the experience of the present and the vision of the future. When the creative impulse cannot flourish freely, when it cannot freely select its methods and objects, when it is deprived of spontaneity, then society severs the root of art. [JOHN F. KENNEDY, "The Late President's Last Reflections on the Arts," *Saturday Review*, Mar. 28, 1964]

The arts: a better primer for our children

Bird in Flight by Robert Vickery.
(Courtesy Midtown Galleries, New York,
Collection of Mrs. Louisa d'A. Carpenter.)

And these I see, these sparkling eyes,
These stores of mystic meaning, these young lives,
Building, equipping like a fleet of ships, immortal ships,
Soon to sail out over the measureless seas,
On the soul's voyage.

Only a lot of boys and girls?
Only the tiresome spelling, writing, ciphering classes?
Only a public school?

Ah more, infinitely more;
(As George Fox rais'd his warning cry, "Is it this pile
 of brick and mortar, these dead floors, windows, rails
 you call the church?
Why this is not the church at all—the church is living,
 ever living souls.")

And you America,
Cast you the real reckoning for your present?
The lights and shadows of your future, good or evil?
To girlhood, boyhood look, the teacher and the school.

Walt Whitman, *An Old Man's Thoughts of School*, 1874

The body of this chapter deals with learning in the elementary schools, much of it as seen through the eyes of educators. There are, however, other eyes through which the schools might be viewed—the children's.

Witness John Culkin had an imaginary conversation with a six-year-old child named Gene and repeated it to this Panel. Gene wonders as he starts to school:

> Why are you sentencing me to twelve years of school? I haven't done anything wrong. Besides, the learning psychologists say that I've already learned 80 percent of what will stay with me for life. In addition, researchers at Harvard say it really doesn't matter which school I go to anyhow. Fourthly, my brother told me you were going to try to make me like things I don't like and dislike things I like. Finally, I've already seen 3,000 hours of television before I set my foot in your classroom. In my short years that's equivalent to about 10 percent of my entire life and a considerably higher proportion of my waking hours. I've been to the moon; I've been to Africa; I've seen the faces of people all over the earth; I've watched a lot of people get killed; I've had a lot of merchandise pushed in my direction; I am not an empty bucket; I am not a blank page on which to write.

Culkin's story contains some fascinating implications. Take Gene's opening phrase, "Why are you sentencing me . . . ?" Does the child, then, look upon school as a prison? What is really going to be important and "stay with me for life"? What does Gene, or rather the "learning psychologists" whom he quotes, consider important? What has he in mind when he says "things I don't like and . . . things I like"?

This Panel lost its childhood years ago and is no more able than any other group of laymen—including parents—to know what goes on in children's heads. The best we can conclude from Gene's outburst is that there is a tension present, a nascent sense of comparative values emerging in the six-year-old. How can we deal with it?

We cannot write the Report from the child's point of view.

Rather than direct our attention to methodology and all the rest, it seems to me that we have to look at the child, the new child in the classroom—the different requirements that the child seems to have. [PATSY T. MINK, Panel member]

51

Jules Feiffer, Nov. 5, 1972, Field Newspaper Syndicate.

Nor are children the public to whom we address it. But they are the focus, and the ultimate audience—not teachers, not administrators, not school boards, but children. They are the consumers, and like other large consumer groups, they have immense potential influence. After all, in our elementary schools there are 34.4 million of them.[1]

John Goodlad of the University of California at Los Angeles, author of *Dynamics of Educational Change*, came close to interpreting Gene's problem when he told the Panel that preliminary studies show that "although among students art ranks at the top in regard to their *satisfaction*, . . . when they are asked to rate the subjects as to which is the *most important*, arts are placed near the bottom."

If arts are the things children like the best, who persuades them they are least important? Their parents? Their teachers? The media? Who else is there for them to listen to? There are in fact all sorts of pressures at work to persuade the child that what he likes he shouldn't like. Maxine Greene, professor of philosophy and education at Columbia Teachers College, called the Panel's attention to another influence, perhaps a hidden one, which suggests that the arts are, for many persons, mysteriously subversive. Those who know little about the arts may fear that contact with art or artists will have an unwholesome effect on people's lives. For all the protestations

about the joys, the uplifting qualities to be found in the arts, there is some fear (usually inarticulate) that the arts may tap regions of darkness, ambiguity, and strange kinds of spontaneity in human beings. This anxiety, often deep-rooted, must be combated in the schools.

The Panel reviewed the issue from various angles. "The artist is generally looked upon as someone outside the conservative system," said one member. The average parent is afraid that if his child gets into an arts program, he or she "will smoke marijuana or who knows what else." Another voice corroborated: "The fundamental temper of the country is conservative. The arts spell trouble because they encourage people to think originally, and outside conventional norms." Many parents, it was claimed, are afraid that "my children are going to think things that I can't comprehend, that they will be drawn away from the line of thinking that I've been taught is right." The Panel concluded that "we have to reassure people that there is a need for this kind of innovative thinking. . . . If we are going to improve the quality of life, then we need to have people around who are capable of innovative solutions."

The arts specialize in forms of knowledge that cannot be translated or expressed in any other way, as Panel witness Howard Gardner of Harvard Project Zero asserted. The key to such knowledge comes from knowing how to read and use artistic symbols—words, pictures, gestures, and the like—how to put meanings into and get meanings out of them. It was pointed out that we need to have skills in order to deal with art objects. We need to be trained and exposed and guided. The arts, as a way of knowing, utilize symbols which are often not verbal. "The educational establishment," said Gardner, "is being derelict and delinquent if it neglects ways of knowing."

. . . in all of our lives we are involved with uncertainties, with fear, even with terror, and in some cases with love and tenderness, and gentleness and sympathy. What has struck me as amazing is that, in talking to people about the arts, they do not realize that this is what the arts deal with—that the arts deal with just those areas of life that everyone keeps hidden, areas that in other societies are sometimes looked upon as primitive. . . . Our job is to touch those people who look at the arts as something expendable. They don't know what the arts are about, and if they, in their own lives, can look at the emptiness, the fear, and the mirror of their emotional selves, it is up to us to make them see the incredible import and fulfillment the arts can provide. [LORIN HOLLANDER, Panel member]

If I could *tell* you what I mean, there would be no point in dancing. [ISADORA DUNCAN, quoted by Howard Gardner, Panel witness]

Working at cross-purposes

A 1975 Gallup poll on education found that a majority of parents would prefer to send their children to schools which placed emphasis on the three R's and offered strict discipline.

Only 33 percent of the public thought it important to "know something about the history of mankind, the great leaders in art and literature." The majority considered the main purpose of schools—just as Tocqueville would have expected—"to prepare students to get jobs and to advance in the business and professional world."[2]

Yet a Harris poll taken about the same time found that 89 percent of the nation's population felt that "the arts are important to the quality of life" in their communities. Moreover, most of the public thought that the schools should be offering even more courses in the arts: 94 percent of the public felt that playing a musical instrument should be taught; 92 percent held that weaving, woodworking, pottery, and other crafts should be taught.[3]

Thus, the American people do appear to believe the arts are important, but simultaneously they are hard put to reconcile that view with their conviction that the schools should concentrate on reading, writing, and arithmetic. Perhaps it should be interpreted simply as a case of wanting to have their cake and eat it too—especially if they can have both for the price of one.

The nation's elementary schools have responded to these conflicting views by respecting Gallup's findings, that is, by generally maintaining a highly structured, traditional

Growth Plan, James Rosenquist, 1966. (Museum of Contemporary Art, Nagaoka, Japan.)

approach emphasizing "practical" subjects. Most elementary schools have grouped children into grades on the basis of age and intellectual achievement, with each grade taught by a single teacher in a self-contained classroom. Though specialists are sometimes introduced to teach music, art, and physical education, the arts have tended to receive limited time, limited resources. Schools continue to look approximately as they were first created in the cities: graded and segmented into priorities which do not include the arts. They are hobbled by factors like "time utilization," which means that there is simply no room in the schedule for something that hasn't always been there—including, of course, the arts.

Even though most of them have accepted these priorities, the nation's schools are failing, even in their chosen practical mission, or so it appears to many: Johnny still can't read, and more recently we have discovered that he can't write either. College entrance test scores have been dropping for a decade. As a result, some educators believe that the "back to basics"

The word curriculum was pretty much based on a presupposition that there was a certain body of knowledge that everybody should have and that there were certain points at which it would be good to have that knowledge. And also, that the student entering the educational system would not be bringing a heck of a lot with her or him. On that basis we used to say, that's a seventh grade subject. Well, there are no seventh grade subjects in the electric age. [JOHN CULKIN, Panel witness]

18—Tues., July 6, 1976 *Tallahassee Democrat*

Writers to Ann all agree:
We must get back to basics

DEAR ANN LANDERS: I read with interest your comment, "The sooner we get back to basics in our schools the better." As one who has worked in education for 30 years I share your concern.

The problem lies in the philosophy of education today. Instead of stressing academic achievement, the idea is to make the student "feel good about himself." A child is allowed to progress at his own rate, which means he can move ahead if he feels like it. Discipline is at the lowest ebb in the history of the public school system. Teachers must spend valuable teaching time maintaining order in the classroom.

Memorizing facts is considered old - hat. Competition and rivalry are said to be damaging because they "create pressure." Grades are "bad" because they can be hard on a child's ego. Our schools are geared to the non-achiever. The result is mediocrity.

In our day we learned how to compete and cope with the world. Now students are encouraged to "do their own thing." If they don't learn anything the world is supposed to cope with them.

Teachers are no longer the focal point for education. They have been replaced by a fanatical preoccupation with programs. So, Ann, what can be done to get schools back to teaching children? May I suggest that parents attend local school board meetings and demand that their tax dollars be spent to educate their children? Thanks for the forum. — From The Athens Of The Midwest — Madison, Wis.

Dear Athens: Several teachers and principals wrote to express a similar point of view, but you said it best. Thanks to all who wrote. I couldn't agree more. (Are you listening, parents?)

Advice
By Ann Landers

Ann Landers, Field Newspaper Syndicate and the *Tallahassee Democrat*.

It is a mistake to relegate the arts to the periphery; they are *basic* in that they constitute a route or a bridge to the underlying order and structure in all the disciplines. [RAY EAMES, Panel member]

cry should be sounded more loudly. By the mid-1970s, more than a third of the states had enacted laws requiring school tests that emphasized measurement of basic skills.[4] With its tradition of pragmatism, the American public is more committed to getting direct results (in terms of the three R's) than to developing the means which produce results; probably it is assumed the arts can only get in the way.

The Panel discussed this "back to basics" movement earnestly with A. Graham Down, executive director of the Council for Basic Education, and subsequently among themselves. As one member put it, "We are just as much concerned [as anyone] about failures of young people to develop themselves fully. In fact, we want to see them develop more fully than they are now, and we think we know how to do it. . . . We are really joining together in pursuit of excellence."

Down agreed. Referring to the report of the Council for Basic Education (November 1975), he said, "The Council has formally included the arts in its restatement of objectives. . . . We believe the arts are a part—and a considerably fundamental part—of basic education."

Child development: the value of the arts

Art is ruled by the two gods, Apollo and Dionysus, who represent the rational and nonrational worlds. In the artistic process these forces battle it out and they have to come to some kind of unified view. How much faith and how much reason? How much of those things is involved in every single perception, in every single thought? It's the very essence of who you are from instant to instant in life. This is why the arts must be there, because they articulate, they transmit, they communicate how everyone has thought—how much reason and how much faith are here. [MICHAEL TILSON THOMAS, Panel witness]

he child psychology scholars begin their respective journeys into the developing mind with at least two shared assumptions. First, the arts are based on symbolic thought and they combine sensation, feeling, and reason to create objects or performances. These objects and performances attempt to interpret experience in a way which expands understanding. Thus artistic thinking is like any other thinking. The impulses that lead to the making of art are identical with those that lead to other kinds of human activity: the urge to understand and to respond; the need to maintain intelligent balance; the desire to predict and control; the wish to celebrate or express delight.

Second, the psychologists recognize a basic distinction between "cognitive" and "affective" learning. Al Hurwitz, coordinator of arts in Newton, Massachusetts, clarified these terms for the Panel:

Suppose you're dealing with paintings: if you have the class gather all the relevant historical and critical information about them and then identify them by style and period, that's pretty much in the cognitive realm. If one child comes up to you and says, "Hey, can I borrow that? I want to take it home and hang it up in my room," that's a form of affective learning. Or, if the student says, "Let me have some paints and a brush, so *I* can paint," that's an affective response. If you teach the student how to mix the paint and how to handle the brush, that's psychomotor.

What has this to do with education and the arts?

> To be able to think . . . the child must be able to evoke what is absent or what has happened to him in the past. In order to be able to do this, the child must construct some kind of symbol to represent what is not immediately present. Representation—the creation of symbols—is the means by which the human being organizes his experience in order to understand or communicate it; language is one way of representing or symbolizing the world; math is another; science another—and the imagery of art is still another.[5]

Since we know that "the child may learn to think with brush in hand,"[6] the arts should have equal time and equal place with the other areas of learning in the curriculum. They can enrich and accelerate development during early childhood and every subsequent growth stage. By examining children's storytelling, drawing, and music, researchers have been able to match the arts with these stages and to help the child move from a reflexive to a reflective human being.

The pleasure of moving a crayon on paper is a complete experience for a young child; as he experiments he varies shapes. He moves from a scribble to up-and-down lines, as well as lines from side to side, eventually making a series of closed circles. What better preparation for writing? Soon he names his works, which are of personal interest to him. This description in words of a painting or drawing is a very simple first effort at creative writing, and gives the child one motivation for learning reading. The arts clearly have influence beyond their immediate boundaries.

A child performs almost as soon as he begins to imitate people around him. All children repeat sounds and movements, mimic their elders, and are generally spontaneous and lacking in inhibitions. Gardner considers the child to have

cognitive: based on or capable of being reduced to empirical factual knowledge
affective: relating to, arising from, or influencing feelings or emotions
psychomotor: of or relating to motor action directly proceeding from mental activity
—*Webster's New Collegiate Dictionary*, G. & C. Merriam Company, Springfield, Mass., 1975, pp. 217, 20, 931.

Science and art are both involved in recognizing patterns; they're both involved in putting these patterns together creatively in ways that no one had ever realized fit together; they both involve not just culture but nature as a whole. Neither science education nor art education is as good as it should be, and I just wonder whether one couldn't stress in this whole thing the fact that the business of noticing and recognizing patterns and of sensitizing people is common to both. [FRANK OPPENHEIMER, Panel member]

Age 5–8

The arts are the natural work of children. The arts are like play—creative, exploratory, purposeful—reality confirming. When painting and constructing, moving and dancing, singing and playing instruments, making and performing plays and stories and poems and songs—when all these are woven into the whole school day, basic subjects are learned more quickly—and are unforgettable.

Age 9–11

This is the age when knowledge is accumulated rapidly and massively. Skills are refined; interests are formed. The arts remain essential knowledge—accessible through all the senses, letting intellect and spirit, body and emotions all become involved. The arts keep school central to students' lives in the years when maturation and growth variance can alienate and separate. Personal investment in arts activities makes the gathered knowledge hold.

Age 12–15

When a person has a need to become strictly private, the arts are partners in privacy. When a person is ready to reach out and give, the arts can be shaped for giving. When a person is ready to see what's in the mirror, the arts are a safe reflection. When a person is ready to rub into the crowd, the arts offer trusty masks and costumes. In the change age of junior high, the arts are comrades as well as the paths for finding camaraderie.

Age 16–18

Appealing and workable, the arts make abstract knowledge accessible and understandable. Tangible and experiential, the arts make concepts clear, memorable, organized. As "invitations to invention," the arts lead students to imaginative, experiential solutions to problems rather than reproducing "right answers." Primary and dynamic as they represent humanity, the arts diminish cultural and racial estrangement. In the making process, constant judgment is required; thus the arts inform choices, declare values, define the self, put events and patterns into perspective.

Arts in General Education Program,
Minneapolis Public Schools, Minneapolis,
Minnesota

within him the ability to be an artist or a performer, as well as an audience member, by the age of seven. Very young children often express themselves artistically long before they have heard of art. Some precocious children may invent simple melodic phrases even before speaking.

As children learn to manipulate the tools of each successive medium they encounter, they learn that each offers a

different kind of experience. They learn to count, compare, touch, smell. They explore their own sensations through movement, make their own music when singing or humming, role-play through creative dramatics, learn to write words and put ideas on paper which then evolve into stories or poems or songs or paintings. They learn to look and really see, to listen, to respond. As children develop, and as they learn various arts languages and acquire various artistic skills, their experience helps them to make personal statements, to make better life choices, and to solve nonartistic problems as well.

By age ten or eleven, many children worry about what their peers think, and have less confidence in their ability to make things look "real," to move freely without embarrassment, to play an instrument or sing without fear of a sour note. They are temporarily "lost" to the arts unless rescued by quality programs. Such children seek other outlets; their drawings become stiff and cliché-ridden, and they become more rigid in presenting themselves publicly, at least in the context of the school. The technical demands of music discourage many; some enter an "awkward" stage and discontinue dance or drama because of an uncertain self-image. It is then that a good arts program is of special importance to children because it can help them to master different skills and to construct a more solid identity.

To run a good race

curriculum: L. *curriculum*, running, a race course.
—Webster's New International Dictionary

The surprising etymology of the word "curriculum" suggests a vision of rapid forward motion toward a finish line. A good deal of what has passed for curricular planning may strike some persons more as running in place like Alice's Red Queen or at least as progressing only haltingly toward a hazy, ill-defined goal, a sort of endless cross-country. Today the state of education is far from static: In the race toward better teaching, many educators disagree on the best way to get there, or even on the exact nature of their goals. But there is no mistaking the character of the race. It is fluid and dynamic, and, in terms of human advancement, the stakes are high.

The arts in their myriad forms stand in great jeopardy for a number of reasons, including the contraction of both the numbers of students and the fiscal ability to provide that which students of all ages should be expected to experience in this type of society. The arts are important for children from the very beginning and the absence of them has observable effect. Colleagues of mine in the Minneapolis public school system have noted the exhilaration and the joy and the expansion of students' intellectual interests because of the availability of the arts and those who are good proponents of them. [JOHN B. DAVIS, JR., Panel Member]

The arts play a radically different role in the open classroom than in the traditional school. Painting, sculpture, music, dance, crafts— these are not frills to be indulged in if time is left over from the real business of education; they *are* the business of education as much as reading, writing, math or science. For the arts are the language of a whole range of human experience; to neglect them is to neglect ourselves and to deny children the full development that education should provide. [CHARLES SILBERMAN (ed.), *The Open Classroom Reader*, Random House, Inc., New York, 1973, p. 749]

Running out in front are three innovative practices which can be described as basic changes in elementary education. They have been initiated and publicized in the last decade, and arts education has been close to their core. The three practices are open education, the ungraded school, and team teaching.

Open education comes to America from the so-called British infant schools and aims to provide a structured setting wherein a free, highly individualized atmosphere enables each child to learn in his own way, at his own pace, from materials appropriate for him.

Such schools have spread widely through Britain since World War II, and in the past five years these methods have been introduced into a number of American schools, ranging from rural Vermont and North Dakota to inner-city classrooms in Philadelphia, Washington, Boston, and New York. Minneapolis, which has more educational options than any city in the United States, also has more open classrooms.

Let us visualize the open classroom in some detail:

> The room itself is . . . an open, flexible space divided into functional areas, rather than one homogeneous unit. . . . The children are free much of the time to explore this room, individually or in groups; and to choose their own activities. . . . The environment is rich in learning resources, including plenty of concrete materials as well as books and other media. . . . The teacher and her aides work most of the time with individual children, or two or three, hardly ever presenting the same material to the class as a whole. The teachers begin with the assumption that children want to learn and will learn in their fashion. Respect for and trust in the child are the most basic principles underlying the open classroom.[7]

It is clear that in such an environment the arts will almost inevitably be woven into the day's activities as children are drawn to paints and clay, to dancing and making music together, along with learning to read and write, add and subtract. The innocent visitor to an open classroom is sometimes startled by its appearance of "chaos" and "permissiveness." It may be this impression combined with the higher cost involved in the open classroom that has prevented its widespread acceptance. Moreover, in a recent Gallup poll it was difficult for parents to respond to a question regarding open education

because only 27 percent of those queried indicated that they knew what it meant. *Of this group, 13 percent were for it, 10 percent disapproved, and 4 percent did not answer.*[8]

Like the open classroom, the ungraded or nongraded school replaces traditional structure. It eliminates grade labels, introduces flexible interage class groupings, and determines advancement in terms of skills or achievement levels,

not on the basis of reaching a certain age or completing a school year. A child may be placed in different groups according to his achievement levels in the various subject areas. This nontraditional structure often deemphasizes grading by letter or number in favor of narrative evaluation. A major difficulty in the establishment of an ungraded school is developing clear, sequential achievement levels. Frequently a school will move

to an ungraded system in only one or two areas, such as math or reading. The ungraded concept is sometimes attacked for not offering a child the security of a fixed group of peers. On the other hand, it does recognize that children learn at different rates. In the same Gallup poll, 64 percent of those interviewed were in favor of ungraded schools, while only 28 percent were against them.

Team teaching—meaning the cooperative efforts of teachers working in groups of different sizes—permits flexibility in time and space, promotes good communication and close working relationships, and expedites both instruction and evaluation. Team teaching has spread slowly because its success is often dependent on teachers' personalities and on the presumed cost of paying several to do the work of one. However, it has the potential to combine fruitfully the work of the specialist with that of the classroom teacher. In particular, when art and music teachers are teamed up with classroom teachers, each can learn from the others, ultimately offering children a richer experience.

Illustrative of all these practices is the new Arts Magnet School in Oakland, California (grades K–3), which emphasizes the arts as basic to learning. In 1973, parents requested a school of this type—open, ungraded, and utilizing team teaching—and parents and teachers participated in the original planning. The curriculum, which includes reading, math, expressive arts, and perceptual motor development, centers around communication (both verbal and nonverbal). Both textbooks and activities were developed by teachers because suitable materials did not exist, and community artists were used as resources.

The Mosswood Mini-School (grades 4–6), also in Oakland, uses the same format of an art-centered, ungraded program. Morning work consists of math, reading, spelling, science, and social sciences, with strong emphasis on art experiences in the afternoon; Mosswood allots six to eight times more art periods than do most other schools. The facilities of the Junior Center of Art and Science in Oakland are also utilized. The children made an average reading gain of two times the normal rate (1.26 years in six months) and an average math gain of 1¼ times the normal rate (0.75 years in six months). Testing done each year has shown similar results.[9]

The question of the most effective use of the arts in elementary schools has been much debated and elicits many shades of opinion. But out of these debates the Panel has distilled five major categories of involvement, which will help some schools to define where they now stand, and where they might prefer to stand.

Category One: The arts are regarded as unessential frills. This, we regetfully report, describes the present status of the arts in most American elementary schools, a position which is borne out by a survey of existing literature on the subject. Evidence of this attitude can be found in *Elementary Education in the Seventies*, a book of readings which attempts to present a forward-looking and progressive view of educational alternatives. Only six of its 579 pages are devoted to anything remotely related to the arts, and even those pages are confined to discussing a scientific study of the poetry which appeals to children.[10]

The curriculum guides issued by various state and local education authorities illustrate how tentative and uncertain are the prescriptions in the arts compared with the clarity of those in math and languages. Thirty-nine states require that art be taught from kindergarten through sixth grade, and five more recommend it.[11] Specific time allocations for art and music are also recommended in many states, but an evaluation of the overall effectiveness of a school is not usually based on its effectiveness in dealing with the arts.

Schoolteachers and administrators are inevitably most concerned about the goals set by their supervisors and the public. Although we have noted that the public places considerable value on the arts as a contributor to "the good life," this same public rarely requests arts education as a necessary area of instruction in the schools.

Category Two: The arts are included as an enrichment to the main business of the school. While most school districts reflect the

We took a look at a couple of hundred classrooms in sixty-seven schools in thirteen major population centers in the United States and we discovered that . . . the arts are not much there; they are in the kindergarten much more than any place else but they fall off rapidly after that. [JOHN GOODLAD, Panel witness]

"frill" attitude, curriculum bulletins may take the view of category two. In this instance, national songs and pieces of thematic music are used to illustrate the subject matter of social studies. Facts and events studied in other fields provide subject matter for drawing and painting. Dramatizations are used to explain historical events and make more vivid the life of people in other countries. But we haven't moved far beyond 1874, the year a U.S. Bureau of Education bulletin admitted that "the end sought is not to enable a scholar to draw a pretty picture, but to so train the hand and eye that he may be better fitted to become a breadwinner." This attitude is reflected in many of the present practices described later under approaches to music, drama, and other arts subjects in the schools (pp. 69–79).

Category Three: The arts are regarded as an important though minor part of the curriculum. More progressive curriculum developers may consider the arts in this category. A number of projects have raised the arts to a distinct, although minor, place in the curriculum. For example, the Mineola (New York) Arts Project begun in 1969 was one of the first to incorporate into the curriculum a substantial number of visits to museums, concerts, and other cultural activities and institutions. Resident artists were placed in some schools, and programs were established which ensured that children would have some contact with works of art.

The director of music and coordinator of the arts was responsible for coordination of the Arts Events Program and its operational aspects. The project included two types of teacher education: training in curriculum development was provided, and workshops and conferences were held to build interest and participation in the arts among all the teachers in the district.

Although The JDR 3rd Fund discontinued funding the Mineola Project after the three-year pilot phase ended, the project has continued with district funding. The project director recently indicated that the district is still implementing portions of the Arts Events Program and that teachers continue to develop curriculum materials on an ad hoc basis. In addition, nearby districts are showing interest in reproducing the Mineola model.

Category Four: The arts are considered equal in importance to other subjects, as a guiding focus in the curriculum or in the context of interdisciplinary learning. The pilot project SEARCH (Search for Education through the Arts, Related Content and the Humanities) was started in New York State in 1971 as an effort to restore the balance of arts and humanities to an overly technological society. Six school districts were selected as pilot areas and each implemented the project in its own manner. For instance, Greece Central School District provided artist-led workshops for students, Fredonia integrated the arts with basic subjects, and Millbrook's Allan Place School faculty received training in aesthetic education strategies.

Utica, the largest district involved in SEARCH, had as its goal the building of a new K–12 curriculum using the arts. Therefore it chose to use its funds for teacher preparation courses, which concentrated on the philosophies behind Project SEARCH, including the elements of "cognitive," "affective," and "psychomotor" learning and the use of interdisciplinary, integrated arts and performing arts approaches. Filmmakers and poets served as artists in residence and learning resources; and workshops were offered in the use of media and packaged materials. As a result, seventy-five teacher-developed curriculum units were published as models. Among these was a unit on impressionism which used music, art, social studies, and English; and a first-grade unit on weather which included language arts, history, music, social studies, and mathematics. Although SEARCH officially ended in June of 1975, all twenty-two schools in the Utica district continued the implementation of this program during the following school year, with every intention of continuing on a permanent basis.

The British primary schools and their American equivalents treat the arts as a major focal point of the curriculum, and the disciplines tend to merge into what is often called the "integrated day." The Unified Arts Program in Brookline, Massachusetts, has scheduled elementary grades in groups which meet daily for rotated nine-week cycles of art, music, home economics, and industrial arts. The other subjects are scheduled around this core. The Pierce School in Brookline (grades K–8) is a new open-plan school centered around an Instruction Materials Center (IMC) and a Unified Arts Center.

To the Denver Post:

My friend Ann Williams who works at the Cultural Arts program of our school told me that the school board wants to stop that program. I am 10 years old and I went to Cultural Arts. Every day I used to look forward to going. I and many of my friends think cultural arts is too neat a program to stop! I may only be a small 10-year-old, but I've got strong feelings. [KERRY STUTZMAN, Sabin School, grade 5, "Arts Course Reaches Youth," *Denver Post*, Nov. 15, 1976]

The latter has flexible boundaries which allow pupils to make use of the art, homemaking, and shop facilities. The school's visual arts specialist conducts a number of interdisciplinary and multi-age activities. One unit of study is organized around the idea of reflections, and among the children's activities are: drawing their own reflected images for an understanding of art techniques, looking at art reproductions containing mirrors and reflections to develop critical skills, and writing about their observations and feelings. The study of symmetry in art is integrated with the study of symmetry in mathematics.

The Governor Mifflin School District, adjacent to the town of Reading, is included in the state of Pennsylvania's Comprehensive Program in the Arts. This program views art, dance, drama, filmmaking, photography, music, and writing as basic to education, and an effort is made to place them throughout the curriculum. Arts are studied both as discrete disciplines and in interdisciplinary approaches. Packets of materials including films, reproductions of art works, and music are organized around a number of themes (for example, texture, sound and light, animals, events in American history). These interdisciplinary materials are used for several weeks to a month, depending upon the depth of study. The Middle School includes a well-equipped art studio, an electronic piano studio, and a large room for teaching guitar and other instrumental music.

Category Five: The arts are regarded as the core around which the curriculum is built and from which science and social studies are derived. This ideal has been advocated by Sir Herbert Read, philosopher and art critic, but few schools have used this approach long enough to prove anything. One unique example is the school described by Elwyn S. Richardson in his book *In the Early World.* [12] Beginning with scientific preoccupations, Richardson details how, through eight years of working in a rather remote rural school, he tried an approach in which the children's aesthetic response to their immediate surroundings gave impetus to general learning. He worked in a seemingly unpropitious environment: religious fundamentalism dominated the community; there were few books, little film or television, and no interest in artistic expression. Yet the children's response was genuine and spontaneous. Starting with clay sculpture and pottery (arts toward which there was

the least initial hostility), Richardson was able to stimulate excellent work in the arts, especially language dramatization, graphic arts, construction, and printmaking.

Perhaps most important was the way basic work in science and curiosity in social studies were stimulated by this aesthetic orientation. The child's primary encounter was with the world surrounding the school, and the focus of that encounter was artistic expression. In mastering that environment the children were led to search for scientific principles and to form and test hypotheses. They discovered that art and science are natural human activities, both growing out of an urge to codify experience through symbols, and that there is no need to separate them.

The work of Don Brigham in the public schools of Attleboro, Massachusetts, illustrates the use of the visual arts and multisensory experiences as the basis for more abstract forms of learning. For example, work organized around the concept of spirals incorporated the following activities:

> Middle school students study the paths of falling seeds, leaves and folded paper. They drop these from stepladders, watching for the patterns of falling. After marking structurally prominent points on the leaves, they watch for the line of descent of each point. The children make drawings of these lines of falling points with felt-tipped pens, and build models of these linear configurations, representing the lines with wire suspended within long dowel rods. Colored gumdrops along the wires mark the relative positions of leaf points during the fall. Discovering that helical and other spiral patterns are characteristics of falling paths of leaves and seeds, they go to pictorial encyclopedias in the school's library to inquire into spiral structures, as they appear in phenomena such as hurricanes, whirlpools, plant growth, and helicopters. They investigate the structural principles relative to forces and counterforces that account for the evolution of these forms. They then write a statement of the functions of spirals and exhibit this report with their leaf-fall models.[13]

Although it has been in existence only since 1974–75 and therefore is not yet subject to long-term assessment, the Magnet Arts school in Eugene, Oregon, regards the arts as the core of its curriculum. Five of the six staff members, as well as the school principal, who initiated this alternative school, had participated in Project IMPACT in 1970.

Photographer Andreas Feininger traced the graceful flight pattern of a Navy Rescue helicopter. This time exposure takes advantage of the lights at the tips of the propeller blades to graph the beauty of motion. (Time-Life Picture Agency. © Time Inc.)

The basic premise of the school is that the arts are instrumental in teaching basic skills, as well as in furthering individual development. With the goal of stimulating the child's visual, aural, and kinetic senses, the arts are not only enjoyed for themselves, but also used to teach other disciplines. Reading, writing, and mathematics are all taught through dance, drama, music, and art. Science and social studies are interwoven with the arts in relevant ways. Classes are flexible in size and age groupings. The 150 students are involved in various interest groups which meet three times weekly, and with projects that encompass four-week time blocks. Each classroom teacher is an expert in one or more of the arts, and the school also makes use of artists in residence, community arts specialists, parents, and university volunteers. The school expects that the rate of learning will be equal to that of a regular school program; students achieved good reading and math scores in citywide tests in September 1976.[14]

The arts can be found in the schools today at varying stages of acceptance. Following is a description of each one's place in the curriculum, with a view of present practices in general, and a glance at the most significant trends for the future.

Drama

Place in the curriculum

Schools are displaying growing interest in drama, although it is rarely found as a separate subject.

Present practices

Drama in the elementary school is often taught by a classroom teacher with special interest in theatre; and school plays are given in the auditorium or cafeteria to celebrate holidays or special occasions. It is sometimes used to amplify other subjects, for example, to dramatize topics in social studies. In some instances, role playing may be used for its therapeutic value. Theatre classes for elementary school children are more likely to be found in community or regional theatres than in the schools.

Recent trends

The use of creative dramatics is growing in importance.*

In the last ten years, there has been an increase in the number of universities offering in-service and pre-service courses in creative dramatics for teachers.

A few states have ruled that creative dramatics must be part of the elementary school day, along with music, art, and physical education. This has made a significant difference, and teachers have shown greater interest in its use.

There is more demand for drama specialists who are used as resources for the classroom teacher.

The Artists-in-Schools program of the National Endowment for the Arts has increased the number of theatre groups which perform in elementary schools.

*Creative dramatics is a movement started in the 1920s by Winifred Ward at Northwestern University, and carried on by Geraldine Brain Siks and others. The improvisational work of Viola Spolin, as well as the British methods exemplified by Brian Way, have helped stimulate creative drama in schools.

Visual Arts

Place in the curriculum

Visual arts are acknowledged and acceptable. They are seen by administrators, teachers, and curriculum planners as a desirable part of the child's school experiences. However, they may be removed in favor of more "basic" activities.

Present practices

An art program in the elementary school usually stresses process, and appears in two forms. The first is an exploration of varied art materials with minimal teacher intervention; the second is a project approach in which students are shown step-by-step procedures to create an art product. Art is used as an instrument to help children represent social studies and science concepts, and to symbolize their historical and cultural heritage—for example, drawing turkeys and Indians at Thanksgiving.

Young printmakers in White Plains, York, roll out their first block prints. (Photograph by Arts, Education and Americans staff.) On opposite page, another child discovers the joys of pain (Photograph by Werner Bischof, Mag Photos, Inc., New York City.)

Typical goals of school administrators

1. Elementary school art should exist only for the pleasure and enjoyment of the children; it has "fun" value.

2. Art can be taught by the classroom teacher.†

3. Art activities keep children quiet and occupied in the time available between other subjects.

†The National Art Education Association has recommended that art be taught by a specialist, with each child receiving a minimum of 100 minutes per week in a specially equipped art room, plus supplementary experiences in the regular classroom.[15]

Recent trends

Art is used as motivation for learning basic skills, for example, reading.

Visual arts are becoming part of interrelated arts and interdisciplinary approaches.

Visual arts are being strengthened with the acceptance of "aesthetic education" in the curriculum.

Art activities which sensitize children to their environment can be found in a few schools.

Music

Place in the curriculum

Music is acknowledged and acceptable. It is seen by administrators, teachers, and curriculum planners as a desirable part of the child's school experience. However, it may be removed in favor of more "basic" activities.

Present practices

A music program in the elementary school usually consists of singing, rhythmic exercises, listening, instrumental study, and school assembly performances with supplementary performances by professionals inside and outside the school. In some cases, students are expected to recognize the concepts of melody, harmony, form, and rhythm.

Typical goals of school administrators

1. Elementary school music should exist only for the enjoyment and pleasure of the children; it helps them to relax.

2. Music can be taught just as well by classroom teachers as by specialists.‡

3. Music lessons can help transmit the culture and heritage of the nation and should be correlated with American history.

4. On the elementary level, all children should have exposure to music; and music skills should be taught in an ordered and sequential manner.

It should be noted that the goals of administrators listed above do not agree with the typical goals of music specialists; and that there is great controversy within the field of music education itself between traditionalists and innovators.

‡The Music Educators National Conference recommended in 1972 that elementary music be taught by a specialist, with each child receiving music instruction in the classroom for a minimum of ninety minutes per week.[16] Most districts do not come close to fulfilling these minimum recommendations.

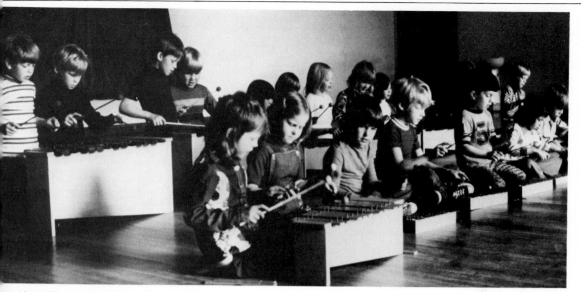

Above: Elementary school children from rural Hancock, Michigan, public schools participating in their Child Development through the Arts program. The music project, begun in 1970, reaches 250 children in grades K through 2, and builds on the theories of Orff and Kodaly. It is a voluntary program for the classroom teachers, and every faculty participant is given a twelve-week in-service music course.

Opposite page: Yankee Doodle. An Old Friend in a New Dress. Pictured by Howard Pyle. Printed by Dodd, Mead and Company 1881. (Rare Book Collection, Library of Congress, Washington, D.C.)

Battle Hymn of the Republic, written by Mrs. Dr. S. G. Howe for the *Atlantic Monthly.* Published by Oliver Ditson and Company, 1862. (Music Collection, The New York Public Library at Lincoln Center.)

Recent trends

There is more emphasis on creative music making and improvisation.

Music is being strengthened with the acceptance of "aesthetic education" in the curriculum.

There is a broadening of the curriculum to include a wider range of music: electronic, contemporary, ethnic, popular, and American.

Music is becoming part of interrelated arts and interdisciplinary approaches.

Work is being done on the absorption and adaptation of foreign methodologies, such as those of Orff, Kodaly, and Suzuki, for use in American schools. (A New York State Education Department report suggests that these approaches can be successfully fused to provide a foundation for a total music curriculum from the nursery to the secondary school.[17])

Dance

Place in the curriculum

Dance is not recognized as a separate subject, but is beginning to establish itself and is gaining momentum. At present, dance is seen as part of the formal physical education program and is taught by the physical education teacher or classroom teacher (if either one is interested and/or knowledgeable). It constitutes only 10 percent of the physical education program, and working space (such as the cafeteria) is often unsuitable.

Present practices

An elementary school dance program usually consists of dancing games and folk and square dances. Activities such as gymnastics and calisthenics are often included as part of the dance program.

Fundamental movement, rhythm games and activities, and folk dance are common at the kindergarten through third grade level.

Rhythmic activities (for example, rope skipping), and folk and square dance are common at the fourth through sixth grade level.

Movement exercises with an emphasis on problem solving can be found in some schools.

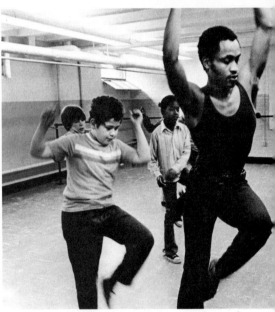

State curriculum guides generally lack any clear-cut design for using movement and dance in the total development of children, although a task force from the National Dance Association surveyed the status of dance in the elementary school and produced a set of guidelines in 1970.[18] In 1972, the American Association for Health, Physical Education, and Recreation published a description of suitable dance facilities[19]; and in 1973, the findings of a national conference on preparing the elementary dance specialist.[20]

Recent trends

Innovative projects developed in the last decade (for example, IMPACT) have been instrumental in bringing dance into the public schools.

The demand for dance in the schools has been increased by the Dance Component residencies of the Artists-in-Schools program of the National Endowment for the Arts.

There is greater acceptance for creative movement as a separate subject, and increased use of the movement specialist.

Dance is becoming part of interrelated arts and interdisciplinary approaches.

Media—Film, Video, and Photography

Place in the curriculum

Media programs are beginning to establish a foothold. However, they are present only in isolated spots, and even there are viewed as a minor subject.

Present practices

Where media programs exist, they are used in several ways:

As an art form—a way of learning and exploring in their own right, including the use of film animation and photographic narratives.

As an adjunct to the teaching of other subjects (for example, literature, social studies, and science).

As a way of overcoming basic learning problems, such as lack of motivation for reading.

Film animation and photography are popular activities, since many teachers are familiar with animation skills, and photographic equipment is readily available.

The magic of a camera is irresistible to children. (Courtesy of the Center for Understanding Media, New York.)

Below and right: Children eagerly man video controls to produce their own television programs. (Courtesy of The Center for Understanding Media, New York.)

Recent trends

There is growing acceptance of media activities as part of the school curriculum. School administrators and teachers are becoming more aware of the media's pervasive influence, especially television's impact on the child's values.

The rapid growth of the Film Component of the Artists-in-Schools program has acted as a stimulus to this acceptance.

The various media are moving from their "special" category into their natural place as one of the standard art forms.

Creative Writing

Place in the curriculum

Children's writing occupies a peculiar place in elementary school curricula. Although it is a customary activity in most schools, little attention has been paid to actual content or its significance for the child's imaginative growth. A slightly higher proportion of schools give attention to creative writing now than fifty years ago. It is doubtful that 10 percent of all schools give time consistently to anything resembling creative writing.

Present practices

Emphasis is placed on factual writing (essays, descriptions) with almost no importance given to imaginative or poetic writing.

Children are asked to write imaginative material on an assigned topic, and the work is evaluated chiefly on the basis of handwriting, grammar, spelling, and sentence structure.

In the past twenty years, most textbooks have remained static, teaching correct usage, outlining skills, and the creation of topical sentences. These textbooks give little help to teachers who want to teach creative writing.¶

The essential purpose of writing is often obscured: children write to get a grade or to check off an assignment.

Few school newspapers are published at the elementary level; and children's writing is rarely made available to others in any form.

Recent trends

There is greater appreciation of the importance of creative writing, which is now seen as an integral part of learning to read.

The Poetry Component of the National Endowment for the Arts, which sends professional writers to conduct writing programs in schools, has had selective success nationwide, and many different approaches to teaching poetry in the schools have been developed.

There is an increased interest in researching the process of poetic composition.

Some inner-city schools, most notably New York and Chicago, have done very innovative work with creative writing.

¶Although a language arts course is required in teacher education in most states, the amount of time given to the teaching of creative writing is minimal, and attention is focused on spelling, handwriting, and grammar. In 1960–61,[21] the National Council of Teachers of English published its first bulletin on research in creative writing (although this had been done on an informal basis before), and more recently (1976) published guidelines for classroom use.[22]

The arts can provide a common ground for understanding new languages. (Photograph by Mark Godfrey, Magnum Photos, Inc.)

Arts and other disciplines: mutual beneficiaries

Creative teachers have integrated the arts with other subjects for years. During the past decade, however, there has been an upsurge of interest in this approach. Sometimes the "humanities" are used to stress the relation of art to past and present societies. Sometimes the emphasis is on the relationship of the arts to each other, or on the arts as motivation for the development of speaking or reading skills. On rare occasions the arts are utilized as the foundation of the curriculum.

The Interdisciplinary Model Program in the Arts for Children and Teachers (IMPACT), was federally funded over two years (1970–1972) in five sites: Glendale, California; Troy, Alabama; Columbus, Ohio; Eugene, Oregon; and Philadelphia, Pennsylvania. Each site had a different emphasis, but all gave the classroom teachers extensive in-service training to help them gain confidence in using the arts as an integral part of their teaching. The programs also took advantage of local cultural institutions and artists provided by the Artists-in-Schools program.

While no longer federally funded, the IMPACT program has survived in Columbus and has grown from the original two schools to twelve schools with twenty-four arts resource teachers and a 1975 budget of $300,000. (The school in Eugene is an alternative school for the arts, and the Glendale Unified School District is one of four sites in California which has an exemplary multi-arts program.)

As described by Martin Russell, IMPACT coordinator, the twelve schools in Columbus are grouped into six pairs, each pair sharing an "arts resource team" consisting of dance, drama, music, and visual arts teachers who work with classroom teachers. The sixth grade students in one such pair of schools decided to recreate an ancient Greek drama festival, which provided the occasion for interdisciplinary study. Students obtained deeper background information on the history, philosophy, and life-style of the Greeks by learning about their dance, drama, music, and art. Each class selected a production for the festival from original plots submitted by every student.

People who question the value of educational "frills" in public education might want to visit Cranbrook or Eastgate Schools, or any of the other ten schools with Arts IMPACT.

Children are coming to school eagerly because of those "frills." . . . The program, designed to introduce students to the creative arts, was federally funded during its first two years. The Columbus School Board has kept it going since funding ran out. [SHARON ABERCROMBIE, staff writer, *Columbus Citizen-Journal*, "Arts Have Impact," May 9, 1975]

Students created masks, costumes, and scenery; they composed songs for the chorus and processional music which was played on recorders, flutes, lyres, and drums. Appropriate dances were choreographed. . . . Throughout the undertaking there was ready evidence that deep intellectual, aesthetic, and social learning was taking place.[23]

The intellectual curiosity engendered by an interrelated approach can sometimes lead students further afield than any preconceived outline prepared by the teacher. The visit of a master dancer and drummer from Ghana inspired one sixth grade class to focus on the arts of Africa for two weeks, during which time they created African art of their own. After discussing the influence of African art on the early cubists,

Martial Memory, by Philip Guston, 1941. Children's feelings of powerlessness and insecurity are quickly overcome during their story telling and play when every child becomes a super hero. (St. Louis, Missouri, The St. Louis Art Museum, Eliza McMillan Trust Fund.)

they became especially intrigued with Picasso's work and eagerly attempted to make art objects in his style.

As a result of working with the plywood and paint used for these projects, their inventive minds conceived the idea of reproducing a World War I airplane. As construction of the airplane progressed, they asked the drama teacher to help them write a play about the Red Baron, a character made familiar to them by the *Peanuts* cartoon. They not only wrote the play but presented an effective production to the rest of the school. It can be assumed that these vivid learning experiences were not only satisfying but will be long remembered.

At the end of the pilot period, almost all teachers reported feeling more comfortable using the arts in their teaching. Moreover, an evaluation of IMPACT, conducted by the Department of Evaluation, Research and Planning in Columbus, Ohio, concluded that the students in the project had made gains in reading and mathematics and were displaying superior problem-solving ability. In addition, the school climate seemed more positive, and parents had become more supportive of the schools.[24]

The Goleta Union School District (grades K–8) in Goleta, California, has a Cultural Arts Program which started with in-service workshops on Orff music and which now numbers among its activities a teachers' council for the arts, the participation of local artists, and pupil workshops in music and drama. The community's attitude toward an Artists-in-Schools dance program can be summarized by a fifth/sixth grade teacher in Ellwood Elementary School:

> As we continued to explore movement, the students began to see its importance in the curriculum. We developed our social studies unit around Career Education and the roles people play at their job and with their families. We improved our handwriting by tracing letters with our bodies. . . . We worked on geometric shapes in math and studied athletes (during the Olympics) by doing various sports movements in a controlled sequence. . . . Each day the (dance) specialist continued to say, "you can do better," and "don't scatter your mind." His memorable comment was "inner discipline is the key phrase."[25]

The use of musical sounds as stimulus for visual expression is an equally common teaching approach at the elementary level.

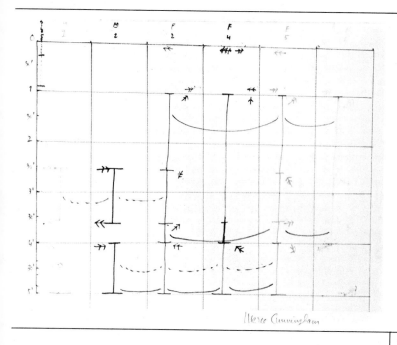

Merce Cunningham

With the exception of the normal hazard of performing, we the dancers have to fasten our minds on this work much as a newsreel camera records some singular life-activity and holds it. I won't say we have that kind of accuracy about repetition, but we have our own kind, which is just as accurate, let us say, as breathing.

This dance notation system is used by Merce Cunningham in choreographing the exact movements of his dancers. These notations are read and performed just as music notations are read by musicians or play diagrams are read by athletes. (Courtesy of Merce Cunningham.)

"Painting how it sounds" or "drawing how it feels" are common strategies to help young children develop aesthetic responses to more than one art form. Puppet shows and various other child-created dramatic productions also function to draw together the visual arts, music, dance, and dramatic literature.

An unusual multidisciplinary venture at the elementary level is the Center for City Building Educational Programs (CBEP) which began in Los Angeles in 1970. It is based on the premise that knowledge is of no use to children unless they can apply it to a specific situation. One way of achieving this goal is to encourage children to think about such issues as architecture and environmental design, and aid them in building their concept of the good city of the future in the classroom. This is a year-long activity, during which time the children learn to marshal facts, consider alternatives, and make decisions; to build a city one must think about the past as well as the future and one must be adaptable to change. The students learn math, reading, science, and social studies in a relevant and integrated context rather than as disjointed activities. Creating the actual model of a city generates active participation and the use of sensory perceptions and physical

Lindafonster
3/14/73
Report

My Experience

I started by getting some materials so that I could make a building how I wanted it for the future. I made a bowling ball & bowling pin room. The structure was two bowling pins that held up a bowling ball. The pins were elevators and the ball was a room.

The next day I was picked to go to the other class so I could help plan a city for the future. We talked about how we wanted our buildings to be in the future. We talked about how we should make our city. Then we picked leaders for each group like for trees, sky, mountains, water and land. Then the rest of the people went to a group that they wanted to go to. Then we made those things. We did that

so, we would have some land to build on.

The next day I went back to there class and other people went to. Some of the people from there class came to our class. The class I went to started by talking about what kinds of things we wanted and didn't want in our city. The things we didn't want were things like pollution. The things we did want were things like transportations that did not cause pollution.

Next we divided into four groups. Each group picked the leader they wanted. Then we picked a mayor and leaders for the trees, mountains, land, underground land, and water. The adults were the federal government. We also decided that each minute would be a week and each two minutes would be a month.

Then each group got a sheet of paper and drew a plan of how they wanted to make a city. We were aloud to make anything we wanted.

Then we started building. There were many different and unusual kinds of buildings. There were small buildings and tall buildings. We built underground, on ground, and in water. The federal government pretended to get phone calls from the president. The president said things like mining men were coming to look for premium so we had to get the mining house ready so they could mine and we had to get a house and some food to. Next he would call and say 1,000 men were coming so we had to get houses, food and transportation ready. Next he would call and say the use

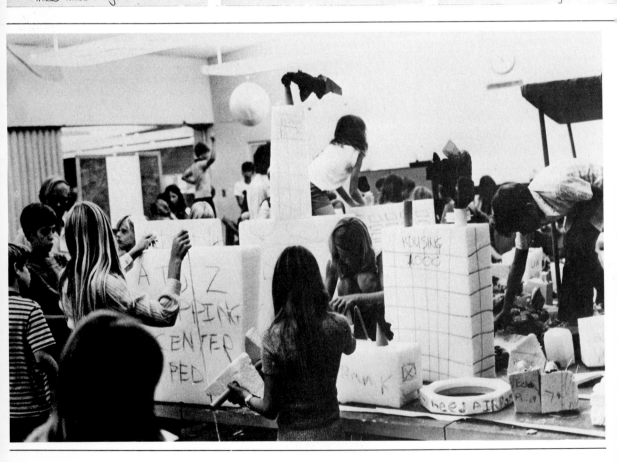

COMING TO OUR SENSES 84 THE ARTS: A BETTER PRIMER FOR OUR CHILDREN

...esident was coming and so we
...d to get the city straightend
...p, food, and a house for him.
...he vise president came in a
...ellicopter and we all had to
...eet him at the place where
...he hellicopter landed. We would
...retend he was asking us
...uestions and we would answer
...em. Next the president would
...ll and say he was coming out.
He came in a hellicopter
...so. We would pretend he
...as asking questions. In between
...those calls we kept building
...d more people came. One time
...e had a argument because
...e needed more land and the
...ederal government wanted to
...ar down part of the mountain
...d throw it in the lake and
...body else wanted to. The
...eral government got there
...y and tour the mountain

down.
When the president came
he asked some questions and
one question was what happened to
the mountain. Someone answered
it was torn down and thrown
into the lake. When we were
done building the city it didn't
look very good. It had just
about everything we didn't
want. For example pollution. Just
about everybody didn't like the
city because it was dirty but
it really was a good city
because we learned from our
mistakes.

This page and opposite: Linda and her classmates gained a new appreciation for the importance of planning and managing a city. They built their own city with the assistance of The Center for City Building Educational Programs in Los Angeles, California. (Courtesy of City Building Educational Programs, Los Angeles.)

skills. Architects and other community resources are used in the classroom. The CBEP program now includes twenty classes in three school districts. An evaluation control study done in 1973–74, using five of the City Building classes, showed that the math and reading skills of the CBEP students were significantly higher than those of the control groups.[26]

Arts: a road to better reading

Through the utilization of both Guggenheim Museum and Elementary and Secondary Education Act (ESEA) Title I funds, arts and reading activities which centered around the museum's collection were developed jointly by the museum and arts and reading specialists in some New York City schools for fourth, fifth, and sixth grade children with low reading scores. The children's new interest in reading and writing was sufficient to produce significant gains in their reading scores measured by standardized tests at the end of the Learning to Read Through the Arts program.[27]

In Irvington, New Jersey, a Reading-Through-the-Arts program was also funded under Title I with four teachers each

in visual arts, music, movement, and drama. All children in grades K–4 participated, but special attention was given to underprivileged youngsters. Art teachers emphasized reading and verbal skills as part of their curriculum, while classroom teachers conducted an arts program with the same focus. Though evaluation of this program has been based on informal observation, teachers feel that it has actually helped students improve their reading skills. As a result, the children have become more receptive to learning in most subjects and more articulate in written and oral forms. The program has been continued with additional funding supplied by the community.[28]

Packaged learning: classroom stimulants and supplements

Although there are more than a dozen federally funded research and development educational laboratories located across the country, only two are actively involved in curriculum development in the arts. Starting with a 1964 pilot project in the University City, Missouri, schools, the Central Midwestern Regional Laboratory (CEMREL, Inc.) of St. Louis has utilized the talents of both artists and teachers to design an Aesthetic Education Program. CEMREL has created and distributed instructional packages which teachers can adapt to the particular needs of their pupils. Printed materials, tapes, films, games, and puzzles may all be part of a package. These materials have gained wide currency and are now being used on an experimental basis in some twenty-one states and over seventy school systems.

The Southwestern Regional Laboratory (SWIRL), located in Los Alamitos, California, has spent three years developing materials in art criticism, aimed at training elementary and secondary teachers to discuss art objects with students, and to make them more perceptive about, and appreciative of, works of art. Now operating in ninety school districts, this program has met with general enthusiasm.

The arts in a humanities framework accentuate the series of learning materials for elementary grades entitled *Self-Expression and Conduct: The Humanities.*[29] The materials fit into

CEMREL is one kind of design or model for the arts in education and there need to be others. I think that we need further work on assessing this kind of program. . . . I would like to see the concentration maybe not at the national level, but at the state school system level . . . and also as a priority area for government support with a new title program coming out of the Office of Education or maybe the National Institute of Education. [STANLEY S. MADEJA, Panel witness]

both interdisciplinary and related arts programs, and use texts, records, activity kits, self-initiated pupil learning activities, and sound filmstrips. The texts and teachers' manuals encourage both convergent and divergent thinking.

Another set of materials, called *Visual Sources for Learning*,[30] contains teacher guides and related slides, and introduces larger themes like Man and Society with its subthemes: Portraits, Family, Work, Recreation and Sport, Performers and Masks. The art projects are followed by suggested activities for math, social studies, and writing. Classroom teachers can thus choose what they want, can expand or interrelate themes, and can work with the art teacher or with other teachers in the schools.

Most significantly, all these learning kits, packaged materials, and guides offer teachers an opportunity to link one field with another. The goal which unifies and characterizes the innovative curricular approaches we have discussed is helping children grow, helping them to realize their potential and to express their innate humanness.

With this end in view, Panelist James Michener was moved to cite William Wordsworth. He said to the Panel:

> I keep thinking of his great poem, in which he says that as the child grows older, shades of the prison house begin to close upon him. No longer is he trailing "clouds of glory." The great imagination, the great fire that kept him going, fades. But how? Much of it is stifled in the school. All the teacher retraining, and all the work of everything else, is to keep that spark alive. Not in the teaching, but in the growing child. For the end is not to do it for the teacher's sake. The end is to do it for the child's.

. . . I say to all the teachers: aesthetic education does not come in a box. . . . I would like you not to view this as little composites you can drag out of the closet and say, "Now it's CEMREL time." That's what happens the first year. . . . But after that it grows and develops. . . . usually it takes two years of working with the materials before the teachers feel comfortable not just going through it sequentially, the way it was printed. [ALICE SWANSON, Panel witness]

87

Creative energy and the adolescent

Schools, rooted as they are in a Victorian Century and seemingly suspicious of life itself, are his natural enemies. They don't help, as they might, to make the bridge between his private and social worlds; they insist, instead, upon their separation. Indeed, family, community, and school all combine—especially in the suburbs—to isolate and "protect" him from the adventure, risk, and participation he needs; the same energies that relate him at this crucial point to nature result in a kind of exile from the social environment. [PETER MARIN, "The Open Truth and Fiery Vehemence of Youth," in Ronald Gross and Paul Osterman (eds.), *High School*, Simon & Schuster, Inc., New York, 1971, p. 27]

Gene, John Culkin's imaginary little friend, who opened the previous chapter, had, as you may recall, an older brother who warned Gene about schools: "They are going to try to make you like things you don't like and dislike things you do." Pursuing Culkin's flight of fancy, let us imagine that Gene's brother is a teenager named Tony; a decade separates the two.

What experiences has Tony had in the last ten years that have caused him to make this rather bitter and disillusioned statement? What *does* he like? He likes television and movies. He has gone as far beyond the classroom as the bottom of the sea, the battlefield, and newsstand pornography. He has seen innumerable scenes of violence and natural disaster which by now have somewhat deadened his sensibilities. He has been suffocated in the suburbs and brutalized in the cities until he is in confusion about the real world; and there are few adults who can give him honest answers regarding his future. So many conflicting authorities are available to him that his main need is for assistance in clarifying his own values.

Television is never discussed in Tony's school as a serious subject. He has never been asked to analyze the styles of different sportscasters or of news broadcasts. He has never counted the amount of time given to advertising or the amount of time he spends watching the set. He has never been asked to criticize a specific dramatic show or assigned a classical play to watch or had to compare a novel and the film made from it. He has never discussed the emotional and psychological effect television has had on him since he was a child, or studied the economics of this industry and what it means to him as a citizen, or made a factual list of the stereotypes of women and minorities presented on it. He's not quite clear about the scientific principles behind the electronic media; has never written a script, cast a film, directed, photographed and edited it; nor created an original TV program of his own and made a videotape of it; nor had the eye-opening excitement of working with a media professional who was an artist in residence.

Tony also loves music. His transistor radio follows him to the beach and the bathroom, and he speaks with authority about the Allman Brothers, Led Zeppelin, and Chick Corea.

He spends a fair amount of money on records and concerts, and he and his friends often listen to each other's records and discuss their relative merits vehemently. One of these friends taught him to play the guitar, and he has a secret yen to play steel drums.

However, the music specialist in Tony's school has not yet recognized the sophistication of African music nor even the history of jazz. He has been busy laying a foundation in what he considers to be the classics (that is, Western European music) and in managing the choir and band. He's not interested in anything electronic, doesn't know how he would manage to give a course in electronic music even if he could get a synthesizer. While he dislikes rock music intensely, it hasn't occurred to him that he might be able to give a course in it—getting the students to analyze its composition, compare it to what he considers good, and perhaps compose some music of their own.

If Tony is black, then he may be reaping the benefits of the new level of black awareness and self-pride which took place before he entered high school. He can feel proud when the class reads poetry by Langston Hughes or Phyllis Wheatley; and since his English teacher is also the drama teacher, he can have the pleasure of trying out for a part in *A Raisin in the Sun*, or researching a report on the historical accuracy of *The Great White Hope*, in which he will discuss the use of dramatic license, or joining a class committee which is selling tickets for the upcoming appearance of the Negro Ensemble Company.

Of course, if Tony is Puerto Rican, he may feel a little out of place—his culture will probably be either derided or ignored. This inheritor of the language of Lope de Vega will be able to take pleasure in the music, singing, and dancing which surround him at home but may never learn that Luis Pales Matos and Luis Llorens Torres are poets of worth.

Tony is also desperately interested in the quality of his life and his future. Air pollution, the population explosion, radioactive fallout, chemical additives in food all are on his mind. He doesn't know whether he wants to go to college, he thinks he might like to live on a farm, he's apprehensive about ever getting a job because he fears he'll be low man on the totem pole. But Tony's school doesn't have courses on ecology, urban planning, highway design, or solar energy.

Let's imagine that Toni is Gene's sister instead of his

brother: Toni is a whiz at math and physics and she's attracted to art, although she knows she'll never be a painter. She wants to do something with her life that will help make the world a better place, but her high school doesn't have a course in the history of architecture, or a work-study program in an architect's office, or someone to set up an independent study curriculum at the art museum. She'll never even know that this was a possible career for her.

And if either Tony or Toni is "gifted and talented"— heaven help them! High school students in America are out of place if they need special instruction or must go to a special school. Why can't their passion be for science or football? Doesn't it seem a little too elitist to let a child out of school early so she can take a ballet class with the kind of private teacher the public school can rarely provide? And on top of that, get academic credit for it, too? Couldn't she wait to become a dancer until she gets out of college? Anyway she'll never make a living that way, and she'll probably end up getting married before she knows it. (What discussion will ensue if it is *Tony* who wishes to become a dancer, we leave to your imagination.)

We have put Tony in the worst situations we possibly could—there *are* schools which do have some of these programs and there are schools which have more than one of them. Unfortunately, he doesn't live in any of those towns.

The inner world of the adolescent

I t is obvious, however, that the world of the adolescent consists of more than arts experience. It is a turbulent and intense world, teeming with problems that must be dealt with if the transition from childhood to adulthood is to be accomplished successfully.

Rapid physical, mental, and sexual growth generates enormous energy which adolescents must learn to channel. Their emerging intellectual maturity makes many courses of action possible. They begin to make occupational, sexual, and ideological choices. They inevitably go through a period of internal confusion in which the search for commitment is

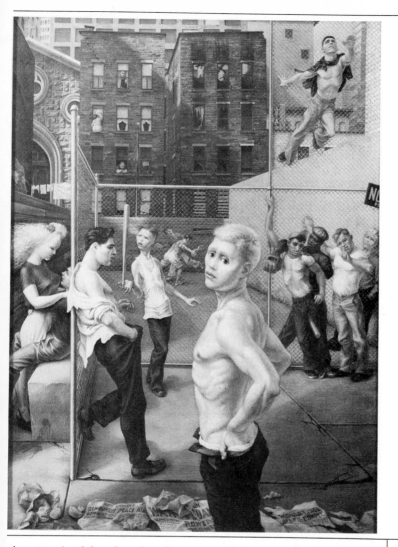

Playground by Paul Cadmus. (The University of Georgia, Georgia Museum of Art, Geoffrey Clements photography.)

characterized by drastic advances and retreats, by both total commitment and total repudiation.

Adolescents tend to organize their ideas according to certain societal expectations. Traditional societies confirm the individual by providing rituals, rites of initiation, an ideological framework, and well-defined roles and tasks. In our complex society, full of conflict and ambiguity, the adolescent has the terrifying task of identifying a coherent set of values in which to invest his energies and self-confidence and against which to test his own meandering self.

Schools should help the student acquire the skills, knowl-

. . . everything which we believe is natural to the adolescent period is really part of the folklore. The behavior about which we complain so bitterly is neither natural nor necessary. It is, in my judgment, conditioned behavior. In the conditioning process, we receive the generous assistance of commercial interests dedicated to the seduction of youth. . . . Not only must the adolescent find himself, but he must do so in a world that refuses to remain the same for two consecutive weeks. [FRANCIS C. BAUER, "Fact and Folklore about Adolescents," cited in Harold W. Bernard and Wesley C. Huckins (eds.), *Readings in Human Development,* Allyn and Bacon, Inc., Boston, 1967, p. 257]

edge, and attitudes which will guide him through life. Yet inside these schools, where the adolescent lives for as much as six hours a day, five days a week, there is often little congruence between what is studied and what is imperative for life development. Many secondary schools have rigorous schedules, and stress the acquisition of prescribed skills, conformity, and submission to authority, leaving little room for the exercise of choice, individuality, and creativity.

To emerge from this period of confusion, the adolescent needs all the internal strength he can acquire, as well as the support of others. Precisely because the arts, especially drama, dance, and literature, deal with problems of identity and values, they provide an excellent context for self-discovery; they can also be an outlet for physical energy and a stimulant to the imagination.

The ability to take risks, high energy levels, flexibility, humor, and heightened sensory awareness are all characteristics identified with highly creative individuals. They are also characteristics of adolescents as a group. Indeed, "adolescent" comes from the Latin word meaning "to kindle or burn."

Strengths of adolescents

Exhibit considerable energy, drive, and vitality

Are idealistic, have a real concern for the future of this country and the world

Are courageous, able to risk themselves or stick their necks out

Are flexible, adapt to change readily

Are usually open, frank, and honest

Have a feeling of independence

Have a sense of humor which often finds expression

Often think seriously and deeply

Often exercise their ability to question contemporary values, philosophies, theologies, and institutions

Possess a strong sense of fairness and dislike intolerance

More often than not, are responsible and can be relied on

Have above-average sense of loyalty to organizations, causes, etc.

Have heightened sensory awareness and perceptivity

Have optimistic and positive outlook on life more often than not

Demonstrate greater sensitivity and awareness of other person's feelings

Are engaged in a sincere and ongoing search for identity

SOURCE: Adapted from Herbert A. Otto, "The Personal and Family Strength Research Projects: Some Implications for the Therapist," *Mental Hygiene,* vol. 48, no. 3, pp. 439–450, July 1964.

Common attributes of creative activity in the arts and sciences have been identified as sensitivity to problems, fluency, flexibility, problem redefinition, and originality. There are, however, pressures affecting the climate of today's schooling which build obstacles to creative thinking. For instance, peer group pressure to conform is at odds with the divergent thinking necessary to creative ability. School and home sanctions against questioning and exploration combine to curtail these tendencies in children and adolescents. Stereotypes which designate sensitivity as a "feminine" attribute and independence as a "masculine" one create a conflict for the creative individual, who needs to exercise both sensitivity and independence in creative endeavor.

Finally, the work-play dichotomy prevailing in our society blocks creative development. Creative individuals like to "play around" with ideas and/or materials in the process of arriving at novel solutions. In schools—and in society at large—an austere, no-fun approach to learning encourages conformity in both thinking and behavior. Perhaps the most difficult thing to teach adults is tolerance toward the nonconformist behavior characteristic of independent-thinking, creative individuals. Few students, however, presently perceive themselves as possessing artistic creativity or critical awareness, because most schools do not give them opportunities to develop these skills.

A 15-year-old sophomore at Stuyvesant High School, a young-looking prodigy who favors jeans, sneakers and a polo shirt, scored highest in the country on a three-hour test of mathematical reasoning and creativity given to the top math students from coast to coast. . . . It was the second time in three years that Stuyvesant had produced the top scorer in the Olympiad. . . . although Mark [Kleiman] was in the 10th grade he was taking 12th-year math; analytic geometry, probability, matrices and vector spaces, among other topics. . . . "It's harmonious when you get a solution," he said, "especially if it's an elegant one. Most solutions aren't elegant, but the ones that are give you the greatest satisfaction. Math holds an aesthetic appeal, to see problems when they're done elegantly." ["Youth, 15, Wins Math Olympiad with a Perfect Score," *New York Times*, May 20, 1976, p. 1]

Changes in secondary education

In recent years, a number of social forces have converged to alter the consciousness of American society. The nation has undergone major transitions in its ideas about women and minorities, about the individual's commitment to his work, to his country, and to other people. These social currents have directly challenged the ideas on which the nation's educational system rested. Much of this challenge has been keenly felt in urban secondary schools, where open conflict has become a daily occurrence. Paradoxically, social disorder has also erupted in suburban middle-class high schools.

These recent changes in young people's behavioral pat-

The adolescent's commitment to the betterment of society is exemplified by the arm medallion which proclaims "Give a Damn." Photograph © Larry Fink.

terns have been accompanied by a growing awareness that secondary schools needed to change. Since 1972, a number of prestigious reports aimed at reforming the high schools have appeared, including those of the National Commission on the Reform of Secondary Education (the Brown Commission),[1] the National Panel on High Schools and Adolescent Education,[2] and the Coleman report.[3]

These reports have depicted secondary education as one segment in a lifetime of learning experience. Some of their recommendations have included: an academic day of two to four hours with every adolescent involved in one or more programs outside of the high school; an extension of the range of nonformal educational opportunities for credit; specialized high schools with no more than 500 students, several of which may be attended by students simultaneously. They have also recommended that schools be integrated with communities so that the physical and human resources of both could be tapped

to mutual benefit. Work-study programs, citizenship education, and aesthetic education have been proposed as areas for which nonschool agencies, in coordination with the high schools, should be given greater responsibility.

Schools must now compete with the media—television, films, radio, and records. Since young people are constantly learning from the world around them, educators would be wise to make use of that world. In the arts, for instance, students should have school-sanctioned access to regional theatres, community orchestras, museums, dance companies, neighborhood arts centers, architectural offices, and individual artists of all kinds.

After all, what is a school about? . . . it is transmitting everything in the tradition that we believe is most important to leading a whole life and being an important human being. The arts are a very large part of that tradition; not the arts that come down from the state department of education and the curricula vote, but the arts that many people all over the community know about. [STEPHEN GOLDSTINE, Panel witness]

Re-organizing school structure

In response to demands for change, some secondary schools have greatly increased students' alternatives both in content and structure. Innovative programs now exist in urban, rural, small-town, and suburban communities for all levels of ability and socioeconomic backgrounds, and for various racial and ethnic groups. Some programs have a strong career education emphasis; others have a large commitment to the arts and humanities. Attempts have been made to match instructional approaches to individual needs by varying teaching methods, content, setting, and grading system.

Some schools offer more elective or short-term courses. Others also permit credit for work-study experiences and activities which take students outside the schools. Quincy II High School in Illinois offers its 1,500 students a choice of seven separate subschools, ranging from a traditional school to a flexible fine arts school, with career training and work-study schools in between. Haaren High in New York City provides minischools, each enrolling 150 students, with a single theme such as aviation, creative arts, or urban affairs.

The structure of the high school is also being altered by experiments with "open" and "alternative" schools. Among the plans being tested are voucher systems, schools-without-walls, independent study, internships, and apprenticeships.

In 1974, an estimated 200 informal alternative schools flourished in sixty districts.[4] In Chicago, Boston, New Orleans, Cleveland, Madison, and elsewhere, these schools emphasize small enrollment, innovative curriculum, cooperative planning by parents, students, and staff, and the use of the physical plant as a meeting place.

In Scarsdale, New York, students in alternative schools spend much of their time in the community with volunteer experts. Pupils have their own curriculum and time schedule. One high school junior in Scarsdale chose the following curriculum:

First term: Sculpture (with volunteer)
 American history (required)
 Children's literature (required English)
 Existential writers
 Independent study with the art teacher in high
 school

Second term: Astronomy (at night)
 History (required)
 Women's studies
 Reading and writing poetry (required English)
 Art classes at a private school in New York City

In Burlington, Vermont, the high school sponsors a program known as ASPIRE, which invites discontented tenth-graders to spend a year away from the formal requirements of the school working alongside skilled adults in the community. They write contracts for these experiences, including specified criteria to be used in evaluating their work.

Union High School in Grant County, West Virginia, also releases students from traditional attendance requirements. The school year consists of four quarters; the school day is divided into flexible time modules; the school week consists of four days of academic studies and one day of work-activity (for which credit is received). The work-activity is specifically designed to meet the goals of each individual. There is a placement office and a job bank, with a file on each student's interest and abilities.

What makes these programs possible is decisions made at the state level. In Oregon, for example, student progress is increasingly being measured more in terms of student goals and demonstrated performance than in terms of time spent in school. Florida offers a performance program that allows

students to graduate regardless of credits accumulated or length of time in school, as long as they meet objectives outlined by a council of teachers, administrators, students, and community resource persons. Credit units as a requirement for high school graduation are being questioned. The New Jersey Board of Education has created an individualized credit plan based on specific and measurable instructional objectives. In Maryland a personalized program for each student, with parental approval, is recommended by a state advisory committee as one route to high school graduation.

Compulsory attendance is being seriously questioned in many communities. Several states—including Kentucky, Georgia, Delaware, Illinois, and Washington—are considering or experimenting with year-round school plans.

All these reforms are extremely propitious for arts education, which has suffered under traditional patterns of limited time periods, compartmentalized learning, dependence on letter grading, and restricted physical mobility. They do not lessen the need for teachers; rather the teacher's role becomes one of facilitator and guide as well as instructor. For arts educators, in particular, the task is to create a stimulating environment, to provide emotional support, and to give relevant information at the proper moment. Whether in or out of the schoolroom, this is not easy. It presupposes a teacher who is vital and sensitive, an expert in his or her discipline as well as in the changing needs of the adolescent.

Present practices

Arts education at the secondary level reflects the philosophy of the situation in which it occurs. Since the long tradition of departmentalization creates barriers to integrative approaches, most arts programs focus on the arts as discrete entities. Where openness and interdisciplinary efforts are encouraged, arts programs are less ironclad.

The character of a course depends ultimately upon the educational philosophy, skills, and interests of the teacher. In contrast to elementary schools, where arts education is often

We still have to fight this tendency in the American culture to formalize, to categorize, to segment, and to specialize the arts. This tendency towards compartmentalization breeds the outlook, "Yes, we have an art class," instead of "Yes, we have the arts in our school." This is a terribly important difference. [Scott Thomson, Panel witness]

part of classroom teachers' responsibilities, music and art courses at the secondary level are taught primarily by specialists, creative writing and theatre by English teachers, dance by physical education teachers, and film by anyone who has any knowledge of the medium.

Most arts programs profess concern for the development of individuals, who are divided into two broad categories: those who will take a serious interest in the performing or creative aspects of the arts, and those who will become audience members or appreciators. The former types are expected not only to understand "about" art, but also eventually to create or perform at an acceptable professional level. While the latter may also perform or create in an art form, only minimal competence is expected, with understanding "about" art the true goal.

In the visual arts, the emphasis is on performance: the active artist is the career model, with the model of art critic or art historian considered only within the context of "humanities courses." In music, performance is reserved for those already showing some talent and persistence, with training for critic and historian reserved for students who participate in "General Music" or a humanities seminar. In the areas of writing and dramatics, the emphasis is again on performance, while criticism receives more attention in literature classes (the content of which is rarely coordinated with creative writing or drama).

Visual arts

There is a trend toward beginning visual arts instruction at the middle school level, where courses include printmaking, weaving, jewelry, sculpture, and pottery, along with drawing and painting. In some schools, all seventh grade students must take visual arts and an introduction to general music; eighth and ninth graders may take art, music, industrial arts, or home economics as electives. In most schools there is a division between "arts" (drawing, painting, printmaking) and "crafts" (pottery, sculpture, jewelry, weaving).

By the time students have entered senior high school, the

visual arts are elective. Courses depend upon number of staff, their interests and training, and the availability of special equipment. In the large comprehensive high school, there is usually an "introductory art" course on elementary principles of color and design, drawing, painting, and possibly mono-printing or silk-screening. Students may proceed to advanced design, mechanical drawing, crafts, wood or metal sculpture, and advanced painting and drawing classes. However, in many high schools, more than half the students enrolled in so-called "advanced" courses have such rudimentary skills and such a poorly developed aesthetic sense that a more appropriate classification would be "aesthetic remediation."

In well-equipped high schools, the emphasis is almost always on studio performance and development of technical skills. Few high schools offer courses in art criticism and—despite recent encouragement to incorporate art criticism and history into the studio format—few high school teachers use this approach, except within the context of humanities or related arts courses.

Traditional programs which promote an understanding of the art process are enjoyable and valuable in their own right. The average student is enriched by "hands-on" experiences, and obviously the gifted student will receive even deeper satisfactions. But too often, traditional programs do not go to the heart of the matter, which is: What is art to life? What is art to me?

What can be more relevant to the student than the physical space where so many hours are spent? The Environmental Design/Architecture course that began in January 1977 in the Irvington, New Jersey, high school is the first such course in the United States offered for credit. This activity had been in operation the previous spring as an after-school club, in which students worked to improve the environment of the class-rooms and the school. Graphics were used to brighten the halls, and dogwood trees now bloom in the garden that the students created in the inner courtyard of the concrete building.

An architect funded by the National Endowment for the Arts is in residence four days a week, team teaching with a high school teacher. The architect also gives in-service training and works with senior citizens and other community groups, besides giving classes in the elementary schools.

I've made nine lectures lately to secondary school kids in the public schools who know nothing about the arts. They go home to their houses with their swimming pools, and drive through the commercial slums that exist in all cities. The poor kids go to a house without any floor, with no heat and so forth. Anyhow, they go home—they see nothing, they have no perception of anything. And I'm outraged that this has been perpetrated upon them, that we have allowed this to happen. . . . The private schools think the same way. There they get Greek and Russian by the sixth grade and they get calculus in the ninth, but what happens is that they don't get any art at all. [O'NEIL FORD, Panel member].

When this funding is no longer available from the Endowment, the school will use local architects paid for out of school funds. The community has been extremely helpful and cooperative; both the town environmental commission and the mayor have contributed funds to the program, and the park and recreation department has contributed plantings and services.

Music

According to a recent report on music programs prepared by the American Music Conference:

69 percent of the students take no music at all in the four years of high school.

Only 10.4 percent of the nation's high schools require music for graduation.

88.1 percent of the high schools do not offer a major in music.

Only 4.5 percent of high school students were enrolled in general music (1972–73).

Courses in secondary schools usually consist of band (offered by 85 percent) and chorus (90 percent); about half the schools offer other kinds of instrumental and vocal instruction; about a third offer courses in general music, music appreciation, theory, and harmony; and a small percentage offer courses in composition and group instruction in piano or guitar.[5]

The Tanglewood Symposium on "Music in American Society" was held a decade ago, and among the issues discussed were the problems of the music curriculum and teaching methods in the schools. It was agreed that music should be in the basic school curriculum, that it "should be expanded to involve music of our time in its rich variety, including currently popular teen-age music and avant-garde music, American folk music, and the music of other cultures," and that it should be available to *all*, not only the gifted few.[6] At that time, the consensus was that music in the high school did not meet the needs of the adolescent student.

Since then, innovative programs in music education have begun to appear. In Kenwood High School on Chicago's

We have succeeded in making music a part of the educational system in every state. If we had strong programs and a fuller commitment to the music and arts programs, many people not now discovered would come to find their talent and interest. The critical issue is the waste of opportunity and human resources. The arts should be opened to all students in every school. [CHARLES L. GARY, Executive Secretary, Music Educators National Conference, in staff interview]

South Side, for instance, the program has its band, orchestra, and chorus, but it also has an electronic music course; early morning jazz, rock, and soul sessions; and after-school piano and guitar classes. Music students have produced a traditional opera, an original opera written by students, and a Broadway musical. Some students have appeared as soloists with the Detroit Symphony, but of more importance is the fact that in 1974, 900 students, or almost half the school population, were participating in the music program.[7]

The relevance of music to other subjects is also being recognized. Ketcham High School in Wappingers Falls, New York, has a music synthesizer which is used to teach theory and composition. It has also been used in the physics lab to analyze sound, in the creative writing class, and in calculus classes to discuss the mathematics of harmonics.[8]

In junior high school, I was in an orchestra where for the first time I was good enough to sight-read a piece of music. And we sat down at this piece by Vivaldi and we played it through from beginning to end. And I'll never forget that because that's the big experience of my life. Here was this thing with all these little black dead blotches on the page, and suddenly WHEEW, there you are in the seventeenth century. . . . That was made available to me by some terrific junior high school music teachers, and later high school music teachers. [MICHAEL TILSON THOMAS, Panel witness]

Sound graph of the song, *John Henry*, from the book, *Phonophotography in Folk Music* by Milton Metfessel, University of North Carolina Press, Chapel Hill, N.C. (Courtesy of the University of North Carolina Press, Chapel Hill, North Carolina.)

In spite of such efforts, the results of 186,406 question-naires sent by the Cooperative Institutional Research Program to college freshmen at 366 institutions (a total student population of 1.67 million) showed that about 80 percent felt their high school art and music programs had been unsatisfactory.[9]

Creative writing and theatre

In most secondary schools, creative writing and theatre activities are administered by the English department. The trend in innovative English programs is toward short electives built around student interests, with emphasis on self-motivated reading and composition. Such programs may also include film criticism and filmmaking.

Pocatello (Idaho) High School, for example, has reorganized its English program, replacing the survey courses with a broad range of shorter, more concentrated units from which students may select. Some illustrative course titles are Folk-Rock Poetry, Media Investigation, With Pen in Hand, Who Done It? Where? When? Why?, and Television Investigation.

At least 92.2 percent of American high schools are engaged in some form of theatre activity, but only a quarter (24.2 percent or approximately 6,000 out of 24,000) presented strong programs, according to Joseph Peluso's study.[10]

The typical theatre teacher has earned fewer than twelve college credits in theatre—most likely in criticism, dramatic literature, or history. Production courses were probably in directing or acting, not in technical skills or design. The theatre teacher directs the drama club, but offers no course in theatre. He or she uses ordinary classrooms in which to teach and rehearse; the productions take place in the cafeteria, with crude lighting equipment and a very low budget. Some schools offer writers' workshops, TV production, actors' studios, and courses which involve theatre-going followed by the writing of critiques. In order to provide learning experiences linked to student interests, the average high school mounts one musical, one full-length play, and a one-act play each year.

By contrast, the Evanston Township High School in

Illinois has a program in theatre which involves up to 400 students. Among the arts program choices for incoming freshmen are the nine-week units in theatre/speech, public speaking, radio and television, oral interpretation, and theatre/acting. This can be followed up with such year-long courses as Acting and Stagecraft, Black Arts in Performance, or independent projects in writing or directing plays. In 1977, the students will begin to receive credit for working with artists in the community. The theatre department presents four productions each year and several more in conjunction with the music department. Smaller student works are given during the year, and the students also participate in the school's Spring Festival of Performing Arts.

The Urban Arts program in Minneapolis, Minnesota, is an example of cooperation between schools and the community. The Minneapolis Children's Theatre Company and School is one of the community resources in which junior and senior high school students (who do not necessarily wish to become professionals) may take classes. The students attend three hours a day, five days a week, and receive instruction from professional artists. Credit courses include modern dance, ballet, singing, commedia dell'arte, and theatre history. Six areas of theatre production can also be studied— lighting, sound, costuming, properties, set construction, and stage management. These studies include formal classes and practical apprenticeships. In-school residency teams, who work with public school faculties and students, are also provided. Such a team went into South High School for eight weeks in the spring of 1975; the trimester's work culminated in a professionally staged performance which grew out of improvisation, was scripted by the students, and was accompanied by student musicians.

The high quality of instruction provided by this institution may be hard to emulate. But it must be remembered that the pursuit of excellence is an important factor in teaching any of the arts. There is a delicate balance to strike: between general knowledge of different media and in-depth study of one or two; between emphasis on the process and the final product; between appreciation of others' work and one's own need for participation and creation. It is part of the educator's job to maintain standards of excellence and craftsmanship in addition to accepting and understanding student works.

. . . the question of methods, disciplines, techniques and all that stuff that people talk about, gives way to a search for beauty and loveliness in one's self. The young minds, the open ones, the ones that still recall the smell of mud in the spring and the way a statue in the park talks at night, will wander in and watch awhile and if they like the tune well enough, they'll play it on their own harps one way or another, beautiful and lovely. [JOHN CLARK DONAHUE, Director, Minneapolis Children's Theatre, *Minneapolis Sun*, Oct. 27, 1976]

The art work of any individual must be his own, but if he is not helped to give his work direction he will not— unless very highly motivated— develop it himself. The teachers have, in effect, not functioned as teachers but merely as suppliers of materials. This is not enough; guidance, leadership, cooperation, suggestions, and occasional prodding are all part of the techniques of teaching. And standards must be set in terms of what each individual is capable of— and he must be helped to achieve these standards. [JEROME HAUSMAN, "Some Current Pressures and Emphases in Our Schools," *Report of the Commission on Arts Education*, National Art Education Association, Washington, D.C., 1965]

Media

Although audiovisual materials have been used in schools for a number of years, their main function has been to augment classroom equipment. Only recently have the media been accepted as art forms and subjects in the curriculum. They are now welcomed in many urban and rural communities across the country.

In Iowa, for instance, the 350-student high school in the rural community of Jefferson has had a program in media for three years. With the help of the school administration and the audiovisual coordinator, a course in "communication" that combined English and media experience was created by an English teacher specifically for students who were not succeeding in the traditional English curriculum. Students (drawing on their own daily experience) wrote scripts, made slides and tapes, and presented their finished projects to an audience.

During the summer of the first year, both the audiovisual and English teachers took courses in media, and during the second year emphasized filmmaking in the communications course. This is the most popular English course in school, and its biggest problem is overenrollment. This happy predicament can be credited in part to a progressive school board which is very much concerned with education and receptive to innovative programs; among its projects was the installation of an artist in residence, funded first by the school and then by the local arts council.

Waterloo, Iowa, has a school system with a total enrollment of 19,000 (grades K–12). A media program which originated in one high school English department four years ago is now a joint effort of the English and art departments. Although the teachers had access to media packages, they preferred to give a course with more depth, and the result was an elective one-semester course in filmmaking. The students (grades 11–12) take a photography course first, and after the film course, may take a second semester of independent study for credit. The course has grown from one to six sections. This

Students in Harrisburg, Pennsylvania, with special interest in the visual arts, music, dance, drama, photography, and television may take advantage of the Riverside Center for the Arts. The center makes use of an elementary school vacated through school reorganization and directly and indirectly serves approximately 3,700 students. Secondary students are shown here producing their own daily half-hour news program for cable television. (Photograph by Bette Acuff.)

year students will present public service spots about their school activities on local television stations. Two other Waterloo high schools have joined the program and each one furnishes its own film and pays for processing. The three schools share equipment and an artist in residence. In-service workshops for elementary, junior high, and high school teachers are also held during this residency.

Dance

A dance class at the High
School for the Performing Arts,
New York City. This public school,
now in its twenty-eighth year, is America's
first high school devoted to training
students for the performing arts.
Admission is highly competitive
and is by examination only. In addition to
a required traditional academic program,
students specialize in either dance,
drama, or music. (Photograph by
Richard Polsky.)

Of all art forms, dance fares worst in the schools. In junior and senior high schools, folk and social dancing are taught as short-term units within the regular physical education classes. In large metropolitan high schools, girls may be offered modern dance.

In the last five years a number of high schools have benefited from short-term residencies by dance movement specialists or dance companies sponsored by the Artists-in-Schools program. There has been little increase, however, in the use of dance specialists as full-time staff members. Although dance performances have become more popular than ever, and though small dance companies are springing up

all over the country, dance teachers at the secondary level represent less than 1 percent of all teachers.

The situation in Salt Lake City is somewhat different. Excellent personnel are available, because the University of Utah is one of the best teacher training institutions in the country for dance, preparing certified dance education majors with a Fine Arts degree. Eighteen high schools in Salt Lake City have full-time dance teachers; some have as many as three. These classes, which can be substituted for physical education, are very popular; in recent years more boys have shown interest in modern dance, and in several high schools there are all-boy and coeducational classes.

At East High School in Salt Lake City, a large weekly lecture class covers the history and theory of dance and presents films and special guests. Modular scheduling allows a studio period of 1½ hours twice a week; at Cottonwood High School studio periods are three times a week. At Olympus High the Dance Production class meets daily from 1:45 to 4:00, which gives sufficient practice time for those dancers who are participating in musicals, concerts, and lecture demonstrations outside of school hours.[11]

Identifying the gifted and talented

Although a few private high schools for the talented have existed (Interlochen Arts Academy in Michigan, established in 1962, is perhaps the best known), such high schools are extremely rare in the public school system. One exception is the High School of Performing Arts in New York City (founded in 1949), which, however, is now in great difficulty because of faculty and budget cuts. There is growing tolerance, though, among educators for schools which specialize, and increasing recognition that talent need not, in the conventional sense, be intellectual. These changing attitudes have allowed the birth of a few public high schools devoted to the arts, such as the Western High School of Performing Arts in Washington, D.C., created only three years ago, and the Houston High School for the Performing and Visual Arts in Texas, which opened its doors in the fall of 1971.

. . . instead he would give them the music and arts they were denied in most secondary schools. They would have their basic academic subjects: science, mathematics, history, English, and foreign language. But they would have time to concentrate on music, art, drama, creative writing, and dance—activities that were still considered "frills" in many schools. . . . The emphasis in Joe's Academy on music and arts was in direct contrast to the curriculum of most high schools. And he could never let people forget that Einstein was once a musician, and so was Albert Schweitzer, and that artistic and academic abilities have always gone hand in hand. [NORMA LEE BROWNING, *Joe Maddy of Interlochen*, Henry Regnery Company, Chicago, 1963, p. 292]

Students at the Houston school combine a college preparatory academic program with their training in the arts: half of each day is given to academic subjects and the other half to professional training. The arts, whenever possible, are integrated into the study of the academic subjects (English, social studies, science, mathematics, and foreign languages). Among the arts taught are painting, drawing, sculpture, pottery, weaving, art-photography, jazz ballet, classical ballet, modern dance, theatre dance, dance history, dance production, acting, voice and diction, directing, theatre history, playwriting, costume design, lighting design, radio and television, electronic editing, closed-circuit video, and cinematography.

An erroneous impression that the arts are overpermissive is held by many people. In actuality, mastery of any art requires tremendous self-discipline. The following provisions are included in the contract which students at the Performing and Visual Arts high school in Houston are asked to sign:[12]

1. I understand that it is my responsibility to attend school daily, to arrive promptly, and to remain throughout the scheduled hours.
2. I will cooperate with the teachers, professionals, and my fellow students by conducting myself in a mature manner, giving respect to all persons.
3. It is my responsibility to complete all required work; I also understand that I shall be expected to work independently. I recognize that it is equally important to achieve in the academic areas as well as in the arts.
4. I will respect and care for all equipment, supplies, and the school property offered for my use.
5. I understand that if I choose to leave or if I am asked to leave this school for any reason, I may not re-enter.

There is strong community support for the school; during the 1972–73 school year for instance, groups from the school participated in more than 100 performances in Houston and nearby communities. In addition to those who plan professional careers in the fine arts and technically related fields, many of the students are planning careers as arts teachers because of their school experiences.

Community resources can also help the gifted student. For instance, Fargo, North Dakota, used ESEA Title III funding to provide tutoring by local musicians and artists for forty gifted high school juniors and seniors. These classes are

held in a Creative Arts Center, where dance and drama students will soon have the same opportunity.

The Nassau County, New York, Board of Cooperative Educational Services (BOCES) operates a Cultural Arts Center for the forty-four school districts which have secondary school programs. Talented public high school students who wish to become professionals can enter an intensive program not available in their local school districts. The center prepares students of vocal and instrumental music, drama, dance, and art for advanced placement in undergraduate schools of fine and performing arts. They spend half a day in their home schools on academic studies and the other half at the center. The daily instruction given by a small group of specialists is augmented by part-time teachers who are respected performing artists.

There are some young people who know they want to become artists with the same assurance that others know they want to become doctors. In fields such as music and dance, continuous training is of the utmost importance. Many students have been forced to drop out of high school in order to continue professional study. However, if there is no special high school or district center available, a study program with the nearest professional school can sometimes be arranged.

Independent study programs are not unusual at the Teaneck, New Jersey, High School, but now, for the first time, this type of program has been prepared for a dance student. The student, who had a straight A average, wanted to continue her academic education along with her studies at the School of American Ballet. Arrangements were made for mornings to be spent in Teaneck and afternoons at the ballet school in New York City; academic credit was given for her work in ballet. This type of program requires the cooperation of an accredited professional school as well as supervision and evaluation by a qualified teacher from the school district who will work with the outside instructor.

Many people are unaware that "special education" has always included the gifted and talented as well as the physically handicapped, the emotionally disturbed, and the mentally retarded. Schools are now legally bound to provide for the handicapped, non-English-speaking, and so on. For too long, the gifted and talented have been left to find their own way; it must be recognized that these students are also entitled to the free public education offered to all others.

If one realizes that if Memphis were to produce a great actor or a great painter or a great architect or a great playwright or a great writer, the whole community would be very proud and the whole end of the state would be very proud; fifty years from now that would be the highlight of the Memphis experience for this period. . . . With that in mind, should a community just trust to chance that one of their boys or girls will come along and do some real good thing or are they obligated to step in from time to time and give encouragement? [JAMES MICHENER, Panel member]

111

Humanities, related arts and aesthetic education

There has been a strong grass-roots attempt to integrate the arts with other subject areas, and many innovative programs have resulted. Two types of interdisciplinary courses have become quite prevalent in secondary schools over the past fifteen years. The first, the humanities course, focuses on the condition of man, using the historical, sociological, literary, and artistic aspects of his development. The second type, the related arts course, is concerned with concepts and principles that appear to be common to various forms of artistic expression.

Before the 1960s, interdisciplinary courses in secondary schools were considered innovative and were relatively few in number. By the end of the sixties, some 325 schools in twenty-two states (principally in Illinois, Iowa, Florida, New York, California, and Pennsylvania) offered humanities and related arts courses.[13]

The Humanities Task Force of the Minnesota State Department of Education prepared guidelines in 1973–74 for secondary schools wishing to incorporate this type of program. Ten members of the task force were teachers from Minnesota high schools. Curriculum models were created with sample themes like "Man's Search for God: A World View," which explored literature, music, art, architecture, and was reinforced by films and written materials. Teachers throughout the state were asked to review, evaluate, change, and use the guidelines in their own ways. Among the "cautions and pitfalls" mentioned in the guidelines was the following statement:

> The course taught by each teacher must be for *his* students, in *his* school, in *his* community. It must try to reach *each* student's needs and develop *each* student's potential to the extent that this is possible. No course, however excellently developed, can be lifted from its native soil and transplanted whole.[14]

The interdisciplinary humanities courses may take a chronological, a thematic, an art elements approach, or any combination of these. Gene Wenner, program associate, Arts in Edu-

cation Programs, The JDR 3rd Fund, has suggested some of their potential pitfalls. For instance, the teacher must be careful not to interfere with the student's aesthetic experience by explaining what a work of art "means" before the student experiences it for himself. The teacher must also be careful to avoid forcing or fabricating superficial relationships among the arts. A "line," for instance, may be identified as an element in music or art, but the concepts of visual line and temporal line do not have parallel meanings. If students lack skills in listening, seeing, moving, or in creative expression, there are many possibilities for conceptual confusion.

Aesthetic education has recently captured the attention of secondary school arts teachers. The arts programs of Pennsylvania, a pioneer in developing the total arts concept, are coordinated by the fine arts division of the state's education department. The curriculum goal for senior high schools is the interrelationship of art, music, dance, and theatre.

The Neshaminy School District in Langhorne, Pennsylvania, with two high schools and three middle schools, has developed a two-track system in the arts. The first follows the traditional disciplines approach with an added emphasis on process. The goals and objectives of the second, a comprehensive arts approach, were developed over a period of several years by an arts advisory curriculum committee (art and music teachers from fourteen schools). The fine arts coordinator and several staff members attended state workshops sponsored by the Arts and Humanities Division of the Pennsylvania State Department of Education. The resulting curriculum guides are based on music and art as they relate to dance, drama, and filmmaking. An artist in residence works with the teachers, and the district hopes to plan future curriculum in partnership with the arts resources in the community. With students reacting positively, forty-five of the fifty-five music and art teachers are involved in the comprehensive arts approach.

We believe that humanistic and cultural values are just as basic as "reading and writing." We cannot tolerate another generation that knows so much about preserving and destroying life, but so little about enhancing it. [Position paper of the Arts Advisory Curriculum Committee, Henry Pearlberg, Chairman, Neshaminy School District, Langhorne, Pennsylvania]

The arts as aids to learning

John F. Kennedy High School is one of nine pilot schools in New York City working to infuse the arts into reading and

math through the RITA program (Reading Improvement Through the Arts). Like many high schools, JFK has students who are not successful in math. Members of the art and math faculties have given youngsters who failed math twice a combination course, using one math teacher and one art teacher in the same room. Students create two- and three-dimensional art work that requires them to count, measure, and apply simple formulas. Absenteeism and failure have been almost totally eliminated. Backup teams of math and art personnel are now being trained to continue and expand the program. The results of tests given before and after the four-month combination course were impressive. The growth in reading for ninth and tenth graders was not only significantly beyond statistical expectations, it was beyond growth normally expected in a full year's program.[15]

At each pilot school, moreover, one class for problem readers has been added to the regular program of the art department. Class enrollment is held to twenty-five students. Funds from ESEA Title III pay for a reading teacher, a coordinator (at JFK, this is the art department chairman), an assistant, consultants, and a secretary. Special studies to replace the regular curriculum have been developed by art teachers, who voluntarily attend after-school workshops. Reading specialists visit the art classes on a regular basis to diagnose reading difficulties, provide corrective work, and to write curricula. Students maintain written logs on themes that interest them as a basis for art works.

This program, and the half-dozen previously mentioned in the chapter on elementary education (Oakland, California; Eugene, Oregon; Columbus, Ohio; Los Angeles, California; New York, New York; Irvington, New Jersey) hold promise for the future. Testing results made available to the Panel bear out the basic hypothesis that learning capability in other subjects does increase when the arts are major components of the student's experiences. However, there are many complex questions raised in educational situations which use the arts as learning devices. Are such learning increases due to perceptual training, individual attention, internalized motivation, or emotional satisfaction? Evaluation in this area is still relatively new, and more research is needed if the full potential of such programs is to be achieved.

The middle and junior high schools have been traditionally difficult areas for reaching children. Flexible and fresh ways of thinking are required of administrators, many of whom have met the challenge successfully. Although the arts have intrinsic values of their own, they are also useful in helping young people resolve their conflicting needs. Monroe-Woodbury Junior High School in Central Valley, New York, requires that each of its 900 students take part in a unified arts program called PAM—Practical Arts, Art and Music. The courses, for a mixture of seventh and eighth graders, boys and girls, are multiteamed (the departments of home economics, industrial arts, art, and music each contribute a staff member to the three teaching units).

There are over 100 courses in the four PAM areas, divided into six-week offerings; each student must take at least two courses in each area. For instance, a student interested in art could take two music courses, two practical art courses, and eight other art courses during the seventh and eighth grade time span. The child who is unsure of what he wants can be introduced to new worlds, such as architecture, American Indian art, wood sculpture, drafting, metalworking, history of jazz/rock, music for tape recorder, and opera. All courses are open to *all* students. The teachers themselves have been creative in planning the curriculum, and the high school arts faculty has reported positive results from this six-year-old program which has received acceptance from both parents and state educational leaders.

. . . children at this age need help in integrating themselves. This is a critical area in curriculum which has mainly been ignored. People are afraid of children at this age. This is a time when dance can serve a purpose other than art, for it can reduce anxiety and schism. [MAIDA WITHERS, Dance Department, George Washington University, in staff interview]

The status of arts education in secondary schools

While it has seemed inevitable to many observers that arts education endured a contraction along with other curricular areas, a survey conducted for this project by the Associa-

tion for Supervision and Curriculum Development in 1975–76 indicates that these cuts have been less widespread than expected.

This survey asked 125 secondary school principals to collect data on changes in the number of arts courses offered, student time spent in the arts, and monies allocated to arts education. Of the 100 principals who responded, 59 agreed with the proposition that there has been an increase in the importance of the arts in education. Only one person noted a decrease.

On the district level 535 persons were asked to analyze changes in personnel, instructional materials, and money allocated to curriculum development activities. Of the 345 persons who responded, 52 percent felt there had been no change, 32 percent believed there was an increase, and only about 10 percent said there had been a decrease.

The same questions were also put to the state school officers regarding the three administrative levels of secondary schools, middle schools, and elementary schools. The officers of forty-nine states and three territories responded in an almost identical manner to those at the district level. (Officers noted, however, that they were providing educated guesses because data had not been collected in their states on these questions.)

While it may be too early to draw any definitive conclusion, it appears that the level of arts education in secondary schools has not been seriously eroded despite declining enrollments and the recession of the early 1970s. However, this lack of erosion is not necessarily an encouraging sign, when the status quo itself has been unsatisfactory. There are approximately 24,000 public high schools in the United States; innovative or exemplary programs in one or more of the arts are to be found in very few of them. Panel witness Kathryn Bloom, director of the Arts in Education Program, The JDR 3rd Fund, claims that not more than 20 percent of the high school population elects even one course in music or art. Thus, while there are about 14 million secondary students, some 11 million may have *no exposure whatever to such courses*. Although students with special abilities may be encouraged and satisfied, the other 80 percent fail to experience the importance of the arts in their own education or their own lives.[16]

This saga of the arts in our high schools has dwelt on

. . . much of what is taught is not worth knowing . . . and little will be remembered. The banality and triviality of the curriculum in most schools has to be experienced to be believed. [CHARLES E. SILBERMAN, *Crisis in the Classroom: The Remaking of American Education*, Random House, Inc., New York, 1970]

many encouraging innovations that have lifted the horizons of secondary teachers, their students, and the educational community in general. But before the reader becomes too encouraged by these signs of progress and enlightenment, it is wise to remember that the exceptions are more heartening than the rule, and that for every one of our teenagers who is participating in "arts experiences" one way or another, three are not. A long road lies ahead before all our adolescents receive the arts experiences which are necessary to help prepare them for life. This is the challenge to secondary education even as it is to our colleges and universities at which we next shall look.

Teenage gathering on the beach at Fort Lauderdale. (Photograph by Lynn Pelham, Time-Life Picture Agency. © Time Inc.)

117

The arts
at home
in college

The integration of the arts into higher education is accompanied by a number of ambiguities and paradoxes.

Item: Although the creation of universities was a first priority of our Puritan fathers and antedated any steps toward establishing formal public elementary or secondary schools, the fact is that as the centuries have passed, America has become more preoccupied with the education of its children than with its young adults.

Item: During those same centuries, the elitist view that a college education was not for everyone was countered by the growing concept of a college education for all.

Item: Government support for higher education in the second half of our century has overwhelmingly been provided for scientific learning and accomplishment and not to encourage "the good life," whatever that phrase may mean in terms of a balanced and cultivated human being.

Item: Schools and colleges are today experiencing an arts boom reflected in all statistics available to the Panel, yet being on the brink of financial disaster and facing the likelihood of zero growth in the years immediately ahead, they hesitate to expand with the speed, commitment, and funds required to meet this demand.

Item: The governance of universities and colleges rests much more firmly in the hands of faculties than is widely realized. Letters and science faculties have the votes to control curriculum and determine other critical academic priorities. Arts faculties are small; they do not have the votes, even though they are rapidly acquiring the enrollments.

At the outset, as explained earlier, this Panel determined to focus on elementary and secondary education. But in order to give proper attention to the position of art in higher learning, it undertook special research and invited selected witnesses to report on this field.

The arts invade the liberal arts

ccording to a Carnegie Commission on Higher Education report, "A majority of students surveyed (100,000) expressed the opinion that the campus did not have sufficient opportunities for expression of their creative interests, including the . . . arts."[1] This is not to say there hasn't been any increase in arts opportunities or participation in recent years; in fact, in eighty universities surveyed by the International Council of Fine Arts Deans, undergraduate arts majors increased from 51,000 to 70,000 in only three years (1971–1974). Professor Claude V. Palisca of Yale has reported that "between the Fall of 1968 and the Fall of 1972, the number of music students enrolled in the 178 schools reporting to the

Woodstock was a phenomenon that demonstrated youth's solid support for the arts and the power of the arts as a unifying force. *Woodstock*, photograph © Shelly Rusten, 1969.

. . . at the college level students are increasingly expecting and demanding arts programs. . . . It is the experience of most university administrators that if one had a truly free student market, that is, if students were free of the restrictions imposed by limited course enrollments or of their anxieties about a career—there's no question in my mind that the number of students preferring the arts would increase even more. [ERIC LARRABEE, Panel witness]

National Association of Schools of Music rose by 26 percent. . . ."[2] However, according to the 1976 *Musical America Directory*, only 705 institutions of higher education (or 23.7 percent) offer majors in music. We must also point out that in 1976, of the 3,055 two-year and four-year colleges and universities in this country[3] only 1,134 (or 37.1 percent) offered a major in art and only 1,214 offered a single course in art. Furthermore, only 233 institutions offered Bachelor of Fine Arts degrees, and just 130 offered Master of Fine Arts degrees.[4]

Many of our universities' problems derive from their own history: their medieval structure, the influence in the late nineteenth century of the German university with its emphasis on discrete disciplines; their tenure policies that began as protection of academic freedom but have evolved into job protection; their promotion system frequently based on the familiar "publish or perish" compulsion. This syndrome is not as prevalent in two-year community colleges, where according to our own survey of selected postsecondary institutions, teacher quality was specified unanimously as the principal

"*It's publish or perish, and he hasn't published.*"

Drawing by Richter. © 1966,
The New Yorker Magazine, Inc.

criterion upon which promotion and tenure decisions are based.

The economic pressures of the 1970s have forced most of our colleges and universities to reexamine seriously their educational philosophy and basic organizational structure. During the mid-to-late sixties, they had attempted to be all things to all people. The arts were no exception, as Edwin Wilson, director of the Graduate Theatre Program at Hunter College, explained to the Panel: "One of the great confusions and part of the schizophrenia which beset a lot of universities has been caused by their trying to function both as a conservatory on the one hand, and provide a liberal arts education on the other."

As our senior institution of higher education, Harvard University has traditionally led the way toward educational change. In November 1976 a task force that had been at work for over two years announced its conclusions; they amounted to the first major overhaul of its liberal arts program since 1945, when the famous "Education in a Free Society" report laid the groundwork for Harvard's subsequent general education program, copied widely throughout the nation.

Henry Rosovsky, dean of Harvard's Faculty of Arts and Sciences, summed up the new proposals thus:

> An educated person should have an informed acquaintance with the following:
>
> "The mathematical and experimental methods" of the natural sciences,
>
> The "main forms of analysis" and the "historical and quantitative techniques" used in modern social sciences,
>
> "Some of the important scholarly, literary and artistic achievements of the past and
>
> "The major religious and philosophical conceptions of man."[5]

In these words, Harvard asserts its modest goal in arts education: " . . . an informed acquaintance with . . . some of the important . . . artistic achievements of the past. . . ."

It needs to be pondered here, not only because it is the latest word from what is often thought of as our number-one oracle, but also because it is a sobering reminder of the vast distance that must yet be traveled before the arts are admitted to full partnership in higher learning in even such a prestigious

Though I recognize the high values of a conservatory training in art, music, dance, and others of the arts, it does not seem to me to be a practical objective to try to bring departments of art to a strictly and exclusively studio orientation. The artist and the musician and dancer must be totally educated as persons and not narrowly educated as artists. [ALAN SHIELDS, "The Future of Art Education," *Studies in Art Education*, vol. 12, no. 2, April 1970, p. 59]

Matriculation at the University of California, Southern Branch (as it was then designated) proved to be a cruel disillusionment. True, I enrolled as an art major. But I discovered to my profound irritation that I was expected to continue the inanities of higher mathematics, and other dreary and cumbersome subjects, and that art was only a small portion of my program. [JOSÉ LIMON, "Statement IV," *Dance: A Projection of the Future*, Developmental Conference on Dance, University of California at Los Angeles, 1966–67, p. 78]

and wise institution as Harvard.

If the dispatch from our oldest university is discouraging in its limitations, it is encouraging to read a statement by Ernest L. Boyer, chancellor of the State University of New York, one of the nation's youngest and certainly its largest university. At a universitywide celebration of the arts in 1974 he said:

> First, it is my conviction that the State University, as an institution, must increasingly be a visible reflection of the highest in the arts.
>
> Second, our creative students and faculty must increasingly be given opportunities for performances, exhibitions, technical assistance, and for critiques. . . .
>
> I propose that we introduce many more of our students to experiences in the arts. . . .
>
> The University increasingly should communicate with artists and arts centers beyond the campus.
>
> A university approaching full maturity must engage in a careful historical study of the arts. In addition . . . we need in the arts creative new research.

Chancellor Boyer's statement summarizes most of the objectives this Panel would like to see achieved in integrating the arts into higher learning.

Many universities have been responding to this demand by building great arts centers. The arts facilities built on the Purchase campus of the State University of New York will probably cost more than $53.8 million when completed; the University of Illinois' Krannert Art Center at Urbana opened less than a decade ago at a cost of $19 million; and theatres, concert halls, studios, workshops, galleries, many of them bursting at the seams, are to be found on almost all campuses.

Colleges have also been enlarging their arts faculties (although not at a pace sufficient to keep up with the rising arts enrollments). It is also important to note that in our survey the reason unanimously cited for the success of the arts on campus was the excellence of the faculty: their dedication to the students, both in and out of the classroom, and their level of training and artistic talent. All other factors, including good facilities, administrative support, and student interest, were

considered of secondary importance.

Another positive response to the challenges of the last twenty-five years has been the proliferation of an estimated 115 college consortia (with almost half forming in the last ten years). A consortium is a "partnership," in this instance a partnership of three or more colleges which have grouped together to sponsor educational programs, and to provide students of the member colleges with more advantages than the colleges by themselves could afford. During the higher education boom of the fifties and sixties colleges found that by sharing faculties and facilities they could generate new programs practically overnight, and at almost no added cost. In the seventies higher education was faced with the problems of a recession, declining endowments, rising operating costs, reduced budgets and levelling off of enrollments. The need for cooperation and a more efficient use of existing resources became ever more acute.

Under the various programs sponsored by consortia, students frequently pursue special courses of study off campus, usually for a semester, in a city or center of learning which offers unique opportunities for both educational and practical experience. In the past, several thousand students have been successfully placed as interns in a wide range of situations from marine biology and science laboratories to art and cultural institutions, both in the United States and abroad.

Participating institutions are usually not paid for taking students "under their wings," but the students are expected to make themselves sufficiently useful to justify their instruction. In many respects, these internship programs call to mind the apprentice system of the Renaissance artists, who took aspiring neophytes into their studios on a work-and-learn basis.

A good example of schools cooperating to provide this sort of student benefit is the Great Lakes Colleges Association (GLCA), a consortium of twelve liberal arts colleges and universities in the Midwest. One of its major projects is placing students in arts apprenticeships in New York City. This program, begun in 1968, is aimed at providing a wider range of arts experience than is usually obtainable on campus, while also addressing the dilemma of trying to offer both a liberal arts education and professional arts training within a liberal arts framework. [6]

Through their apprenticeships with professional artists, students gain an early insight into the arts and what it means to work as a professional. An apprentice from Ohio Wesleyan helps prepare a canvas alongside painter Chuck Close and an Oberlin college student plays the bells with The New York Pro Musica. (Courtesy of the Great Lakes Colleges Association Arts Program in New York.)

Over the past eight years, the GLCA Arts Program has placed over 500 students in Broadway and off-Broadway theatre organizations, opera houses, dance companies, and with more than 150 individual artists. Some difficulties are to be anticipated with operating this kind of program, such as helping students to adapt to the life-style of a hectic metropolis and the higher professional standards of their sponsors.

However, the GLCA Arts Program has worked exceptionally well for a number of reasons: first, because the age-old apprenticeship concept is educationally sound; second (and critical), the care given to the screening of students and pro-

spective artist sponsors, and the selection of the program's staff—those persons who are to be the matchmakers and evaluators of the apprentices. Surprisingly the greatest difficulty for the GLCA Program is trying to recruit qualified students to work with the many artists and arts organizations that are anxious to have apprentices. This is due to the lack of early arts training available to students and certain campus policies which require college seniors to spend their final semester on campus.

According to the developers of the GLCA Arts Program:

> The aptitudes required by most New York sponsors for successful apprenticeship placement, coupled with the Program's intention to supplement on-campus study, suggest that most participants will be upper class majors in the arts. Nevertheless, non-arts majors or underclassmen with proven capabilities also take part in the program.[7]

A number of important fringe benefits for the GLCA consortium have resulted from the increased interaction of the New York based artists and the Midwest campuses. Many students have formed enduring relationships with their sponsors and have had jobs in the arts dropped into their laps (although finding positions for students is not one of the stated goals of the project).

Six faces of the arts on campus

Colleges and universities have established for themselves by the second half of the 1970s six roles in arts education which they practice with varying emphases and with varying degrees of success.

First, they serve as patrons of artists, writers, composers and performing ensembles, whom they receive onto their campuses for brief or long associations, sometimes as faculty members, or part-time consultants, or simply as campus residents. The presence of a Claes Oldenburg, a Twyla Tharp, a Leonard Bernstein, a Gwendolyn Brooks, a Guarneri Quartet have fulfilled Russell Lynes's observation that the "colleges and universities are

127

surely the most consistent patrons . . . partly because they want [artists on] faculties and partly because they want them as elements of the atmosphere."[8] Whatever their motive, colleges and universities are now the new Medicis, with the important difference that they bestow their benefits far more democratically.

Some of the Panelists, who have recently served on college faculties, were not impressed by the new Medicis. "It was to me very depressing," said poet A. B. Spellman, "to learn that the second greatest patron to the arts in America are the universities. If universities do enjoy this position, it is often hard to see how their patronage affects students or campus life."

Dancer Melissa Hayden added, "Colleges invite artists as a drawing card for students rather than using them for their real talent. . . ."

Second, they perform an increasingly large role as sponsors and impresarios for symphony orchestras, touring opera and dance companies, soloists from Bach to rock, chamber music ensembles, professional theatre companies, rock bands. Between September 1975 and May 1976, the Association of College and University Concert Arts Administrators (ACUCAA) reports that at least $16 million was expended to bring 3,515 orchestras, theatre and dance companies, bands, and soloists onto 195 American campuses.[9] How many other arts events scheduled independently may have occurred it is impossible to know, but one can estimate that they matched the 3,515 above.

The importance of this impresario role is threefold. First, it is one of the major ways the universities serve their surrounding communities. Those which inhabit metropolitan centers like New York and Boston have a lesser role to play than those located in Iowa City or Chapel Hill or Fargo where the campus is the cultural hub of the entire area. But everywhere the university has a responsibility to share its assets with its neighbors, to provide a flow of educational experience for young and old alike. This is by now a recognized mission and one which most campuses practice with enthusiasm.

The impresario role also provides standards of excellence against which students of the arts may assess their own accomplishments, and by which they may be inspired. At the same

time the student body at large, put in touch with the performing arts professionally, comes to learn the satisfactions they offer. For many students, life on campus has provided the first opportunity to visit an art gallery or see a modern dance troupe. It may have been their first experience of a place where there is opera or live music available, a milieu where interest and involvement in the arts is an acceptable, even highly regarded, activity.

Probably the most significant ongoing objective the universities must aim toward is to foster an appreciation of and demand for the arts that will support their graduates throughout life. It should begin, of course, in the classroom, the lecture hall, and the studio. But it must be furthered in the concert hall, the theatre, and the gallery.

Third, the colleges and universities are educating students to become appreciative laymen vis-à-vis the arts. By so doing, they evidence their concern for audience building, for long-range consumer support. Many are well aware that in their classrooms today sit tomorrow's school board members, legislators, college trustees and administrators, school principals, mayors, teachers, parents, and taxpayers. Future attitudes toward the arts, toward their role in education, indeed toward the quality of American life, are being formed on our campuses every day.

Even if students have no intention of becoming artists, they expand their knowledge and understanding of the creative process, as well as of culture in general, by including the arts in their formal education. There is every indication that such students are more likely to continue enjoying the arts in their adult life than those who have never been exposed to them in school.

A major question in educating the layman is whether his learning should derive from looking and listening and reading, or from doing. The nineteenth-century idea that a proper means of art education is to surround students with "suitable examples of art work"[10] is losing acceptance. True, many educators still contend that the proper way to educate laypersons in the arts is by showing and telling them about the great works. But others in the last two decades have become increasingly convinced that an arts experience must be participatory.

I am proposing that universities become artistic enterprises, professional in the true sense, pulling together the rich resources in faculties and facilities and offering them in a new style to their community of students, indeed to the community that surrounds the university. I am not suggesting that all people should be trained to be practicing artists, but I am suggesting that all people should be helped to be creative about how they live their lives and how they go about the process of learning and living.

To help achieve the goal of a stable society the university of the future will have to encompass the arts in a new way. There will have to be a university within a university as a place for the study of and practice of creativity open to undergraduates, graduate students and people from the community. [MARGARET MAHONEY, "Opportunities and Constraints," *Arts in Society*, vol. 10, no. 1, p. 121, Spring 1976]

Separation and clarification of goals in teaching the arts

The arts as a participatory activity

I	II	III	IV
Pre-professional and professional training for those planning a career in the arts. At studios and conservatories such as Purchase and Juilliard.	The arts—painting, singing, dancing, acting—as an avocation. For personal fulfillment and enjoyment. Participating in art as a means of learning about art.	Creative dramatics, role playing, sociodrama for self-development, increased awareness, exploring group dynamics. Here, art is a means, not an end.	The arts as a tool or technique for intensive therapy, such as dance therapy, art therapy, and psychodrama for retarded children and the emotionally disturbed. Undertaken only in conjunction with trained therapists and medical personnel.

The arts as an observed activity

I	II	III	IV
Art history—painting, music, theater. Combined arts history courses. Teaching various arts simultaneously by historical period. Relating the history of art to total history: social, cultural, political.	How art is created. How the writer writes and the painter paints. How theater or opera is created through the combined efforts of a writer, a director, actors, designers, and technicians. Facts and precepts of art. Discovering common elements in the arts: the use of time, space, rhythm, symbol.	The art experience for the viewer or listener. What is seeing or hearing art all about? What does it mean to go to a concert or a museum? What happens when we are there? What exchange takes place? What should we expect or look for? What does the transaction or experience mean in our lives?	The relation of the arts to other disciplines—psychology, sociology, philosophy. The way art interacts with other aspects of our lives. The effect it has on us. Studies in behavior learning and the like.

SOURCE: Chart prepared by Edwin Wilson, Hunter College, City University of New York, for The Arts, Education and Americans Panel, September 1975.

Too often, however, a distinction is drawn between "appreciation" and " participation"; one is set at odds with the other. This seems to be an unnecessary separation. Neither one can do without the other, and art education is most effective when the student actively engages in both.

"Appreciation" is not enough. At its best, the entire mode of "appreciation" teaching is only an awakening of the sensibilities to a limited perception of beauty; at its worst, it is little more than the slavish dictation of taste. But "participation" is not enough either. At its best it involves the student directly in the creative process, and at its worst it is undisciplined indulgence in self-expression.

Clearly the responsibility is to cultivate, but not to dictate, both taste and a personal, lively perception of the arts' abundant possibilities. This can only be done by encouraging both participatory and appreciative involvement in the arts; and an understanding of the creative process, and the way

aesthetic experience shapes peoples' views of the world and themselves.

Studio courses in painting or sculpting have for some time been an acceptable part of the college campus, along with instruction in playing musical instruments and producing theatricals. More recently, these have been joined on some campuses by courses in photography, video, electronic music, dance, and other art forms. Increasingly, these studio courses are being opened to nonmajors who have no specific drive toward professional accomplishment. Indeed, the rise in so-called studio training—whether the studio be a theatrical rehearsal hall or a bona fide painter's or sculptor's studio, or a film or dance studio—is probably the most important basic curricular change in the past few years.

Many university administrators have still to be persuaded that this kind of activity can and should be graded or awarded college credit, that performing is just as vital for the aspiring artist as lab work for the scientist, that the experience of dancing or playing in a string quartet or acting before an audience is vital to the artistic learning process. There are still many colleges and universities which refuse credit for performance courses, or restrict enrollment or credit to majors.

More and more at the postsecondary, as well as at the secondary level, arts curricula are being expanded to include interdisciplinary courses relating the arts to one another and to other disciplines. Even though these courses have gained popularity at the college level, they are nonetheless threatened by the vested interests of the traditional academic divisions. Interdisciplinary arts courses also suffer from this threat.

In some places, a team-teaching approach has been adopted for the "survey of the arts" courses; to be sure, there is some uncertainty about how the arts can be taught as a whole, despite general agreement that it should be done. Since various arts have common roots and share the same concerns and purposes, a multi-arts experience can well be richer and more valuable than exposure to a single discipline. The major obstacle to a solution seems to be the fences that have been constructed over the years. Generally speaking, faculties continue to teach their separate disciplines in a more or less traditional manner. The boundaries between the disciplines are so rigidly guarded that it will take a major effort to start breaking them down.

. . . difficulties appear to revolve around the inability or unwillingness of each of the necessary units within institutions to work cooperatively across departmental or disciplinary lines. . . . the heart of the problem is that the arts faculties are so single discipline oriented themselves that they are seldom able to look beyond their own departmental concerns. . . . there is an increasing awareness on the parts of both teacher education faculties and arts faculties generally that the traditional, limited relationships haven't worked out well for either party. . . . [JUNIUS EDDY, Ford Foundation Memorandum, April 1971, pp. 12–14]

131

F-111, 1965, by James Rosenquist.

"People need to be able to think about art, beyond the patron's option of taking or leaving it, because art—high, low, pure and applied, commercial and vernacular—shapes our environments and our life styles whether we appreciate it or not."*

*Amy Goldin, "The University Art School: Limbo for Alienated Youth," *Art in America*, vol. 61, no. 3, May 1973, p. 47.

Institutions have a responsibility to provide a basis whereby a human being can go out into the world and live as a human being, and still use dance to affect the world. There is a large range of activity available in the profession of dance—therapy, administration, history, criticism, teaching, choreography, research, documentation, anthropology. We need a broader definition of dancer than just as a mover; not everyone wants to perform. What are the other ways of taking this passion and affecting society by it? This is the purpose of curriculum. [MAIDA WITHERS, Dance Department, George Washington University, in staff interview]

Fourth, colleges and universities recognize an obligation to provide professional training for specially talented students that will prepare them for careers in the arts. While not every campus is equipped to do this, either in terms of faculty or facilities, a number of outstanding schools have been developed within some of our major institutions. The University of Indiana, for example, has established a remarkable professional school of opera; the University of California at Los Angeles, the University of Southern California, and New York University have developed highly competent professional programs in filmmaking; professional schools of theatre, dance, and/or music have been instituted at the State University of New York at Purchase, the University of Texas at Denton, New York University, and the universities of Utah and Akron.

Most of these professional schools of the arts are at the graduate level; the degree awarded is the Master of Fine Arts, and admission to their programs is regularly by audition or portfolio. Faculties frequently contain or are augmented by distinguished practitioners of the arts (although the University of California at Los Angeles denied a chair to Jascha Heifetz some years ago because he lacked acceptable academic credentials). So many universities have established graduate theatre companies that in 1973 a new national organization came into being: the University Repertory Theatre Association (URTA).

An analysis of curriculum structures, such as has been useful earlier in this Report seems unrewarding here, for each art has such specialized needs that no overarching generalizations can be made. Courses and independent study plans, as well as performances and exhibition schedules, vary from dance to film to stage to music to the visual arts. So, inevita-

bly, the technical mastery of each discipline is bound to vary.

There is a danger in all this. Can the university campus in fact provide the appropriate environment in which professional training in the arts can and should be pursued? Can it adjust to "the drive or fanaticism or whatever of the person who has made his choice and will eschew anything else—money, the elite identification of a university degree, even health—to develop the talent he hopes he has"? Can the campus tolerate "such distortion as a way of life"?

These were questions raised a number of years ago by W. McNeil Lowry, then director of the Ford Foundation's Program in Humanities and the Arts. He was addressing the Association of Graduate Deans. He went on to assert:

> The future of professional training in the arts depends, first, upon a radical shift in the university atmosphere surrounding students considered potential artists, and second, upon the provision of postgraduate opportunities for professional apprenticeship removed from an academic environment. . . .
>
> The requisite shift in the university environment for the arts will be achieved only under great difficulties, if at all.[11]

The question this Panel asks is, Has there been a change in recent time or has Lowry's gloomy prognostication of fifteen years ago come true? One graduate dean is on record as supporting Lowry. Robert Brustein, of the Yale Drama School, has stated:

> . . . it is possible to examine Mr. Lowry's conclusions to see whether they were prophetic. And it must be conceded at the outset that for the most part, his diagnosis was correct and his prognosis realistic. The problem is not so much that our institutions of higher learning have encouraged dabbling in the

arts—part-time painting, dramatic society acting or weekend orchestra. Such activities . . . are not only an important adjunct of liberal education, but also a necessary prelude to serious practice and appreciation. The problem, rather, is that the university has embraced amateur *standards* as a measure of creative achievement, and in so doing has reduced the distance between attempt and accomplishment, between neophyte effort and artistic achievement. . . . [12]

Dean Brustein is clearly not accusing his own university; Yale Drama School has a long and distinguished record of professionalism. But elsewhere there is evidence that standards of top excellence are often too carelessly maintained.

Fifth, a number of colleges and universities retain their classical role of training scholars, historians, and critics, and of supporting research in the arts as in other fields of letters and science.

In recent years, a few graduate programs have expanded this role by adding two additional areas as subjects for expert training: museum directorship and performing arts management. The complexities of these institutional posts—combining as they must a knowledge of business, fund raising, internal personnel relations and external community relations, promotion, legal problems, and basic to it all, a substantive command of their respective arts—require serious professional preparation. An increasing number of universities are offering graduate degrees in museology and arts management.

Sixth, teacher training is an historic mission of higher education. Since the competence of teachers is of paramount significance in our study, and cuts across everything that has preceded, this subject is dealt with in a separate section.

To summarize this brief overview of the arts in higher education, we return to Robert Brustein,

> . . . I persist in my peculiar but passionate conviction that the university remains the brightest hope not just for the preservation but also for the development of high culture in America. I say this less on the evidence of what the university has achieved, though it can boast of real success in recent years, than on the fact that it enjoys a special position as the locus of youth and age, experiment and tradition, art and intellect, working process and realized results, apprenticeship and professionalism, the possibilities of the future and the heritage of the past. . . . [13]

Powers behind the curriculum: teachers, artists, and administrators

Who shall teach the arts?

The question of who shall teach the arts, and with what training, is a lively one. Should the arts be taught by specialists or by generalists? Should the age level of the student determine this? If so, at what age should a change occur? Are arts for all young people or only for those with special interest or talent? Does this affect the kind of teacher needed? Should the emphasis in teaching be directed toward theory, appreciation, and history, or toward participation in creative arts experi-

Peanuts, by Charles Schulz. © 1968 United Feature Syndicate, Inc.

ences? There can be no simple answers. While all teachers of the arts should know something about both teaching methods and artistic experience, the relationship between these two components will vary with the age of their students.

At the *elementary level*, all children need the opportunity to grow, to explore, and to develop by having as much of the universe introduced to them as possible. In the elementary school this involves an extension of all the senses: hearing and making organized sounds; seeing and creating colors and textures; moving the body through space in relation to rhythms; story making and story telling.

Teaching in elementary schools is best done by individuals who can take personal interest in the young child. Usually this is an elementary classroom teacher, who, backed up by a consultant or specialist, can do as good a job in the arts as in other areas of learning. For elementary arts programs, then, there is a need for classroom teachers with training in the special problems of young children, and some knowledge of music, art, movement, and verbal arts.

At the *secondary level*, the adolescent's insecurities and gropings toward adulthood can be successfully directed into creative arts. In addition, the adolescent has the capacity to undertake intellectual arts-related activities—history and criticism of works of arts, music, poetry, and drama—which will build a kinship between the achievements of other persons and the strivings of youth.

For art teachers at the secondary level, training in an art form and understanding of the adolescent personality are both imperative. The arts teacher at this level tends to be more of a specialist, but may also teach other subjects. The teacher usually has some college training in an art form, but practicing artists are seldom expected or found.

As a fifth grade teacher, I teach everything, so I have to concentrate on more than just art. I teach reading, writing, arithmetic, and all the rest. But, when most of the children come to me . . . they have not been exposed to the arts very much. In fact, they don't even know what the arts are all about. . . . So the first thing I try to do is to get them to try to understand that the arts are everywhere—just take our homes and think of art in the home. We start from there, and after that, we talk about how art is a part of our life, and we cannot exist without art. [PEGGY BREWER, Panel witness]

I am concerned about that child in the third grade classroom who is going to grow up and vote or not vote money toward the school board, and he's going to make some decisions about buildings, and he's going to decide whether or not to maintain the symphony orchestra in his city, and to support his museum, and I think these are terribly important learnings that the children have to have. And they cannot have them unless their teachers understand that those things are important. [JUDITH ARONSON, Panel witness]

At the *college and university level*, the arts should be available to all students: those who wish to gain a broad understanding of the arts, those who want to become more involved in a specific art form, and finally those who are considering teaching or professional involvement in the arts. These various objectives require both analytical-historical courses in which the arts are taught as part of the humanities and making-doing-creating courses, with instruction by an artist.

The training of the art specialist for the college level has traditionally emphasized technical courses designed to assure acceptance as an artist, rather than training as an educator. In fact, the college arts teacher is likely to be an artist who has been hired to teach. At the precollege level the arts teacher is generally an educator first, and an artist second, while on the college level, just the opposite is usually true.

This distinction indicates an important difference in emphasis. With so many demands on their time, it is virtually impossible for public school teachers to be creating-performing artists as well. Outside of class, lessons must be planned, students counseled, conferences with parents undertaken, dances chaperoned, football games attended, and help given with the yearbook. The teacher simply has no time to devote to his or her art.

There is the opposite problem at the college level, where exhibitions and performances are almost a requirement for the job. To keep his artistic standing, and thus his job, the college arts teacher must devote himself to his personal work, despite faculty responsibilities.

In programs not connected with schools, the clientele defies simple description, and the teaching demands are correspondingly difficult to categorize, but good training is no less important here than in the school programs. There are adult groups learning how to paint in oils or participating in little theatre activities. There are preschool programs, day care centers, and free schools for young people who do not fit the established school structure. There are neighborhood and community arts centers, as well as educational programs run by the large arts institutions.

Any arts teacher, it appears, should be both an artist and a teacher; but this double role is seldom recognized in existing teacher-training programs. The important question is what kind of preparation is appropriate for the artist-teacher or teacher-artist. A better way must be found to develop those who can bear the personal and organizational demands of teaching while continuing to create or perform.

Teachers and teacher training

Although a number of elementary schools have the services of arts specialists, 90 percent of elementary school arts are taught by classroom teachers.[1] Thirty-seven states place responsibility for teaching arts on their shoulders, while only four states expect specialists to perform this function at the elementary level. These already hard-pressed elementary classroom teachers—of whom there are some 1,300,000—may have but a limited interest in the arts. "Many are scared to death of them," is Panel witness John Goodlad's phrase. More distressingly, they may be inadequately trained to teach the arts. Prospective classroom teachers in 30 percent of the nation's colleges may receive certification without having taken a single course in art or music, and yet they will be expected to teach these subjects. Arts courses offered to elementary classroom teachers, in addition to readings and lecture methods, typically consist of a survey of arts activi-

ties that might later be used with children. These courses are not designed to give first-hand experience in creation or appreciation; instead they have a methodological orientation. Thus, the teacher is encouraged to view arts teaching as dominated by the traditional graded curriculum with little emphasis on originality or a personal, individual response.

So far as elementary arts specialists are concerned, there are approximately 45,000 music[2] and 12,000 visual arts teachers[3] to serve more than 34.4 million children.[4] (There is no available data on the number of drama and dance teachers in American elementary schools today, but their number is very small.) These specialists are generally prepared to teach in only one field. A young man or woman can easily graduate as a state-certified music or art teacher without having had a basic course in any second art area; and most will have had little, if any, training in the historical background of the arts. Arts specialists will often be called upon, moreover, to help classroom teachers integrate art or music into the nonarts curriculum; yet in most teacher training institutions, students preparing to teach the arts at the elementary level receive only limited training in teaching math, reading, or social studies and so have no real understanding of how integration can be accomplished.

In order to ensure the establishment of some minimum basic standards, guidelines have been set by two major arts education organizations: The National Art Education Association and the Music Educators National Conference. For elementary classroom teachers who include the arts as one of the areas they teach, there are also various state requirements, usually including a single course in music or art teaching methods as an option.

The National Art Education Association "Guidelines for Teacher Preparation," dated 1970, lists and describes the following as components of

One of the major difficulties we face in contemporary teacher training programs in the visual arts is that we do not strike a proper balance between artistic performance and the development of critical skills. . . . Teachers of art in private middle and secondary schools do offer courses in art history; but the typical public school art specialist bases the program almost exclusively on studio activities. There is no convincing evidence, however, that a school arts program devoted exclusively to studio performance develops the sort of visual literacy, aesthetic understanding, and critical insight which ought to be the goal of instruction aimed at the total school population as opposed to the minority of pupils who will become professional artists. In my view, instruction which gives pupils opportunities to develop the ability to describe, analyze, and interpret works of art varying greatly in medium, style, and cultural origin has to be given by the trained art specialist. To do this the art teacher must understand the critical process; then he or she can make his knowledge of art accessible to students. . . .
[EDMUND B. FELDMAN, Panel witness]

141

recommended standards for teacher education in visual art:

The Teaching Specialty

Humanistic and Behavioral Studies

Teaching and Learning Theory

Student Teaching and Internship[5]

The Music Educators National Conference's *Teacher Education in Music*, its final report of 1972, lists three major curricular areas:

1. General Education (science and humanities)

2. Basic Musicianship and Performance (understanding of language and grammar of music, composition, methods by which music is conceived, and performance skills)

3. Professional Education (student teaching and demonstrations, methods and materials, educational psychology, philosophical and social foundations)[6]

Both these recommendations follow the existing pattern of teacher education and certification, demanding general education, professional education, and a discipline.

In training arts specialists for public school teaching, a typical program will consist of some variation of the following combination of semester credit hours:

For Art Teachers	Semester Hours of Course Credits
Studio arts	40–50
Art history and theory	12–20
Art education (including student teaching)	24–32
Education	12–16
Academics and electives	30–36
Total required for a bachelor's degree	124

For Music Teachers	Semester Hours of Course Credits
Applied music	32–40
Music history and theory	22–28
Music education (including student teaching)	16–20
Education	10–14
Academics and electives	24–30
Total required for a bachelor's degree	124

Such course-credit distribution is relatively typical of training for either prospective music or art specialists in secondary schools. Few programs exist for teacher training in other arts such as drama, dance, or creative writing.

Some new directions

A number of ideas with implications for educating teachers in the arts have started to take hold in American education—among them an emphasis on creativity and self-expression, the acceptance of popular arts and ethnic arts, a new awareness of the community as an arts resource, and an increasing interest in interdisciplinary training, which combines the specialist approach with the more traditional academic curriculum. Yet on the whole, separate disciplines continue to be taught in a more or less traditional manner. No one is quite sure how to go about teaching the arts as a whole, yet most will agree that it should be done. The arts have common roots and philosophy. They share the same concerns and purposes. A multi-arts experience is unquestionably richer and more valuable than exposure to a single discipline.

But educators have only gone far enough to realize the potential a multi-arts approach might have.

They ask the question: "How can the arts be combined and related, and how can they be taught?" The major obstacle to coming up with an answer seems to be those walls between the disciplines which have been created over the generations.

It is apparent that if teachers are to help students acquire valid experiences with various art forms in an interdisciplinary context, sufficient time must be provided for team-planning, for sharing the frames of reference unique to each art, for developing goals that take into account the various levels of learners' abilities, and for developing procedures to assess student learning. To begin with, prospective teachers need to acquire interdisciplinary experiences that could enable them to participate in such collaborative teaching.

The demand for this multi-arts experience has had an impact on a number of teacher training programs. New York University's Division of Arts and Arts Education, for example, has developed a new program which combines art, dance, and music to educate classroom teachers and specialists in the arts. Faculty members have developed interdisciplinary courses and curricula, created more productive arts internships for pre- and in-service teachers; created new relationships with various New York City schools and community resources in arts education; and developed consortia arrangements with other institutions and agencies. The program consists of course work, practice, and fieldwork related to various arts. In addition to work in New York City, two staff members (one a visual artist, the other a music educator) are conducting a series of in-service workshops at the elementary level in Utica, New York.

Jerrold Ross, head of this division, describes the course for specialized teachers in the arts as follows:

The teaching of "specialization" courses is at least a

". . . What has to be done, in order to
 improve
the quality and pertinence of teaching,
is immediately to begin to capture
the very best in every field, that
 already exists,
using film and all other appropriate
 technologies; . . .
so that these units become
a network of top-level thought and feeling,
 exponentially available
as a concentrated vitamin supplement for
 a malnourished country . . ."

[RAY EAMES, Panel member]

. . . Interdisciplinary curriculum development is under way in a number of quarters, and the professional associations are making statements at their conventions, and publishing papers in their journals, which suggest that the old isolationism may be dying. Whether these interdisciplinary concerns are expressed as something called "aesthetic education," "a related arts program," or as "a combined arts approach," the belief seems to be growing that—within the context of education, at least—the arts have much to gain by talking and working together for broader educational goals.
[JUNIUS EDDY, "Perspectives on the Arts and General Education," unpublished information paper for the Rockefeller Foundation, January 1974, p. 31]

five-fold task. Work in the artist's specialization must serve to:

1. Acquaint him with the literature, history, and traditions of his profession.

2. Provide him with guidance for the development of technical proficiency.

3. Help him to relate the content of his specific discipline to related fields.

4. Provide him with a richness that reveals his discipline in many and varied ways, while developing his perception of his art to as great a depth as possible.

5. Increase his ability to articulate and communicate the above.[7]

The Graduate School of Education at Rutgers University offers an interdisciplinary program leading to the Ed.M., Ed.S., and Ed.D. degrees in Creative Arts Education. The director, in conjunction with the New Jersey Department of Education's Division of Research and Planning, is developing a model for integrating the arts into general education for all New Jersey children. The hope is that the model (which includes re-education of both classroom teachers and arts specialists) will be adopted by all school districts under a mandate from the state board of education. The masters program not only is designed to educate people who can operate in schools with typical normal children, but also to educate individuals who are interdisciplinary in their approach to teaching children with special learning problems.

The doctoral level program is designed to educate individuals for two broad areas of service: the Ed.S. degree will educate people for work in clinical settings, such as centers for special education, mental health centers, community agencies; the Ed.D. degree will educate individuals to administer and coordinate creative arts programs for school

systems, communities, hospitals, drug or prison rehabilitation programs, or special schools. In addition to taking courses in a variety of arts, students do field work in community agencies related to their special interests.

Numerous courses stress studio participation in teacher training. One such program occurs at Illinois State University at Normal, where 200 future elementary teachers are currently enrolled in a four-semester arts education program. In the second semester of their sophomore year or the first of their junior year, students enroll for twelve hours of credit in an arts component, made up of visual art, music, creative drama, and human growth. Arts subjects are taught by specialists from the various departments in the university's College of Fine Arts. The keynote—designed for those with little or no arts experience—is flexibility, with an emphasis on participation rather than a traditional lecture program.

Outside pressures on schools

As we have noted, there are very real pressures affecting today's schools and those who teach in them, including a decline in school populations with an accompanying decline in the number of teachers; problems relating to re-education of the remaining teaching staff; the emergence of teacher bargaining power; the right-to-education legislation and citizens' demands that the schools meet the needs of students with special abilities, disabilities, and differing cultural backgrounds; the knowledge explosion and management of vast new stores of information; and the general financial crisis. These pressures affect all public school education, including the arts, but two trends particularly rele-

vant to the arts are a decline in the number of teachers and a growing concern for accountability.

In recent years, the accountability movement—stemming from the taxpayers' demand for a fair return on their tax dollar—has distressed the teachers who are being held accountable for what is learned in the classroom. Arts educators have special problems with this approach. While they have sought to respond to demands for accountability by painfully restructuring curricula to make results measurable, they find that their subject areas—dealing with such phenomena as feeling, aesthetic sensitivity, and musicality—are exceedingly difficult to measure.

Nevertheless, "the arts will be held accountable in the same way as any other subject," declares W. Todd Furniss, director of the Office of Academic Affairs, American Council on Education. "Unless the arts themselves develop their own accounting, somebody will do it, and the terms may not be satisfactory."[8] Panel witness John D. Sullivan, director of Instruction and Professional Development at the National Education Association, has reminded the Panel, on the other hand, that we are dealing with human beings, not automobiles. He claims, furthermore, that accountability has not assured a quality education, that its results have not proved worthwhile in terms of the investment of personnel, pupil time, and cost.

Competency-based teacher education (CBTE) which has gained momentum in three-quarters of the states, is a product of this movement. It requires that teacher educators define the knowledge, skills, and attitudes that they believe are important for beginning and continuing teachers to attain. In addition, it requires the educators to design strategies for achieving stated goals, to evaluate achievement, and to feed the results of evaluation into the system as a basis for improvement.

A review of the aims of competency-based teacher education, as well as the philosophy of the

Accountability . . . derives from applying a business management approach to education, growing out of the McNamara era. Lessinger's book *Every Kid a Winner* is the classic statement—inputs, processes, and outputs. According to this point of view, you have to hold the institution responsible for output. Quality control, cost effectiveness—all the terms from business suddenly come into education. [BERNARD H. McKENNA, National Education Association, in staff interview]

The development of music teacher competencies should result from the total program of the teacher-training institution. The demonstration of competence, rather than the passing of the course, should be the deciding factor in certification—musical skill and understanding must be acquired more through oral than through visual perception. For example, the emphasis on improvisation demands this approach—teachers must develop a comprehensive musicianship that, coupled with an open-mindedness toward the use of any sounds combined in a music context, will enable them to address themselves to any music theme encountered. [*Teacher Education in Music: Final Report*, Commission on Teacher Education, Music Educators National Conference, 1972]

145

states which have adopted it indicates that it:

Focuses attention on competency rather than on courses and hours.

Supports a personalized, individualized approach to education, encouraging flexibility and creativity.

Encourages innovative, experimental programs for the prospective teacher who will, in turn, transfer this to the elementary and secondary school classrooms.

Shifts emphasis from "educational-methods" courses to field work in the schools.

Broadens the base of responsibility for teacher training and evaluation to include both the colleges and the schools where the field experiences occur.

It is evident that these characteristics are quite compatible with those of arts education. Moreover, competency-based teacher education has set in motion collaboration between teacher-education institutions and surrounding school districts to work out specific solutions to educational problems. As a training method, it focuses heavily on practical training in the school classroom, rather than on theory classes at the university.

The promise of this movement for arts education lies in two directions: one is the cooperative relationship between teacher training institutions and schools, resulting in a movement into the classroom. The other is the emphasis on a teacher's creative and experimental approaches to education. If as a result of this movement, more balanced criteria for certification were developed to include artistic production and performance, then this might eventually make possible the ideal of the artist-teacher.

When it comes to another handmaiden of accountability, evaluation, Araminta Little, chairperson of dance at California State University at Fullerton, observed in an interview: "Evaluation in any of the arts is always a problem because of the intangible things that happen to people during the passage of time. Skill and knowledge evaluation are possible, but other areas are problematic."

Calvin W. Taylor, professor of psychology at the University of Utah, has conducted joint research with the Bella Vista School in Salt Lake County on the many identifiable talents of children, which include such abilities as expressive talents in the arts, interpersonal relationship talents, and mathematical talents. He states that standard education utilizes only about ten to fifteen of these talents, and estimates that 75 percent of the 100 measurable talents, found to date by basic researchers, can be stimulated through arts activities.[9] However, the complexities of testing in this area and the need for long-term evaluation are indicated in the experiences of the Columbus (Ohio) IMPACT project. Reporting on the dramatic rise in test scores at Eastgate School in reading vocabulary and arithmetic concepts and computations, a local newspaper columnist observed:

> Eastgate observers believe that a real change has taken place at the school, but the change did not come overnight or even in a year.
>
> Rather, the changes have evolved over a period of years and the fact that last year's test scores did not reflect this change was a disappointment to the school and evidence of just how complex is the educational process and the testing process itself.
>
> Ironically, related Evelyn Jones, Eastgate principal, an important factor in bringing about the change was the arts IMPACT program—a program which is not directly aimed at academic subjects such as reading and arithmetic.
>
> Jones explains that the arts IMPACT program was a key factor in bringing together staff, parents and students as a team.

But the arts IMPACT program is only part of what Jones described as a "long story," including several years of experimentation and "extremely hard work on the part of the staff. . . ."[10]

The intricacies of evaluation in the arts were further explored at a meeting of the American Council for the Arts in Education. The sessions revealed that there are many affirmative studies which indicate that the arts can help improve reading skills. But many important questions remained unanswered: Do all the graphs and questionnaires tell what the arts can do for a child in a personal sense? Is it true that the arts stimulate learning? Do the arts in fact make a child happier and give him a feeling of accomplishment? If the arts do these things, is the impact quantifiable and measurable? Are the appropriate methods being used in evaluation?

The sessions also stressed the need for evaluating the effect of early arts experiences on later life. And for this purpose, long-term as well as short-term studies are clearly needed.

We are in the process of trying to develop a system for evaluation. This is most difficult since I am unaware of any effective system being developed to measure the affective area. My personal feelings are that the total education accountability picture is very bleak, simply because educators have tried to adopt the accountability procedures used in business and in the military, which do not fit the educational scene. It is my opinion, that educators must develop their own measurements for their own system of accountability in order for it to be realistic. The evaluation that I can give you is one that reflects the attitude of our staff and their relationship to their students. . . . [Personal communication from HENRY L. PEARLBERG, Coordinator of Fine Arts, Neshaminy School District, Pennsylvania, to staff member, Nov. 26, 1975]

Outside support for teachers

In the 1960s the schools were still in a period of expansion. However, in the 1970s—with the rate of population growth in the United States currently below replacement level—schools are being forced to contract. The influx of new, young staff members has almost stopped, leaving a resident staff which is getting older and, perhaps, less flexible. It is estimated that reduction of school enrollment will reach 25 percent within ten years and that there will not even be a need for more new schools (except for replacements and relocations) at that time.

Thus, diminished school populations, reduced

staff, and less financial support for schools will tend to create a static educational situation in which human and material resources are limited. How does one educate arts teachers to survive and press for more arts programs in such an environment?

"Eighty percent of the teachers who will be teaching in ten years are already in the classroom," testified Judith Aronson, chairperson for the Aesthetic Education Program at Webster College in Missouri, before the Panel. "If you ask me 'where should we put our money?,' I would say, put it into teacher re-education, in-service education, the renewal of teachers. . . . Put your money there."

Webster College in St. Louis offers an intensive re-education program for teachers who say "we have an intuitive feeling that the arts are important, but what do we do about it?" The college replies, according to Aronson, "We are not equipped to turn you into arts or music supervisors. Our purpose is to take you, a classroom teacher or even a specialist who has been trained too narrowly, open the world to you, and say, 'Look, there is a world of using your senses which enables you to enjoy the best that man has thought and done.' It is not art education that we do; it is, in a very kind of corny sense, life education."

Francis Keppel reminded the Panel of those 1,300,000 elementary teachers who are going to have to be re-educated. Norris Houghton did some quick calculating: "Webster College can take ninety students, that still leaves 1,249,910." Other voices spoke up: "Have we even got enough people to select the people who are going to provide the re-education?" "Who are going to teach the teachers who are going to teach the students?"

Incentives for teacher re-education were also a matter of concern: subjects like "released time" for in-service and training and opportunities for salary increments. Panelist Donald Carroll noted the power of another incentive, albeit intangible. "No one wants to go to work every morning and fail," he observed. "I don't care who you are, you want to be successful."

Preliminary research indicates that experienced teachers are regularly more able to profit from in-service courses in the arts than are beginning teachers, probably because the former have mastered problems of discipline and are familiar with the existing curriculum. They are ready to try new things, while beginning teachers are just learning to function in their classrooms.

In some training programs, pre- and in-service teachers are educated together; in some, teachers from all levels participate simultaneously or team up for solving particular problems; some programs are primarily school- or district-based, with occasional consultation from university teacher educators; other programs are primarily university-based, with teachers coming to campus workshops or courses that prepare or renew their skills.

In all the programs it is apparent that extensive collaboration—teaming of personnel and pooling of resources from within and without the schools—has been necessary to achieve results. In all programs, extrinsic incentives for teachers to re-educate themselves have been built in (such as salary increments, stipends, or release time.) The programs also demand a strong commitment to the arts by administrative personnel.

CEMREL Aesthetic Education Learning Centers: As a logical extension of its work with curriculum packages referred to earlier, CEMREL has now entered the field of teacher education. With the combined help of The JDR 3rd Fund, the National Endowment for the Arts, and financial support from the National Institute of Education, CEMREL is working with school systems, colleges and universities, and arts-service organizations around the United

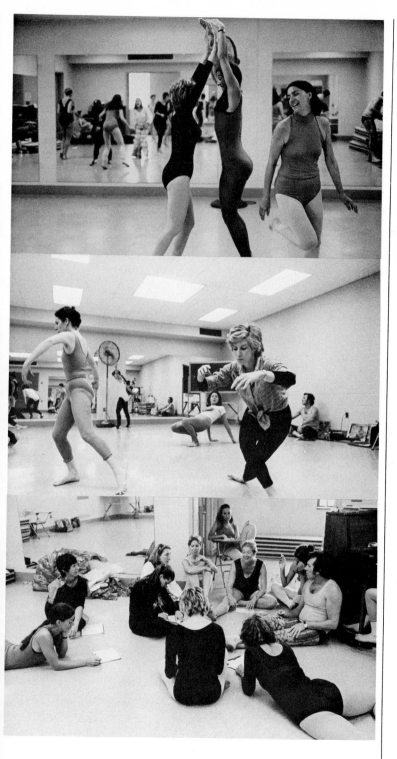

The Connecticut Commission on the Arts has sponsored dance education workshops which include teachers of dance, physical education, special education, and music and classroom teachers, students, and artists. (Courtesy of the Connecticut Commission on the Arts and June Kennedy, Dance Consultant. Photographs by Joseph Linsalata.)

States. The result of this collaboration has been the formation of eight Aesthetic Education Learning Centers designed to (1) provide immediate conceptual and curricular support to the cooperating school systems, (2) bring together agencies and their resources to develop aesthetic education programs for local schools and community and teacher education agencies, and (3) develop an aesthetic education curriculum suited to each cooperating system but applicable to other similar systems nationwide.

The intent is to create an Aesthetic Education Learning Center network which will generate several alternative curricula and approaches to problems of arts education.

The Memphis Aesthetic Education Program is one of the eight components of this network. Involved in the project are the Memphis Public Schools, CEMREL, and Memphis State University. The Memphis Teacher Education Center provides for teachers' visits and workshops, graduate and undergraduate courses, and a learning environment for both students and adults. College credit and in-service credit are given for participating in the center's activities.

Dennie Smith, associate professor of Curriculum and Instruction at Memphis State University, reports that the following factors have been most helpful in the efforts to implement Aesthetic Education in Memphis: (1) support of the principals, (2) a minimum of two teachers in a school to provide mutual support for one another, (3) workshops to train teachers and principals, (4) provision of materials and/or monetary support, (5) implementation conferences to discuss successes and problems, (6) university and school system cooperation, and (7) periodic classroom visitations to help teachers.

The National Humanities Faculty: A unique kind of in-service approach is provided by the National Humanities Faculty, established in 1968 to improve the teaching of the humanities in American schools. In this program, leading teachers in the traditional humanities disciplines—as well as teachers from the fine and applied arts, sciences, and social sciences whose concerns draw upon the values associated with the humanities—are sent out to work with groups of teachers at individual schools or community colleges. The arts have been included in a number of school projects from Arizona to Mississippi, from Oregon to Illinois.

Presently this program—which has been supported by the National Endowment for the Humanities as well as private funds—is seeking new ways to strengthen arts education in American schools. Its Creation and Appreciation in the Arts Planning Committee supported by the Rockefeller Foundation starts from the premise, based on National Humanities Faculty experience, that the term "aesthetic experience" refers to all artistic endeavor, be it verbal, aural, visual, or kinesthetic, and that "the arts are not peripheral to schooling as current budget allocations might suggest, but are fundamental to formal education just as they are to daily human experience."[11]

A teacher development program is being initiated for both the arts specialist and the nonarts specialist, which will emphasize development of curricula employing arts materials, preparation of teachers to work in multi- and cross-disciplinary approaches which use the arts effectively, and heightening of skills required for sound criticism and interpretation of art works. Finally, the program will develop strategies to enrich collaborative ventures between the schools and local arts resources and personnel.

Pennsylvania's Comprehensive State Program: A comprehensive approach at the state level to re-educate teachers is that of Pennsylvania, which has inaugu-

Filmmaker Stan Brackhage is seen here instructing teachers on the use of film in education at Nederland High School, Nederland, Colorado. (Courtesy of the Center for Understanding Media, New York.)

rated a number of programs since the concept of aesthetic education first emerged at Pennsylvania State University in 1965. By 1970, the secretary of education had established "Arts in Basic Education" as an educational priority in Pennsylvania. Federal money was being fed into the Elementary and Secondary Education Act (ESEA) Title III projects in nineteen places across the state. In 1971, the state's sixty-seven county offices were replaced by twenty-nine "Intermediate Units" which now share much of the responsibility for in-service education.

The state's Division of Arts and Humanities has instituted a curriculum program planning system

for local school districts, using in-service training and guidance materials which urge teachers and administrators to formulate their own programs. The Pennsylvania Aesthetic Education Program, an ESEA Title III project, offers teachers the materials, resources, and skills to supplement existing arts programs, and workshops are open to all teachers.

In the last six years, a sizable number of school districts have begun to take over the re-education of teachers, offering workshops in curriculum and materials development, new teaching strategies, and evaluation. The apparent isolation of teacher training institutions from local instructional problems and student populations has led teachers and curriculum specialists to seek federal monies in order to mount staff development efforts that take place on site.

Jefferson County, Colorado: The Arts in Education Program in Jefferson County, Colorado (JEFFCO), started under the aegis of The JDR 3rd Fund, in 1971, utilizing an Arts Resource Team which was to assist teachers in methods of interdisciplinary techniques with the arts as a base. The program consists of in-service workshops for teachers and development of curriculum materials and teaching strategies by teachers, members of the Arts Resource Team, and various curriculum coordinators.

The Arts Resource Team is housed in a center where teachers may go for consultation. The five team members bring expertise in crafts, theater, environmental design, music, dance, photography, creativity, art history, and filmmaking. Each team member, in addition to working with others, operates individually within the community, identifying local resources that might be used effectively in the schools.

An interesting feature of the in-service education

is a series of weekend arts workshops called "Sandcastle," at which teachers and administrators are given a variety of arts experiences in a mountain retreat. According to an evaluation by the team, participants actively involved in such activities as craft workshops, choral singing, and improvisational theatre became more aware of how arts can function in the classroom, and gained a new sense of confidence in their own creativity. The program presently extends its services to the entire school system and is funded wholly by the school district, which consists of 80,000 students in 113 schools. Salary increment credit is given for participation in the workshops.

Community Programs: In many urban areas, arts programs at settlement houses, community action agencies, recreation centers, museums, and churches have expanded to provide teacher training and educational services. Some concentrate on short-range "enrichment" experiences, others on continuing "integrated" experiences. They may provide training for "aesthetic education," for "career education in the arts for the talented," for "arts in general education," or for the traditional "art as a special subject area."

Based on his experience with teachers, Richard Lewis, who directs the Touchstone Center for Children, Inc., in New York City, believes that only long-term, in-depth exploration of the arts and their relationship to other subjects will provide teachers with the insights and tools they need to incorporate the arts into the curriculum. He has developed a series of workshop-seminars for both experienced and student teachers who work with artists to integrate artistic experiences and human relations skills into the curriculum.

The Sojourner Truth Players, Fort Worth, Texas, which serves as both a community art school and a community service agency, conducts

teacher training workshops in conjunction with a local college, and employs school arts teachers on a part-time basis. Supported by a federal HEW. grant under the Emergency School Aid Act, Title VII, the agency provides instruction in drama and dance for a racially and economically integrated group of children, with an emphasis on professional quality training. Eight productions a year are viewed by approximately 100,000 persons, both at performances scheduled for schools and public and private agencies, and on television.

A research program to determine the needs at the schools led to the establishment of a teacher training workshop series conducted by the High Museum in Atlanta, Georgia, for elementary-level classroom teachers. The purpose of the workshops is to train teachers to "see," to incorporate the arts into the existing curriculum, and to provide them with the tools for doing so.

During the first half of the workshop series the teachers learn how to relate visual elements such as line and color to the various subject areas they teach—English, ecology, sociology, math, and so forth. During the second half, they seek out art in specific environments—that is, a grocery store, post office, florist shop, junk yard, city park—and create lesson plans around them which include the arts and other disciplines. The program lasts for thirteen weeks and includes forty hours of class work for which teachers receive credit from the Atlanta public school system.

A striking example of cooperation among schools, classroom teachers, professional performing groups, and volunteers from the community is the organization called Performing Tree, which serves almost 200 elementary schools throughout southern California. Performing Tree has provided a multicultural experience in performing arts for school children, drawing upon the rich ethnic and artistic resources of the Los Angeles community. An integral part of its program is teacher in-service

Our first and most important step in facilitating the change process is to convince teachers and administrators of the possibilities. . . . Instead of teaching the arts (music, art, drama, etc.) as separate entities, why not search for a "common thread" and organize the curricular content under Aesthetic Education? Administrators whose straitened budgets have not permitted them to employ all the arts specialists necessary to teach the arts as separate entities can often see practical advantage in having the regular classroom teacher teach Aesthetic Education. [DENNIE L. SMITH, Panel witness]

To most persons majoring in Art Education, the term is interpreted to mean a preparation for becoming a teacher who is to train individuals from the observation of nature and the ability to record accurately the socially agreed upon symbolic conventions and facts by a process of drawing and painting. . . . the term Art Education in this sense then, merely confuses the issue, which is not to teach teachers to teach the making of artists; but to free the individual so that he may discover his inner-self and nurture his individual ability to search for, find and apply truths in relationship to himself. . . . [MICHAEL F. ANDREWS, *Synaesthetic Education*, Syracuse University, Syracuse, N.Y., 1971, pp. 8–9]

training to relate the performances and the arts to classroom work. Its volunteer staff, in consultation with professional arts educators, has produced a *Guide to the Performing and Visual Arts*, designed for the elementary classroom teacher who has had little or no experience in the arts. The guide is so designed that it can help the teacher prepare students for the performance, as well as to follow up with discussions and activities. A singular feature of the guide is a section relating the arts to English communication skills and mathematics through specific classroom exercises. Performing Tree has been identified by the California State Department of Education and the California Alliance for Arts Education as an "exemplary/promising practices program" in arts education.[12]

Looking toward the future

The view that declining enrollments are so severe as to warrant almost *no* training of new teachers is somewhat short-ranged and must be balanced by the view that eventually a serious shortage of teachers may result from the present recession. Many experts conclude that we already have a shortage of educational personnel since half our communities are without kindergartens; preschool education is nonexistent in most parts of the country; there are insufficient teachers trained to aid physically and mentally handicapped children; a formal structure is lacking to fulfill the unmet needs for continuing education of adults; many arts teachers carry too heavy a teaching load; high schools have less than one counselor for every 500 students; there are hundreds of overcrowded classrooms with resulting ineffective or shallow teacher-pupil relationships.[13] It is estimated that we need approximately 600,000 new educational personnel to bring our system up to top-quality level.[14]

As the right to education for all children becomes more firmly established, programs for bicultural and learning-disabled children will be given increased attention in budget planning for schools. The arts must compete with these programs for dollars. Arts teachers, moreover, will have to learn fresh strategies to enable children with special needs to participate in meaningful arts experiences (rather than in token "handwork" experiences that have characterized much of the work in special education in the past). In addition, the emergence of a variety of community arts centers is creating new opportunities and goals for arts educators.

As we move toward a society calling for improved quality of life—one in which people start to demand satisfying work, a cleaner environment, the heightening of political consciousness, the reduction of hierarchy and bureaucracy, and greater self-development—the arts may be expected to play an important role. The implications of all these expectations for teacher education have not been considered in any significant way by the planners of teacher education programs. The relationship between experiences in the arts and aspirations for personal satisfactions, for self-development, and for a higher quality life-style must be more fully examined and built into the rationale for teacher-education programs.

Artists as teachers

Eric Larrabee described for the Panel a program in upstate New York at Kenan Center in Lockport in which schoolchildren visited artists at work in their own studios. One girl, when asked if she liked what she saw, replied, "Oh yes, it was wonderful. I didn't know any artists were still alive." That, Larrabee suggested, is an attitude many artists confront on their first visit to a school.

The Artists-in-Schools program of the National Endowment for the Arts is the most highly publicized and most heavily funded federal program for the arts in education. (For a more detailed discussion see the chapter "Analyzing the Present, Mapping the Future.") The Endowment's guidelines explain that Artists-in-Schools is a nationwide program involving the cooperative efforts of professional artists, students, parents, and teachers. Its purposes are primarily to improve children's powers of perception and their ability to express themselves creatively. Although viewed with uneasiness by some professional artists, educators, and classroom teachers, the program is praised by funding agencies, newspapers, art organizations, and many other artists. Congressman John Brademas of Indiana, in his reference to the program on the floor of the House of Representatives, recently asserted that Artists-in-Schools "is widely regarded as one of the Endowment's most successful programs."[15] The Endowment hopes this effort will be a humanizing force in education, will build audiences for the arts, and will provide additional employment for artists.

Panelist Thomas P. Bergin, chairman of the Endowment's Artists-in-Schools Advisory Panel, presented the program in this perspective in 1974:

I have seen in many school systems and individual schools, a new commitment to the arts and a trend toward wanting to uplift the human spirit of every child. But can you really do that unless you have a professional to teach that child? And if you are really successful in that spiritual uplifting you are going to find any number of children who want to do something with their spirits, once they have been lifted. They may, in fact, want to become a musician or writer. What do you do then? That is why we must provide for those children a vehicle for professional education, which exceeds what is incumbent upon us to do for each and every child. [PEGGY COOPER, Panel member]

155

At a time when the United States Office of Education has disbanded its arts and humanities program, when the National Institute of Education's attention seems elsewhere, and when many schools are dropping art and music teachers from their staffs as they slash their budgets, the Artists-in-Schools Program takes on an even greater significance.

In our schools, this program still is opening avenues of perception and awareness for our children and demonstrating to education systems and to the public the great value and necessity of incorporating (not excluding) the arts into school curricula.[16]

The U.S. Office of Education, although no longer an equal partner in the program, emphasizes the relevance of Artists-in-Schools to its own educational objectives: giving children in low-income areas a greater sense of identity and pride; helping those with physical and emotional handicaps; creating school jobs for professional artists, developing student interest in arts-oriented careers; improving curriculum construction; building greater understanding among minority and racial groups; and increasing language skills.

In Columbus, Ohio, as at other project sites, Project IMPACT operated an in-service program remarkable for its effective use of visiting and resident artists. Several artists and performing arts groups were supported by the federal Artists-in-Schools program in cooperation with the Ohio Arts Council. In addition, local artists from the Columbus Symphony, local university and repertory theatres, and volunteers from the Columbus Gallery of Fine Arts became involved in programs for both students and teachers.

The Rhode Island State Council on the Arts relies on the Artists-in-Schools program for implementation of its Arts in Education Project, a teacher training program aimed at increasing the use of artists, arts organizations, and art processes as classroom resources. Unique among the Endowment's programs in that it employs as many as six artists in residence on full-year appointments, the Rhode Island Council approach involves artist-supervised programs for generalists as well as art teachers. The ripple effect of these programs has been felt in community centers, libraries, prisons, hospitals, and senior citizen centers, and the state of Rhode Island now has a cadre of experienced artists who have done school and community work and found it helping their art work. But the Council notes that artists are not the only beneficiaries. Classroom teachers, as well as parents and children, have felt the educational and personal value of arts in their classrooms and are asking for more. The executive director of the Council on the Arts has commented that "the greatest beneficiaries of the Artists-in-Schools Program in the long run may be the art educator."[17]

John Biguenet, a young poet serving for four years in Arkansas as an artist-in-schools, told the Panel the following story. It provides heartening evidence, not only of the link between artist and students, but also between artist and community at large.

The only thing I knew about Little Rock was Central High School in 1957. I was in a restaurant fairly late at night when a gigantic man walked up to the table. He said, "My daughter tells me you're a poet." And I thought that this was the trouble I expected; but I said, "Yes, I am a poet." And he said, "So am I," and he pushed me over and pulled out a sheaf of poems and I sat there in the restaurant reading his poems.

The first week I was in Arkansas a meat packer called me and asked, "Are you really a poet?" and I replied, "Yes" and he said, "Well, come to my house for dinner tomorrow night at seven to read my poems," and he hung up.

Biguenet went on to explain his approach to the
school assignment.

I tried to show that poetry is self-defense. This
approach was necessary because I've been working
in inner-city schools, Central High and the others,
and the kids are not about to sit still for a poet to
walk in and teach Keats. They're not interested in
that because it doesn't seem necessary. So unless I
can somehow prove to them that if they can't use
words they're in trouble, as much trouble as if they

"Kung Phooey," a spoof on modern
westerns was created, performed, and
filmed by children in the San Francisco
Public Schools under the sponsorship of
the National Endowment for the Arts,
Artists-in-Schools program. Instructor
Darrell Sevilla is seen here rehearsing with
his young actors on a movie lot. (Courtesy
of the Center for Understanding Media,
New York.)

can't fight (which in the case of many of the students is a way of life), then they're not going to listen. And so by showing them how advertisements work, how the misuse of language occurs in politics, how words have often been used against them, how images have been used to force them into certain decisions, they have become interested and curious about the technique of these arts.

I believe that art is necessary and I convince the kids that art is necessary. In the most drastic example I can think of, I try and prove to high school kids that words can kill. That if a person is effective enough, he can force another human being up to a certain line, then make him cross that line and die in the process, all through the use of words. The old adage states: "Sticks and stones may break my bones but words will never hurt me." But when a kid jumps out of a tree and breaks his leg, it's because someone has called him "chicken." "I dare you to jump," and it's the *word* that makes him jump. When somebody is seventeen years old and his friend says, "If you're a real man you'll drive this car 75 miles an hour down the interstate the wrong way," the "real man" is the thing that kills him, not the truck.

From that point of view we were able to move into Keats and Shelley and Byron; and eventually and more important perhaps, into getting the kids to write their own poems and to talk about their own life and their own insights. . . .

Biguenet's long experience led him to make the following specific suggestions regarding the administration of Artists-in-Schools:

1. The artist needs a stamp of approval from a board made up of teachers, administrators and professional artists using precise and consistent selection procedures.

2. Orientation programs including demonstrations and consultations are necessary for both artists

Cartoon by J. B. Handelsman. © The New Yorker Magazine, Inc.

and for school personnel (teachers *and* administrators).

3. The artist should remain in the school long enough to become a sustaining and fundamental influence.

A recent evaluation (1976) of the Artists-in-Schools program by the Western States Arts Foundation found that, despite some procedural problems, 96 percent of the visual artists and 98 percent of the poets responding said that they would participate again in Artists-in-Schools. And 81 percent of the teachers and 90 percent of the administrators said Yes to the question, "Do you want an artist or poet in your school next year?"[18]

In spite of the great potential in programs which use artists as teachers, each one must be fairly and rigorously evaluated, if they are to overcome the skepticism of critics like Elliot W. Eisner, professor of education and art at Stanford University. His questions about Artists-in-Schools include: Is this a fad or a significant educational breakthrough? Is this an effective use of public monies? Are the failures as well as successes carefully enough analyzed? Is elitism an inevitable corollary for a program that reaches such a small percentage of schools? If not, on what basis can the public assess the success of programs so narrow in terms of audience? Are the producers of art the best teachers of art? Eisner asks for more extensive debate about numbers of students involved, goals, assessment of the effects of the programs, evaluation of the participant's experience, flexibility of study conditions, and the artist's personality and skill as they affect his classroom communication.[19]

Perhaps some of these questions are finally being answered. There is no doubt that artists can be good teachers if they have both creative talent and an ability to communicate. They face tough problems, however, such as the insecurities of some

There should be increased cooperation between artists and arts educators. There are problems in that neither are aware of the specific needs of the other. Teachers are frequently fearful of how to use the artist as a resource, and many artists' training precludes their ability to understand the needs of the classroom, students, and teachers. The solutions range from artist training to administrative awareness. . . . [WILLIAM M. DAWSON, Executive Director, Association of College, University and Community Arts Administrators, Inc., in staff interview]

They come into the schools with no advance notice and with no knowledge of child development, curriculum, learning, or the ways schools operate, and they leave for their next glamorous assignment, leaving us to patch up their mistakes and follow up on their titillating remarks. The schools would be better off without them. [Anonymous elementary school teacher]

The artist somewhere along the line may often have had a counterproductive educational experience. He is frustrated by the bureaucracy and is de-energized by being made to teach rather than do. Money, time, and space need to be provided without special efforts on the part of the artist, who really needs support for the mundane needs. [ROBERT GELLER, President, Learning in Focus, in staff interview]

teachers, competition for students' allegiance, and adequate provisions of space and equipment.

Artists-in-schools programs are often popular with students and receive a kind of publicity that classroom teachers and arts specialists rarely get. Teachers who work with 500 students per week without adequate materials or equipment find their work compared unfavorably to that of the professional artist who has been assigned twenty children and given all the necessary supplies. No wonder, perhaps, that some artists sense teachers' lack of support.

However, harmony between teachers and artists is the usual result when there have been intensive training sessions in which both groups can exchange ideas, goals, practices, and skills.

The steering committee for the Western States study concluded that the "successes far outnumber the failures and that there is an overwhelming positive response to the work of artists and poets in classrooms. It also appears that the value of Artists-in-Schools goes beyond the arts to affect other areas of learning." However, the committee emphasized that "the Artists-in-Schools Program is not a replacement for professional arts teachers and a strong arts curriculum. It is, rather, a separate and complementary experience which will contribute to the realization of the goals of arts education, as well as those of education in general."[20]

Panel witness Stanley Madeja, director of CEM-REL's Aesthetic Education Program, suggested a variety of roles an artist might play in the schools—not just that of producer or performer, but of active participant in the definition of course content, designer of curriculum materials and strategies, and creator of a total learning environment—both physical and emotional. Or the artists themselves could be treated as role model or subject matter, demonstrating for children what an artist is and does.

Joan Abrahamson, in testimony about community arts programs in San Francisco, recommended that art commissions compile a resource bank of local artists. Artists and craftsmen could be hired as school consultants to work on performing, visual, and folk arts projects with teachers, students, and parents.

Charles DeCarlo, president of Sarah Lawrence College, suggested that the artist on campus could play a role in meeting the growing challenges which confront higher education. The artist, more accustomed to taking risks than the scholar, could help to reformulate the college mission, to cultivate new clients, and to connect the college more closely with the community.

And what of artists and tenure? The Panel debated the question from several angles. At Sarah Lawrence, it was noted, nontenured positions were created to benefit artists. Eric Larrabee spoke of the benefits in having creative faculty members granted tenure on the basis of artistic output, given an importance comparable to the scholarly writings of their colleagues. The Panel suggested that without full faculty status and without administrative support an artist's authority would be curtailed. But, in the end, the Panel felt that a combination of tenured and nontenured arts faculty was the right compromise.

Panel witness Jason Seley, sculptor and professor of art at Cornell University, described "the dilemma of the serious creative artist in the field of education," whose faculty responsibility often results in the draining of crucial time and energy from his or her own work. Panelist Melissa Hayden emphasized that books cannot teach many things of importance which the performing artist can demonstrate directly. Actress Mildred Dunnock, a Panel witness, said that in her college teaching, she sought not to train actors but to broaden life for the students through theatre.

Concert pianist Lorin Hollander, a Panelist, suggested that teaching is of professional benefit to the artist, however difficult it may be to bring artists and students together in a school environment. Not content to concertize on campus, Hollander himself works with students individually, then takes them through the experience of performing before audiences in schools, hospitals, or nursing homes. Most important, he wants students "to see what it is like to fight for silence, fight to quell the laughter, fight to keep the audience in their seats, to see what it is like to play for people who have never heard music before."

He believes that "today the artists and art teachers must be trained for a different type of existence than those who came before. A young musician today must be an analyst, a guidance counselor, must know how to deal with people and to express his ideas other than through his instrument. His presence in a school does something to students which is valuable and different from their daily routines."

Hollander further recommends breaking a symphony orchestra into ensemble groups—string quartets, string trios, woodwind trios, rock, jazz, or percussion ensembles—and sending them into the schools to perform. This could do many things for symphonic musicians themselves, allowing them to be soloists and chamber musicians and helping to change attitudes in the community toward music. Are artists willing to go into a community and really dig in for a few days? Hollander replies:

For me to go, say, to Cedar Rapids, and *not* go into the schools is a waste of talent, time, money, and energy. In a world where there is such poverty, dread and sickness, such emptiness and loss of meaning, there are few places that one can turn to except the university, museum, places of worship,

I am a firm believer that the better the artist the better the teacher. I don't deny for a moment that it's the day's pay that is probably the most single important factor as to why artists teach. And thank goodness! Teaching supports many more artists today than would have been true thirty-five years ago. [JASON SELEY, Panel witness]

The artists who have been successful working in public schools in Connecticut have been those who have a clear commitment to their own work and a sense of the direction in which they are moving as artists. They bring to the classroom their feeling for the importance of learning by doing, of experiential education. They can transmit their excitement about the creative act because they believe in its validity. . . . Today, more and more young artists are becoming, in the broadest sense, political, concerned with change beyond their own immediate work and struggling for more sensual and humane values in the larger society. [STEPHEN SHAPIRO and RICHARD PLACE, with the assistance of Richard Scheidenhelm, *Artists in the Classroom*, Connecticut Commission on the Arts, 1973, pp. 88–89]

Manifesto of a School Superintendent: The Arts and the Full Meaning of Life

There are many things that I want my children—and yours—to gain from education.

I want them to know something of beauty—the forms it takes, the many ways in which it is revealed, the sometimes unexpected places in which we find it, the art of expressing it.

I want them to be sensitive to the world around them—to feel the wind, to see—to really see—the stars, and the moon, and the trees, to hear the sounds of nature, to live as one with their environment.

I want them to develop a sense of aesthetic taste—to have a feeling for and about the things in their lives, to be something other than a passive recipient of someone else's sense of what is aesthetically appealing.

I want them to be discriminating—not only in their intellectual tastes but in their artistic and cultural tastes as well.

I want them to know, in full measure, the wonder of being human—I want them to be sensitive to the human condition, to know themselves and to see themselves clearly in relation to others, to know that we have struggled since the beginning of our existence to express our thoughts, our convic-

tions, our fears, our dreams—and that we have done this in a variety of ways.

I want them to realize that history is a human story in the sense that in this story are found many examples of people's attempts to liberate themselves from the limitations and restrictions imposed upon them by the society of which they were a part—to know that some people have never made this attempt—that they have in Thomas Wolfe's words remained in the "unspeakable and incommunicable prison of this earth."

I want them to realize fully that every person, as long as he or she lives, must make some kind of response to certain fundamental experiences of human life, ranging from birth to death and all that lies in-between; each of us, in our own fashion, must respond also to such aspects of our search for meaning as trust, compassion, authority, discipline, freedom, hope, beauty, truth, love.

The question, "How shall I find the full meaning of life?" has reference to every individual, and the answer, or more accurately, the parts of the answer, come from many sources.

My strong conviction is that the schools must provide part of the answer, and that in the arts, we have one of our richest resources for working toward this end.

Former Superintendent Charles E. Brown
Newton Public Schools, Newton, Massachusetts

and the concert hall. In these times—and I hope I speak for artists—I think we are willing to give.

Panelist Flora Hurschler of Young Audiences, an outstanding national audience education organization, confirmed Hollander's words. "Artists who will give of themselves, who will reach out to be human, and communicate over and beyond their art, particularly to those who know nothing about their art, but who can identify with them as human beings—therein lies the bridge."

Administrators as partners for renewal/change

"Very few school administrators in the United States have a commitment to the arts or any understanding of what an arts program in the school would look like," John Goodlad told the Panel, speaking of the potential for change at the school-building level. This theme was echoed a dozen times during the Panel meetings, with regard not just to school principals, but to district superintendents, state commissioners of education, and federal officials.

It has become clear to the Panel that the difficulty of the administrator's job is compounded by attitudes in our society which affect the arts. Witness Sam Ingram, state commissioner of education in Tennessee, told the Panel that "to talk with the general public, concerned as it is with their youngsters being able to get a job and earn a living—to talk to them about significant amounts of money in the arts area before these youngsters have reached an acceptable level in the basics is almost a waste of time." And Seymour Yesner, consultant for English and humanities in the Minneapolis public schools, told the Panel that "the possessors of power within the school structure typify the values and background of the servants of industry who regard the schools as training grounds not for the rich, sensitive life, but for the workaday world." As long as the educational establishment and the public it serves persist in clinging to the belief that the arts are *not* basic, this problem will continue. Until the case for the arts has been won with administrators, until they are brought to agree with Panelist Frank Stanton "to get the arts into the central core of the whole program, rather than being looked upon as peripheral to the educational

Principals must be made aware of the value of the arts to a well-rounded program. The principal is a key. If he values an arts program, there will be one. The teachers want to do what the principal expects. He reinforces. [WILLIAM L. PHARIS, Executive Director, National Association of Elementary School Principals, in staff interview]

I am cautiously optimistic when we talk about change in arts education for the coming decades. Many of us have been talking mostly to ourselves and not to policy makers, who often regard the arts with an Archie Bunker mentality. Recently, however, we have seen more and more people convinced of the value of arts in education, and our battle cry is being heard. But it must be shouted yearly at budget time. [ENRIQUE DURAN, Panel member]

system," the need to increase their awareness and broaden their perspective persists.

At the same time, the Panel noted the myriad problems which beset administrators during a period when financial crises are causing severe cutbacks in education budgets. In discussing the need to reallocate existing resources, Panelist Bernice Frieder pointed out that "in a period of decline, we're talking about people being laid off. The point now will be not to add people, but which people to let go first." "We must think of a shrinking educational dollar and how it can best be spent," asserted Panelist Barry Bingham. The Panel asked: How does one first educate administrators to appreciate the values of the arts so that even with shrinking resources they will support the development of arts programs?

"We have to help the administrators," said Panel witness John Culkin, "to give them a direct non-threatening experience where they have a chance to grow and present their ignorance in an honorable fashion. But if you have an administrator convinced of a program, that doesn't mean that it's automatically going to get into the schools. We also have to help them convince the community and the teachers." Another witness, Al Hurwitz, echoed this theme: "No matter how well your reasons are stated, there comes a certain point where it becomes an act of faith, where you have to tell someone who has never moved his mind expressively, who has never created music, has never spread pigment over a flat surface, the joy in this. Unfortunately, people in decision-making positions are notoriously lacking in firsthand art experience, so it's not easy to convince these people with words."

One "nonthreatening experience" was relayed to the Panel by Joe Warlick of the Division of Supplementary Education Services in the Memphis schools. The summer Institute for Administrators which he had attended at a CEMREL Aesthetic Education Center had six principal goals:

1. To assist administrators to become aware of aesthetic values and their importance in the school curriculum

2. To assist administrators in exercising leadership in the establishment of aesthetic education

3. To acquaint administrators with methods of introducing aesthetic education to their constituents

4. To inform administrators of existing resources for implementing aesthetic education into the curriculum

5. To provide administrators time to devise step-by-step procedures for initiating aesthetic education

6. To develop a model institute for administrators in education

The attitude and motivation established at the beginning of the institute were "really overwhelming" to Mr. Warlick, as was the association with other administrators, who "didn't fear one another because we were all the same in this environment." He explained how he felt about his experience:

> As a nonartist, a pragmatic administrator . . . I could just see myself being put into the position of doing something artistically that would frighten me. . . . I took part, and I was resisting, but I really enjoyed it. I did ballet. I did movements. I lay on the floor. I made film. We did something I have been wanting to do all my life, and that is sculpture, modeling, and we did it with baking dough. I sat there and modeled, and I said to Dr. Counce, "I'm going to model your face," and I did. . . .

An effective example of strengthening the teaching-administrative partnership was provided dur-

ing the fifties and sixties by the John Hay Fellows Program. Through a series of academic-year fellowships to high school teachers, as well as summer institutes for teachers and administrators, it had a strong impact on humanities in our schools. Participants in a preliminary humanities seminar agreed:

> The ideas, forms, and ideals of philosophy, religion, history, and the arts no longer have the effect on the lives and relations of men that they had when they were cultivated more earnestly and fully and it has been increasingly difficult to construct programs of education adapted to raise standards of esthetic appreciation, intellectual understanding, and moral motivation.[21]

In addition to providing individual study opportunities for teachers at selected universities, the fellowships were also a means of improving particular schools and education in general. Teachers themselves outlined aims for improving their own teaching and their school systems. The year of study and examination ("soul-searching") centered on the task of relating courses of study and activities to definable, concrete goals.

Among the first group of Fellows were three art teachers: one worked to develop a course for high school students which would help clarify the relationships among all the arts—music, art, drama, literature, and dance—and explore the contribution of the arts to American culture. Another served as a liaison between the school and various community organizations, and aspired to advance the cause of art for the community. And the third explored the media—radio, television, and films—in relation to art disciplines he taught. Over the years in the Fellows program there continued to be a number of art teachers working on such projects as the importance of "affect" in teaching, the purpose of art education, and the development of a course in art values.

Art has had a long history of second-class citizenship among the subjects taught in the schools. Like music, it has been considered a "minor" in larger school systems, while in many poor school districts the arts often are not included in the curriculum at all. Many educators, and certainly humanities-minded John Hay Fellows, however, consider art and music essential to children's learning experiences. The problem of upgrading art education, of course, is closely related to the teacher and the mode of instruction. [DANIEL POWELL, *John Hay Whitney Foundation: A Report of the First Twenty-five Years*, John Hay Whitney Foundation, New York, 1972, vol. 2, p. 97]

From the first year, school officials had an opportunity to become actively involved in the program; superintendents and other administrators came together with the Fellows from their school districts, their university advisers, and spokesmen for the Whitney Foundation, sponsors of the Fellows program. This enabled the administrators to see ways in which the Fellows' experiences could be used to improve their schools and enrich their humanities curricula.

The addition of summer institutes for teachers and administrators united these two groups in academic, social, and cultural activities, ranging from discussion of secondary education to attendance at plays and concerts. The music and art activities of the summer institutes were important components of the program. "Often it was in these areas that teachers and administrators found their greatest interest, for here their education had been most neglected."[22]

Appointments were made which involved administrators and teachers from the same school or school system in both the summer institutes and the following year's program. This mix was a unique feature of the program which helped to promote significant change in schools. "The program ended formally in 1966, but humanities-minded teachers and administrators who participated in the year and summer programs have kept alive its goals and spirit in schools around the country."[23]

More recently, a group of professional arts education organizations formulated objectives for all five Project IMPACT sites which included a recognition of the crucial role that administrators play in arts education programs:

To reconstruct the educational program and *administrative climate* of the school in an effort to achieve parity between the arts and other instructional areas and between the affective and cognitive learnings provided in the total school program.

To conduct in-service programs, including summer institutes, workshops, demonstrations, and other similar activities, for the training of teachers, *administrators*, and other school personnel in the implementation of programs exemplifying high aesthetic and artistic quality into the school program.[24] [Emphasis added.]

The other three goals had to do with developing programs of high educational quality, finding ways to infuse the arts into all aspects of the school curriculum, and utilizing artists and performers from outside the school system.

The Jefferson County (Colorado) Arts in Education Program (see page 152) included administrators in the planning and implementation phases of its activities. The Arts Resource Team worked with administrators 50 percent of the time to designate participating teachers as well as to discuss program proposals. The team has also held a workshop for every principal in the district, at which the Arts in Education Program was outlined and the principals were invited to become involved.

With the support of the superintendent of the Neshaminy School District in Langhorne, Pennsylvania (see page 113), the Arts Curriculum Committee developed its own workshops in addition to planning the curriculum. The Coordinator of Fine Arts pointed out that "we must also convince the administration and the total staff that the arts in education concept is a positive approach in developing the arts as the catalyst for directing the curriculum, and the arts are not in any way a threat to any discipline."[25] The kinds of supportive services required from administrative personnel are listed as part of the position paper of the Arts Advisory Curriculum Committee:

I. *Building administrator*
 1. Develop better understanding of the arts programs by attending arts workshops, arts advisory committee meetings, frequent class visitations, inquiry and by having arts demonstrations by arts staff members to the faculty.
 2. Support the arts programs through the best possible scheduling of arts team meetings and student scheduling.
 3. Support the arts programs through adequate staffing.
 4. Support the arts programs through providing sufficient equipment and supplies and adequate physical facilities.
 5. Support the arts programs through budget allocations which are consistent throughout the district for materials and equipment.
 6. Support a realistic and meaningful evaluation of both program and staff.

II. *Fine arts coordinator*
 In addition to providing curriculum guidance and leadership, the coordinator should have a continuing role in the selection of staff, input in budget, teacher evaluation and program implementation. This will create an effective use of the talents and knowledge of the coordinator.

II. *Supervisor of curriculum and instruction*
 1. Provide continual support and commitment for the arts.
 2. Clarify the responsibilities of the coordinator, staff, principals and district in their relationship to the arts programs.[26]

The Unified Arts Program of Brookline, Massachusetts, exemplifies the techniques of staff cooper-

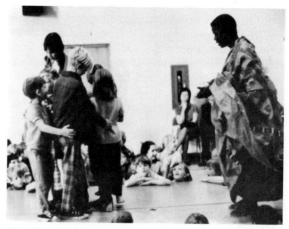

John Bennison instructs students in the Columbus Arts IMPACT program on the culture of Africa through ritual dance movements. (Courtesy of Columbus, Ohio, City School Administration.)

From left to right: Doris Pfeuffer, an IMPACT dance resource teacher; Elaine Leach, an Arts IMPACT school principal; and Jan Lowe, a film teacher of art and education, taking part in an aesthetic education course for administrators at Ohio State University. (Photograph by James Pilbeam.)

167

ation built up by a skilled administrator hired to coordinate this integrated arts program. He convinced the superintendent that at least five years were required to develop a well-grounded arts program, and although he met with some resistance from teachers, parents, and the school committee, was able to work out his rationale: that the program is the staff; that it must be developed with existing material and financial resources; that it must not depend upon externals; that all strategies must be vigorously tested; and that the administration and staff must be prepared for long-term payoffs. He was then able to advance on several fronts: staff development, curriculum development, facilities development, administrative structure and logistics. The director instituted an autonomous central warehouse for all arts supplies, so that teachers could order supplies and receive them the same day. The resource management system is so efficient that the supply budget has not been increased in five years and teachers are no longer frustrated by lack of arts materials. The Unified Arts effort indicates two essential ingredients for a solid arts program: first, a strong commitment by top administration that allows sufficient time, funds, and mistakes; second, a willingness to grant autonomy to leaders such as the arts coordinator so that strong management and support can be developed.

Stress on another facet of administrative leadership comes from the Fargo, North Dakota, public schools, which have made a strong commitment to comprehensive arts education and have taken on the responsibility for statewide lobbying for the importance of the program. The arts coordinator noted:

> . . . My position with the Fargo Schools is Cultural Resources Coordinator, a fully district funded position on the administrative level. The major thrust of the job is to involve the community arts organizations as resources for arts education to articulate the importance of what we are trying to do to the community at large, and to provide learning opportunities for teachers (K–12) on how to approach comprehensive arts education in a practical sense in their own classroom.[27]

The leadership role described by the coordinator in lobbying for the arts involves keeping abreast of developments in the arts locally, regionally, and nationally; seeking additional funding; organizing citizens groups for the arts; identifying and cooperating with leadership in community and professional groups; following media and information programs; and helping parents comprehend the importance of arts education for their children.

The role of leadership in arts and education was discussed at a 1975 miniconference sponsored by the National Art Education Association.[28] One participant suggested three broad areas to which an arts supervisor should relate: schools, community, and administration. He should not only be concerned with educational change through a continual transformation of curriculum, but should work with the central administrative staff in developing program goals and ideas. In addition, the supervisor should be actively involved in the community with business and industry, parent groups, and the public at large, in order to gain acceptance and credibility for the arts education program. At the same conference it was stressed that to be really effective, arts education administrators must be no less creative than artists. Their role calls for imaginative and dynamic, not static, approaches.

To recapitulate, one of the fundamental difficulties in developing arts-in-education programs is the lack of arts experience among nonarts teachers and administrators and board of education members. Their lack of exposure builds a core of school personnel afraid of performing in the arts themselves and possessing little basis for critical reac-

tion. Since administrators control the character of the educational atmosphere for both teachers and children, they must be encouraged to acquaint themselves with the benefits of an arts experience for human growth, both personally and socially.

In all the efforts at educational change through the arts which we have been examining, one can see common characteristics, among them the necessity to secure administrative support for the basic ideas and purposes of the program to be implemented. This support may take the form of policy statements; financial and material support or various incentive awards for participating teachers; the necessity for a comprehensive training strategy for teachers, supervisors, and administrators; and continued support services as a program with its inevitable problems is being implemented.

There are a variety of administrative positions related to planning and implementing arts in education programs, from the school principal and district superintendent to the state commissioner of education. And those most directly involved in supervising or coordinating arts programs must play a unique role, providing a new blend of administrative talents in which they combine substantive leadership in curriculum development, advocacy for arts in education in the community, and coordination of supportive services from a variety of sources. Just as there is a need for the artist-teacher, there is a need for the artist-administrator.

Beyond the schools

. . . I think the school ought to be seen as an agency for coordinating
all the experiences that a child can have . . . all the resources;
I have a feeling in my own case that if I had been left to the schools
I would have been a very bleak individual . . . no sense of
esthetics whatsoever. James Michener, Panel member

Learning is not confined to the classroom. . . . Superior instruction
may occur in a variety of settings, both on and off the school campus.
As the sponsor and caretaker of the educational needs of youth,
schools will necessarily develop a broader definition of education
than commonly is applied today. The community as well as the school
affords splendid opportunities to learn.
Statement by National Association of Secondary School Principals, *This We Believe*, 1975

The role of community arts resources in arts education is a complex and controversial topic. These resources are distinct from the public schools and colleges, but they are often used to perform similar educational functions. Community arts resources include not only such arts institutions as museums, concert halls, theatres, and local arts councils but also housing agencies, neighborhood associations, folk arts groups, churches, prisons, parks departments, libraries, private arts schools, teachers, and of course artists themselves.

In order to gauge the quantity and breadth of these resources, the Panel's staff has studied reports prepared by nonschool arts institutions across the country. Staff members also have interviewed many persons directly involved in these agencies, using both a random sampling procedure and a list prepared by soliciting recommendations of exemplary programs from a wide variety of professionals in the field. The staff also has reviewed research and evaluation reports of such agencies as the National Endowment for the Arts, the Council on Museums and Education in the Visual Arts, the Center for Southern Folklore, and many others.

We have not attempted to provide an in-depth description of community-based programs. However, we will discuss the range of programs and the kinds of services they provide, because the Panel is convinced that these agencies can serve as links between the larger community and the arts programming of the schools. Indeed, some community programs may guide schools to better art education. Also, in many cases they may be directly employed by the schools in their efforts to provide education in the arts.

A burst of community arts

Edward L. Kamarck, editor of the scholarly journal *Arts in Society*, in his introduction to a special issue dealing with community arts, traces three separate movements in the United States during the twentieth century.[1] The first occurred during the decade before World War I and left us a heritage which included vital "little theatres," the Chautauqua movement at its height, the settlement house as a neighborhood art center, and extension programs in the arts begun by the land-grant universities.

During the Depression of the 1930s according to Kamarck, a second surge of community arts programs led to the creation of the WPA arts projects, which included arts clubs, theatres, writing groups, choral societies, and symphonies. Also, the Farm Securities Administration developed many skilled and imaginative photographers, and did much to establish photography as an art form. Most of these programs were not established solely for aesthetic purposes but rather to support unemployed artists or to provide a record of America's journey through the nadir of her economic history.

The 1950s saw a third crest of interest in community arts, culminating during the sixties in the creation of the National Endowment for the Arts, and the Arts and Humanities Program of the Office of Education.

This also was a period of awesome activity in constructing habitats for the arts. According to the publication *Museums USA*, 26 percent of the 340 museums now in operation were

Walker Evans' photograph of the interior of a West Virginia coal miner's home in 1935 was taken on assignment with the WPA. The prestige, glamour, and hope afforded by an education in the 1930s is epitomized in a cardboard advertisement of two young graduates standing on top of the world. (Reproduced from the collection of the Library of Congress, Washington, D.C.)

built between 1960 and 1970. During this decade elaborate new homes for the performing arts, such as Lincoln Center in New York and the Music Center in Los Angeles, were completed, and equally elaborate projects like the John F. Kennedy Center in Washington were begun. A burst of activity in regional theatres and a need for new arts facilities on college campuses likewise contributed to the building boom.

The Panel agrees with Kamarck that we are at the crest of a fourth wave of interest in and support for community-based arts programs. The most recent surge has witnessed the birth of arts resources in areas which previously had few. There has been a development of arts agencies linked to many of the country's ethnic groups, demonstrating that the arts are sup-

ported widely and that our former notions of "proper" places for the arts were greatly restricted. Kamarck also believes that the broadened financial support structure that exists today, through a network of federal, state, and local art councils, will assure greater longevity for new community programs. Thus with the creation of the National Endowment for the Arts (NEA) in 1965, the federal government's role in financing the arts was put on a more permanent basis. Federal appropriations for the NEA have risen from $2.5 million ten years ago to $82 million in 1976. Increasingly, mixed funding packages are being formed by combining governmental and nongovernmental funds. But arts education programs have not benefited in most cases.

Starting from the premise that many nonschool arts resources have educational programs which offer a great deal to arts education, the Panel has sought to analyze the nonschool educational programs. We have examined programs on the basis of their purpose and accomplishment—what it is that they do, as well as whom they serve or hope to serve.

Types of programs

Community resources can serve education in a variety of ways. They can provide a stimulus for learning at all levels. They make resources available to adults and young people who are already motivated and desirous of managing their own education. They serve as resources which traditional schools, colleges, conservatories, and institutes can orchestrate to reinforce their own classroom and workshop programs. In addition, they are frequently, in their own right, educational institutions which offer formal learning programs.

Six major types of nonschool arts education programs have been identified on the basis of their principal functions; however, it should be noted, programs often have more than one function and sometimes have stated goals not "matched" by their actual practices. These types are:

Apprenticeship programs
Appreciation programs

Cultural identity programs
Therapeutic programs
Leisure-time programs
Quality-of-life programs

Apprenticeship programs

> . . . not every school is going to be able to provide
> training in music and dance, in painting and draw-
> ing or in drama and film . . . that is when you can
> utilize the resources in the community.
>
> John Jay Iselin, Panel member

Nonschool art agencies often provide facilities and opportuni-
ties for developing skills through apprenticeship programs.
Such agencies allow students the opportunity to focus upon
single subjects and activities in ways which the public schools
with their myriad concerns cannot. Artists conducting classes
provide living guidance for students who might otherwise see
only finished art products in museums or in slide presenta-
tions. The problem with these apprenticeship programs is that
they cannot be designed to serve large masses of students.
Apprenticeship, however, may well provide the most effective
form of arts training for the limited numbers who are
accommodated.

The Mendocino (California) Art Center is a good example
of an apprenticeship program. Operating on an annual budget
of $180,000 drawn from membership fees and fund-raising
events, it offers after-school art instruction workshops for
elementary school children, an art gallery, and a performing
arts program. It supplies in-school instruction in a variety of
arts disciplines through a basic school program. The center
also operates a unique three-year apprenticeship program in
weaving which graduates fully qualified professional designers
who may move directly into industrial positions or function as
independent textile artists.

Appreciation programs

Appreciation programs, usually conducted by museums and
performing groups in nonschool settings, offer the public
direct experiences with art objects, artifacts, and perfor-

mances. Museums, originally designed for the collection and preservation of art objects, have begun in recent years to develop methods of presenting those collections to wider audiences. Nearly 66 percent of the museums which responded to the National Endowment for the Arts' 1974 survey reported that they conducted programs for groups of children visiting the museum. And 56 percent reported that they schedule regular or occasional presentations at schools. In many communities, a field trip to the local museum is a regular part of every child's schooling. Mary Smith, chairman of the Cultural and Ethnic Affairs Guild at the Oakland (California) Museum, suggested to the Panel:

> We need a closer liaison with schools because every school child in Oakland should use the Oakland Museum as a classroom; it's paid for by our taxes; our schools cannot duplicate the kind of cultural situation that our museum presents. And yet our children cannot go to the museum and use it as a resource or a classroom because we don't have the busses to take them there; we don't have the trained persons to organize the programs. If you must do something with the schools, keep the schools from duplicating what the museums have already done, and set up a situation where the museum can be the classroom for all the children of the community to use.

In recent years many museums have recognized also that some children and adults find the kinds of art presented there far removed from their lives. One solution has been the "community" museums, such as the Anacostia Museum in Washington, D.C., and in New York City the Museo del Barrio and the Harlem-based Studio Museum; another is mobile museums and music programs which bring art objects and performances to the community rather than bringing the community to the institutions.

These museums are modeled after the larger cultural institutions, though they shape their programs and select their artifacts with an eye toward the particular ethnic, economic, or social characteristics of their immediate community. Their effectiveness is demonstrated by the large number of people from the neighborhood who attend the agencies' programs each year. Satellite museums, and community or neighborhood museums at sites closer to schools, can provide space and facilities to supplement larger museums, thus solving the problem of transportation.

Pittsburgh, 1955, photograph by Eugene Smith. (Aperture.)

When you've got your own, you can enjoy somebody else's. Therefore our focus has been with the students at the Elma Lewis School to make them love themselves, to make them understand how rich their contributions have been and continue to be; to make them understand that they did bathe "in the Euphrates when dawns were young" and they did look out "upon the Nile and raised the pyramids above it." [Elma Lewis, Panel witness]

Cultural identity programs

Some programs take as their primary goal "bringing new insights to a community about its human condition."[2] Orrel Thompson, when director of the Akron (Ohio) Art Institute, said of the Neighborhood Arts Program, "To get dialogue, participation, community-based ideas . . . we're doing away with the studio approach. We've thrown out beginning painting and drawing courses and opened up short, four-week workshops, and gotten into jazz seminars, street theatre and open jam sessions."[3] Likewise, Topper Carew, former director of New Thing Art and Architecture Center in Washington, D.C., advocates the use of art as "a means to make people more aware of their presence in the world, more aware of their historical origins and the vitality of their own culture."[4]

Such conceptions of the role of arts agencies have had impact upon the established institutions. For instance,

museum educators are beginning to seek wider roles for their own agencies, and American museums are beginning to shed their image as "sanctuaries of high culture remote from the interests or needs of society at large."[5]

The social elements of cultural identity programs parallel in many ways the models discovered by anthropologists among so-called primitive communities of the world. For example, Clinical Associate Professor Warner Muensterberger, Department of Psychiatry at the State University of New York's Downstate Medical Center in New York, reports that among homogeneous societies, the artist's role is more conspicuous and that his work is "linked with the determinative issues of tribal life." He points out that the Bushongo "ranked their artists immediately under the king," and that among the Bambara, the blacksmith, woodcarver, and artisan are "the center of religious and social activities."[6]

The arts programs which serve social functions, such as unification and identification, often involve the same activities as more traditional arts agencies, namely the creation and appreciation of art objects or the training of individual skills; but they do not consider these activities as the major reason for their existence.

Therapeutic programs

Therapeutic programs seek to improve or alter the outlook of particular individuals or groups through the use of the arts. Programs which see a therapeutic or remedial value in the arts are like cultural identity programs in that the arts are used in an instrumental fashion to assist in the achievement of other ends. They usually are directed at older Americans, maladjusted children, prisoners, or others who have special needs.

To this end, a number of institutions are beginning to explore the possibility that long-dormant creativity in elderly persons can be awakened, revitalized, and taken to new levels. Prison arts programs in several states have been supported by the Expansion Arts Program of the National Endowment for the Arts and by a million-dollar grant from the Law Enforcement Assistance Administration. These programs support professionally directed arts projects inside prisons as well as community-based correction programs combining ethnic and

These senior citizens are seen here satisfying some of their basic needs in an old age home in New York City. (Photograph by Leonard Freed, Magnum Photos, Inc.)

folk arts traditions, conventional art forms, and the vocational possibilities of arts-related skills as a result of apprenticeships with master crafts people.

Leisure-time activities

> Usually the major thrust of the arts is toward implanting of the skills. But I think the skills are secondary. My own theory about education is that it should not teach you how to make a living but teach you how to live.
>
> Elma Lewis, Panel witness

Art education theorists such as Dennis White and June King McFee believe our educational system lags behind other social and technological developments because it does not "prepare individuals for a lifestyle where the possibility of leisure, not work, may be the mainstay of living."[7] Unlike a century ago,

most individuals in the United States today currently spend two-thirds or more of their waking hours in activities other than work. Our contemporary society provides us with vast amounts of "free time," and White notes:

> If the adult individual of tomorrow is to live to enjoy a creative, humane and sensitive life, the educational and instructional milieu must alter foundations which currently place great stress on work and labor. Such an educational realignment promises to create a condition wherein free-time would no longer be a personal source of dread and guilt feelings.[8]

The leisure-time programs are most often implemented through coalitions of artists with park and recreation departments, with multiple advantages accruing to both. This represents an attempt to merge administrative and philosophical creative goals.

For instance, in Waterloo, Iowa, a former football coach directs a recreation and arts center where the major visual and performing arts have found a home alongside hobby groups and civic activities. The center is equipped with a professional theatre seating 350, and with two art galleries, one of which is devoted to children's art. The staff of the center seek out school administrators, students, and teachers for advice and ideas, and provide the artists with many kinds of help, from program planning to transportation.[9]

There are those among the arts community who fear that the public association of the arts with leisure time or recreation will only strengthen a general view of the arts as less than essential to basic living. However, recent social, political, and technological changes have prompted major reinterpretations of the relationships between work and leisure, the spiritual and the physical aspects of life. There is an emerging view of life as an integrated whole in which work and leisure are inextricably linked to an individual's life-style. Reflecting this outlook, many arts and recreation institutions have combined forces to create promising programs that relate to their particular fields.

Max Kaplan, director of the Leisure Studies Program, University of South Florida, lists several advantages which the arts can obtain from a working relationship with recreational programs:

181

1. To make more explicit the functions of the arts relating to identity, therapy, and personal growth.
2. To relate the arts more explicitly and systematically to new audiences.
3. To uncover creative possibilities within groups not ordinarily in contact with the arts.
4. To utilize the organizational skills and experiences which are an integral part of the recreation and park profession.
5. To coordinate research in such areas as architectural developments, group dynamics, personality needs, and sources of cultural innovations.

Among the advantages accruing to parks programs:

1. To have official access to the institutional structure, professional organizations, leadership, and training programs of the various arts.
2. To obtain direct advice and knowledge about local performing or teaching groups and individuals in the arts.
3. To engage leaders from the arts who represent professional standards.
4. To expose recreation users to experiences in the arts that permit a maximum of creative as well as personal growth.
5. To enlarge the total recreational philosophy and practice.[10]

Quality-of-life programs

Finally, the quality-of-life programs seek to counter the disjunction between art and life wherever it has grown up in this country. Many people believe that aesthetic considerations should be integrated with other elements in our everyday lives. As Edmund Carpenter of the Museum of Ethnology, Basel, Switzerland, notes:

> Life-as-art is taken for granted by preliterate peoples, many of whom have no word for it. . . . In such societies, art is invisible: it belongs to that pervasive environment which eludes perception. It serves as a means of merging the individual and his environment, not as a means of training his perception upon that environment. . . .
> In native societies I know first-hand, art belongs to ordi-

Watts Towers, constructed by Simon Rodia in his backyard in Watts, California, from 1921 to 1955. These spiraling towers of cement, wood, glass, and other found materials stand almost 100 feet high. What started as one man's fantasy has become a public monument to the spirit of creative resourcefulness. (Photograph by Seymour Rosen. © 1974)

nary day-to-day experiences: the way a father addresses his son, decorates his house door, butchers a pig, dances, puts on his loin cloth in the morning or addresses his guardian spirit.[11]

In an effort to capture some of that atmosphere, various institutions have attempted to demonstrate ways in which the

arts may become a part of whatever else people are involved in. For example, the John Michael Kohler Arts Center in Sheboygan, Wisconsin, is a unique place where industry and the arts meet to build a better community. This Arts in Industry Program began informally when the museum was asking local corporations to provide funding for specific exhibitions. The Kohler Company, which manufactures ceramic plumbing fixtures, agreed to sponsor the first program, a national ceramics invitational in which eighty artists from across the country participated. After the exhibition, the museum sponsored a seminar on industrial methods and techniques which generated much enthusiasm and resulted in the extension of the project. Two ceramists were invited to spend a month in the factory working alongside the industrial craftsmen, learning standard production techniques and methods for increasing efficiency in glazing and firing. Other similar projects involved graduate students in a direct-learning environment with artists and industrialists.

A publication of the Kohler Arts Center describes the program:

> The project will reach a broad cross-section of people in a variety of ways. The residencies will give the artists access to a body of knowledge not usually available to the individual craftsman. These new technical possibilities may stimulate new concepts of form and subject matter. Because a number of the artists are or will be teachers, the processes, ideas and directions will, in turn, be carried into university programs across the country. A mutual respect for and appreciation of the work of the artists and industrial craftsmen will undoubtedly develop.[12]

The communities served

Whatever the nature of various arts programs, all of them must have a concept of the "community" which they hope to serve. The nature of the community, of course, must affect the decisions that have to be made concerning the location of arts resources. Most obviously, a community is composed of those who live in the same geographical area,

whether it be a neighborhood, a city, or a metropolitan area. But we shall also think of a community as made up of those who share common social characteristics, norms, and values.

The arts always have been both a cause and effect of the development of communal life, and often they are deeply ingrained in a community. A 1973 poll of American attitudes toward the arts taken by Louis Harris Associates indicated that 89 percent of those polled wanted facilities "like museums, theatres, and concert halls in the community," and that 50 percent felt that there were not enough "places for cultural events . . . in the community where they live." The study also indicated that 80 percent felt that cultural facilities were important "to the business and economy of the community." This view was not confined to those who used these facilities, for among nonattenders, 79 percent felt that cultural agencies were "important to the quality of life in the community."[13] Every community has cultural resources; this point must be emphasized. While not every town can have an Art Institute or a Metropolitan Opera Company, every town has something that can be developed. There are great differences among communities in what has been developed, however.

Factors governing the establishment of nonschool arts resources often are economic rather than cultural or aesthetic. Arts agencies which require large-scale financing generally have been developed in the nation's largest urban centers. Here they may draw upon a population large enough to provide the audiences they need for survival. Here, too, they find the public and private financial sectors large enough to provide them with needed revenues. The bulk of the major arts patrons and philanthropic foundations are located in or near the largest cities, and the local governments have sufficient resources to include the support of culture. Once established in major cities, arts institutions don't simply compete with one another for audiences; rather they build and enlarge audiences, and an experience at one often prompts more people to become interested in the others.

Despite the wealth of arts resources, educators in many cities have had limited experience in their use. In such programs as Philadelphia's Parkway School, Chicago's Metropolitan High School, and other "schools without walls," cultural agencies have been sources for many of their educational activities. The Urban Gateways Program, which serves about

185

510 schools in the metropolitan Chicago area, represents an outstanding example of a program which facilitates the interaction between a school system and the community's arts resources. Urban Gateways supports a school program which takes children to cultural events and helps make the arts a part of the curriculum in inner-city schools; a metropolitan program, which brings art to schools in all six Chicago-area counties; a community program, which encourages adults and families to share in the artistic life of the community; a teacher training program, which sponsors teacher training workshops, art safaris, workshops in classrooms, and artists-in-residence projects. The program director noted that Urban Gateways is

> committed to providing inter-cultural, inter-racial and inter-ethnic activities in all art forms for the school children of this metropolitan area. We believe it is necessary for us to maintain a strong cultural heritage component in our programming and we do this. We also believe our work must help teachers learn how to enrich the educational experience by using art as a component of all the curriculum experiences for the children.[14]

Urban Gateways has a complex governing structure that includes educators, artists, parents, corporate representatives, and patrons of the arts. Its equally complex funding package includes support from Model Cities/Chicago Committee on Urban Opportunity (CSA), Title VII (ESEA), Comprehensive Employment and Training Act (CETA), the National Endowment for the Arts, and The Illinois Arts Council.

Many arts institutions limit their activities to specific parts of a city. The Henry Street Settlement Arts for Living Center is the latest phase of a nationally famous arts agency which has served New York's Lower East Side since 1893. A pioneer in the use of the arts for socially oriented services, it serves a multiethnic population and provides instruction in all art forms for everyone in the community.

In smaller cities throughout the nation arts resources are frequently less well developed. In 1966, the National Endowment for the Arts funded a three-year project in Wisconsin aimed at developing the arts in small communities. The project was conducted in five communities and concentrated

upon the establishment of "regional" cultural centers where activities such as touring plays, sculpture exhibits, ceramics classes, dance concerts, and poetry readings could be presented. Study of the project's results by Maryo Ewell and Peter Ewell revealed an increased demand for art in these communities, particularly on the part of a newly mobilized, highly educated elite class. The Ewells found a tendency for women, the well-educated, white-collar workers, and professionals to become involved. Other groups tended to feel excluded; consequently, they became alienated and bitter toward the arts.[15] "The presence of an arts project in a community not previously exposed to the arts is likely to be a highly charged emotional issue, stirring up tremendous bitterness and enthusiasm. . . . It seems that towns which are the scene of a major arts endeavor become intensely polarized as a result."[16]

The Ewells concluded that an arts specialist working with all groups in a community was a necessity. And they recommended that when outside organizations are involved in the initial development of regional arts resources, they move as quickly as possible to shift responsibility to local support.

In contrast to the Wisconsin example, the Epworth Jubilee Community Arts Center in Knoxville, Tennessee, is a regional program which adapted well to the surrounding area. The Epworth Center includes a children's program wherein parents teach their children music, sewing, quilting, photography, and folk dancing. They conduct their own tutoring programs using a booklet of the oral history of the area collected and illustrated by local artists. The center has established an experimental theatre group, a musicians' co-op, and is organizing a filmmakers' workshop. All these activities are aimed at helping local artists develop professionally while remaining in the region.

Historically, much of the recent emphasis on efforts to serve geographic areas, particularly on the establishment of regional arts councils, derives from European examples. The *maisons de la culture* and *centres educatifs et culturels* in France and the regional art associations in England were designed to institutionalize the culture of the masses. In Mexico, rural traveling culture missions, artists in residence in small villages, and museum programs were "aimed at uplifting the dignity of village life."[17]

Communities with common cultural heritage

> The one thing about the ethnic community, especially in the arts, is that it involves total family participation. Our programs express the ideas and dreams of that given community.
>
> Ben Hazard, Panel witness

Programs serving communities defined by shared values or socioeconomic characteristics frequently coincide with ethnic entities, and many of these projects take as their goal the changing of the local society.

Some of the more exciting Broadway and Off-Broadway theatre in recent years originated in community theatres such as the Henry Street Settlement House, and in performing groups created by members of specific ethnic groups, such as the Negro Ensemble Company. As Don D. Bushnell, former president of the Communications Foundation in Santa Barbara, California, notes,

> . . . to speak of Afro-Americans, Puerto Ricans or Mexican-Americans as culturally deprived is an absurdity. And the arts movement that has been developing in the city ghettos since 1967 testified to that absurdity.[18]

School projects in the arts also have been developed to serve particular communities. *The Fourth Street i*, for example, is both the name of a magazine and of the organization for teenagers in a largely Puerto Rican neighborhood in lower Manhattan that publishes it. The bilingual magazine contains poems, stories, articles, photographs, and drawings and is used in the schools of the neighborhood. The staff hopes to reach people throughout the country who are not Puerto Rican " . . . with the hope of building understanding, respect and some feelings of empathy."[19]

There is movement and pressure toward the creation of similar agencies in other areas. The Michigan Joint Legislative Committee on Arts saw the establishment of neighborhood art centers as a major requirement for the future of the arts in that state. The committee further noted:

Inner-city areas or areas in need of renovation should be especially appropriate places to establish arts centers, perhaps with an MCA grant. The federal department of HUD has a ready supply of buildings that could be renovated as community projects and which could be supplied with equipment in order to furnish studio facilities for both developing and developed artists. Such centers would be of great benefit to indigenous artists and would-be artists, and would stimulate and facilitate the creation of art. They would be an asset to the neighborhood and perhaps could become the core of local projects to enhance the environment.[20]

The Michigan recommendation avoids critical or aesthetic judgments about the content or nature of the art which will be produced in these centers and concentrates upon the contributions such agencies will make to their community.

Not everyone agrees that arts programs and agencies should be designed for those who share the same social or economic conditions. Such programs can become isolated and segregated from the rest of the society, thus running the risk of stagnating without the interchange of ideas. And programs directed at particular ethnic or racial groups may only temporarily satisfy the need to strengthen a sense of self or to articulate fully the messages and forms which derive from social and historical heritage.

There is an assumption on the part of the major institutions that "ethnic" means something other than excellence. . . . I think that this is an error and a bad one on the part of those who run the institutions which are basically responsible for the preservation and development of culture in this country. . . . it does not recognize the validity of indigenous culture and the pluralism that exists in esthetics as they relate to mass culture. [A. B. SPELLMAN, Panel member]

The role of nonschool arts resources

One of the central questions raised by the activities of nonschool arts agencies in arts education is, Who should teach the arts? This has as an important corollary the question, How shall the arts be taught? The answers are interdependent. Teachers who work in the classroom and who have been trained as educators often believe that they alone know the best kinds of activities for instruction, especially for younger children. However, many artists feel the arts can be taught best by those who know the arts best—those who produce them. Despite the occasional vehemence of the debate, James P. Anderson, chairman of the Art Department at Northern Arizona University, points out that teachers' and

artists' positions are equally devoid of evidence. Indeed, Anderson concludes, " . . . when one considers a total teaching-learning situation in art, it is evident art must be taught by someone especially trained in both art and education."[21]

Cultural agencies outside the schools have come to depend on a heterogeneous group of artists, scholars, educators, volunteers, and interns to run their education programs. Thus, little consistent attention has been given to establishing techniques which work best with the widely varied populations they must reach.

Museums have been particularly concerned in this area because they seek to provide a wide range of activities for schoolchildren. They have moved toward larger and larger educational staffs in recent years. Yet some 57 percent of the museum directors who responded to the *Museum USA* study reported they needed additional educational staff; this was the second highest area of need. Twenty-eight percent of the museums reported a need, though not always sufficient funds, for additional instructors and teachers, while 59 percent of the art museums reported that school presentations were made by volunteers. Some 23 percent of those responding said they needed department heads to coordinate school programs, though most museums reported a minimal level of planning between schools and museums.[22]

Educators have learned that enjoyment is crucial to increased learning. Enjoyment doesn't mean "ease" or "triviality," however, but rather ego involvement in learning. The arts can provide this kind of "enjoyment." Museum educators stress that they are not attempting to duplicate learning in the classroom, but to enlarge upon it by using objects rather than words as their principal educational tools. Some children seem to respond more immediately to objects, and yet the schools are often unable to provide the kinds of concrete learning experiences with art objects that other institutions can offer.

The Children's Art Carnival, for example, was created by the Museum of Modern Art in 1969 under Victor D'Amico, who was then the museum's director of education. The carnival has been called a school, a community arts center, and a multimedia educational institution—reflecting both enthusiasm for the program and confusion over its educational role.

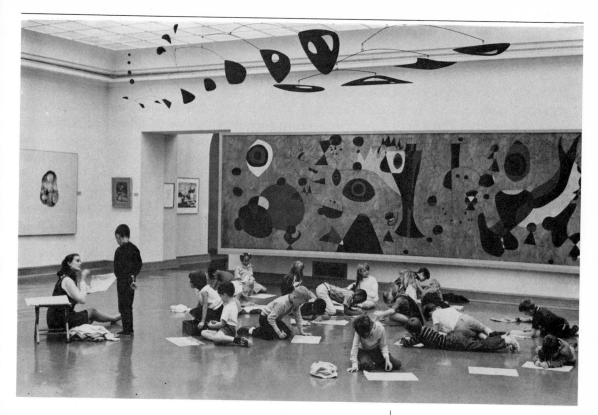

The carnival lists as its goals:

To maximize growth as it emanates from highly personalized experiences, to create an environment in which a positive mental attitude can be fostered within each child contacted, and to provide each child with a strong image of himself and his potential for becoming a positive productive adult.[23]

The program also seeks to stimulate children's creativity, both for its own sake and for its intellectual and personal benefits, to involve parents, and to serve as a demonstration project to show teachers how art activities enrich and support other aspects of education.

The Creative Reading Program provides individualized reading programs for children in grades two through four under Title I of ESEA. The students meet twice a week at the carnival's small reading laboratory and three times a week in their own schools with reading improvement teachers. At the in-school centers, the children work on reading and communications skills, using their arts experiences at the carnival. The

Public school children find the Cincinnati Museum of Art a congenial and stimulating place to make their own pictures. (Photograph © David Hurn, Magnum Photos, Inc.)

191

program has had great success as measured by standardized reading tests. Because of the dramatic improvements shown in test scores, the U.S. Office of Education has chosen the program as an exemplary reading program.

The carnival's educational program has both after-school and in-school components. Its after-school and Saturday workshops provide opportunities for painting, sculpture, film-making, photography, printmaking, collage, puppetry, sewing, and costume design.

Links and cooperation

If the nation's students are to benefit fully from the wealth of resources maintained outside of schools, the kind of cooperation and planning that is needed to make an Artists-in-Schools program successful is equally crucial to the full utilization of other nonschool arts resources. Few would dispute the benefits of a cooperative program that enables a school to schedule preparatory and follow-up activities which help integrate visits to museums, and other arts resources, into the curriculum. Yet Barbara Newsom, project director of the Council on Museums and Education in the Visual Arts notes ". . .the general listlessness of the schools in their movement toward the museum.. . .Beyond the inevitable field trip the art museum has not been taken very seriously by the schools as a place of learning."[24]

Both artists and museum educators are finding that they can adapt school techniques for work in nonschool agencies; and the schools are learning that techniques developed elsewhere can be adapted effectively to the classroom. This type of mutually beneficial cooperation is frequently hindered by a gulf between schools and other institutions, a gulf that sometimes breeds suspicions. To date, linkages are not forged with sufficient frequency.

There are a number of examples of cooperation. In Oklahoma City, the Opening Doors Program has established a

model program for the city's fifth graders which is jointly planned by school faculty members, consultants, and the educational staff of the city's major cultural institutions.

Another example of this cooperation is provided by the Open City Project in New York City. This early childhood reading and arts project, which is supported by ESAA funds, has brought ballet dancers from The Downtown Ballet Company to workshops in the schools before and after the children attended a performance. It has involved artists such as Red Grooms in workshops with children who visited the Ruckus Exhibition, an exhibit of the artist's version of New York skyscrapers. The children, their parents, and their teachers have created their own simulated environments, guided by the artists.

Operating through a New York City school district, the Open City Project provides a highly coordinated series of art and cultural events for a group of kindergarten and first-and second-grade pupils. The project provides a trained staff of professional teachers and a group of consulting artists who develop supporting curriculum materials and activities for each event and then train the classroom teachers in the best approach to their program. The activities are also coordinated with the early childhood reading program in the district.

Boys Harbor, a privately operated social service agency in New York City, provides a performing and visual arts program in two city school districts and also operates a junior high school for specially talented youngsters in conjunction with one of the school districts. The junior high school faculty is a unique combination of performing artists and professional teachers. The children who enroll in the school are interested in careers in the performing arts; they receive specialized training from professional performing artists and general academic training from licensed teachers. Boys Harbor also owns and operates a campground at East Hampton, Long Island, which students and teachers regularly visit for group training, environmental studies, and performing arts activities. The teachers and artists work jointly in planning all the activities.

Junius Eddy, arts education consultant to The Rockefeller Foundation's Arts Program, who has long observed arts education, has identified some programs which provide new and potentially important models. He discusses, for example, the "regional cultural center," "cultural arts center," or "learning

193

resources center"—which centralize many of the services required for art education. Cleveland's Supplemental Education Center, Pensacola's Escarosa Humanities Center, St. Louis's Metropolitan Education Center for the Arts, and the Southwest Iowa Learning Resources Center are examples of this type of program. For Eddy, these centers form a new kind of "educational half-way house" within the public education system. They provide the schools with "a differently organized extension of themselves." By offering concentrations of arts resources and personnel and by establishing direct connections with the public schools, these centers reduce the need to "enrich" the regular curriculum. They make it possible to infuse the entire curriculum with the "richness, the flexibility, and the diversity it now denies to all but a few." To accomplish these high aims, the centers must involve both school and nonschool staff in the curriculum planning and development required to integrate the arts into all aspects of learning. They must recognize that " . . . neither professional teachers nor professional artists have an absolute monopoly on the best ways to teach the young."[25]

Resources

There are few who would doubt that arts education needs additional resources if it is to function effectively.

Specialized performing and arts production equipment such as kilns, easels, dance floors, and print shops are usually too expensive for most schools, particularly for elementary schools. Where are these resources to be found? The universities and community arts resources usually have them, but the future professional artist in the elementary and secondary school may not see these kinds of equipment until very late in his or her public schooling. Can these items benefit a child at earlier ages? Can they be useful in arts education? Can universities, artists' studios, and other arts institutions supply these to a school?

Some argue that school programs which are designed to utilize the expertise of professional artists will fail if they cannot provide the artist with access to professional tools. Yet school budgets, because of other priorities, seldom provide such tools. Other arts educators have decried the appeal for more and richer arts supplies and equipment, insisting that what is needed is more imagination in the arts curriculum. Research is needed to answer these questions.

Community arts resources have put together equipment, facilities, and staff in ways which might provide models for schools, and some of these programs have combined funding from a variety of sources. Such combined funding packages seem to survive the faddish funding policies of some foundations, and the limited funding possibilities of government agencies. The Walnut Creek Civic Arts Center in California receives most of its funding from tuition and city funds; the Mobile, Alabama, Museum receives funding support from the board of education, and the Milwaukee Arts Center is paid for entirely out of county funds. The Cultural Education Collaborative in Massachusetts offers information and services to schools and arts organizations statewide, and is supported by a funding mix of local foundations, the state arts council, NEA and state education funds. The Urban Arts Program in Minneapolis and the Neighborhood Arts Program in San Francisco have constructed viable funding programs which include both city and school funds. Stephen Goldstine, program director of the Neighborhood Arts Program, feels that the final test of acceptance for an alternative approach to the arts is its becoming a line item of the regular school budget.

Perhaps what is most important to note in these examples is that cooperation between schools and nonschool institutions may be a promising route for increasing the funds that are available for arts education, as well as providing new ways of learning.

In closing this description of community resources for arts education, the possibly apocryphal remark of Margaret Mead's mother may be appropriate: "I wanted my daughter to have an education, so I kept her out of school." It reminds the Panel of some of its more haunting questions: Is the job of integrating the arts into education on a nationwide basis too big for the schools? Can the schools alone provide the right environment? If not, where do we turn?

The promise and the problems of the media

A colloquy on the media

The Panel's discussion of television, radio, film, and still photography may seem somewhat unrelated to its main concern in arts and education, and especially to its study of artists as teachers and of teacher training. But on closer scrutiny the underlying relationships will become apparent. The dialogue which follows is a collage of related comments, drawn from all Panel meetings. It indicates the background of the Panel's recommendations in that vast, varied, and burgeoning field: the media.

"I don't like that word," panelist Frank Stanton, former president of CBS, commented. "I wish someone would find a better term, but I confess I've not been able to."

Panel witness John Culkin responded: "There's a remark of yours, Mr. Stanton, that I've been using for years. Namely, that TV has come into the living room so fast that we've had more reactions to it than reflections about it. I want to thank you for that observation and reply with a media story of my own.

"I was invited to a junior high school to share films made by students elsewhere. Because of space problems, a note from the principal asked all teachers to send ten 'media-minded' students to see the films. When they assembled I asked how many considered themselves 'media-minded' and about a dozen raised their hands. I asked one boy: 'What do you mean by media-minded?' He answered, 'Well, I'm not too smart and I'm not too stupid. I guess I'm just kind of media-minded.'"

After the laughter died down, panelist Jay Iselin, president of Educational Broadcasting Corporation, Channel 13, New York, suggested: "Perhaps our difficulty with the word media has something to do with the way we think about it. Frank says he regards television as a transmission belt. I disagree slightly.

"We're now beginning to see and use television as a means of expression. We have some prospect that television can give its viewers a sense of genuine involvement. I think those of us who work in this elusive medium have to treat it as a potential art form rather than a conveyer belt for verbatim pictures

The arts have potential in providing a perceptual and emotional screen so that we are not manipulated by the media. The arts can assist us in evaluating so that we can distinguish between the good and the harmful, the beautiful and ugly. [JOEL L. BURDIN, Associate Director, American Association of Colleges for Teacher Education, in staff interview]

which in the translation process somehow turn out to be less than verbatim. I think shortly we'll be able to bring into the classroom and home not merely a pictorial record of a dance but a dance experience well worth the extra effort."

"It's still the quality of the ballet, Jay, that makes the difference, and not the medium," rejoined Stanton.

"I'd just like to make a comment," said panelist Barry Bingham, Sr., chairman of the board of the Louisville *Courier-Journal*. "I sat around tables like this more than a decade ago where I heard that the media and television were going to revolutionize education, and I have to tell you that it just has not happened."

"I couldn't agree with you more," responded Iselin. "I think that our disappointment with the so-called media in their early years came from expecting too much too soon. We foresaw their impact on the educational system. But the early demonstrations were so disappointing, so miserable, that we left the skeptics in command of the field while they proclaimed that there is no place for all this claptrap in a classroom. As a result, there has been a belief in many quarters that television can never really become an effective educational tool. I think that's absolute claptrap itself."

"All arts, but especially the visual arts, have been changed by technology," noted Charles De Carlo, president of Sarah Lawrence College, a Panel witness. "We have an opportunity to acquire a completely new way of seeing and demonstrating in the visual arts thanks to these new technologies. But this new emphasis brings new changes. In theatres these new technologies pose a whole set of problems. We have just finished a performing arts building in which we tried to keep the theatre's spaces simple and small so that the technology would simply not become the end in itself. We didn't want to overwhelm the innocence and imagination of our artistic students. Dance too has gone beyond training the human body to become obsessed with all kinds of technologically complicated material. So we must try to blend artistry with technology for their mutual enhancement."

Robert Geller, president of Learning in Focus, in an interview with a staff member, called the Panel's attention to an aspect of this subject more related to the potential arts consumer than to the arts producer. "The arts," he said, "must be ingested, and not fragmented. The artist or arts teacher must have the energy to work in the total educational environment.

By and large schools have been slow to adopt media education as part of teacher education. You can produce the finest program in the world, but the real test is in how it is utilized in the classroom. These programs are not intended to stand alone; they must relate to the total educational environment. [WILLIAM G. HARLEY, President, National Association of Educational Broadcasters, in staff interview]

Television can be a tremendous teaching tool, but the medium must be taken more advantage of. A closer relationship could be developed between departments of media and departments of theatre at the university level. If the quality of theatre on TV could be improved, the attitudes of the public toward theatre going could also be improved. [ANN HILL, Past President, American Theatre Association]

The media invite this kind of integration rather than a one-shot live experience with the Pied Piper who comes in and leaves the real problem unsolved."

John Culkin told the Panel: "If you want to communicate with today's child and talk about influencing his visual, acoustical, tactile powers, you have to realize that we're just 'cut-men,' that we're just in there after a lot of other educators called the media and the environment have a go at the kids. We must acknowledge that the environment is the great teacher, that the schools no longer have a monopoly on teaching facts or forming values. The school is now but one among a number of competing communicators and educators."

"In the face of these comments, how retrainable are the teachers?" queried Stanton.

"Very," asserted Judith Aronson, reaffirming her optimism that was noted earlier in this Report. "We find that what teachers who come to our program need is visual literacy. I'm not a learning psychologist, so I don't know how it happens, but somewhere along the line most adults' perceptions, especially in hearing and seeing, are knocked down. That's one

"You see, Dad, Professor McLuhan says the environment that man creates becomes his medium for defining his role in it. The invention of type created linear, or sequential, thought, separating thought from action. Now, with TV and folk singing, thought and action are closer and social involvement is greater. We again live in a village. Get it?" Drawing by Alan Dunn. © 1966, The New Yorker Magazine, Inc.

reason why we do a lot with media. In the first two weeks of classes we bombard our students' senses in a way they've never experienced before. Then we sit them down and say, 'Now what's happening to you?'" There's an explosion of new perceptions and meanings. Along with their increasing awareness, many students and educators develop a new concept of art.

"We begin more and more to think of the process—the mind creating—as the art object," commented Gerald O'Grady, director of the SUNY, Buffalo, Educational Communications Center and the Center for Media Study. "Art properly understood is no longer exclusively an object, but the creative evolutionary interplay between the subjects and their objects. If we acknowledge media to be all the codes of human expression and communication, which include their materials, their equipment, and their technological systems, then the study of these codes—language, gesture, the moving image, etc.—is an absolute necessity. . . .

"Unless one has competence in using and understanding communication codes, whatever they may be, one cannot adequately participate in life. The twentieth-century need— and it has something to do with Stanton's search for a new word—is 'mediacy': the ability to use, understand, and have access to the codes and modes of expression, communication, and information-transfer in contemporary society. All our senses must be open to all the media which we have evolved to pursue knowledge. Only thus can the brain be instructed, only thus can teaching and learning take place. For America to neglect developing this area of serious activity would be totally irresponsible."

"I foresee a time," author James Michener, a panelist, added, "when our society will be divided between the 70 percent who will receive their total education from television and the 30 percent who will continue to get it in the Socratic-Aristotelian fashion. This doesn't terrify me because I think one can get a very good education from television, but only if television continues to improve. Quite frankly, I know a good many people, a lot of them young, who are living the way of the 70 percent now. It is with the assumption that some day nonbookish people will rule the world, except perhaps in scientific and highly cultural fields, that we should view the life of the arts in the future. Anything that cuts even one shred of one art away from television is just going to impoverish this country."

The last group to understand how to use television has been professional educators. This is especially astonishing when one considers that by the time an average child has graduated from high school, he will have spent some 11,000 hours in a classroom, but more than 15,000 hours in front of the TV.

After twenty-five years, however, teachers are finally waking up to the effectiveness of television and its power to do more than entertain. And they are beginning to lose their fear of television, perhaps because a new generation of teachers has grown up with it. It was, in any case, a fear based on a fallacy. Teachers worried that television would replace their own services and they conjured up images of roomfuls of schoolchildren watching a TV where once a teacher stood. It may be that when books were invented, teachers regarded them, too, with hositility, fearing they would eliminate the need for oral explanations. [NEWTON N. MINOW, former chairman, Federal Communications Commission, *Change*, October 1976, p. 48]

The Screen Actors Guild survey taken a couple of years ago. . . . found minorities were only represented in 12.7 percent of the roles on television and this is where people all over the country learn about the ethnic minorities. . . ." [SUMI HARU, Panel witness]

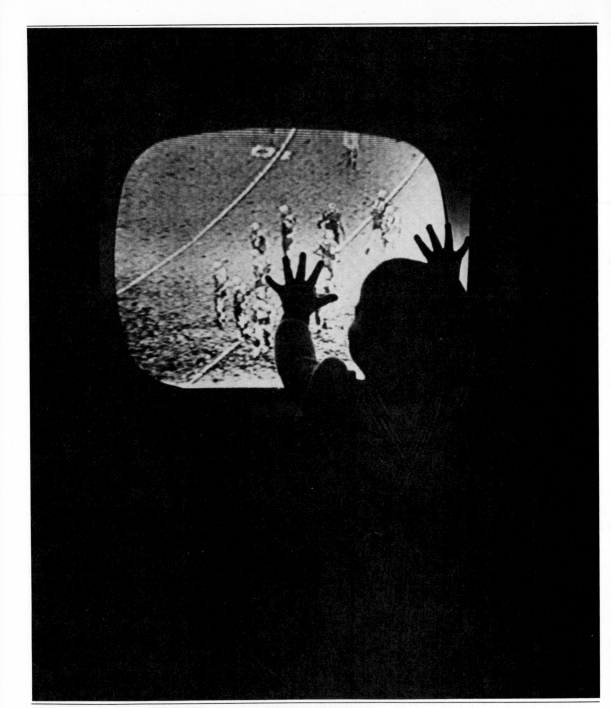

Football fan, photograph by Bill Binzen, 1960. The silhouetted infant, drawn
to the fascinating images on a television screen, reminds us of TV's inherent
power and its use and misuse as educator, baby-sitter, and playmate.

Television producer Norman Lear, in response to a question, gave the panel his opinion on the subject of the amount of arts programming on television: "Why aren't there more arts on TV? Television is an industry like other industries in this country. Unfortunately, because of its high visibility, it receives an unfair share of criticism. The profit motive applies to television as it does to all other industries. Ratings are all-important, because they mean dollars. Networks are always inclined to think that what sold yesterday is all that will sell today. That accounts for a lot of the sameness in TV and the reason why very few new things are tried. If something more artful were put on TV at 9 P.M. on Thursday night—something more artful versus something more artful versus something more artful on three networks—it is my belief that America would not turn away. People seek diversion. They will rise to it and select one of the three programs."

"The tube" as tutor

The media's role in arts education has scarcely been touched in this Report, or this dialogue. Nor have the possibilities of instructional television been adequately explored by the academic establishment itself. However, when 90 percent of the households of North America have television sets (not to mention Australia, Japan, and New Zealand, where the same startling percentage obtains), it ill-behooves the schools to look the other way. The real problem, one suspects, is that the field is so vast that it is hard to know where to begin. Once again, its influence is exerted largely outside the classroom. Essentially the problem is how to utilize television, radio, and films within the school setting. To many arts educators, the mechanical and technological worlds seem by nature to be anti-arts. Those who hold these reservations have an almost built-in resistance against classroom use of the media in their classes.

This does not mean that the more traditional means of expression should be ignored or downgraded. Rather, it means that elementary and secondary school educators should

Our young people are an endangered species due to too much passive TV watching, and too much emphasis on spectator sports. Fortunately, during school hours we have the open classroom so that students may move freely within the class area. But unfortunately, after school, evenings, Saturdays, Sundays, and holidays, many enter the TV trance and atrophy. ["Goleta Program Gets A-Plus," *Goleta Valley Today*, Apr. 6, 1976, p. 4]

expand their definitions of what constitutes the arts and what are appropriate vehicles of self-expression. The newer media should be taught in the same way the more traditional arts are examined.

First, the students should be exposed to the particular medium and given an opportunity to explore its unique characteristics. There should follow a period of analysis of the medium. Next, the students should learn to appraise it critically, and finally, they should be given an opportunity to express themselves in the medium. This approach is in contrast to examining the new media as systems for delivering knowledge about the more traditional arts.

Today in American education there is evidence that radio, television, film, and still photography are gaining some recognition as valid vehicles for artistic expression. While most educational settings are still primarily print-oriented, there do exist a number of programs, nationwide, that focus on these newer media.

It is noteworthy that educational programs that examine

WNET/13 Members' Guide, January 1977, vol. 2, no. 10. © Educational Broadcasting Corporation, 1977.

School Television Service Spring Schedule 1977 (Jan. 28-May 27, 1977)

Monday	Tuesday	Wednesday	Thursday	Friday
8:00 Legacy Americana[3]	8:00 Dealing With Classroom Problems [4]	8:00 The American Heritage Series	8:00 Western Civilization[3]	8:00 Biology Today/Man and the State (3/11)/Biology Today (4/29)
8:30 Let's All Sing[1]	8:30 Cover to Cover II[2]	8:30 All About You	8:30 About Animals/Real World of Insects (3/17)/'Way to Go (4/28)	8:30 Cover to Cover I
8:45 Vegetable Soup[1]	8:45 Vegetable Soup[1]	8:45 Vegetable Soup	8:45 Vegetable Soup	8:45 Vegetable Soup
9:00 Sesame Street[1]	9:00 Sesame Street[1]	9:00 Sesame Street	9:00 Sesame Street	9:00 Sesame Street
10:00 All About You[1]	10:00 About Animals[1]/Real World of Insects[2] (3/15)/'Way to Go[1] (4/26)	10:00 Forest Town Fables/ Uncle Smiley (3/3)	10:00 Assignment: The World[2]	10:00 The Word Shop
10:30 Infinity Factory[1,2]	10:15 The Draw Man	10:15 Odyssey	10:15 Safe and Sound	10:15 American Scrapbook
11:00 The Word Shop[1]	10:30 Truly American[2]	10:30 Infinity Factory	10:30 Search for Science	10:30 Inside/Out
11:15 Bread and Butterflies[1,2]	10:50 The Metric System[2]	11:00 Images and Things	10:45 Cover to Cover II	10:45 Wordsmith
11:30 Ripples[1]	11:10 Comparative Geography[1,2]/ Stories Without Words[1,2] (3/29)	11:20 Alive and About	11:00 Community of Living Things	11:00 Matter and Motion
11:45 Self Incorporated[2]	11:30 Community of Living Things[2]	11:40 The Metric System	11:20 Calling Captain Consumer/Many Americans (4/28)	11:15 The World of B. J. Vibes/ Whatcha Gonna Do? (3/18)
12:00 Short Story Showcase[3]/ Explorations in Shaw[3] (2/28)	11:50 Images and Things[2,3]	12:00 In-Service Teacher Training (TBA)	11:40 Basic Earth Science	11:30 Odyssey
12:30 The Electric Company[1]	12:10 The Humanities[3]	12:30 The Electric Company	12:00 Paths of Rebellion/ OURSTORY (2/24)	11:45 1977
1:00 Safe And Sound[1]	12:30 The Electric Company	1:00 The Word Shop	12:30 The Electric Company	12:00 Western Civilization
1:15 Search for Science[1,2]	1:00 Inside/Out[1,2]	1:15 Bread and Butterflies	1:00 All About You	12:30 The Electric Company
1:30 The Draw Man[1,2]	1:15 Wordsmith	1:30 Tell Me a Story	1:15 Cover to Cover I	1:00 Self Incorporated
1:45 Let's All Sing[1]	1:30 Forest Town Fables[1]/ Uncle Smiley[1,2] (3/1)	1:40 Calling Captain Consumer[1,2]/Many Americans[2] (4/27)	1:30 About Animals/Real World of Insects (3/17)/ 'Way to Go (4/28)	1:15 Ripples
2:00 Cover to Cover II[2]	1:45 Odyssey[2]	2:00 Truly American	1:45 The World of B. J. Vibes/ Whatcha Gonna Do? (3/17)	1:30 The Metric System
2:15 Matter and Motion[2]	2:00 Alive and About[1]	2:20 Basic Earth Science[2,3]	2:00 Assignment: The World	1:40 Comparative Geography/ Stories Without Words (4/1)
2:30 Wordsmith[1,2]	2:20 Tell Me a Story[1]	2:40 The Humanities	2:15 1977	2:10 Community of Living Things
2:45 1977[2,3]	2:30 American Scrapbook[1,2]	3:00 Nova	2:30 Biology Today[3]/Man and the State[3] (3/10)/Biology Today (4/28)	2:30 Legacy Americana
3:00 Paths of Rebellion[2,3]/ OURSTORY[2,3] (2/21)	2:45 The World of B. J. Vibes[2,3]/ Whatcha Gonna Do?[1,2] (3/15)		3:00 The Third Testament	3:00 Masterpiece Theatre
3:30 The American Heritage Series[3]	3:00 Short Story Showcase[3]/ Explorations in Shaw[3] (3/1)			
	3:30 Special Programming			

1. Primary K-4
2. Intermediate 5-8
3. Secondary 9-12, adult
4. Teacher Training

these newer media often do so without concurrently examining their role in the curriculum at large, as well as their relationship to the more traditional art forms of drama, sculpture, painting, dance, and music. The departmentalization so often present in American education frequently influences the study of these newer expressive forms. Fortunately, however, there is some awareness of this tendency, and some educational programs do attempt an integration of these newer media with the study of the more established curriculum. The examples described here, while not comprehensive, illustrate a variety of approaches.

Eliot Wigginton, who teaches journalism at the Rabun Gap—Nacoochee School in Georgia, has been directing the innovative Foxfire project there for over ten years. Wigginton's project, which is largely student-directed, attempts to capture and document the lives, dying arts, and character of the people who live in rural Georgia near where his school is located. The high school students interview elderly residents and capture their reminiscences about rural life in a bygone era. They do photographic essays to complement the interviews.

Wigginton's students are also interested in recording interviews with rural craftsmen, and learning about their crafts, many of which are rapidly dying out. Through audiotape interviews, still photography, and videotape interviews, these students make sight and sound records of these craftsmen as they show how to make an ox yoke, gather and prepare wild plant foods, make a foot-powered lathe, and demonstrate an entire process from raising sheep to weaving cloth.

These records are then compiled by the students and have been published in the series of *Foxfire* books.[1] The unusual characteristics of the Rabun Gap–Nacoochee School project are that it is largely student directed; it combines photography, audiotape and videotape, and print; and it uses the community as a resource.

New Trier High School West, in Northfield, Illinois, has instituted a program on the high school level to bring together students and community members in an educational program to promote artistic growth through curricular and extracurricular activities. The program's goals are to develop artistic awareness, understanding, and skills. The project is staffed by members of the New Trier West Fine Arts Association, and

205

includes teachers of art, music, speech, drama, dance, and theatre.

The project offers courses in six areas:

1. *Media Fundamentals* This is an introduction to the light-sensitive, image-making processes of still photography, movies, and television. The course also incorporates historical and philosophical concerns.

2. *Photography* Here both the aesthetic and technical aspects of photography are examined.

3. *Film* This is an interdisciplinary course with seminars, lectures, and workshops in television, graphic arts, and photography. The students work with the school's television equipment to learn techniques for television and film production.

 Included in the course are a study of acting techniques; the roles of the director, technicians, lighting specialists, and editors; and the interdependence of these various skills.

4. *Printmaking* There are three levels to this course; drypoint, engraving, and multimedia printmaking are all taught.

5. *Oral Communication* This course is given by members of the school's department of speech and drama, and emphasis is on the various aspects of mass communication.

6. *Radio Workshop* This course concentrates on studio work in the school's radio station, as well as the study of radio as a mass communication medium. It is anticipated that students will receive their third-class operator's license upon completion of the class.

 This workshop course attempts to integrate several of the media. While outside guest artists and professionals from the community contribute to the classes from time to time, it is primarily designed for high school students, in the school setting, during the school day.

A media program at the college level is being offered by the Center for Understanding Media in conjunction with the New School for Social Research in New York City. Students in this program can earn the M.A. degree in media studies, which includes photography, film, radio, television, and other new electronic media. Emphasis is given to the preparation of

teachers who want to make their students more intelligent, critical, and selective about what they see and hear. This study is also related to an understanding of the traditional artistic forms.

In this program, "production courses are offered to aid in the basic understanding of the media codes rather than as a preparation for professional careers in the media. In practice, this means that the participants view, discuss, and analyze a variety of film and television offerings; that they make their own photographs, slides, audiotapes, live action and animated films, and videotapes; and that this teaching about the new media is integrated with teaching about literature, drama, and the fine arts."[2]

An effective local program focusing on the new media has been in operation in the Mamaroneck, New York, public schools since 1971. Each of the 6,000 students in this K–12 system has an opportunity to study photography, animation, live-action, filmmaking, and the creation of videotapes. At the junior high school level, every seventh grader takes a two- to three-week media course that includes television-studio work, filmmaking, and the use of the portable television pack.

Mamaroneck encourages in-service training for its teachers, and each semester there is at least one media course offered. Because the school system recognizes the importance of integrating the new media with other curriculum areas whenever possible, the district's three media specialists work closely with the classroom teachers on curriculum that profitably can have a media component.

The Mamaroneck public schools also have an extensive closed-circuit television system which is used daily to transmit programs produced by the senior high school students.

Nationally, the growing interest in the new media among high school students is illustrated by the Young People's Film Festival held in 1974, and sponsored by the Public Broadcasting Service and 100 local public-television stations. Over 5,000 elementary and secondary school students submitted films they had made to the festival. Many were shown on local public television, and a selection of the best ones from around the country were sent to New York where they were shown on Channel 13, the local public-television outlet.

As discussed earlier in this Report, the Artists-in-Schools program has played a major national role in bringing

Coast Community College has already reached national prominence through its imaginative production of a wide series of television courses. Along with the extension division of the University of California at San Diego, Coast has also been responsible for the distribution of course materials of three notable public television series, "The Ascent of Man," "The Adams Chronicles," and "Classics Theatre." The first two series have each had over 300 cooperating "for credit" colleges, and Classics Theatre has reached 250 campuses. A thorough look at the related texts and student and teacher guides (ably published by Education Associates in Boston, a division of Little, Brown and Company) shows an imagination that makes one wish for more. Traditionalists may sniff at such media-oriented material, but most of it is first-rate, and some of it is clearly superior to the quality of teaching in the average institution of higher learning. [GEORGE W. BONHAM, Editor, *Change*, April 1976, p. 33]

together students in the classroom and artists from the community—as well as artists working in the more traditional media. The program has enabled movie makers, photographers, animators, and video artists to work in the schools for periods of from two weeks to six months.

A unique joining of the traditional arts and the new media is exemplified by the creation of the new Fine Arts Center of the Annenberg School of Communications. The center will be a division of the existing Annenberg School of Communications, which presently has branches at the University of Pennsylvania and the University of Southern California.

Courtesy of the Center for Understanding Media, New York.

The new center, the primary function of which is to make the world's art more available to mass audiences, will use the most advanced techniques of modern communications—films, television, tapes, publications, slides, reproductions, and other devices. The center also plans to grant graduate degrees in communications.

The new center may do much to elevate the new media in the minds of educators, artists, and the general public. Skillfully used by the staff of this new center, the media will be seen as an art form in itself as well as a means of disseminating man's past artistic achievements.

Panelist Iselin, in speaking about the future of television, told the Panel: "I hope we get a second chance from the school systems which have heretofore refused to accept the fact that there can be anything but twenty-minute segments in neat little packages to fit predetermined curricula—therefore repudiating most of what we've been talking about in this Panel. And in that sense I think television should be considered as both a partner of the artist and as a form of artistry that must fight for reevaluation of our elaborate schooling systems. The rigidities we all discuss and deplore are terribly difficult to overcome whether we're artists or brokers of artistic endeavor."

General audiences for arts programming would probably be even greater if programs for children were as good at introducing their audiences to a variety of art forms as they have become in introducing children to other phenomena—from learning how to count to learning how to solve interpersonal problems. [STEPHEN STRICKLAND, Keynote Speaker, fifth national symposium on Children's Television and the Arts, *ACT News*, vol. 5, no. 3, Spring 1976, p. 12]

Analyzing the present, mapping the future

Though the intensified drive for arts education has been under way for less than a half century, its champions have gained an abundance of valuable experience. They have pooled their discoveries, distilled wisdom from their mistakes, and formulated what in effect is a guidebook that ranges in its coverage from high-level problems of administration, patterns of command and blueprints for action, down to practical classroom advice on what to do, what to avoid, and how to survive in the new *terra incognita* of arts education.

The greater part of this chapter is a survey and analysis of the present situation. It covers in detail a variety of working plans in a variety of conditions, on the theory that readers can extract what is most useful for themselves in their own territory.

Getting back to a basic premise, Panel witness Kathryn Bloom, director of the Arts in Education Program of The JDR 3rd Fund, pointed out that for the majority of people active involvement in the arts has not been a significant part of their education. If the role of the arts is to be changed, educational decision makers must have a rationale that explains not only the value of the arts for their own sake, but equally important, how these subjects can meet broad educational goals. She went on to say that policymaking grows from the conviction that you have a concept you can believe in, that there are some specific ways in which you can concentrate on how to change the content of instruction, and that there is a plan for every orderly process of change. If appropriate policy is made, what follows is obvious: the arts have parity with other subjects in the curriculum, so that when the total budget is conceived, the arts are considered equal to science, math, and other areas of instruction. That means we must pay more attention to overall goals in education than we do now.

The diversity of arts and the sectional differences in America suggested to Panel witness Scott Thomson, associate secretary for research, National Association of Secondary School Principals, that arts education is a complex subject which must be dealt with differently in different school systems, according to the meanings it has for those communities.

There is something going on in this country worth taking note of. . . . There are tens of thousands of people who have participated in all sorts of movements, people who are working underground and above ground in Harlem and Chinatown, in Newark, in Chicago, in Santa Fe, with every sort of imaginative program, which given the right kind of funding could take flight. We should bear in mind that the National Endowment for the Arts has something like one four-thousandth of the national budget to spend on the arts. And it is safe to say that only about 10 percent of this goes to community arts programs.
[STEPHEN GOLDSTINE, Panel witness]

"The roots, I think, are what is important," he told the Panel, "not some kind of a veneer that's put on afterwards. In my opinion, the program for schools must build on what we have in the local communities, whether it be a pioneer museum or something else. . . ." As another Panel witness, Jerome Hausman, president of the College of Art and Design in Minneapolis, put it, "You start by focusing upon natural advantage, things than can be done and done well. If you have a school system with a strong urban arts program, start there. If you have a good museum program in the community, start there. Build on what you have and add to it."

"The real action with the arts in education is at the school district level and in the classroom where the kids are," said Kathryn Bloom. The districts now have many more successful models and programs to work with than they had ten years ago. But even assuming the district has some financial assistance assured from local, state, or federal sources, successful application of these resources can be achieved only through careful planning—a need identified by more than one Panel witness and in more than one research report.

The school board of Michigan has suggested a strategy:

Goals must be collectively established by teachers, administrators and citizens of the community defining what the status of the arts should be within a particular school district and how much time should be required to reach full implementation.
1. The first step should be assessment of exposure to arts at present to serve as a basis for determining the adequacy of exposure.
2. Determine the adequacy of exposure to each of the fine arts—these evaluations should be made cooperatively by all elements of the school community, with sufficient flexibility to develop a sound working compromise plan of action.
3. Identify needs for additions to the curriculum.
4. Determine how these needs will be met, whether they are long- or short-term goals.[1]

Panelist Edward Hamilton pointed out that since local school districts are numerous and far-flung, overall planning at the state level would be more practical and effective. Floyd Keller, director of elementary and secondary education for Minnesota, reported to the Panel that Minnesota had initiated the development of a comprehensive plan to increase communication between the state and local levels. In order to do this,

the State Department of Education, in cooperation with the Alliance for Arts Education state committee, initiated a review of the place of the arts in relation to other parts of the curriculum. A state plan for integrating the arts into education is being formulated as a basis for discussion with superintendents and Educational Cooperative Service Units (ECSU's) to aid administrators and citizens engaged in educational planning. It is anticipated that this plan and process, operating on a statewide basis, will maintain and enhance the integration of the arts in the total education programs of the local school districts.

The Panel was cautioned, however, that setting up a department, a pilot project, or program is not the whole answer. Said Panel witness Jerome Hausman, "Beware of the project mentality, which lets institutionalization take over, lets structure seek its own justifications apart from instrumentality." Panelist Francis Keppel, former United States Commissioner of Education, pointed out that since his days in Washington, a shift has taken place: educational funding can no longer be justified in terms of growth, or quantity, but on the ground of *quality*. "If we can teach knowledge about aesthetics—how to hear, how to see, how to feel, how to make judgments of quality—then we have provided the basic argument for coming to the aid of arts and education," he said. But, he warned, we cannot go any faster than the quality of our teaching will permit, and that means we must move more slowly.

Harold Hodgkinson, director of the National Institute of Education, discussed with the Panel one of the chief problems of education. Why is education so hard to change, and is it actually resistant compared to other contributions to American life? In noting how long it took, in a number of cases, from the conception of an idea to its first application, he pointed out that the zipper took twenty-seven years, wide use of hybrid seed corn thirty-eight years, the kindergarten forty years, and the cotton picker fifty-three years from working model to wide usage. Dennie Smith, associate professor of education at the Memphis State University, told the Panel, "One of the fallacies innate to work with educational change models was the assumption that things are going to change within three years. I think our studies indicate that the process takes much longer."

Schools are large, conservative, bureaucratic institutions, with relatively well-trained staffs who are, nevertheless, not all wonder-workers. The cycle for absorbing any significant change (such as career education or accountability) is several years long, at best, and the change will probably be attenuated in this process. In addition, in the context of declining enrollments, the urge to innovate may diminish, as a result of increased concern for job security. [FRANCIS KEPPEL, "Humanizing Education," speech at Boston University, April 7, 1976]

Innovation Time Lags (in years)

CONCEPTION OF IDEA TO FIRST APPLICATION

Hybrid Seed Corn	25
Heart Pacemakers	32
Zippers	27
Input-Output Economics	28
Television	22
Xerography	13
DDT	3

FIRST WORKING MODEL TO WIDESPREAD USE

Hybrid Seed Corn	13	
Kindergarten	40	
New Math	5	
Cotton Picker	53	
Continuous Annealing	20	
Diesel Locomotive	11	
Grocery Products, Drugs		SOURCES - ERIC (NIE) AND MEDLARS

Harold Hodgkinson speaking to the Panel in Minneapolis on the innovation time gap between the conception of an idea and its first application. (Printed by permission of the National Institute of Education.)

So far as the arts in education are concerned, John Good-lad reminded the Panel of John Dewey's *Democracy and Education*, which stated in 1916 that it is not enough to produce good citizens and parents, but that we must develop human beings capable of achieving their potential in all areas. Yet we have had educational goals related to the arts for only about two decades, and have still not successfully integrated the arts into the schools. According to Goodlad, improvement can come only if an attack is made simultaneously on three levels: first, achieving commitment from lay citizens; second, establishing the arts as central within the local school; and third,

What can you do on a budget of no dollars and no cents? A lot—just an incredible amount of things. If you want to do something in body movement, no big hassle about budgets and things like that. If you want to do something in photography, everybody's got a camera hanging around the house someplace. Audiotapes—that equipment is around someplace. If you want to help students analyze the moving images of film and TV, they all have a moving-image machine in their own homes, and they can look at programs and come back and talk about them the next day. I think we have to realize that a tremendous amount can be done even under the current circumstances. [JOHN CULKIN, Panel witness]

winning acceptance of the arts by teachers and administrators, including their acquiring the skills necessary to carry out a comprehensive arts program.

Even if there are programs and projects to serve as models, if there are formal and informal structures to implement them, what about the period of financial stringency in which we find ourselves? The management of decline was a recurring leitmotif throughout the Panel discussions. Sam Ingram, Tennessee Commissioner of Education, told the Panel that for too long we have assumed we can't do anything without more money, but "the truth of the matter is we're not going to get a lot more money, but our real wealth lies in significant ideas—and some new money, certainly, but not a lot." Panel witness Frances Coe of the Memphis Board of Education reinforced what the commissioner had said:

> To me, the board of education, the school principals, and the local college are all sold on the value of art in education from kindergarten on. . . . It's not a lot of extra money; it's the way you do your curriculum; what you believe. I don't think we should let money stand in the way.

Panel witness Kathryn Bloom pointed to a new sense of commitment on the part of school districts and state departments of education which has resulted in mixed funding formulas: outside money can provide for planning and development services; the school districts pay operating costs.

The Panel, then, received a number of messages and impressions impinging on the complex area of policymaking in the arts and education.

The great diversity in our culture and the tradition of local control of education suggests that there is no one answer, model, or program that will apply to all our schools or school districts. Careful planning and coordination—drawing upon teachers, administrators, bureaucrats, artists, parents, students, and businessmen—are required to develop effective programs which will not only make the arts part of general education in the schools, but make better use of what is available in the community. In a time of declining budgets, a sharing and reallocation of existing resources—financial, human, and physical— must be developed in addition to long-range planning. Solutions are not bureaucratic, but substantive and strategic.

However, in looking at local, state, and national issues in the arts and education, the Panel also became aware of the increasing involvement of government at all levels. In spite of the traditions of local control of education and government nonintervention in the arts, much has changed in the last two decades. While all levels of government are involved in making policies affecting arts education, there are vast differences in the roles played by each level. Federal and state governments often function as bankers, providing the funding for school and community programs which meet their guidelines, while program control is left to local units of government. Governmental agencies are also becoming linked to arts institutions and organizations managed by private citizens.

In considering future courses for the arts in education, the Panel looked at the historical threads and present policies, as well as the constraints on those policies, which emanate from government—first federal, then state, then local governments.

The federal perspective

What has been the role of the federal government in supporting arts education? What federal legislation exists? What federal programs have evolved? What have been the roles assumed by different federal agencies in the support of arts education?

The first year of substantial federal interest in arts education was 1962. In March of that year President John F. Kennedy appointed August Heckscher his Special Consultant on the Arts, a newly created position. Heckscher was charged with examining the federal government's posture toward the arts and recommending a policy for the administration. A supporter of the arts, Heckscher believed that "in the eyes of posterity, the success of the United States as a civilized society will be largely judged by the creative activities of its citizens in art, architecture, literature, music and the sciences."[2] His

Poet Robert Frost's reading of his inaugural poem on January 20, 1961, heralded a new period of enthusiasm for the arts under the Kennedy administration. (United Press International.)

report—published in May 1963, under the title *The Arts and the National Government*—contained a set of far-reaching recommendations advocating an enlarged role for the federal government in the arts. Among other things, the report noted that "the Office of Education, the chief agency of the government concerned with education, had until recently given little attention to the arts," and recommended that

> . . . further consideration be given to increasing the share of the Federal Government's support to education which is concerned with the arts and the humanities. This should include the same type of across-the-board assistance now given to modern languages, mathematics, and science: for example,

facilities and equipment, teacher training, teaching techniques and materials, scholarship and fellowship programs. The predominant emphasis given to science and engineering implies a distortion of resources and values which is disturbing the academic profession throughout the country.[3]

Most federal education assistance programs administered by the Department of Health, Education, and Welfare's Office of Education either ignored or specifically excluded arts education projects from support. The curriculum development emphasis of this pre-1962 era was on the teaching of traditional subjects, particularly the three R's. When the Russians launched Sputnik in 1957, the period's emphasis on the importance of teaching science, in particular, was increased.

An important break with the past occurred in 1962, however, when the Cultural Affairs Branch within the Office of Education was established to develop programs and activities aimed at improving arts education at all educational levels. Despite its small staff and limited budget, the branch represented a significant step taken by a federal agency in recognizing the role of arts in education and the need for support. By 1963, this recognition had grown within the government, because of the convergence of several factors: the climate of interest in and support for the arts generally created by the Kennedy administration; the release of the Heckscher report; and the appointment by the President of a Commissioner of Education, Francis Keppel, who saw a greater role for the arts in education and appointed a strong champion of arts education, Kathryn Bloom, as director of this new Cultural Affairs Branch (to be renamed the Arts and Humanities Program the following year).

The year 1965 marked the beginning of a significant trend in arts education support within the federal government: two important pieces of legislation were passed, and the Office of Education's Arts and Humanities Program grew in size and influence. In the spring of 1965, the Elementary and Secondary Education Act (ESEA) was passed, and for the first time in the history of federal education legislation, a partnership between the arts and education was initiated. The act's major purpose was to assist state and local education agencies in providing special compensatory programs for disadvantaged children (Title I), innovative educational programs (Title III),

The famous launching of the Sputnik satellite by the Soviet Union led to an upheaval in the teaching of science, particularly at the secondary and to some extent at the elementary level. It led to the creation of all new courses in science (with the support of the National Science Foundation), and many summer institutes and so forth, for the retraining of teachers in these methods, were given. It got a lot of people trying to do better teaching and had a dramatic national impact. The result of this has been an enormous ferment in science education within the last fifteen years that I don't think would have happened without that kind of stimulus. Maybe what we need is some kind of artistic Sputnik. [GLENN SEABORG, Panel member]

and support for educational research (Title IV). Arts and humanities projects were "eligible" for funding if local and state school officials chose to incorporate them into their proposals. It has been estimated that during the Elementary and Secondary Education Act's first five years (1966–1970), Title I funded $267 million of arts-related projects,[4] while Title III funded $80 million.[5]

Portions of the Elementary and Secondary Education Act legislation still exist today, although their form and provisions have been revised. Of particular interest is an Office of Education program, "Educational Innovation and Support" (authorized by the Education Amendments of 1974, PL 93-380), incorporating many provisions of the 1965 Elementary and Secondary Education Act Title III. This program authorizes support for innovative educational projects which may include arts components. Formula grants are made to state education agencies which in turn allocate funds—on a competitive basis—to local education agencies. The decision whether or not to make arts education a priority is left, not up to federal administrators, but rather to state and local school officials.

A second important piece of legislation, passed in 1965, created the National Endowment for the Arts and the National Endowment for the Humanities. While funding was limited during the early years of their existence, both Endowments were to emerge by the early seventies as significant champions of arts and humanities components in American education. The original legislation (PL 89-209), though, placed the major responsibility for arts education with the Office of Education: " . . . it is desirable to establish a national foundation on the arts and humanities and to strengthen the responsibility of the Office of Education with respect to education in the arts and humanities." As a result, the Commissioner of Education was authorized to allocate sums totaling $500,000 to be expended on equipment for arts and humanities education, and also for teacher training institutes in the arts.[6] These provisions were later repealed by amendments in 1970 and 1973 (PL 91-230, PL 93-133).

The third important event of 1965 was the emergence of the Office of Education's Arts and Humanities Program, located in the Bureau of Research. According to Junius Eddy, "The program represented a new awareness on the part of the Federal education agency that the arts and humanities—previ-

ously categorically excluded from virtually every piece of Federal school legislation—were an important, though long neglected, aspect of education."[7] The principal concern of the Arts and Humanities Program was the administration of the Elementary and Secondary Education Act Title IV funds for research and development in arts and education. During its first six years, the program supported over 200 research and development projects covering basic research, applied research (especially curriculum development studies), and developmental activities (centering on twelve conferences). The program supported only research and development projects, not projects in schools. Of this critical period Junius Eddy has noted: "From virtually nothing in 1965, federal financial support for pre-college educational programs in the arts, the humanities, and cultural activities generally, leaped to somewhere between $70 and $75 million only a year later . . . and generally remained at this level for the next three fiscal years."[8]

Even though it was far from clear what the tangible results of these years had been in terms of research findings, curriculum improvement, and published reports, there seemed to be agreement on the less tangible and indirect benefits of this focused support for arts education. These activities brought together—in many cases for the first time—educators, administrators, arts educators, and artists, who began to see the issues in arts education in national rather than local or narrow terms. As a report about this program indicates:

> Title IV made possible a solid little enclave within the Office of Education. The Arts and Humanities Program, as the only cohesive arts group within the federal educational establishment, constituted itself a communications center not only among government agencies and between government and arts educators, but also in a measure, between these groups and the arts and education world generally. Thus, the Arts and Humanities Program helped guide and occasionally instigate the far larger outlays under other Elementary and Secondary Education Act titles, and played a catalytic part in advancing the arts in education.[9]

The next significant event in arts education federal history was the transfer by the Office of Education (as directed by the Bureau of the Budget) in 1969 of $100,000 to each of the

National Endowments. The Arts Endowment used its $100,-000 to finance a visual arts component of the new Artists-in-Schools (AIS) program, a joint venture of the Arts Endowment and the Office of Education. The Artists-in-Schools program, an outgrowth of the Endowment's earlier poets in schools program that began in 1966, involves the placement of professional artists in elementary and secondary schools to demonstrate their artistic disciplines. The artists are considered as artistic resources, not as formal teachers, and are expected to work with teachers as well as students. The second and final Office of Education transfer of $900,000 to the Arts Endowment for the support of the Artists-in-Schools program occurred in 1970. Since that time, while the Office of Education has sporadically identified funds from various programs to support Artists-in-Schools-related projects (such as the Emergency School Aid Special Arts Projects), the Endowment for the support of the Artists-in-Schools program itself. Endowment expenditures for the Artists-in-Schools program had grown to about $4 million in 1976, and during the course of the 1975–76 school year "more than 2,000 artists worked in 7,500 schools with nearly one million students in all fifty states and five special jurisdictions."[10]

The Artists-in-Schools program represents the single largest Arts Endowment program which has as its primary purpose —defined by policy, as opposed to legislation—the support of arts education–related projects. The Artists-in-Schools program is the largest of the three subprograms administered by the Arts Endowment's Education Program, the other two being Alternative Education and Arts Administration. Alternative Education is currently being redesigned into a program which will support exemplary experimental programs, in which artists serve primarily as models and instructors. It is important to note that the Education Program is but one of twelve programs administered by the Arts Endowment, most of which have some potential for assisting arts education projects in one way or another. The Endowment has included education as one of its basic goals, first established by the National Council on the Arts at its second meeting on June 2, 1965. In addition to its Education Program, it has also provided (1) assistance to enable cultural organizations to offer their resources and services for education, both inside and outside of schools; (2) support for

research and demonstration projects related to the arts in schools; and (3) activities which advocate the cause of the arts in the lives of American youth.

In the twelve Endowment programs, including education, the total number of projects related to schools and school-aged youth—both in and out of school—rose from 143 projects in fiscal 1971 to 570 projects in 1975, approximately a fourfold increase.[11]

Similarly, the National Endowment for the Humanities administers a number of programs which may support arts education–related projects. Its Division of Education programs seem to provide the greatest amount of support in this area. As defined by its enabling legislation, the Humanities Endowment supports projects of organized study in the "humanities" which may include "historical, theoretical, and critical studies in the arts."[12] A subprogram called Education Projects supports imaginative approaches to education and the development of new curriculum materials on all levels. Numerous arts education–related projects have been funded, including, for example, a recent award of $250,000 over a three-year period to the Lincoln Center Institute in New York City, which set up a program for performing artists to work with schoolteachers of various humanistic disciplines.

The National Institute of Education (NIE) was established in 1972, assuming responsibility for funding all educational research and development—including arts education research—within the Department of Health, Education, and Welfare. Out of the total NIE 1976 budget of $70 million, approximately $1.5 million supported arts education–related projects, such as CEMREL and Harvard's Project Zero, which were formerly funded by the Office of Education's Arts and Humanities Program. While the arts and humanities are considered important and the director of NIE has a special assistant to advise him in these fields, they take a lower priority among the research needs identified by the Institute, such as reading, and career education.[13]

With the Institute taking over its specific research-oriented mandate, the Arts and Humanities Program underwent a series of organizational shufflings within the Office of Education in the early 1970s. By 1975, its staff was established in the Office of the Executive Deputy Commissioner of the Office of Education. At present its major responsibility is to

work with the Alliance for Arts Education (AAE) in administering the first congressionally mandated Arts in Education Program. AAE was established in 1973 jointly by the Office of Education and John F. Kennedy Center for the Performing Arts to function as the Center's education program. The Alliance office (located in the Kennedy Center in Washington, D.C.) has helped establish state AAE committees throughout the United States in an attempt to develop a grass-roots arts education movement at state and local education levels.

The Alliance is working jointly with the Office of Education in the coordination and implementation of the Arts in Education Program as authorized by the Education Amendments of 1974. It bears repeating that this is the *first* congressionally mandated program of support for arts education in federal legislative history. In its first year of operation, 1976, this program with a congressional appropriation of $750,000 made grants to state and local education agencies "to establish and conduct programs in which the arts are an integral part of elementary and secondary school programs."[14] Even though grants were in the $5,000 to $10,000 range, response to the first year of funding has been overwhelming: some $3.3 million worth of proposals were received from forty-six states and territories and 215 local education agencies.[15]

Kathryn Bloom pointed out to the Panel that this $750,-000 program is of major significance because it now provides guidelines enabling local school districts and state education departments to propose plans for comprehensive arts in education programs. "The amount of money is not large, but the fact that there are funds to initiate plans has had an electrifying effect on the school systems and state departments nationally. In fact, I think that the combination of a model or a demonstration that works, along with money to make some grants, has created much more quickly than any of us would expect something which really is a national movement for the arts in education in the schools."

By the end of 1976 the federal government's efforts to provide direction and financial support for arts education were divided among seven principal programs, as well as a number of smaller ones. Only two programs, to reiterate, had a specific legislative mandate to assist arts: the *Alliance for Arts Education* and the *Arts in Education Program of the Office of Education*. In addition, however, there are two other programs

with the primary purpose of supporting arts education projects, though this purpose is not officially mandated by legislation: the *Special Arts Project of the Office of Education*, which operates under the Emergency School Aid Act, and the *Education Program of the National Endowment for the Arts*. The former, begun in 1974, funds projects which help children develop appreciation for art and for their own creative abilities through direct contact with artists from various art disciplines and various racial and ethnic backgrounds.

In addition, three other programs offer significant financial support for education programs in a number of fields, including arts education. These are:

The Educational Research and Development Program of the National Institute of Education, which supports educational research and efforts to disseminate the findings of such research.

The Educational Innovation and Support Program of the U.S. Office of Education's Bureau of School Systems, which provides funds for supplementary educational centers and services in all fields, including the arts.

The Division of Education Programs of the National Endowment for the Humanities, referred to above.

Numerous other potential sources of assistance exist throughout the federal government. Examples of support are diverse, ranging from the Department of the Army's $14 million Arts and Crafts Program in fiscal 1976, to the government's extensive system of libraries available for use by art researchers, to Fulbright-Hays grants for art students and teachers for study abroad.[16]

Because the seven major arts programs and the myriad tangential ones are responding to different legislative and policy directives, duplication and overlapping occur in some areas, gaps and omissions in others. Two efforts have been made to coordinate the federal government's activities, as well as to make them more responsive to public needs. One is the Federal Council on the Arts and the Humanities, established by Congress to promote coordination between the two National Endowments and the heads of nine other federal agencies which support the arts and humanities. The second is the Federal Interagency Committee on Education (FICE),

chaired by the Assistant Secretary for Education of HEW. The Federal Interagency Committee on Education is composed of representatives from thirty federal agencies involved in education, including not only the Office of Education, the National Endowments, and the Office of Child Development, but also such agencies as the Department of Defense and the Civil Service Commission. The FICE's subcommittee on arts and humanities is particularly concerned with our subject.

Despite these attempts at achieving coordination in arts education, and indeed, as is the case with virtually all federal programs in education, the distribution of responsibility is often unclear. In a report on federal programs in education prepared for the American Council on Education, Rufus Miles, Jr., of Princeton University noted, "A coherent philosophy of relationships that can enlist the support of responsible officials at all levels is urgently needed."[17]

The administrative problems that plague federal efforts in arts education stand little chance of receiving adequate attention within the massive Department of Health, Education, and Welfare. As Miles said, "Educational issues are of low priority"[18] within HEW because of the broad range of important issues which must be settled by those heading the department. By the same token, the funds which the Secretary of HEW can allocate for education are sharply limited by the demands on the budget caused by automatic increases in programs such as Social Security, Medicare, Medicaid, and Public Assistance. When mandatory requirements are increasing rapidly, there are unavoidable pressures to restrain or cut back the controllable portion of the budget. According to Miles, "This is what is happening to the education components of HEW's annual budget."[19]

While the federal government's involvement in arts education began with the financing of research projects and experimental programs, its role, as we see, has expanded. The federal government is able today to exert significant influence through its funding requirements and decisions. However, it has not attempted to demand basic changes in existing arts education programs. Much of the power to shape those programs still rests with governmental agencies on the state and local levels.

It seems to me that leadership is needed if the arts are to receive the kind of attention they should. It must be made clear to the voters and the budget makers that there is no dichotomy between the arts and learning to read. In fact, a student who really gets an appreciation for beauty is much more apt to be able to read than the one who doesn't. Now the question is, What can the Commissioner of Education do in a leadership position to bring this about? If he does nothing, it is not going to happen; things are going to get worse instead of better. [ELIZABETH J. MCCORMACK, Panel member]

The attitude of state governments toward the arts in education has been changing dramatically in the last two decades. Formerly, the states were solely concerned with exercising broad powers in financing and directing the nation's elementary and secondary schools. Now, however, a number of states are rising to the challenge of the arts and, through a willingness to experiment and to make mistakes if necessary, are starting to include them in public education.

In 1960, Governor Nelson Rockefeller took the lead in creating the New York State Council on the Arts which had an initial appropriation of $500,000. At about the same time, Governor Terry Sanford and the North Carolina Legislature created the North Carolina School of the Arts as a unique state-subsidized institution. As the pace of state involvement in the arts quickened, California launched its arts commission in 1963 and Michigan, Washington, Pennsylvania, and other states soon followed suit. By the mid-1970s, the principle of state support for the arts was firmly entrenched.

In order to show in some detail the complexity of the planning process for arts education at the state level, the Panel's staff has selected three states for intensive examination.[20] They represent three regions of the country, but they also reflect fairly diverse interests, problems, and pressures. Moreover, they give us an opportunity to observe major activities and a typical cast of officials in their policymaking process: the governor, the state legislature, the department of public instruction, and the states' art councils and commissions. The three states chosen for study are Michigan, North Carolina, and Washington.

While the particulars of arts education decision making vary from state to state, there are a number of broad observations which apply to all three states, and probably to most others as well.

Goals mandated by a legislature or education department in each of these three states tend to be meaningless. Although the lack of any official state commitment to the arts in educa-

tion may be symbolic of a real dearth of interest, the integration of the arts into a state's educational policy statements does not necessarily guarantee integration of the arts into the actual processes of education. Reading and math are not taught in response to a mandated set of goals, and neither are the arts. The gulf between policy and practice is often wide.

What is much more important than any goals statement is the commitment of money in a budget. And more important than the amount of money is its source and reliability. Financial support for an institution often depends on the strength of its constituency as much as on the merits of its activities.

The governor

In each of the three states studied, the governor has only indirect control over education. His ultimate power over education policies lies chiefly in his political strength and in the prestige of his office. By contrast to the strong tradition of local control over schools, the governors have complete control over appointments to the state arts councils and, indirectly, over the hiring of council staff members.

The Governor of North Carolina appoints eleven of the thirteen members of the state board of education, but the superintendent of public instruction is elected by the people, and thus has minimal allegiance to the board or governor.

Like his North Carolina counterpart, the superintendent of public instruction in Washington is elected. However, the governor submits the state's education budget to the legislature after consultation with the superintendent. Through his power over the education budget request, in the mid-1970s the governor chose to promote arts education through an ambitious Cultural Enrichment Program.

In Michigan, all eight members of the board of education are elected, and they choose the superintendent of public instruction. While the governor submits an education budget to the legislature, the board submits its own proposal as well, leaving it to the legislature to develop the final spending plan.

The legislature

In all three states, the legislature's principal power lies in determining the state public education budget, in deciding the terms under which state funds are distributed to localities, in designing and funding such new education programs as it wishes, and revising existing ones. All three state legislatures tend to respond to, rather than initiate, education policies, particularly in arts education. Consequently, the state legislatures have shaped arts education policies only when one or more legislators have taken up the issues as a personal cause. Thus, the Michigan Legislature is a major force for arts education, largely because of the interest of a single member. One state representative introduced the legislation which established the Michigan Arts Council in 1966. Subsequently elected to the state senate, he has used his position as chairman of the education committee to establish a joint committee on the arts and to press for increased statewide commitment to arts education.

Among the major actions taken under the senator's sponsorship was a 1974 study of the status of the arts in Michigan, with emphasis on arts education. He has personally promoted arts education conferences for local school officials and sponsored legislation to increase state funding for arts education and for arts specialists within the department of public instruction. Traditionally, the Michigan House of Representatives has controlled the state's budget process. But due to the senator's interest, the state senate has also become involved in the education budget.

Because of the severe impact of the recession and the energy crisis in Michigan, recent measures appropriating funds for arts education have failed to pass. The senator has nonetheless continued his efforts to persuade a generally uninterested department of public instruction to begin planning for arts education.

By contrast, the Washington Legislature's major role has been to make a specific allocation of $1,111,000 in the biennial budget for a statewide Cultural Enrichment Program. Local

229

control of the schools is prized everywhere, but appears to be particularly important in Washington. Consequently, the legislature hesitates to pass educational legislation until the state superintendent of public instruction and local school districts have agreed upon it.

Department of public instruction

In each of the three states, there is a department of public instruction which bears responsibility for public elementary and secondary schools. Because of its involvement in developing programs, recommending course content, and testing and evaluating students, the department's degree of concern for the arts can greatly affect the quality of arts education.

In North Carolina, the department of public instruction maintains a division of cultural arts, with a director and a staff of six. The department had only an art supervisor and a music supervisor until 1970, when the position of division director was created, and additional specialists in other art forms were appointed. This small, but nonetheless significant, increase in a department of 600 employees is attributable to the interest and efforts of a sympathetic superintendent and board. While the role of the division is chiefly advisory, it also manages a special program budget of $125,000, which is used as seed money for individual districts.

Arts education in North Carolina has been included in a statewide program of educational progress assessment, created to gather data for program planning and decision making. In contrast to the conventional objective tests used in other subject areas, the test used in the arts segment of this program is a perception survey which emphasizes pupil exposure, interest, and attitudes.

The North Carolina Administrative Code adopted by the state board of education on July 1, 1976, mandates a standard course of study consisting of a K–12 continuum in six broad areas, one of which is "Cultural Arts Education." A curriculum guide indicates suitable instructional materials, learning experiences, and teaching methods.

The division of cultural arts believes that knowledge and interest in the arts vary considerably across the state, and so it has not presented a statewide curriculum. However, North Carolina is unique among the three states studied, in that it has a state textbook commission which selects and purchases all texts, including art and music books, for all public schools.

Michigan's elected, eight-member state board of education hires the superintendent of public instruction, who then serves as chairman of the board as well as head of the department of public instruction. The department has approximately 2,000 employees, but only a single fine arts specialist for music and art, and the department has shown very limited interest in arts education. There is no mandated curriculum for the arts (or any other subject except civics). However, statewide minimum performance objectives for art and music education were published in 1974, despite their not being included in the statewide testing and evaluation programs.

There are two groups attempting to create a more receptive atmosphere for the arts within Michigan's department of public instruction: the first, a working committee attempting to work the arts into other curriculum areas and give the arts more prominence in existing priorities; the second, an advisory board for arts education, created by the state board of education as an outgrowth of a previous independent advisory group. This new advisory board was badly needed because of the number of demands made on the department's sole arts specialist. There had been little opportunity for contact with individual schools except on the most incidental basis, nor was there much communication between the specialist and other arts organizations in the state.

Washington's superintendent of public instruction is chosen for a four-year term in a nonpartisan election. He oversees the state's division of curriculum instruction, which has a staff of approximately 250. The division had only one full-time music specialist and a part-time art specialist—both of whom were on leave in 1976. However, there is a broad interest in arts education within the department because of a sympathetic superintendent and curriculum director and good working rapport with other arts organizations in the state, including the state arts commission.

To date the arts have not been included in Washington's statewide testing programs. It is hoped that they will be

What we have now as a result of getting a few people's attention is a regular program in the Seattle public schools, funded from various sources, but backed by the public schools even in the face of tax levy failures. We have an arts-in-education program where top people from arts organizations, from the schools, from service groups and the community of artists have agreed to discuss and implement long-range, simultaneous and immediate plans toward objectives. It's not a perfect mix, but it is a mix. And was made with the conscious understanding that the schools couldn't do it alone, the community organizations couldn't do it alone, the Seattle Arts Commission couldn't do it alone. . . . [JOHN BLAINE, Panel witness]

integrated into the legislatively mandated upcoming reorganization of the K–12 curriculum. The division is also developing a small schools curriculum for districts too small to develop their own curricula; it will include a specific effort to restructure the approach to arts education.

The single major statewide arts education program in Washington—the Cultural Enrichment Program (CEP)—functions somewhat independently of the superintendent of public instruction because of its own line-item appropriation in the state budget.

The Cultural Enrichment Program received millions of dollars in Title III funds between 1965 and 1970 and became a major source of funds for professional arts organizations in the Seattle and Kings County area. In anticipation of a withdrawal of federal funding in 1969, supporters of such organizations as the Seattle Symphony, the Seattle Opera Company, and the Seattle Repertory Company persuaded the Governor to propose legislation continuing the program and extending it to all schools in the state. By 1975–76, all but six of the state's 303 school districts had participated in some portion of the Cultural Enrichment Program.

Arts councils

In each of the three states studied, the arts council or commission was created in response to the establishment of the National Endowment for the Arts in 1965. In all these states, the governor appoints members of the council and directly or indirectly controls its budget requests. In North Carolina, the director and staff are appointed through the Department of Cultural Resources; in Michigan and Washington they are employed by the council.

The Artists-in-Schools program of the National Endowment for the Arts represents in each case the council's major contact with the schools. While there is communication and cooperation between council staffs and the public instruction departments in all three states, the relationship appears more distant in Michigan than in North Carolina and Washington,

where the councils regularly provide ideas and technical assistance to the departments of public instruction.

When in 1973 North Carolina became the first state in the nation to create a Department of Cultural Resources, the North Carolina Arts Council was made a component of its Division of the Arts (see the following table). The depart-

NORTH CAROLINA DEPARTMENT OF CULTURAL RESOURCES, 1976

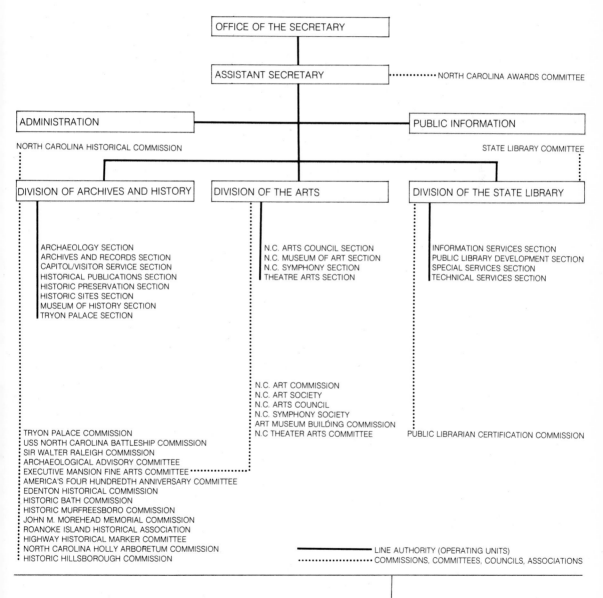

ment, headed by a cabinet-level secretary appointed by the governor, provides the governor with much greater control over the arts than over education. The North Carolina Arts Council, which has a staff of one half-time and seven full-time employees, is strictly a grant-making agency with no programming of its own. The Artists-in-Schools program is administered by the council's fiscal officer but operated by the department of public instruction which thus becomes more actively involved in the arts. The council makes most of its grants to local community arts councils, even for arts education programming. It often asks schools to match its grants with local funds. This strategy is designed to create a constituency for arts education programs and to introduce an arts appropriation into the school budget.

The Michigan council, with a budget of $2,286,150 for 1975–76, and a staff of twenty-two, is the largest of the three states studied. It functions more independently than those in North Carolina and Washington. This independence, however, may be detrimental to efforts to create a broader statewide constituency for the arts. The council recently reorganized its staff so as to develop working relationships with trade unions and other organizations and community groups.

The council has three staff members working full time on arts in education and sponsors a number of arts in education programs through grants and consultant services; these are administered independently from arts education programs of the department of public instruction and the legislature. The arts council acts to expand the federally supported Artists-in-Schools program through a state-sponsored program of short-term artist residencies for communities. The arts council also permits Artists-in-Schools grants to be made to community arts councils, a strategy designed to build a local constituency.

The Washington Arts Commission has a full-time staff of eight, with one assigned part-time to the Artists-in-Schools program. More than 10 percent of the commission's total budget of $1,258,608 for the 1975–76 fiscal year was devoted to Artists-in-Schools, which is the commission's basic education program. Although only 21 percent of the commission's budget is derived from the state, the independent Cultural Enrichment Program (described above) relieves the commission of many obligations faced by other arts councils. Moreover, the commission staff works closely with both the Cul-

American labor has upgraded its mission in the field of the arts to bring good performances and increased appreciation to its membership. A number of programs are underway in the AFL-CIO Labor Studies Center in Maryland; we have art and photography exhibits, as well as funds to provide live productions for the trainees who come there, so that when they go back to their respective states they are aware of what labor at the state and local level could do. Legislation at the federal level to increase the availability of the arts would be supported by us. [WALTER DAVIS, Panel member]

tural Enrichment Program staff and the Office of the Superintendent of Public Instruction.

Arts education conferences

In addition to conducting ongoing policy, each of the states studied has held an arts education conference for local school administrators; these have had a discernible impact on school policies and practices. In 1974, for instance, the Division of the Arts of North Carolina's Department of Cultural Resources held a conference in which virtually all the state's approximately 150 local district superintendents took part. The conference was a conversation of peers: educators discussed their local arts programs with other educators; and the conference resulted in greatly increased arts activities in many school districts.

Michigan's statewide conference in April 1975 was followed by eight regional miniconferences. The statewide meeting was funded by the legislature and organized by the Ad Hoc Advisory Committee on the Arts in Michigan Education, a group composed of representatives of professional and arts-oriented education organizations. Participants included administrators, arts educators, and community leaders, brought together to develop a state plan for arts education and methods for its implementation.

The Washington conference, held in 1973, was cosponsored by the University of Washington, the Division of Continuing Education, the Office of the Superintendent of Public Instruction, the Washington Arts Commission, and the Seattle Arts Commission. Administrators, educators, and community representatives were invited from potentially receptive school districts. The conference was intended to build enthusiasm for the arts in the schools as well as show the participants programs which they could use immediately in their own districts. The Artists-in-Schools program, with the aid of increased local school district matching funds, doubled in the year following the conference. In addition, two local districts

235

chose to pool their resources and initiate their own arts education programs; one region hired an arts coordinator for the first time. This and other conferences were effective because they provided participants with specific programs and ideas that could be applied in their local school districts.

Local governments

In all the states studied, counties, municipalities, and special-purpose governments such as school districts are creatures of the state, having only those powers expressly conferred upon them by state constitutional or statutory provisions. Yet real educational policy is made at the local school-district level. The state can mandate programs, hours, and ratios; it can also define goals, issue guidelines, and offer services. But it is the individual school district which selects books and materials, hires teachers, determines priorities, prepares curricula, and actually educates children. The Panel's staff examined the nature of the formal policymaking processes at local school districts in the three states studied.

In North Carolina there are 148 locally administered units or school districts. In 1975–76, the 2,013 schools in the state had 56,000 certified employees, including 2,400 arts specialists, to educate a total enrollment of 1,150,000 children at an annual per-pupil cost of $1,055.68, for a total state/local expenditure of approximately $1.25 billion. North Carolina is unique among the three states studied in that it is able to estimate how much is spent on arts education and where the monies come from (see the following table, "Who's Paying for What"). While a statewide salary scale for teachers is used to determine the state appropriation, individual districts often set local teacher salary supplements.

Of the 148 local school boards, 93 are elected; the remainder have a combination of elected and appointed members. The major source of public control over these boards lies in the election of members, since their specific actions and decisions usually are not voted upon by the public.

Arts education in North Carolina: Who's paying for what

Listed here are the principal expenditures for instruction in our schools, the money that provides teachers and materials for instruction in all subjects. Not included here are such things as bus transportation, food services, and the varied costs for maintaining and operating buildings and grounds.

The national AAE and several other councils and committees are concerned with the federal input into arts education, a concern which these figures heighten.

These figures come from the Department of Public Instruction and, where estimates were necessary, the figures are the best judgment of the Division of Cultural Arts.

INPUT FOR:	INSTRUCTION	ARTS INSTRUCTION	PERCENTAGE
FEDERAL			
ESEA TITLE I	$43,246,049	0	0
TITLE II	2,216,252	$110,826	5.0
TITLE III	2,850,516	142,526	5.0
TITLE IVb	2,495,845	0	0
ESAA	9,867,111	0	0
OCCUPATIONAL	10,452,150	73,165	0.7
NDEA III	786,782	9,996	1.2
NATIONAL ENDOWMENT	50,000	50,000	100.0
TOTAL	**$71,964,705**	**$386,513**	**(Av.) 0.5**
STATE			
TEACHERS	$432,450,091	$20,000,000	4.6
KINDERGARTEN	12,191,120	600,000	4.9
OCCUPATIONS	23,299,280	816,424	3.5
TEXTBOOKS	9,154,808	548,000	6.0
SUPPLIES	7,709,191	770,919	10.0
HANDICAPPED	3,387,478	0	0
SPECIAL INSTRUCTION	3,130,070	1,316,486	42.0
THEATER	124,500	124,500	100.0
TOTAL	**$491,446,538**	**$24,176,329**	**(Av.) 4.9**
LOCAL			
TEACHERS	51,823,495	6,000,000	11.6
KINDERGARTEN	276,536	27,536	10.0
OCCUPATIONS	8,918,277	142,692	1.6
SUPPLIES	8,133,249	813,324	10.0
TOTAL	**69,151,557**	**6,983,552**	**(Av.) 10**

New buildings and teaching spaces are financed primarily with local funds. It is estimated that more than 10 percent of the 1973–74 expenditures were for arts spaces.

$ 4,251	Federal
2,960,197	State
37,638,057	Local
$40,602,505	Total for new buildings

SOURCE: The Division of Cultural Arts, North Carolina Department of Public Instruction, 1975.

While local school boards have complete control over expenditures, they have virtually no control over taxation. The board of county commissioners determines all school taxes, including those for independent and partially independent county districts in North Carolina. The residents of some independent school districts may vote a tax supplement, but the board of commissioners is not required to levy the supplement voted. There is no statutory ceiling on the tax levy which the board of commissioners can impose, because an elected board is considered unlikely to raise taxes too high.

In Michigan, of the 587 school districts, 530 run complete K–12 systems and 57 operate only K–8 or less. (A few districts operate no schools themselves, and contract with neighboring districts for educational services.) The state's 4,800 schools have a total enrollment of approximately 2 million pupils and a total budget of about $3 billion; the state share of this sum is about $1.25 billion. The existence of a county allocation board to levy taxes for county and town purposes is a matter of local option under the state constitution.

All local school boards are elected in Michigan. They prepare the school budget, which is discussed at a public hearing held at least six days before the public votes on the tax levy. The final budget must be filed with the state by November 1 with an assurance that no deficit will be incurred. These budgets are not subject to state rejection, but districts may be asked to rework them. Since 1973, many districts have had difficulty in winning passage of the tax rate on time, because the recession has caused taxpayer resistance. As a result, the state has sometimes had to amend the school code, the election code, and the property tax limitation in order to keep the schools operating.

Although the public vote is on the tax levy and not on the school budget, it is possible to dedicate funds to a specific program. This can provide a method of strengthening specific programs, such as arts education, if the community is willing but the administration weak. However, it could also give a school board an opportunity to let voters specifically disapprove a controversial program.

In Washington, there are 303 school districts which employ 33,700 certified teachers, including 741 art and 1,145 music teachers, and enroll 780,730 pupils. Each school district

belongs to one of the twelve regional Educational Service Districts, from which it may purchase programs and services that are generally beyond a single district's capabilities. These intermediate organizations do not receive any direct state aid, but they do receive special grants and program funds. The state's share of school costs averages $538 per pupil or a total of $420 million in the 1975–76 school year. Total state/local expenditures are about $1.1 billion.

All school board members are elected in Washington. Any difference between state aid and actual school costs is financed by the local property tax. Though there is no limit on this levy, the depressed state of the economy in Washington recently has made it difficult for local boards to pass any increases.

In all three states, it is clear not only that fundamental control over the public schools resides in the local boards of education, but also that these boards are governed by policy-making processes which provide opportunities for citizen participation. The major question put to the residents of a school district pertains to the level of spending for education, but the school boards' decision-making processes also provide opportunities to shape the substance of education as well as the budgets. While school policy in the three states studied tends to be made by education professionals, concerned citizens, if they are willing to persevere, have opportunities to present their case to the school boards and the voters. Most localities have sought to remove school boards from municipal politics. However, in the highly decentralized American educational system, grass-roots influence still counts for much, a fact which reformers recognize.

Arts in communities

The arts, like the schools, have strong roots in individual communities. Many of the nation's great arts institutions were created through the efforts of dedicated and wealthy citizens seeking to improve their communities. Economic and

The National Committee for Cultural Resources strongly affirms that the preponderant source of support for the arts must continue to be local and that this support must increase as public subsidy grows. The Committee's study shows that more than 80 percent of the funds that now sustain the arts organizations studied comes from local sources—individuals, foundations, corporations, and city and county governments. This "mixed economy" of support for the arts is unique to the United States and underlies the phenomenal growth of the arts in recent years. [*National Report on the Arts*, The National Committee for Cultural Resources, October 1975]

demographic forces, however, have caused a major transformation in arts institutions and organizations. In recent years, increasing affluence and education have widened the circle of people interested in the arts. At the same time, mounting financial needs have forced arts institutions to seek a wider circle of supporters. Institutions that once may have been run by a half dozen generous families are slowly finding they must rely heavily on thousands of $10-a-year members. Individual donors are seldom able now to provide the massive sums needed by some of the great orchestras, museums, and ballet companies. Moreover, neighborhood arts institutions have been equally hard-pressed to find the funds needed to support their work.

As a result there has been a growing demand on the local level—as there has been on the federal level—for governmental agencies to become involved in supporting the arts. At the same time that local pressures were pushing arts institutions to widen their base in the communities, developments in Washington were pulling them in the same direction. After the National Endowment for the Arts was created in 1965, it set off a broad wave of amalgamation on the state and local levels, as various arts groups banded together to coordinate arts resources, and—incidentally—to qualify for federal funding.

As a result of these forces, in the last decade more than a thousand local arts councils have been created as part of city and county governments. According to research undertaken by the Associated Councils on the Arts, scores of additional nongovernmental arts councils have been created at the local level. There are vast differences in the range and vigor of these arts councils. Some function solely as fund-raising organizations for the arts. Like the United Fund, they sponsor a single joint campaign to raise funds which are then distributed to the arts organizations in their community. Others are coordinating and information agencies which attempt to maximize the effectiveness of local arts institutions. And some function as grant-making bodies, taking city and private funds and dispensing them to local arts institutions.[21] Whatever their particular function, these local arts organizations have helped coordinate the arts institutions in their communities and broaden interest in them. They have often transformed disparate local cultural undertakings from rival baronies to more coherent community programs.

Municipal arts organizations now provide direct governmental subsidies for various cultural programs in New York, San Francisco, Philadelphia, New Orleans, and Seattle. Other cities, including Chicago, Atlanta, Minneapolis, and St. Louis, have established complex taxing or bonding arrangements that help support the arts. In some cities, a portion of the local hotel tax is allocated to support the arts; in other cities a portion of the city's capital borrowing capacity may be reserved for arts institutions.[22]

Increasingly, city officials are recognizing that investments in the arts offer an attractive rate of return, for many cities count tourism among their important sources of income, and the strength of their local cultural institutions has much to do with their attraction to tourists.

Even more important, the idea of increased involvement of local governments in the arts has won the endorsement of many political leaders because they have recognized the breadth of support for the concept. A poll taken in 1974 for the U.S. Conference of Mayors revealed that 89 percent of the public thought arts facilities were important to their community's "quality of life." Moreover, a majority of respondents—even among low-income households—indicated they would accept additional taxes to support the arts.[23]

There are growing efforts to add support of the arts to the roster of services regularly provided by local governments. However, many urban governments find themselves increasingly hard-pressed to meet the demands already placed on them because of demographic and economic changes. While this country has experienced, as everyone knows, a massive wave of urbanization in recent decades, there has also been a simultaneous migration by the more affluent out of central cities into suburban areas. Thus, as Panelist Edward Hamilton has pointed out, those who can pay higher taxes live increasingly outside the cities, while those who live inside the city require large amounts of city services—and can pay few taxes. While city governments often find they lack funds for the arts, suburban governments often find their towns and villages are too small to create or maintain arts institutions on a major scale. In an effort to find the funds they need, many local cultural institutions have been turning to state and federal agencies to supplement local funds.

The control of arts institutions is undergoing an impor-

The cultural bubble of the 1960's has never really burst; contrary to rumor and recession, the arts are flourishing in America. . . . It is tragic that just at this time of supremacy the arts are seriously threatened by a shortage of funds and support. State Arts Councils, firmly established in the last decade, are forced to deal with drastic budget cuts. . . . More than half of the construction grants given by the National Endowment for the Arts are going for the adaptive use of existing buildings, from New York's Sailor's Snug Harbor to the Old City Hall of Lincoln, Nebraska. Movie theatres become concert halls, railroad stations are turned into community cultural centers, landmarks are given new creative life. In adversity, the arts are pulling a heritage together. If all this is happening in economic extremes, the arts are clearly one of this country's major strengths and sources of vitality. . . . [*New York Times*, editorial page, Sept. 27, 1976]

tant transformation. Their systems of governance are today responsive to a combination of wealth, political power, and other forces. Reflecting those changes, the programming offered by arts institutions is becoming more responsive to a broader range of groups in their community. Minority racial and ethnic groups find that arts institutions provide more programming aimed at their interests and needs. A number of museums have mounted special exhibitions of interest to blacks and Hispanics, for example. Moreover, newer ideas in the arts are finding themselves welcome at many older arts institutions. This is especially true in cities where the institutions are less encrusted with tradition. For example, Jerome Hausman told the Panel that "the Minneapolis community invites involvement in the arts because of its imaginative diversity of forms. There is something going on for everyone and, importantly, those events are readily accessible."

The changes in the configuration of arts institutions that are occurring in many American communities are bringing with them important changes of another sort: They are creating a broader, more vibrant constituency for the arts, one which has the potential for influencing other institutions, such as the schools. The next step must be to bring that constituency's strength to bear on education.

America's complex, multileveled policymaking processes remain responsive to demands and requests. It is still the squeaky wheel that gets the grease. As Kathryn Bloom told the Panel, "There is a very simple fact about the arts in education: literally, nobody is against them. No one can afford to be, unless he wants to be labeled as uncouth and unsophisticated." Arts education has gotten that far, but it must go further. Arts education must move from having no enemies to having more and more ardent friends in order to win a position in which it can realize the potential we believe it holds for the individual and for the nation.

The shifting balance of authority: A summing up

America has experienced a surge of interest in the arts in recent years, but as yet this growth is not reflected in any firm policies guiding the nation's school systems. There is no longer any doubt that the arts, in all their life-giving vitality, are part of our national resources. To let them go undeveloped and unused in education is not only irresponsible but, in the deepest sense, unpatriotic.

Fortunately, during the few years that the nation's schools have been investigating and experimenting with arts education, a good deal of practical wisdom has been accumulated. As a result, we have access now to a storehouse of facts and figures, as well as subjective evaluations, which are extremely helpful.

As they stand today, the public policies governing arts education in America are formulated in a complex process, involving federal, state, and local government bodies along with a number of nongovernmental institutions. The balance of authority shifts slightly from time to time as the occasion demands, but the forces remain substantially the same.

Since the early 1960s the federal government has played an increasingly important role in developing ideas and initiating new programs. As a rule, federal agencies have influenced art programs by providing finanacial incentives within broad and flexible guidelines. Predictably, the rapid growth of federal involvement has been accompanied by a dispersion of responsibility among a number of separate federal programs and agencies. Despite the creation of coordinating bodies, there are significant duplications of effort in some situations, and serious omissions in others. Not only is responsibility for arts education diffused at the federal level, it is also subordinated to other concerns within the massive Department of Health, Education, and Welfare. HEW must deal with a broad range of issues, and it must manage a budget constantly being consumed by uncontrollable social welfare expenditures. As a result, there are severe limits on the amount of time and money which HEW officials can allocate to arts education.

I do not have to tell you that the arts are considered as "extras," not only on a professional performance level, but also in education. It is most difficult to convince people of their importance, particularly when funds are difficult to obtain. Because of this, and other related reasons, a set of priorities must be established. . . . There has to be a stronger voice from our government in reference to the arts and the part they play in education. [Personal communication from HENRY L. PEARLBERG, Coordinator of Fine Arts, Neshaminy School District, Pennsylvania, to staff member, Nov. 26, 1975]

243

Notwithstanding the importance of federal government in the nation's schooling, formal responsibility for education still rests with the states, and the fifty state governments continue to exercise the most direct control over the public schools of America.

In a study of three states, which provides a spectrum of problems that confront our educators, the Panel found that the governors themselves often have limited control over state education systems, while the legislatures seldom initiate policies and confine their role to passing the education budget. Arts education policies are frequently made by state departments of public instruction. As a result, the degree of interest in arts education shown by those who direct these departments is a key determinant of the quality of arts education. The Panel found that, whatever the differences in the formal administrative structures, the interests and concerns of individual officials may have a strong impact on policymaking. That is, in arts education the human equation can be of major importance.

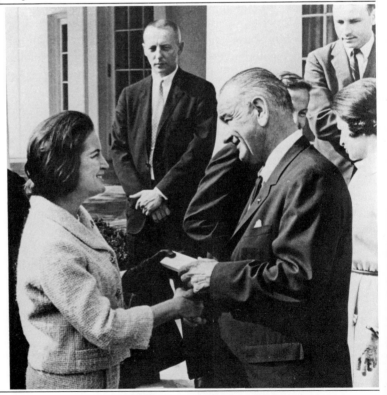

President Johnson shakes hands with Nancy Hanks at the White House and presents a souvenir pen, after signing 1965 legislation creating the National Endowment for the Arts. (Courtesy of the National Endowment for the Arts.)

Since the establishment of the National Endowment for the Arts in 1965, all the states have established arts councils or commissions, and these groups can play a crucial role in sponsoring specific programs as well as fostering enthusiasm for arts education at the state level.

While the states are ultimately responsible for education, day-to-day control rests with thousands of local school districts across the country. Most of them, separated from partisan political processes, have independent systems for electing members, as well as the authority to set their own budgets and levy taxes. In theory, school boards are responsible directly to the people rather than to the local government, and in fact many school boards do respond to the people, expediting their preferences and demands.

In numerous American cities, there have been growing demands for increased municipal support for the arts. This has entailed changes in the funding and control of many local art institutions and the creation of a sizable constituency able to influence and improve arts education.

As we have noted, the great diversity of our culture, and the tradition of local control over education are valuable parts of our national heritage. They virtually guarantee that there can be no single answer, no national model or program, that will apply to all schools in all districts. Arts education is not, strictly speaking, a subject at all. It is a process, a field of study that refuses to be fenced in.

In view of the diversity of approaches to arts education, the following section offers a variety of recommendations which can be taken singly or in combination to fit a broad spectrum of educational situations.

When we look at the arts, we are looking at much more than the arts, we are looking at what a concerned society should do in improving the basic human condition. I am increasingly convinced that education as it is constructed now is incapable of doing all that we want done. We're nibbling at a pillar of the structure, while in reality a much more massive attack on a general societal condition is called for. [JOHN B. DAVIS, Panel member]

Recomm

endations

Basics

This Panel reaffirms the conviction of our founding fathers as expressed by Benjamin Franklin, that "nothing can more effectively contribute to the cultivation of a country . . . than a proper education of youth."

In this Panel's view "proper education" consists equally of four things:

1. The acquisition of knowledge, skills, and the power to reason.

2. The development of critical faculties and moral judgment.

3. The cultivation of creative potential.

4. The promotion of self-knowledge and effective inter-action with others.

To deprive individuals of any one of these is to deny them their opportunity to lead a full and balanced life.

If he had been writing today, Franklin might have spoken not only of youth, but also of infants, adults, and the elderly. For learning is truly a lifelong process, not bounded by academic levels, and the arts have enormous power to stimulate learning at any age.

Nor, of course, does learning occur only where there is a school or a teacher. It occurs in the home and in the street, in museums and movie houses, in fields and factories.

The arts are a function of life itself, and the process of making art—both creative and recreative—can give insight to all other areas of learning. The arts help people understand themselves in historical, cultural, and aesthetic terms; they provide people with broader choices about their environment and influence the way they do their work and live their lives. Since artistic expression is also truly basic to the individual's intellectual development, it must be included as a component of all education.

The following three principles underlie the fifteen recommendations which follow:

1. The fundamental goals of American education can be realized only when the arts become central to the individual's learning experience, in or out of school and at every stage of life.

2. Educators at all levels must adopt the arts as a basic component of the curriculum deserving parity with all other elements.

3. School programs in the arts should draw heavily upon all available resources in the community: the artists, the materials, the media, and the total environment—both natural and man-made.

1. Making art

Making a work of art is a powerful act of learning which should be available to all people. Those who paint, write poetry, or play an instrument not only broaden their understanding of the arts, but also develop a variety of social and intellectual skills.

Currently a student's opportunities for active engagement in the arts are concentrated in the lowest grades, where drawing and singing, dancing and storytelling often do enrich the learning process.

The Panel recommends that:

☐ Schools make opportunities for creative work available to all students at every level, not just to the very young, the talented, or the aspiring professional.

☐ Colleges continue to promote scholarly study of the arts but enlarge programs in studio work and performance as well. All college students, not only arts majors, should have an opportunity for active participation in the arts.

2. Beyond "music and art"

Those who teach the arts should recognize the existence of many art forms and should be aware of change in the world of the arts. Arts courses must not be bound by rigid definitions of the medium, time of creation, or culture from which the art emerges. The traditional curriculum consisting only of courses in visual art and music is no longer sufficient. Other arts should be recognized as valid components of learning, and however the arts are redefined, arts education should adjust accordingly.

The Panel recommends that:

☐ The curriculum be expanded to include the disciplines of dance, film, drama, poetry, design, and so forth.

☐ Arts educators expand their definitions to incorporate newer developments such as electronic music, and to recognize art forms from other cultures. Just as jazz and folk music are now accepted as legitimate components of music, so must educators continue to be receptive to new forms in all the arts.

☐ Existing standardized materials be reevaluated constantly in order to meet the needs of particular student populations. Materials should be changed or amplified if they do not illuminate the students' life experiences or if they condition students to a narrow definition of acceptable forms of art.

☐ As artists expand the frontiers of art, they be encouraged to familiarize arts educators with the new terrain.

□ Artists and scientists recognize the special bond between them, arising from their mutual awareness of nature, by pursuing all possible opportunities for interweaving the teaching of their respective disciplines.

3. How children grow

In order to maximize the impact of early arts programs, we need to know more about how aesthetic growth takes place in children. In spite of the work of psychologists, teachers, and aestheticians who have explored the arts and child development, our knowledge about the potential contribution of the arts to human growth remains in its beginning stages. In each of the arts we can make intelligent guesses about the kinds of work which bring useful results and even the approximate stages of growth at which certain materials and processes can best be introduced. We have yet, however, to develop sequential arts education programs which reflect a sophisticated understanding of child development and aesthetic growth.

We also need to make research results available to teachers in such a way that they can make appropriate amendments to the curriculum.

The Panel recommends that:

□ Special workshops and in-service seminars be conducted by research teams and scholars to introduce teachers, arts specialists, artists, and curriculum developers to recent research results which deal with how children learn about the arts.

□ As our knowledge in this area increases, curricula reflect the new information; evaluation of curricula relative to the child's needs be continuous; and dissemination of models developed from these studies be made available on a national basis.

The importance of people

We believe that the key to good arts education will not be found in bureaucratic systems or organizational structures, nor in hardware, curriculum packages, textbooks, budgets—though all these are important factors. The crucial element is people: from administrators and organizers—those who work to build supporting frameworks—to the classroom teachers, arts specialists, and artists—who work directly with students. Nor can we overlook the great contributions and, often, significant expertise of school parents and volunteers working in arts and community organizations.

Neither can we forget the most important group of people: students. They are the clients

of the educational system, the future parents, teachers, leaders, audiences, and artists. The best-conceived programs will not work unless they fit the needs of students.

The nature and quality of leadership is also crucial in determining whether effective links will be forged—links between the arts and education, between and among the various arts and other disciplines, between the schools and other institutions, between public and private institutions. It is individual leaders, working in communities and schools, who have the power to start the process of change which can gradually stretch to the district, the region, the state, and ultimately to the nation.

4. Teachers

Because most of our teachers do not receive extensive training in the arts as part of their preparation, there must be a restructuring of teacher education. Declining enrollments and a diminishing demand for new teachers make it imperative that experienced teachers be given an opportunity for re-education and in-service experiences in the arts.

The Panel recommends that:
In the area of teacher preparation and in-service training

- ☐ All prospective classroom teachers have experience in a variety of arts and learn to relate them to each other and to other disciplines.

- ☐ All prospective teachers understand the importance of the media for education, both as teaching resources and art forms.

- ☐ The training of all teachers include an introduction to existing research on aesthetic growth, personality development, and the unique nature of creative individuals.

- ☐ All prospective teachers spend considerable time, outside the college classroom, where teachers or artists are working with young people. This work should begin early in the teacher's preparation.

- ☐ Arts specialists have mastery of their particular art forms and the competency to teach them.

- ☐ Prospective teachers in the arts be encouraged to complete comprehensive portfolios of work or records of performance for presentation to prospective employers, as an additional means of demonstrating competence.

- ☐ In-service arts education programs for teachers be offered either within the schools or in other appropriate locations, especially those where the arts are active. In-service training should also be available to administrators and arts specialists, and adequate incentives should be provided for all.

- ☐ Training programs acquaint prospective and experienced teachers with community arts resources and help prepare them to utilize these resources.

The Panel further recommends that:
Within the schools

- ☐ Arts teachers, arts specialists, and artists take part in all phases of program planning and basic curriculum development for each school system.

- ☐ Classroom teachers be supported by an arts resource team composed of artists and specialists in such fields as music, dance, drama, creative writing, visual arts, and the environmental arts.

- ☐ Teachers be given enough flexibility in school scheduling to enable them to offer their students much more than superficial exposure to the arts.

- ☐ Teaching positions in the arts be filled by well-qualified persons, even in the face of a decrease in the total number of teachers, and vacancies not simply be filled with unemployed teachers from other fields.

- ☐ Arts specialists have the option of being released from their teaching duties, without jeopardy to their jobs, either for sabbatical leave to work on their own arts projects or, if qualified, to serve as artists in schools.

The Panel further recommends that:
Concerning certification

- ☐ Teacher certification codes for arts specialists be developed through collaboration among arts faculty at all levels, candidates for certification, artists, and arts education organizations.

- ☐ Portfolios of art work or records of artistic performance be accepted as credit alternatives in support of an application for certification or recertification. Recertification requirements should include independent work experience outside the academic institution.

5. Artists

Artists should be far more widely employed in all aspects of education. Practicing artists can invigorate a student's interest and understanding of the arts and other disciplines as well as improve the student's technical skills. Existing programs such as Artists-in-Schools of the National Endowment for the Arts should be enlarged and encouraged.

The Panel recommends that:

- ☐ Schools, colleges, and community agencies regularly invite artists of different disciplines to become part of the resident or visiting faculty and to be accessible to interested students.

- Individual artists and performing groups be selected both for the quality of their art work and for their potential as teachers.

- Teacher certification standards be waived for all artists in residence and visiting artists participating in academic programs.

- In advance of artists' visits to schools, orientation sessions for teachers, artists, and administrators be provided so that the functions of each are clearly appreciated and defined.

- Artists be encouraged to join the teaching staff of schools, museums, community centers, and the public media. In every case, they should be fairly compensated for doing so.

6. Leaders

There is considerable evidence to suggest a serious leadership gap in arts education and a failure to deliver good programs even to the willing learner. As schools move beyond "music and art," and recognize the value of arts in the whole curriculum, a new kind of management will be required. The art teacher and the music teacher will still be important for their specialized knowledge. But in addition, a new breed of professional will be required in order to connect the arts with the general system of education. Although their backgrounds might vary, such professionals ought to understand the place of the arts in the school-community structure, to exercise a style of management which cultivates rather than commandeers the talents of others, and to respect both the practitioners and teachers of the arts. These qualities are sorely needed among leaders not only of schools and colleges, but of arts institutions, community agencies, and both state and local policymaking bodies.

In order to develop arts education leaders who can inspire, encourage, and educate—persons who are not only committed to the arts in education, but skilled in developing and mobilizing the talents of others—a national arts education leadership program should be undertaken.

The Panel recommends that:

- A national task force be created to assess current arts education leadership and to recommend ways to infuse the field with the necessary leadership skills, including management, political action, and human relations.

- A pilot training program be established in several states to develop both group workshops and individual study programs which would benefit people engaged in arts education leadership positions at the state, regional, district, and school building level.

- A long-range program be undertaken to develop regional leadership centers, where

both educational research and leadership training can be coordinated with teacher education programs.

☐ A special program be established for artists and art educators wanting to work outside of the school, enabling them to work with the management of cultural centers, community and neighborhood programs, museums, and other art institutions which supplement school programs.

☐ Programs be established for school administrators to acquaint them with the importance of the arts in education. Such programs should include extensive experiences with art forms and artists representing various disciplines. The program envisioned would serve to expand the awareness of school administrators and increase their commitment to arts education.

7. *Future artists*

Most children will not become professional artists. Consequently, this report has placed its emphasis on the majority of students whose involvement in the arts will be as audience or as amateurs and patrons.

We also have serious concern, however, for those students who have the talent to become professional artists, and since artistic talent often can be identified in young children, gifted children should be encouraged from the earliest possible time and provided continuous support throughout their education.

The Panel recommends that:

☐ During the early years, schools enable gifted children to work on a one-to-one basis with music teachers, and in small classes for other performing arts and visual arts.

☐ At the secondary level, specialized programs in the arts be developed both within the public system and at privately supported training centers.

☐ In communities where specialized arts training does not exist, programs be available at the regional, state, or multistate level to serve prospective artists. Vocational and personal counseling should also be provided, including advice on job availability.

☐ Conservatories and other professional schools and programs of high standards, which now assume the major responsibility for developing the majority of young artists, be strengthened with private and government dollars.

☐ Financial assistance be available from private foundations and state agencies to gifted young people who cannot afford to develop their talent.

☐ In order to destroy the sense of isolation so prevalent among exceptional young students of the arts, established and developing artists endeavor to include such students in their informal artistic and social activities.

Many rivers, many bridges

American culture is a quilted fabric with numerous national minorities interspersed. The artistic creations of our ethnic peoples are the most visible expressions of this variegated culture, and they can provide an invaluable resource for arts education.

Much artistic activity originates in cultural institutions which were created to serve more homogeneous audiences than those addressed by the larger, better-funded museums, symphony orchestras, and other arts organizations that lend so much stability to American art. Many so-called community programs are directed toward a single ethnic group or a few indigenous cultures, while others have no particular ethnic organization and tailor their programs to neighborhood or regional needs.

Unlike the major institutions, the community-based organizations are frequently young. Many of them are the products of artists-activists who have chosen to use their art to influence social conditions. Thus, the community-based arts organizations, as a rule, are well-rooted in the culture of the people they serve, but are less well connected to donors and foundations. Furthermore, funding policies of many granting agencies have changed. Their initial support for the community-based programs seemed an attempt to mollify urban dissidents rather than to support the ethnic arts movement, itself a central force in American culture. Many innovative programs which were begun in the 1960s have thus disappeared or are in severe financial trouble.

The Panel urges all levels of government to reaffirm the importance of good community arts programs and exhorts granting agencies to develop policies which will assure that funds will be available to maintain these community centers. We further urge that schools take advantage of such programs to improve their own arts education efforts, both by presenting to their students arts and artists with whom they may identify and by promoting an intramural display of the many arts which represent our national culture.

8. Local treasure

In order to ensure that the resources of community-based cultural organizations be maximally used by arts educators,

The Panel recommends that:

☐ An arts commission be established in each city or municipality where one does not presently exist. One function of such commissions should be to develop and support community arts projects that promote the arts and education.

- Local arts commissions work with parks and recreation departments to develop arts in education projects.

- School districts adopt policies which allow students to receive credit for work done in community arts programs of recognized educational value.

- Nonprofit community arts programs have available to them at minimal cost: public and private buildings such as churches, historic preservation sites, local government office space, museums and galleries, storefronts, and recreation centers, as well as other physical resources, including abandoned properties and industrial materials.

- Museums, symphony orchestras, dance companies, and resident repertory theatres become more aware of their responsibilities for arts education. These responsibilities rest not only in the formal programs offered by these institutions but in the planning of acquisitions, displays, performances, and master classes. By changing their self-image, museums can become libraries of experiential materials and can serve as a resource for arts education programs in schools, colleges, and social service organizations. A like service should be offered by performing arts institutions.

- Federal, state, and local funds be made available for transportation to nonschool arts programs offering arts education to children who live far from them.

- Funding for community arts programs be generally increased (see funding recommendations for suggested funding patterns).

- An annotated national directory of education programs within community arts resources be created for the use of those who plan new projects or desire to improve existing ones. The directory should identify exemplary programs and provide models for other community arts resources, describe cooperative ventures and financing alternatives (see Recommendation Categories No. 9 and No. 13—*Sharing the Wealth* and *Policy*).

9. *Sharing the wealth*

Arts education programs, whether originating in schools or elsewhere, can benefit from collaboration with other elements of the community, such as museums, theatre groups, art centers, community groups, and teacher education institutions. Schools especially can expand their use of community resources and improve the quality of school-centered programs by encouraging cooperative ventures which utilize the skills of teachers, artists, arts councils, parents, and other groups concerned with the planning of arts education projects.

To stimulate interaction among groups involved in arts education,

The Panel recommends that:

- In each locality responsibility for coordinating the use of local arts resources in arts education be assumed by the state arts council in cooperation with local arts councils.

☐ Regional clearinghouses be created to provide information about resource personnel and materials, model programs, cooperative ventures, and financing alternatives.

☐ The appropriate arts agency in each area compile a roster of available artists capable of working in schools and make it available to school administrators and arts specialists.

☐ Wherever possible, programs be expanded and given funding priority when they promote cooperation between the schools and those community arts organizations which reflect excellence in the art forms of minority people.

☐ Special care be taken to maintain and improve the already enormous service which parent and volunteer organizations render to arts education efforts in schools, museums, and human welfare agencies.

10. The ill, the isolated, and the handicapped

Since the arts are multilingual and multisensory, we urge their availability to all Americans, particularly those with special needs. It is our belief that the arts can be crucial to those who are deprived of many of the benefits of normal social life, such as people in prisons, mental hospitals, and nursing homes. In like manner, the millions of Americans who are blind, deaf, or otherwise handicapped should have special arts programs.

The Panel recommends that:

☐ Specially designed arts programs be established in all institutions which have responsibility for these various disadvantaged populations.

☐ Existing programs which attempt to bring the arts to the physically or mentally handicapped or to those who are segregated for antisocial behavior be evaluated and the results used to improve further programming in this area.

☐ Arts programs be established for disabled children in school and the necessary training be provided for their teachers.

☐ Artists in all disciplines be encouraged to participate in educational projects with special populations and be given fair compensation for such work.

11. New technology, mass media

Technology has created new and flexible media for artistic expression. Where they do not already do so, educators should recognize as art forms radio, video, film, and still photography, each of which has a technology and vocabulary that must be understood before its artistic and educational potential can be realized. At all levels of American education these media should become an integral part of arts programming both as resource and subject matter.

257

The Panel recommends that:

☐ Teacher training institutions recognize the tremendous impact new technologies have made on all Americans, especially the impact of television on the young, and accordingly provide courses which examine mass communication technology, its effects on the individual and society, and its implications for the arts.

☐ Greater use be made of videotape equipment as a teaching, learning, and research resource. This technology can be used to (*a*) record the arts activities of children at work in painting, sculpture, or the performing arts; (*b*) evaluate teaching methods for student teachers; (*c*) record working techniques and philosophies of master artists in all media; or (*d*) record student work and the critical discussions of it.

☐ The best teaching in the arts be captured on film and videotape and shown to elementary and secondary school personnel (including those in supervisory positions) to underscore its usefulness to students and teachers. An archive of such media presentations should be part of the proposed National Center for Education and the Arts (see Recommendations Category No. 13—*Policy*).

☐ In designing the curriculum, elementary and secondary teachers take advantage of their students' immense attraction to and interest in these new forms of expression. For example, television programs could be discussed and evaluated for artistic and value content and compared with other more traditional arts media; arts performances presented on television could be assigned for homework and used as a base for developing critical skills.

☐ Those leaders and agencies concerned with the future of the media give increased attention to the arts, promote a more positive image of the arts and artists, and develop programs which introduce the various arts to a mass audience.

☐ A national television arts program on the "Sesame Street" model be produced by a major network.

12. Higher degrees

America's institutions of higher education have become centers for education in the arts and focal points for community arts activities. The past several decades have seen the growth of new arts facilities and the expansion of arts curricula on campuses. As a basic part of their community function, universities and colleges should make these resources available to the greatest number of persons interested in cultural events or creative involvement.

The Panel recommends that:

☐ A careful self-assessment of both human and physical resources in the arts be made by each college or university, so that arrangements can be made for joint arts

programs, cross-registration, and sharing of arts faculties and facilities.

☐ Institutions of higher learning not only be concerned with the aesthetics of their own environment, but also provide courses on the function and form of design as it pertains to everyday living.

☐ Colleges and universities sponsor performances and exhibitions for the academic community and the surrounding region.

☐ Colleges and universities employ artists in residence from a broad range of arts disciplines to provide for all students direct experiences with artists, both in formal courses and informal workshops.

☐ Students be able to receive academic credit for approved arts courses taken off campus.

☐ In addition to courses in arts appreciation, colleges and universities encourage and give credit for student hours in studio work and performance.

☐ Whenever appropriate, the arts be incorporated into such fields as humanities, anthropology, and history, and interdisciplinary arts experiences be more broadly available to students.

☐ Professional training programs be maintained and strengthened at those institutions of higher learning which are continuing to produce high-quality graduates in their particular arts disciplines.

☐ Colleges and universities continue to serve as laboratories for experimentation with new forms of expression.

☐ In order to encourage secondary schools to give arts courses and students to take them, college admissions offices recognize achievement in the arts as satisfying entrance requirements.

Next steps

The formulation of policy for the arts in education should flow from and be consonant with the general goals of American education. If the arts are important in themselves, as well as a fundamental part of general education and an important way of learning for every student, then national, state, and local educational policy and practice should reflect this belief.

Funding should not be developed in isolation from policy considerations or apart from basic questions regarding the place of the arts in education, the kinds of arts experiences most

successful for students, and ways in which these can be provided by artists and teachers.

To provide a better basis for program policies and funding patterns, there must be better information about the arts in education. Research and development programs are needed to study both theoretical questions such as the nature of the aesthetic experience and more practical matters such as current patterns in curriculum design or methods of evaluation, and even to generate rudimentary statistics on spending and employment.

Art education is currently relegated to a subordinate status at all levels of American education from preschool through graduate school. Perhaps, if some of these basic questions were studied and answered, art would become essential to education, to the individual, and to American society. But we cannot afford to wait for these answers. We must proceed on the basis of the past history of humanity which indicates that art has always been central to civilization.

There is increasing recognition that aesthetic awareness is essential to the quality of American life and that individual creative expression is of value to Americans of all ages—in short, that the arts are an important part of our national life. There are new projects and programs—both in and out of our schools—which attest to this. Yet policies and programs concerning the arts have on the whole been formulated separately from those in education, leaving the arts at the periphery of organized learning.

13. Policy

Since the arts are part of a basic education and are a vital way of learning for every student, this status should be reflected explicitly in policy and practice at all educational levels. Arts-in-education programs are too often designed without the necessary consultation and cooperation between those working in the arts and those working in education. Policy planning should emerge from a common source and should follow a common channel of implementation within which the two streams of arts and education could flow as one.

The Panel recommends that:

☐ A Secretary for Education be added to the Cabinet. In any resulting departmental structure, the arts in education should have a prominent position, and a Special Advisor for the Arts in Education should be appointed to serve the Secretary.*

☐ Immediately, and until a separate Department of Education is established, a Special Advisor for the Arts in Education be appointed to serve the Secretary of Health, Education, and Welfare.

☐ The President appoint a Special White House Advisor for the Arts, who would include among his concerns the role of the arts in education.

*The following three Panelists do not agree with the concept of making the Office of Education into a separate department:
John B. Davis
Walter Davis
Edward K. Hamilton

☐ A new federal agency called the National Center for the Arts in Education be created as a coordinating mechanism for federal programs in the area where education and the arts intersect. The following services should be included in such a center:

(*a*) An information bank open to the public and containing a library of printed reports, microfilms, and relevant literature about artists and arts education programs including community-based programs.

(*b*) Conference areas for professional arts educators and associations.

(*c*) A library of information on federal, state, and private funding sources.

(*d*) Publication of periodic bulletins about recent developments in arts and education.

(*e*) A separate information program on research and development to be operated in connection with the proposed National Institute for the Study of Arts, Aesthetics, and Education (see Recommendation Category No. 15—*Research*).

☐ The President appoint a National Citizens Council for the Arts in Education which would act as an advisory body to the center and would include in its membership parents, artists, representatives from community groups, private and professional arts and education organizations, as well as teachers, school administrators, and school boards. Their responsibilities should include the consideration of policy and appropriate combinations of public and private funding.

☐ The Federal Council on the Arts and the Humanities oversee development and implementation of a ten-year national strategy for the arts in education (in two five-year plan segments, the second to be based on findings from the first). State arts agencies and state departments of education should be consulted in the national planning process, and each state should appoint a task force to devise a state plan consistent with the national strategy for integrating the arts into education.

☐ A "saturation" program be piloted in three cities of moderate size. These pilots should run for five years initially, and for a second five years upon review, and should engage the talents of the entire community in an intensive effort to make the arts a central concern of the schools. Parents, teachers, and artists should obviously be involved, but so should representatives of business, local government, arts institutions, community service agencies, and public school administration. Funding should begin by coming predominantly from the national level; at the end of ten years, it should be predominantly local. An evaluation of the three pilots should be made broadly available and should be an important resource for the second five-year strategy supervised by the Federal Council on the Arts and Humanities.

☐ Each state governor appoint a high-ranking assistant charged with formulating and coordinating state policy in arts education.

☐ State arts agencies be partners with state departments of education for the purpose of formulating statewide arts education policy.

☐ In order to encourage sharing of information and quicker identification of problems and strategies on a broad scale, national networks like those initiated by the Alliance for Arts Education, the Associated Councils of the Arts, the Ad Hoc Coalition of States, and the Artists-in-Schools program be strengthened and cultivated.

14. Funding

Lack of financial support is a critical problem that seriously restricts the effectiveness of education at all levels and in all subjects. As a low priority within education, the arts particularly suffer from insufficient budgets. But although new sources of funding should be vigorously developed on the federal, state, and local levels, any consideration of funding for the arts in education must include a better allocation of existing resources at all levels.

The Panel recommends that:

☐ New funds for arts education be concentrated on programs for curriculum development, placement and training of artists in educational situations, in-service education for school personnel, arts education leadership training, and research and evaluation.

☐ Guidelines governing federal funding of vocational and career education programs be amended to permit a broader range of artist-trainees to qualify for assistance.

☐ Funding agencies be willing to provide longer funding periods for pilot programs in arts education.

☐ Each state analyze its education budget and require that a percentage of its incremental allocations be spent on the arts in education.

☐ State and district supervisory personnel have budgetary discretion to use nonschool arts facilities and to hire noncertified personnel, that is, artists.

☐ Private foundations increase their support for arts in education. Private and corporate foundations should use their national service agencies to sponsor joint standing committees responsible for monitoring and buttressing the field of arts education.

☐ Public and private funding agencies usually require that arts institutions develop public education programs as a precondition to a grant.

☐ Local funding sources respond to local needs. Foundations and business donors should list community arts resources as a priority; and community arts programs should share more equitably in coordinated fund collections and existing dedicated taxes.

15. Research

The power of arts education is well demonstrated in hundreds of American communities, and some people even claim the arts will regenerate the school curriculum, but there is only scattered data of a systematic nature to support the strong conclusions intuitively reached. Much more research is needed, and among the areas requiring greater examination are basic research on the role of the arts in child development, the nature of creativity and aesthetic growth, the interplay between affective and cognitive learning, and the relationship of the arts to other areas of learning and to American social and cultural life generally. Applied research is needed to improve methods of teaching aesthetic sensitivity and perception, to test and evaluate existing curriculum models, and to determine the effect of media on learning. Finally, a statistical data base is urgently needed for such fundamental areas as the number and distribution of artists, arts teachers, and courses.

The Panel recommends that:

☐ A National Institute for the Study of Arts, Aesthetics, and Education be established.

☐ A national study be undertaken to provide basic data about curriculum content, facilities and equipment, the number of students, teachers, and artists engaged in the arts, and similar information. Such a study would be designed cooperatively with national arts education organizations and appropriate state and local arts and education agencies. A joint funding formula should be developed by the private and federal agencies which have concern for the quality of arts in education in the United States.

☐ Research results be delivered in forms usable to practitioners in the field, and that the National Center (see Recommendation Category No. 13—*Policy*) maintain a comprehensive record of information on current research and develop a mechanism for distribution of all results.

☐ Research be undertaken to improve early identification of the artistically gifted, and to develop appropriate program and advisory structures for them.

☐ In addition to its other functions, the Institute encourage universities to conduct specialized arts research through a program of fellowships and grants.

☐ Specialized research projects be sponsored by such organizations as the National Institutes of Health and Mental Health with the goal of improving arts education programs for special populations (see Recommendation Category No. 10—*The ill, the isolated, and the handicapped*).

"The arts live continuously, and they live literally by faith; their nature and their shapes and their uses survive unchanged in all that matters through times of interruption, diminishment, neglect; they outlive governments and creeds and societies, even the very civilizations that produced them. They cannot be destroyed altogether because they represent the substance of faith and the only reality. They are what we find again when the ruins are cleared away."

Katherine Anne Porter

Appendix

Plan of research

The project research plan was designed to elicit information from as wide and varied a set of sources as possible, given strict time, manpower, and budgetary limitations. Information upon which the report is based is drawn from the expertise of the Panel itself, testimony given before the Panel by witnesses, review of the existing literature in the field, site visits, and interviews with a variety of individuals.

AREAS OF RESEARCH	ELEMENTARY
	SECONDARY
	COLLEGE
	COMMUNITY

PRIMARY DATA COLLECTED	SITE VISITS
	PANEL DISCUSSIONS
	INTERVIEWS
	WITNESS TESTIMONY
	STATISTICS

SECONDARY DATA COLLECTED	BASIC LITERATURE
	STATE INFORMATION
	EXEMPLARY PROGRAMS
	STATISTICS

Research staff

We wish to express our appreciation to the Research Specialists, who found time—often at considerable personal inconvenience and sacrifice—from their regular full-time duties to work with this project:

Bette Acuff
Terry Baker
Charles Fowler
August L. Freundlich
John Melser
Richard Polsky

Research consultants, assistants, and interviewers

The Research Specialists and Project Staff received assistance at different times and for varying periods from the following persons:

Robin Alexander	Laura Lasker
Ellen Berk	Anne Lindsay
Eric Brown	Sandy Martenson
Betty Carlisle	Porsche Pierson
William Clohan	Anne Pollinger
Linda C. Coe	Nancy Retsin
Jeffrey Freundlich	Kathy Robens
Pearl Greenberg	Mary Rogers
Judith Hale	Joan Simmons
Mary Hallett	Barbara Sobel
Joan Jacobs	Dorothy Spencer
Annette Dexter Jones	Virginia Wells
Mary Killary	David Wolf
Carol Landolfi	Anne Zimmer

Research locations

WASHINGTON
MONTANA
OREGON
IDAHO
YELLOWSTONE
NATIONAL PARK
WYOMING
CALIFORNIA
NEVADA
UTAH
COLORADO
ARIZONA
NEW MEXICO
ALASKA
HAWAII

◉ PANEL MEETING SITES

◙ PANEL MEMBER'S COMMUNITY

◈ PANEL STAFF REGIONAL REPRESENTATIVE

▣ REPLIES FROM STATE BOARDS OF EDUCATION

◆ REPLIES FROM ALLIANCE FOR ARTS EDUCATION (AAE)

○ RANDOM SITE VISITS: ELEMENTARY SCHOOLS

● RANDOM SITE VISITS: SECONDARY SCHOOLS

▽ REPLIES FROM STATE ARTS COUNCILS SURVEYED

▲ PANEL WITNESSES

■ PANEL STAFF INTERVIEWS

▲ HIGHER EDUCATION SURVEY SITES

◗ EXEMPLARY ARTS EDUCATION PROGRAMS

BASE MAP © COPYRIGHT AMERICAN MAP
COMPANY, INC.

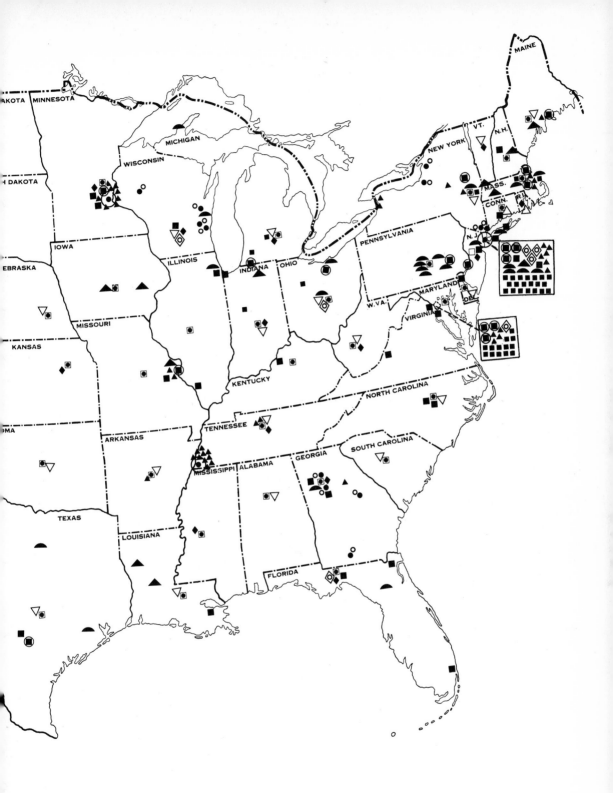

Notes on methodology

1 National organizations

A questionnaire using an open-ended format was administered both in person and by mail to seventy leaders representing some forty organizations in the arts, in education, and in arts education. In cooperation with the project, the Association for Supervision and Curriculum Development also sent out mail questionnaires on state, district, and building levels concerning the perceived increase or decrease during the last year in arts education resources.

2 State information

Every state department of education was contacted by letter, and forty-three states then responded to a structured telephone interview. Additional written information was received from four more states. Every state council for the arts, as well as a representative in each state of the Alliance for Arts Education, was contacted by letter. Twenty-six councils responded and nineteen Alliance for Arts Education representatives replied.

3 Specific site information

A. Elementary and secondary schools

Structured interview schedules were devised for the district superintendent, the district arts coordinator, elementary and secondary school principals, department chairmen, and elementary and secondary school teachers. The schedules made use of both closed and open-ended questions. These ques-

tions covered the areas of philosophy, purposes for art education, available resources, perceived strengths and weaknesses of a school program, the role of different individuals in a program, curricular approaches, and future expectations for a program. The schedules were piloted in two districts and revised accordingly. Sixteen elementary and sixteen secondary schools were visited, chosen according to the following sampling plan:

> The fifty states were divided into quartiles according to the variable of per pupil expenditure, and the median state within each quartile was selected. These median states were California, Georgia, New York, and Wisconsin.

> Four districts within each state were chosen by using two variables—per pupil expenditure and enrollment size. Districts in each of these four states were categorized as high enrollment (defined as 10,000 and up) or low enrollment (defined as 0 to 9,999). High-enrollment districts and low-enrollment districts were ranked according to per pupil expenditure, then divided into halves. The median school districts were then selected. These were:

	CALIFORNIA	GEORGIA	NEW YORK	WISCONSIN
High enrollment/high per pupil expenditure	PALO ALTO	ATLANTA COUNTY	NEW ROCHELLE	WEST ALLIS
High enrollment/low per pupil expenditure	LOS ANGELES	COBB COUNTY	NORTH SYRACUSE	APPLETON
Low enrollment/high per pupil expenditure	PITTSBURG	BROOKS COUNTY	TUCKAHOE	WAUWATOSA
Low enrollment/low per pupil expenditure	MADERA	GLASCOCK COUNTY	WATERTOWN	CHIPPEWA FALLS

An elementary school and a secondary school were chosen within each of these districts through a table of random numbers. The schools chosen in this fashion show geographic and economic distribution, as well as urban, suburban, and rural settings. The following schools were visited:

Palo Alto

Superintendent, Palo Alto Unified School District
 Enrollment: 13,000
District Coordinator, Palo Alto Unified School District
Principal, Henry Gunn High School
 Enrollment: 1,480
 Grades: 9–12
Principal, Garland Elementary School
 Enrollment: 258
 Grades: K–6
Department Chairman and Teacher (1) Art,
 Henry Gunn High School
Secondary Teacher (1) Music, Henry Gunn High School
Elementary Teacher (2), Garland Elementary School

Los Angeles

Superintendent, Area G, Los Angeles Unified School District
 Enrollment: 45,000
District Coordinator, Los Angeles Unified School District

Principal, John C. Fremont High School
Enrollment: 3,000
Grades: 10–12
Principal, Malabar Street School
Enrollment: 1,150
Grades: Pre-K–6
Department Chairman, John C. Fremont High School
Secondary Teacher (2), John C. Fremont High School
Elementary Teacher (2), Malabar Street School

Pittsburg

Superintendent, Pittsburg Unified School District
Enrollment: 6,003
Principal, Hill View Junior High School
Enrollment: 760
Grades: 6–8
Principal, Marina Elementary School
Enrollment: 405
Grades: K–5
Department Chairman, Hill View Junior High School
Secondary Teacher (2), Hill View Junior High School
Elementary Teacher (2), Marina Elementary School

Madera

Superintendent, Madera Unified School District
Enrollment: 7,825
District Coordinator, Madera Unified School District
Principal, Madera High School
Enrollment: 2,300
Grades: 9–12
Principal, Ripperdan Elementary School
Enrollment: 274
Grades: K–8
Department Chairman, Madera High School
Secondary Teacher (2), Madera High School
Elementary Teacher (2), Ripperdan Elementary School

Atlanta

Superintendent, Area III, Atlanta Public Schools
Enrollment: 17,524
District Coordinator, Area III, Atlanta Public Schools
Principal, Grady High School
Enrollment: 700–900
Grades: 9–12
Principal, Ben Hill Elementary School
Enrollment: 700
Grades: K–7
Secondary Teacher (2), Art, Music, Grady High School
Elementary Teacher (2), Ben Hill Elementary School

Cobb County

Superintendent, Cobb Country District
Enrollment: 50,422
District Coordinator, Cobb County District
Principal, Daniell Middle School
Enrollment: 1,545
Grades: 6–8

Principal, Powers Ferry Elementary School
Enrollment: 483
Grades: K–5
Department Chairman, Daniell Middle School
Secondary Teacher (1), Daniell Middle School
Elementary Teacher (2), Powers Ferry Elementary School

Brooks County

Superintendent, Brooks County Board of Education Office
Enrollment: 3,089
Department Chairman, Brooks County High School
Enrollment: 579
Grades: 10–12
Secondary Teacher (2), Brooks County High School
Elementary Teacher (2), Quitman Elementary School
Enrollment: 655
Grades: 4–7

Glascock County

Superintendent, Glascock City
Enrollment: 642
Principal, Glascock County Consolidated School
Enrollment: 642
Grades: K–12
Secondary Teacher (1), Glascock County Consolidated School
Elementary Teacher (1), Glascock County Consolidated School

New Rochelle

Superintendent, School District of New Rochelle
Enrollment: 12,000
Principal, New Rochelle High School
Enrollment: 2,950
Grades: 10–12
Principal, George Davis Elementary School
Enrollment: 740
Grades: K–6
Secondary Teacher (1), Music, New Rochelle High School
Elementary Teacher (2), George Davis Elementary School

North Syracuse

Superintendent, Syracuse City School District
Enrollment: 26,000
Principal, William Nottingham High School
Enrollment: 850
Grades: 10–12
Principal, Ed Smith Elementary School
Enrollment: 640
Grades: K–6
Secondary Teacher (2), William Nottingham High School
Elementary Teacher (2), Ed Smith Elementary School

Tuckahoe

Superintendent, Tuckahoe Union Free School District
Enrollment: 1,100
Principal, Tuckahoe High School
Enrollment: 600

Grades: 7–12
Principal, William E. Cottle Elementary School
 Enrollment: 500
 Grades: K–6 (plus 2 Special Education)
Secondary Teacher (2), Tuckahoe Junior, Senior High School
Elementary Teacher (2), William E. Cottle Elementary School

Watertown

Superintendent, Watertown City Public Schools
 Enrollment: 5,900
District Specialist, Watertown City School District (2)
Principal, North Junior High School
 Enrollment: 550
 Grades: 7–9
Principal, Ohio Elementary School
 Enrollment: 455
 Grades: K–3
Secondary Teacher (1), Watertown High School
 Enrollment: 1,400
 Grades: 10–12
Secondary Teacher (1), Case Junior High School
Elementary Teacher (1), Wiley School
 Enrollment: 1,400
 Grades: 4–6

West Allis

Superintendent, West Allis School District
 Enrollment: 16,800
District Coordinator, West Allis School District
 Visual Arts: K–12
Principal, Lane Junior High School
 Enrollment: 715
 Grades: 7–9
Principal, Parkway Elementary School
 Enrollment: 286
 Grades: K–6
Secondary Teacher (2), Art, Music, Lane Junior High School
Elementary Teacher (2), Parkway Elementary School

Appleton

Superintendent, Appleton School District
 Enrollment: 9,000
District Coordinator, Appleton School District
Principal, West High School
 Enrollment: 1,934
 Grades: 10–12
Principal, Lincoln Elementary School
 Enrollment: 339
 Grades: K–6
Department Chairman, West High School
Secondary Teacher (2), West High School
Elementary Teacher (2), Lincoln Elementary School

Wauwatosa

Superintendent (would not be interviewed)
Principal, Longfellow Junior High School
 Enrollment: 820
 Grades: 7–9
Department Chairman, West High School
 Enrollment: 1,200
 Grades: 10–12
Secondary Teacher (2), Longfellow Junior High School
Elementary Teacher (2), Wilson Elementary School
 Enrollment: 370
 Grades K–6

Chippewa Falls

Superintendent, Chippewa Falls
 Enrollment: 4,806
Principal, Chippewa Falls High School
 Enrollment: 1,600
 Grades: 9–12
Principal, Ninth Ward Elementary School
 Enrollment: 279
 Grades: K–6
Secondary Teacher (2), Chippewa Falls High School
Elementary Teacher (2), Ninth Ward Elementary School

B. Exemplary programs

In addition to schools selected in this manner, site visits were made to schools recommended as having exemplary programs in arts education. Programs were chosen for visitation in the following manner:

> State departments of education, state arts councils, acknowledged experts, and national organizations were asked to recommend programs they felt were "exemplary." Names of such programs were also drawn from the existing literature in the field.

> Approximately three hundred and fifty recommended programs were contacted by letter and asked to provide more extensive information.

> Programs from those responding to this letter were then selected for visitation or an extensive telephone interview in order to demonstrate

275

state, district, and building initiative and to illustrate different curricular approaches. The information on these sixteen programs was ultimately compiled from written reports, observations, and interviews with people involved in these programs, either in person or by telephone. These programs were:

Bayside High School, New York
Brookline Unified Arts Program, Massachusetts
Columbus Arts IMPACT Program, Ohio
Cooper County Intermediate School District Child Development Through the Arts Program, Michigan
Houston High School for the Performing and Visual Arts, Texas
Irvington Cultural Arts and Reading Through the Arts Program, New Jersey
Jeffco Arts in Education Program, Colorado
John F. Kennedy High School Reading Through the Arts Program, New York
Multiple Talents and Teaching Through the Arts, Florida
Newton Public School Visual Arts Program, Massachusetts
Oakland Arts Magnet School, California
Oakland Renaissance School, California
Project SEARCH, New York
School of Performing Arts, New York
The State of Pennsylvania's Comprehensive Program in the Arts:
 Aesthetic Education Program
 Arts in Education Project
 Governor Mifflin School District
 Riverside Center for the Arts
 Ways and Meanings Place
The Touchstone Center for Children, New York

C. Post-secondary institutions

Responses to a telephone questionnaire were solicited from appropriate authorities at fifteen colleges. The authorities who answered the questionnaire included arts department chairmen, individual faculty (where no arts department existed), and deans or division heads. The fifteen post-secondary educational institutions were chosen in the following manner:

> Four categories of college types were established: community college (public two-year), state university (public four-year), small private college (four-year), and private university (four-year). Two schools within each category were chosen through a table of random numbers.

> Certain institutions were selected because of an especially favorable reputation for a strong arts program. One such institution was selected for each of the four categories.

> After preliminary investigations were completed, it became apparent that three of the selected campuses were in circumstances which made comparison to other selected schools difficult. Therefore, three additional colleges were selected where conditions were similar to their counterparts among the original twelve, so that certain conclusions could be drawn.

The following colleges and universities were selected:

Community Colleges (public two-year)

Dixie College, Saint George, Utah
Louisiana State University at Alexandria, Alexandria, Louisiana
Mount Saint Antonio Community College, Walnut, California
Southeastern Community College, North Campus, West Burlington, Iowa

State Universities (public four-year)

Northwestern State University, Natchitoches, Louisiana
University of Iowa, Iowa City, Iowa
University of New Hampshire, Durham, New Hampshire

Small Private Colleges (four-year)

Amherst College, Amherst, Massachusetts
Goshen College, Goshen, Indiana
Thomas College, Waterville, Maine
Unity College, Waterville, Maine
Williams College, Williamstown, Massachusetts

Private University (four-year)

Brigham Young University, Provo, Utah
New York University, New York, New York
Saint Louis University, Saint Louis, Missouri

D. Community-based programs

The following four programs in the previously selected states were chosen according to a table of random numbers. These were:

Atlanta High Museum, Atlanta, Georgia
Henry Street Settlement Arts for Living Center, New York, New York
John Michael Kohler Arts Center, Sheboygan, Wisconsin
Mendocino Arts Center, Mendocino, California

Three more programs were interviewed after recommendations were solicited from experts and drawn from existing literature. Programs were selected to illustrate a variety of settings and approaches. All programs were contacted for a telephone interview. These programs were:

The Sojourner Truth Players, Incorporated, Fort Worth, Texas
The Supplementary Educational Center and Space Theatre, Cleveland, Ohio
Urban Gateways, Chicago, Illinois

Summary of questionnaire responses: sixteen school districts

Professed philosophy with regard to the arts

An overwhelming majority of respondents agree that the arts should be one of the most important areas of the curriculum for everyone. Yet they acknowledge that others in the field would endorse arts education *only for individuals who display special talents* or as an *optional* experience for everyone.

Disagreements such as this, along with many differences of attitude and shades of opinion have turned up in the hundreds of questionnaire responses summarized in this appendix. Constituting as it does the most technical part of this report, it may be of limited interest to some general readers. But it provides essential information to educators and researchers who will want to know exactly how we reached our findings, and to administrators, school boards, and curriculum planners who must know where we went, what kinds of schools and communities we visited, and the reactions we received. In addition to serving as a source of precise information, the appendix dramatizes the complexity of the subject, exposing its many facets and the many considerations that educators must take into account.

Proceeding now to specific cases, in West Allis, Wisconsin, which has a strong arts program, most of our respondents there feel that others in the district *agree* that the arts should be one of the most important areas of the curriculum for everyone. They also report that the superintendent and one secondary school principal feel confident that the town school board concurs and supports them. This is borne out by the number of arts teachers employed (almost two music teachers for every school, an elementary visual arts teacher for each elementary school, two to three visual arts teachers for every secondary school) and by the fact that it is the only one of the sixteen districts that has had a continuous artist-in-residence program for the last five years. In addition, the superintendent indicated an 80 percent enrollment by secondary students in arts classes.

In Madera, California, the two elementary school teachers believed that the local school board endorsed the view that the arts should receive minimal attention in education. It should be noted that Madera is one of the poorest and most rural of the districts visited, with the majority of students coming from lower-middle-class and poor Spanish-speaking environments.

Professed attitudes toward various goals for arts education

Respondents were asked what priorities they put on the following five goals of arts education. They answered:

To develop
1. More discriminating consumers of art
2. Better art producers or performers
3. Better learners
4. More integrated human beings or better persons
5. Better community or society

Priority of goals

Elementary school level

To develop
1. Better learners
2. Better persons
3. More discriminating consumers
4. Better communities
5. Better producers

Administrators and teachers seem to view individual learning skills and self-development through the arts as proper goals of arts education at this level; goals involving the community or the existence and extent of the arts in society are seen as less important. This choice of goals seems to enforce the concept that the arts are for everyone rather than that they should be optional or only for the talented.

Secondary school level (by type of district)

HIGH ENROLLMENT/HIGH EXPENDITURE AND HIGH ENROLLMENT/LOW EXPENDITURE	To develop	1. Better producers 2. Better persons 3. Better communities 4. More discriminating consumers 5. Better learners
LOW ENROLLMENT/HIGH EXPENDITURE	To develop	1. Better producers 2. More discriminating consumers 3. Better persons 4. Better communities 5. Better learners
LOW ENROLLMENT/LOW EXPENDITURE	To develop	1. Better communities 2. More discriminating consumers 3. Better persons 4. Better producers 5. Better learners

In three types of districts it seems that secondary school personnel place more importance on the arts for the talented (the producer) than for everyone, while the fourth type (low enrollment/low expenditure) places their emphasis on achieving a better community. Since the better learner is the least-mentioned goal, all appear no longer to consider the arts as a tool to improve learning skills.

Goals thought more appropriate to post-secondary education

HIGH ENROLLMENT/HIGH EXPENDITURE AND HIGH ENROLLMENT/LOW EXPENDITURE	To develop	1. Better producers 2. Better communities 3. More discriminating consumers 4. Better persons 5. Better learners
LOW ENROLLMENT/HIGH EXPENDITURE AND LOW ENROLLMENT/LOW EXPENDITURE	To develop	1. Better communities 2. More discriminating consumers 3. Better persons 4. Better producers 5. Better learners

The stress on the production of art, and its place in society, may result (1) from the idea that higher education should become more specialized and (2) from an acceptance of the increased role of universities and colleges as cultural centers of their communities. It would seem that those in public schools in the more sparsely populated areas of the country feel the arts contribute most to the general enrichment of life. The arts for everyone, as well as the training of performers, would appear desirable.

While many interviewees endorsed the goals completely, several felt they could endorse them in principle but found them difficult to implement in practice. Many were unable to enunciate this idea further except in vague statements stressing that implementation always presents more problems than theory.

In addition to this type of comment a number of interesting reservations were expressed. One secondary teacher feared the possibility, in developing a more discriminating consumer, "of developing student elitist groups in the arts" while another believed it to be unrealistic because, "I don't think people carry it throughout life, or beyond school." Another remarked that to carry out this goal "we need more supportive services; we need a change in philosophy and the support of the board and the administrators to achieve this." One teacher found the goal of developing community vague. One principal worried about the practicality of using the arts to develop a more integrated human being (or a better person) because leading a pupil to realize "that emotional release might be gained through the art media would be difficult to attain."

Several issues were raised concerning the goal of developing a better producer or performer. One secondary teacher in Appleton, Wisconsin, thought it important for *all* students to have arts experiences and to learn processes, in order to gain a better understanding of the artist. One principal concurred, noting that teacher training has overemphasized a concern with performance and that a lifelong appreciation and enjoyment of the arts should be the main concern of education. He further thought that stress on techniques causes the arts to become too isolated from other areas. A secondary school teacher from Brooks County, Georgia, remarked that

"often performance in the arts is regarded as an effeminate pursuit." An elementary school teacher said, "I don't feel all students need this, and it is difficult to find a time when I can work with only those students who need and desire this help." The district arts coordinator from Watertown, New York, endorsed the development of the better producer as "okay" but felt that the primary thrust of arts education should be toward experience and exploration, and that focusing on developing skills would be more constructive than experiences with practicing artists. A superintendent suggested that the development of technical and performing skills might place an unjustified emphasis on a professional career for students.

The most common obstacles cited, however, to achieving these goals were insufficient resources—staff, materials, time. One arts coordinator lamented that she gets more requests for help than she can handle. "I won't ever catch up." Other comments point to this same problem: "insufficient funds, inadequate materials, insensitive administrators"; "not enough time in the school day"; "lack of supplies and resource people"; "lack of specialists"; "lack of support from the community"; "there is not enough time allotted for specific areas and the pupil-teacher ratio is not ideal."

Staff qualifications and performance evaluation

Hiring and rehiring practices
In most of the sixteen districts, superintendents do not play an active role in hiring or in the evaluation of teachers. These responsibilities are shared by district coordinators in the arts (where they exist), and by the principals. Exceptions are in Brooks County, Georgia; Glascock, Georgia; and Chippewa Falls, Wisconsin, where the superintendent shares with the principals the responsibility of hiring and rehiring teachers. In Los Angeles, California; Appleton, Wisconsin; and Cobb County, Georgia, departmental chairmen also play a role in the hiring and rehiring of teachers.

In all districts, at least a bachelor of arts degree is required for hiring, with personal interviews and letters of recommendation accepted as proof of competence. Some districts require the master of arts for teaching at the secondary level (Tuckahoe, New York; Cobb County, Georgia; and North Syracuse, New York), while others deem graduate work desirable (Los Angeles). Watertown, New York, requires that thirty hours of study toward a master of arts be completed within five years of hiring. *Only two districts (Cobb County, Georgia, and New Rochelle, New York) stress direct evidence of performance competence* (such as a visual arts portfolio or a music performance attended by those hiring the teacher) *or teaching competence* (actual classroom observation). Apparently, all other districts assume that a teaching certificate alone is sufficient indication of competence.

When evaluating both elementary and secondary teachers for rehiring, administrative personnel are in substantial agreement: they judge teachers to be effective if they exhibit good rapport with students and good classroom control. Most evaluators also look at the quality of student work produced (even for elementary students) as an indicator of teacher competence. A goodly number of respondents regard teacher attention to the personal growth of the student as a prime characteristic of an effective teacher.

Elementary teachers

Half of the elementary teachers interviewed have master's degrees; over half of these have taken a number of courses in the arts. Two of the most experienced Palo Alto, California, teachers have over fifty undergraduate credits distributed among all the arts areas, and even the least experienced teacher (West Allis, Wisconsin) has a number of courses in all the art forms except theatre. One teacher in Pittsburg, California, has 114 credits in the various art forms (with the exception of theatre). One Brooks County, Georgia, teacher has seventy undergraduate credits in creative writing and sixty graduate credits in music, theatre, and the visual arts. A teacher in Wauwatosa, Wisconsin, has forty-two undergraduate credits across the various arts. Those teachers who have the fewest credits in the arts have at least taken several undergraduate survey courses.

Secondary teachers

Slightly fewer than half of the twenty-nine secondary teachers interviewed have master's degrees. All the teachers have taken graduate credits above their bachelor of arts degrees, ranging from eight to thirty units. In all the districts, except those in the low enrollment/high expenditure category, the visual arts and music teachers practice their art outside the classroom; only one music teacher in Pittsburg, California, pursues his art outside of school hours.

Only four teachers belong to their respective national arts education organizations; less than half of the secondary teachers interviewed belong to local, state, or national arts or arts education organizations. Several visual arts teachers say that they " . . . don't like organizations: they don't do anything for us."

Program and staff development

The number of arts administrative staff and their effect on program development appears to be correlated with enrollment. For example, both the high enrollment/high expenditure, high enrollment/low expenditure districts each have a coordinator for the visual arts and music. The information for low enrollment/high expenditure schools is so incomplete that it is difficult to make comparisons (in order to arrive at conclusions). Only two low enrollment/low expenditure districts have coordinators. (From the interview data it appears that these coordinators do not take an active part in program or staff development.)

The role of coordinator for the high enrollment/high expenditure and high enrollment/low expenditure districts appears to be somewhat consistent: Each coordinator regards program or curriculum development as a primary responsibility; and that it is also important to present periodic workshops so that teachers can learn new strategies or be introduced to new media processes, and to observe and help teachers as their individual needs arise. (In Los Angeles, California, however, where there is only one coordinator for 572 schools, the coordinator has elected to assist teachers by preparing new curriculum materials and distributing them to teachers each year. Since many new curricular approaches cannot be properly implemented without

adequate training for teachers, it is doubtful that these curricula are adopted after they have been distributed.)

Palo Alto, California, appears to be the only district which has a rather systematic in-service education program with media workshops for elementary teachers, an open workshop at a central location for teachers and parents, and a districtwide steering committee in the arts (composed of teachers and the district arts coordinator) which meets periodically. This committee has just revised the elementary arts curriculum and is in the process of revising the secondary curriculum. Pittsburg, California, also has a districtwide curriculum development committee. The arts coordinators concentrate their efforts primarily at the elementary level; it is assumed that department chairmen and their teachers are qualified to develop curricula at the secondary level.

Principals in all sixteen districts say they meet with their staff to plan new programs and while they make suggestions to the faculty, their primary functions appear to be program endorsement and fund allocation for implementing faculty-initiated ideas. In the picture which emerges (except in the case of Palo Alto, California, and West Allis, Wisconsin), it appears that the individual teacher is mainly responsible for initiating new programs and for maintaining existing programs. In all cases, after a proposed idea receives principal approval, it may be necessary for the principal to go to the school board for final approval of funds or other necessary resources.

Apparent scope, content of program, and teaching approaches in the arts

None of the sixteen districts has a clearly articulated curriculum which sequences concepts and skills to be mastered for grades K–12 in the visual arts or music. One district (Pittsburg, California) has a number of curriculum guides in the arts (for example, creative writing for grades 6–12, music for grades K–5, theatre for grades 9–12, visual arts for grades K–12, and media for grades 9–12). These were developed by the district wide committee, and according to the superintendent, every school in the district is supposed to use these guides as a means of "providing some uniformity in achieving objectives." The district also has an unusual guide developed by the superintendent, which proposes related activities in environmental education and poetry, with references to aesthetic qualities of the environment.

A perusal of the districts' objectives and some of the curriculum guides in the arts show that the approach is not based on a comprehensive view of all or any one of the arts but is instead rather piecemeal. In district after district, administrative personnel stated that guides existed but that their use was "optional." Teachers interviewed usually were vaguely aware of the existence of guides but did not use them.

For example, in Palo Alto, California, there are a number of visual arts mini-curricula (for example, one stressing the relationship of art and social studies; a multicultural curriculum focusing on Jewish artists, arts of Nigeria, and Chinese-American artists; and a "Meet the Masters" curriculum aimed at developing skills of art criticism). Few teachers mentioned using these guides, although the elementary teachers know about the "Meet

the Masters" program. In Los Angeles, California, where the arts coordinator issues at least two new curriculum guides a year, no teacher interviewed was familiar with the guides, let alone used them.

It seems that a comprehensive approach to curriculum development includes not only the development of stimulating guides which present a variety of activities but also a teacher-education program which lends support to teachers as they learn new approaches.

Few districts have an articulated curriculum for promoting learning about the interrelationships between the arts, or between the arts and other disciplines. Even where such guides exist, the teachers interviewed indicate somewhat naïve notions of curricular integration. The majority of elementary teachers endorse the notion of integrating the arts with other subjects, and many believe they do this. However, the examples of such teaching approaches indicate rather simplistic notions. For example, one elementary teacher believes she integrates music and mathematics by having the children sing the multiplication tables. Another believes she integrates art and mathematics by having the children make window displays and by using graphing activities in mathematics. In fact, nearly half of the elementary teachers questioned gave as an example of interdisciplinary teaching the use of "art in drawing geometric shapes." Other examples given by elementary teachers were "acting out stories that abstract pictures," "movement to music," "using the visual arts in puppet shows," "writing about one's own drawings," "drawing to music." Besides rather vague statements referring to the bicentennial, none of the teachers mentioned attempts to organize interdisciplinary or related arts experiences around a central theme or idea (for example, growth, balance, force, structure, and function). Still a number of elementary and secondary teachers do use the dramatic arts as a means of unifying several art forms or, as one elementary teacher says, " . . . to invent dramatizations as extensions of other learning experiences."

The responses of elementary teachers as a whole indicate a rather low level of sophistication with respect to the formal nature of the arts. In Palo Alto, California, however, the two teachers who have the greatest number of credits in arts areas state they teach line, texture, and three-dimensional concepts in the visual arts and that they stress melody and note reading in music. Several high school teachers mentioned teaching units on line, texture, balance, and other formal concepts in the visual arts. There is no information regarding teaching of formal concepts in music, although this may exist. It is notable that of the twenty-nine high school arts teachers interviewed, only three mentioned focusing on formal qualities of art works as part of their teaching.

Sources of support

When asked about support of the arts by various groups, respondents agreed that the legislatures in their states were generally unsupportive. Lack of funding was the reason most often cited. One respondent stated that she believed " . . . the legislatures are uneducated in the arts themselves. How could they understand what the arts do for people?"

Respondents in six districts judged their respective state departments of

education as "somewhat supportive" of the arts, but no concrete examples were advanced. The majority of respondents in eight of the districts credit their school boards with being somewhat supportive, while in one district (Tuckahoe, New York), most respondents describe the board as "very supportive." Palo Alto, California, and New Rochelle, New York, spoke well of their school board support by citing the following reasons: " . . . board provides needed funds for supplies" and " . . . listens to course proposals from coordinators, principals, and staff." Cobb County, Georgia, and Appleton, Wisconsin, respondents, save for one complaint, likewise commended their school boards by citing " . . . remodeling of several schools, added music and arts rooms," " . . . we have always been given what we ask for," " . . . principals asked for reduction in time for art and general music—the board asked us (principals) to go back and reconsider—no changes were made," " . . . they don't stop our ideas," "approve equipment, activities," "financial support," "attendance at arts functions," " . . . they are trying to be very progressive and are open to suggestions."

Apparently, where school boards are rated as supportive, the board members are open to ideas for program innovations and are willing to provide the funds, equipment, facilities and other necessary resources. In addition, members lend personal support to school staff by appearing at arts functions.

Where respondents perceived the school board as nonsupportive, the reasons most frequently cited were lack of funding and a "back to basics" thrust, with an alignment of curricular priorities to exclude the arts.

Number of personnel

Of these sixteen districts, six have no visual arts or music coordinators at the district level. All others have a district visual arts and music coordinator; in most districts the coordinator's responsibilities focus on the elementary level. (An exception to this is Wauwatosa, Wisconsin, where the visual arts coordinator serves grades 7–12.) The only district which has a dance coordinator is Appleton, Wisconsin. (The dance coordinator is part of the high school physical education staff and serves two schools.) Appleton, Cobb County, Georgia, and Syracuse, New York, have district-level creative writing coordinators.

Information regarding arts teachers was not always available. For those districts which furnished information, however, the comparative ratio of arts teachers to schools can be seen.

Staffing patterns of music and visual arts programs

By and large, these staffing patterns support the notion that arts specialists are more frequently used on the secondary level than on the elementary. At the elementary level when there are a low number of teachers per number of schools, the teaching of arts is probably primarily in the hands of classroom teachers.

			Elementary	Secondary
High enrollment/ high expenditure	Atlanta	Music	4 teachers/9schools	3 teachers/6 schools
		Visual Arts	5 teachers/9 schools	9 teachers/6 schools
	Palo Alto	Music	4 teachers/20 schools	10 teachers/6 schools
		Visual Arts	3 teachers/20 schools	36 teachers/6 schools
	New Rochelle	Music	3 teachers/10 schools	10 teachers/10 schools
		Visual Arts	1 teacher/1 school	20 teachers/1 school
	West Allis	Music	32 teachers/17 schools	12 teachers/7 schools
		Visual Arts	19 teachers/19 schools	17 teachers/7 schools
Low enrollment/ high expenditure	Brooks County	Music	¼ teacher/2 schools	2 teachers/2 schools
		Visual Arts		4 teachers/2 schools
	Pittsburg	Music	2 teachers/6 schools	4 teachers/1 school
		Visual Arts	1 teacher/6 schools	7 teachers/1 school
	Tuckahoe	Music	1 teacher/1 school	1 teacher/1 school
		Visual Arts	1 teacher/1 school	1 teacher/1 school
	Wauwatosa	information not given		
High enrollment/ low expenditure	Cobb County	information not given		
	Appleton	Music	15 teachers/15 schools	21 teachers/6 schools
		Visual Arts	8 teachers/15 schools	18 teachers/6 schools
	Syracuse	Music	information not given	8 teachers/6 schools
		Visual Arts		8 teachers/4 schools
	*Los Angeles	Music	21 teachers/8 schools: 16 teachers/1 school 1 teacher/2 schools 4 teachers/5 schools	26 teachers/8 schools

*Los Angeles information is for Area "G" only; districtwide information was not given.

Low enrollment/ low expenditure	Chippewa Falls	Music	5½ teachers/7 schools	4 teachers/2 schools
		Visual Arts	1 teacher/7 schools	7 teachers/2 schools
	Watertown	Music	None	1 teacher/11 schools
		Visual Arts	None	7 teachers/3 schools
	Madera	Music	3 teachers/10 schools	2 teachers/1 school
		Visual Arts		5½ teachers/5½ schools
	Glascock	Music	None	1 teacher/1 school
		Visual Arts	None	None

Budgets for arts programs



Budgets for arts programs

(Data supplied by superintendents)

Far more extensive information would be needed to draw any generalized picture of arts budgets within school systems. However, these figures are presented as examples of actual budgets. In all cases supplies and salaries are the largest elements.

Brooks County	Elementary	salaries (band)	$4,000
		supplies and equipment	5,000
	Secondary	salaries (band, choral, art)	$30,000
		supplies and equipment	5,000
Glascock County (estimated)	Elementary	salaries	$9,000
		supplies, equipment, facilities	1,500
	Secondary	same	same
Pittsburg	Elementary	salaries (2 music teachers)	$25,000
		equipment	4,000
		facilities	4,000
		visiting artists	1,500
		special events	2,000
		transportation: field trips (plus $8,000 reserve for whole district)	$1/student
	Secondary	salaries	$180,000
		supplies	9,000
		equipment	12,000
		facilities	5,000
		special events	5,000
		transportation: field trips	1,000
Tuckahoe	Elementary	salaries	$40,000
		supplies	6,000
		equipment	6,000
		visiting artists	900
		special events	700
		transportation: field trips	500
	Secondary	same	same

Madera	Elementary	salaries	$26,665
		supplies	1,919
		travel and conferences	858
		transportation: field trips	614
		music textbooks	130
	Secondary	salaries	$13,333
		supplies	4,970
		equipment	2,600
		music textbooks	638
		art textbooks	174
	Elementary and Secondary	repair of musical instruments	$5,500

Money put aside for purchase of band uniforms.

Lists of resource people maintained through vocational and career education.

Creative arts building funded through state loan under *Earthquake Safety Law, Field Act* (approved by school board).

Budget figures not representative of total expenditures due to decentralizing of budget.

Nonschool resources

Where nonschool resources are used, such as museums and concerts, the arrangements are generally made by a dedicated teacher or arts coordinator. The pattern of decision making and cooperation between school and nonschool resources varies according to location.

Those districts which are close to metropolitan areas naturally make use of a greater number of resources, such as municipal arts organizations and visits to dance and television studios, than do those in rural areas.

In Atlanta, Georgia, the visual arts coordinator maintains contact with a number of community resources and assumes responsibility for cooperation with them. The assistant superintendent of instruction, the area superintendent, and an administrative cabinet are all consulted about district funds used for transportation and materials. Nonschool agencies cooperating are:

High Museum of Art The Museum makes special presentations for students, such as concerts, museum exhibitions, and puppet shows: 80,000 students, grades K–12, participate in these events annually.

Neighborhood Art Center The Center provides drama specialists who work with approximately forty tenth, eleventh, and twelfth graders annually.

Atlanta Arts Festival $1,250 has been provided by the city for murals and "wall art" in school buildings, and for the annual "Art in the Park" exhibit of student work.

Atlanta Arts Council Until this year, the Council provided a number of visual

art and drama programs in the schools, serving approximately 8,000 students annually.

Georgia Council for the Arts With funds from the National Endowment for the Arts, the state council has provided artists-in-residence and Artists-in-Schools programs.

In West Allis, Wisconsin, the local Arts Alliance provides exhibits and conducts art contests for students, while the Milwaukee Art Museum provides a staff member who visits the schools to talk about current exhibits as preparation for trips to the museum. Moreover, West Allis has had an artist-in-residence for five years; to comply with school board policy, he is paid as an elementary teacher. District funds are allotted for special equipment and for transportation for the programs. Costs are shared by the school district and the participating organizations.

At the Tuckahoe High School in New York State, the principal cited several nonschool agencies which cooperate with schools in that district: Lincoln Center for the Performing Arts in New York City sends them special programs, and the Westchester Council of Arts and the State Council on the Arts also work with the district. Local district funding is used for these projects, but it was stated that "if the state dropped the funds for the poet-in-residence program, the school could not afford to continue it alone." It was felt that " . . . the poet-in-residence program has a good effect on the students' attitude. . . . their respect for the arts goes up." In addition to the poet-in-residence program, on the elementary level in Tuckahoe, school funds are used to present holiday programs of puppeteers, and outside professional acting groups. Evaluation of these programs has been primarily through their effect on student work.

In the Wauwatosa district in Wisconsin, the Milwaukee Arts Center presents traveling exhibits accompanied by speakers with slide presentations on both the elementary and secondary levels. These are instigated by teachers and funded out of school art budgets. On the secondary level the Milwaukee Symphony gives three young people's concerts a year, for which the students pay. Participation in this program is initiated and maintained by the music teachers. On the elementary level the recreation department organizes children's performances. Participation is initiated and maintained largely by the school administration. The PTA sponsors ballet and symphony performances, and is responsible for buying tickets for the children.

The Watertown district in New York State has a lyric theatre which has apprentice programs in acting, singing, and orchestra; students take part on a voluntary basis. The State University's orchestra from Potsdam, New York, gives performances which are funded by the district; the music specialist for the district is responsible for setting up the concert program. On the secondary level, there is an art contest at a home for the aged every year in which students design posters on a specific topic. They are exhibited at the home, and the winners are honored at a special tea.

Palo Alto, California, is the only district which appears actively to seek parental involvement. For example, the visual arts coordinator trains parents to run noon-hour arts programs at ten elementary schools. A number of parents travel from school to school with the "Meet the Masters" program and give special workshops on request.

Evaluation of Programs

Evaluation seems to be a nebulous affair, with no clearly articulated criteria for evaluating program effectiveness. Neither program goals nor criteria for evaluating for achievement of such goals were articulated by any of the respondents. Apparently, evaluation is an elusive, rather subjective activity carried out informally by administrators and teachers alike.

Both elementary and secondary teachers wish their students to give increasing evidence of confidence as they work with art media. Teachers said they judge their teaching and program by "'kids'' involvement," "by the enthusiasm of the children," and by "student feedback." Beyond rather vaguely stated indicators that they would like students to enjoy their arts activities, none of the respondents volunteered any criteria they might use to judge the quality of the students' arts experiences.

Apparently evaluation is informal and intuitive—or at least has not been systematized to the extent that those interviewed could articulate what, how, and why they evaluate. Just as there appears to be no comprehensive approach to curriculum or program design in the arts, there is no evaluation plan: one which might assess growth of student interest in the arts, growth of sensitivity to the formal or expressive qualities of art forms, and growth in the skills of art production or art criticism.

Where formal evaluation measures are used, as in Atlanta, Georgia, they tend to be standardized tests that may not relate to the growth of artistic sensibilities but instead measure reading and mathematics skills. The connections between such measures and the goals and content of arts programs are not clearly articulated and appear tenuous at best.

Existing programs—their strengths and problems

There is considerable variability across the sixteen districts with regard to the perceived strengths of arts programs. The data are organized here according to the job of each group of respondents.

Superintendents
Of the superintendents interviewed, the following factors were cited by the greatest number of respondents as contributing to a successful district arts program: community support (funding and parental interest), good technical and teaching skills, and competent arts coordinators. Other factors had to do with the number and quality of staff, the cooperation among teachers, and teachers' willingness to accept supervisory help to improve their teaching.

Principals
The majority of principals cited the level of teacher training, teacher talent and interest, as well as cooperation among teachers, and the willingness of teachers to accept supervision as the major sources of program strength. Apparently, the saying "the teacher is the program" sums up the principals' view of program effectiveness. Community support, adequate budget, adequate resources, and strength of the district arts coordinator were the next

most often cited reasons for program strength, while the principals' support of arts programs and adequate time allotments for them were mentioned least. Only one principal (Palo Alto, California) mentioned the size and design of facilities as a strength.

District coordinators

All the district coordinators agree that the teacher is the most important factor for a strong program. Three coordinators mentioned community support as an important factor, while only one mentioned size and design of facilities (Atlanta), and one mentioned the support of the principal as important. In Los Angeles, the coordinator sounded a note of bitterness when she bemoaned budget cuts and said that she perceived as a strength the fact that " . . . they haven't obliterated us entirely."

According to the majority of respondents, the most frequent deterrent to a better arts program is a limited budget. Next most important deterrents were cited as follows: time limitations, rigid scheduling, and an unfavorable teacher-student ratio. Student apathy toward the arts was cited by several respondents at the secondary level. The "back to basics" emphasis, and parental pressure on students to perform in academic areas were viewed by a number of respondents as factors which made it difficult to expand or improve arts programs.

Secondary teachers

Teachers in only two districts appear to regard their budgets as sufficient: those in Palo Alto, California, and West Allis, Wisconsin. Teachers in only two districts regard their programs as being flexible enough to offer strong arts experiences: those in Atlanta, Georgia, and Brooks County, Georgia. Teachers in Atlanta feel that the program is strong because they are allowed flexibility in pulling students from the school for special programs or performances, or both, and they value the fact that they are autonomous in developing their own programs.

For all districts, other frequently mentioned assets are size and design of facilities, level of student talent or interest, and level of teacher training. Teachers in only two districts feel that community support is a point of strength: those in New Rochelle, New York, and Syracuse, New York.

Elementary teachers

At this level, teachers are in substantial agreement about the value of the following (in order of most importance): support of the principal, community support (including parental support), cooperation among teachers, level of teacher training, and availability of resources. With respect to the latter, teachers in Pittsburg, California, also feel they are fortunate in having federal funding " . . . to buy almost anything desired."

It is interesting to note that at the elementary level the support of the principal is apparently a more important factor than at the secondary level. Perhaps this reflects the differing patterns of funding that exist at the two levels of schooling. (At the elementary level, principals have more discretionary funds to allot than do secondary principals, who delegate funding allotments—within certain district-set limits—to department heads.)

291

Improvements, innovations, and future plans

The majority of respondents, especially district coordinators, have plans to improve or enlarge programs by adding more course offerings (at the secondary level), by developing integrated arts approaches (elementary level), by adding more staff, or by educating existing staff. Without exception, respondents cited lack of financial support as the major deterrent to implementing planned innovations. The next most frequently mentioned deterrent was lack of school board interest. At the secondary level, the need for more staff was repeatedly mentioned, while at the elementary level, lack of sufficient time for arts activities and adequate musical equipment were cited as obstacles to future plans.

Secondary teachers are unanimous in stating that practical experience with children or with the arts is the most valuable preparation for teaching (for example, working, practice teaching, traveling to see art, performing with a musical group, and participating in summer workshops in the arts). Teachers also cited good instruction at the college level as a major contribution to their competence as arts teachers. Secondary teachers concur that education courses in the arts or in general education, as they presently exist, are not relevant: they are " . . . too theoretical and not related to the practical problems of teaching," or they are composed of "mickey-mouse things . . . not real artistic experiences."

Following are some suggestions by secondary teachers for the improvement of teacher education:

> " . . . a background in the humanities"
>
> " . . . earlier experiences with children and more of it as part of teacher preparation"
>
> " . . . see real works of art, not slides"
>
> " . . . a background in the related arts"
>
> " . . . more applied arts courses, and less theoretical reasons for teaching it"

The interviews reveal that teachers are interested in practical experiences with children prior to actual teaching, and as many field-based experiences as possible.

Elementary teachers agree with secondary teachers that practical experience and life experience in the arts and with children are the most valuable aspects of teacher training. Elementary teachers also felt that required education courses were not valuable to them. Following are suggestions for improving teacher education in the arts at the elementary level:

> " . . . experiences with children earlier in teacher preparation."
>
> " . . . experiences with visiting artists for at least one year: emphasis on participation, making art."
>
> " . . . professors should be involved in schools, developing curriculum and teaching teachers."
>
> " . . . there should be more role playing in teacher education, so teachers wouldn't be afraid of doing dramatics."
>
> " . . . arts should be required as part of teacher education, and a lot of them."

" . . . teachers should be given opportunity for using media in teaching."

" . . . would like to see educational theory and philosophy courses replaced with more helpful courses, such as acting, theater, mime. We need courses that will loosen teachers up."

" . . . there should be more of teachers sharing ideas with one another so they won't feel threatened."

In effect, elementary teachers regard their own arts training as inadequate and think that there should be more active participation in all the arts for a longer period of time. They also feel that there should be more collaboration between schools and teacher education institutions during the teacher's training process and that their training should be practical in orientation.

Research reports prepared for the project

"Adolescence, Creativity and Arts Education in Secondary Schools," *Bette Acuff*

"Arts Education and the Elementary School," *Cynthia Hettinger, Editor*

"Community-Based Arts Resources," *Terry Baker*

"Developmental Stages in Teaching the Arts," *John Melser*

"Exemplary Programs: Case Studies," *Bette Acuff and Richard Polsky*

"Federal Support for Arts Education," *Linda C. Coe*

"Higher Education and the Arts," *August L. Freundlich*

"Interviews with Leaders in Education, the Arts, and Arts Education: An Interpretive Report," *Charles Fowler*

"Pre-Service Teacher Training," *August L. Freundlich*

"The Re-Education of Arts Teachers (Elementary Level)," *Pearl Greenberg*

"The Re-Education of Arts Teachers (Secondary Level)," *Bette Acuff*

"Significant Non-School Resources and Arts Education: Critical Issues and Compilation of Goals," *Terry Baker*

"The State of the Arts on Campus: Case Studies," *Carol Landolfi*

"State Education Policy," *Joan H. Simmons*

"State Profiles: The Arts and Education," *Cynthia Hettinger*

"Summary of Questionnaire Responses: On-Site Interviews," *Bette Acuff and Richard Polsky*

"Summary of Questionnaire Responses: Sixteen School Districts," *Cynthia Hettinger, Editor*

"Teacher Certification Requirements," *Cynthia Hettinger*

"Teacher Training and Non-School Resources," *Terry Baker*

Resource persons

The following persons presented their views either in testimony before the Panel, in interviews with staff members, or as participants in special meetings. (In general, titles given indicate the present position of participants. In some cases, however, titles refer to positions held at the time information was given to the Project.)

ABRAHAMSON, JOAN, Consultant on Community-Based Programs, San Francisco, California
ALLISON, JIM, Project Coordinator, JEFFCO Arts in Education Program, Jefferson County Public Schools, Colorado
ALPERT, MURRAY, Associate Director, Millhauser Laboratories, Psychiatric and Behavioral Science Research, School of Medicine, New York University
AMARANDOS, DOROTHY, Executive Secretary, National Guild of Community Schools of the Arts, New York, New York
ANDERSON, JAMES, Chairman of the Art Department, Northern Arizona University, Flagstaff, Arizona
ANDREWS, MICHAEL, Chairman, Synaesthetic Education, Syracuse University, Syracuse, New York
ANTHONY, MARY, Director, Mary Anthony Dance Theatre, New York, New York
ARBERG, HAROLD, Director, Arts and Humanities Staff, U.S. Office of Education, Washington, D.C.
ARONOFF, FRANCES WEBBER, Professor of Music Education, New York University, New York, New York
ARONSON, JUDITH, Chairperson, Aesthetic Education Program, Webster College, St. Louis, Missouri
AUSTIN, JOY, Chairperson, Tennessee Arts Commission, Memphis, Tennessee

BAIRD, JO ANN, National Chairperson, Public Relations Advisory Committee, Music Educators National Conference, Reston, Virginia
BAKER, DAVID, Director of Visual Arts and Industrial Arts, Unified Arts Program, Brookline Public Schools, Brookline, Massachusetts
BAMBERGER, JEANNE, Project Zero, Harvard Graduate School of Education, Cambridge, Massachusetts
BARWICK, KENT, Executive Director, New York State Council on the Arts, New York, New York
BAUMHARDT, JOHN R., President, Secondary School Theatre Association, Washington, D.C.
BAUMOL, WILLIAM, Economist, Princeton University, Princeton, New Jersey
BECKERMAN, BERNARD, Dean of School of the Arts, Columbia University, New York, New York
BERGER, THEODORE, Director of Education Programs, New York Foundation for the Arts, New York, New York
BERKEY, MILDRED, Immediate Past President, Kentucky Music Educators Association, Elementary Music Specialist, Jefferson County, Kentucky
BIEGEL, STEVEN, Vice President for Student Activities, American Institute of Architects, Washington, D.C.
BIGUENET, JOHN, Poet-in-Residence, Little Rock, Arkansas
BLAINE, JOHN, Executive Secretary, Seattle Arts Commission, Cultural Affairs Consultant to the Mayor, Seattle, Washington
BLASDEL, HUGO, Executive Director, National Architectural Accrediting Board, American Institute of Architects, New York, New York
BLOOM, KATHRYN, Director, Arts in Education Program, The JDR 3rd Fund, New York, New York
BOAL, DEAN, President, Community Association of Schools of the Arts, St. Louis, Missouri
BOGUSCH, GEORGE, Vice President for Research, American Theatre Association, Washington, D.C.

BOOTH, ETHEL, Media Consultant, Los Angeles, California

BOOTH, JOHN, Associated Director, 20th Century Fund, York, New York

BRAUN, SUSAN, President, Dance Films Association, Inc., New York, New York

BREWER, PEGGY, Elementary Teacher, Snowden School, Memphis, Tennessee

BRONER, MATT, Chairman, Studio Art Department, Manhattanville College, Purchase, New York

BROWN, GEORGE ISAAC, Graduate School of Education, University of California at Santa Barbara

BURDIN, JOEL, Associate Director, American Association of Colleges for Teacher Education, Washington, D.C.

BURRIS-MEYER, HAROLD, U.S. Institute for Theatre Technology, Florida Atlantic University, Boca Raton, Florida

BURROWS, ALVINA TREUT, Professor Emeritus of Elementary Education (Language Arts), New York University

C

CABEZAS, RICHARD, High School Teacher, Board of Education, Teaneck, New Jersey

CALLIAN, WILLIAM D., JR., Assistant Superintendent of Instruction, Memphis Schools, Memphis, Tennessee

CAMERON, ELSA, Director of the De Young Museum School, San Francisco, California

CAPONNETTO, JOSEPH, Board of Trustees, National Institute for Architectural Education, New York, New York

CARDEN, BETSY, National Chairman, American Dance Guild, New York, New York

CASSMEY, HOWARD, State Superintendent of Schools, Minneapolis, Minnesota

CASTILE, RAND, Director, Japan House Gallery, New York, New York

CAWELTI, GORDON, Executive Secretary, Association for Supervision and Curriculum Development, Washington, D.C.

CHARITY, RAYMOND, Director, Educational Program, American Institute of Architects, Washington, D.C.

CLARKSON, AUSTIN, Faculty of Fine Arts, Music Department, York University, Downsview, Ontario, Canada

COE, FRANCES, Member, Memphis Board of Education, Memphis, Tennessee

COLE, EDWARD, formerly Yale Drama School, Branford, Connecticut

COOLIDGE, ARLAN, College Music Society, Providence, Rhode Island

COUNCE, SHELBY, Deputy Superintendent, Memphis City Schools, Memphis, Tennessee

CULKIN, JOHN M., Director, Center for Understanding Media; Director, Media Studies, New School for Social Research, New York, New York

D

DAVIS, HAL C., President, American Federation of Musicians, New York, New York

DAWSON, WILLIAM M., Executive Director, Association of College, University and Community Arts Administrators, Inc., Madison, Wisconsin

DECARLO, CHARLES, President, Sarah Lawrence College, Bronxville, New York

DEROSA, CLEM, President, National Association of Jazz Educators, Long Island, New York

DILEO, JOSEPH, Director of Developmental Clinic, New York Foundling Hospital, New York, New York

DISTLER, PAUL, Chairman, Department of Performing Arts and Communications, Virginia Polytechnic Institute and State University, Blacksburg, Virginia

DONAHUE, JOHN, Director, Children's Theatre Company, Minneapolis, Minnesota

DORN, CHARLES, President, National Art Education Association, Reston, Virginia

DOWN, A. GRAHAM, Executive Secretary, Council for Basic Education, Washington, D.C.

DUNHAM, KATHERINE, Director, Performing Arts Training Center, Southern Illinois University, East St. Louis, Illinois

DUNNOCK, MILDRED, Actress, South Norwalk, Connecticut

E

EARLE, MARLOWE, President, California Music Educators Association,

EDDY, JUNIUS, Arts Education Consultant to The Rockefeller Foundation, New York, New York

EICKMAN, PAUL, Associate Director, Center for Innovation, Syracuse University, Syracuse, New York

EISNER, ELLIOT, W., Professor of Education and Art, School of Education, Stanford University, Stanford, California

EKMAN, RICHARD, Assistant Director for Higher Education, National Endowment for the Humanities, Washington, D.C.

ELDRIDGE, ELSOM, JR., Director, Educational Arts Association, Cambridge, Massachusetts

ELLIS, RICHARD, Assistant Director, Junior Arts Center, Barnsdall Park, Los Angeles, California

ELSEN, ALBERT, President, College Art Association, New York, New York

ENGEL, MARTIN, Arts and Humanities Advisor to the National Institute of Education, Washington, D.C.

ESTABROOK, DAVID, Director, Office of Elementary and Secondary Education, Smithsonian Institution, Washington, D.C.

FALLON, RICHARD G., President of the University Resident Theatre Association, Washington, D.C.

FALLS, GREGORY, Artistic Director, A Contemporary Theatre, Seattle, Washington

FARRELL, JOSEPH, President, National Research Center of the Arts, Inc., New York, New York

FELDMAN, EDMUND, Professor of Art, University of Georgia, Athens, Georgia

FINN, ROBERT, National Executive Board, National Education Association, Washington, D.C.

FORBES, LEAH, Director, Alvarado School Art Workshop, San Francisco, California

FREUND, GERALD, Dean of Fine Arts and Humanities, Hunter College, New York, New York

FRIEDMAN, MARTIN, Director, Walker Art Center, Minneapolis, Minnesota

FUNKHOUSER, PEGGY, Performing Tree, Los Angeles, California

FURNISS, W. TODD, Director of the Office of Academic Affairs for the American Council on Education, Washington, D.C.

F

GAINES, JOAN, Director of Public Relations, Music Educators National Conference, Reston, Virginia

GARDNER, HOWARD, Co-Director, Project Zero, Harvard University, Cambridge, Massachusetts

GARY, CHARLES L., Former Executive Secretary, Music Educators National Conference, Reston, Virginia

GELLER, ROBERT, President, Learning in Focus, New York, New York

GINGRICH, JOHN, President, Association of American Dance Companies, Inc., New York, New York

GLIDDEN, ROBERT, Executive Director, National Association of Schools of Music, Reston, Virginia

GOLDSTINE, STEPHEN, Program Director, Neighborhood Arts Program, San Francisco, California

GOLSH, LARRY, Artist-in-Residence, St. John's Indian School, Phoenix, Arizona

GOODLAD, JOHN, Dean, Graduate School of Education, University of California at Los Angeles; Director of Research, Institute for Development of Educational Activities, Los Angeles, California

GRACEY, JANET, Head of Special Projects, Theatre Development Fund, New York, New York

GRANT, VANCE, Chief of Reference Section, National Center for Education Statistics, Washington, D.C.

GREENE, MAXINE, Professor of Philosophy and Education, Teachers College, Columbia University, New York, New York

G

HAAS, ROBERT, Director, Department of Arts and Humanities, University of Southern California, Los Angeles, California

HALL, BARBARA, Director of Community Services, Mount Saint Antonio College, Walnut, California

HALL, JAMES R., Director of Cultural Arts, Department of Public Instruction, Raleigh, North Carolina

HALPERIN, SAMUEL, Director, Institute for Educational Leadership, Washington, D.C.

HANNAPEL, RAYMOND, Program Manager in Special Activities and Analysis, National Science Foundation, Washington, D.C.

HANSEN, BRIAN, Associate Professor and Chairman, Department of Theatre, University of Delaware, Newark, Delaware

HANSON, MARGIE, Executive Secretary, National Dance Association, Washington, D.C.

HARLEY, WILLIAM G., President, National Association of Educational Broadcasters, Washington, D.C.

HARU, SUMI, Producer-Moderator, Channel KTLA, Los Angeles, California

HAUSMAN, JEROME, President, College of Art and Design, Minneapolis, Minnesota

HAYSLIP, ELLWYN, Associate Professor of Art, Plymouth State College, Plymouth, New Hampshire

HAZARD, BEN, Curator of Special Exhibits and Education, Oakland Museum, Oakland, California

HILL, ANN, President, American Theatre Association, Washington, D.C.

HILL, JENIFER, Director of Public Relations, San Francisco Conservatory of Music Community Services Program, San Francisco, California

HODGKINSON, HAROLD, Director, National Institute of Education, Washington, D.C.

HOFER, LYNNE, Co-Director, Young Filmmakers Foundation, New York, New York

HOGAN, ROBERT F., Executive Secretary, National Council of Teachers of English, Urbana, Illinois

HOPE, SAMUEL, Executive Director, National Association of Schools of Art, Reston, Virginia

HOROWITZ, HAROLD, Research Director, National Endowment for the Arts, Washington, D.C.

HOTH, SUE, Coordinator, Museum Education Program, George Washington University, Washington, D.C.

HOVING, THOMAS, Director, Metropolitan Museum of Art, New York, New York

HOWARD, JOHN, Chairman, Art Department, Texas Southern University, Houston, Texas

HULL, ROBERT, Dean of Fine Arts, University of Arizona, Tucson, Arizona

HUNT, JOHN, Vice President, Aspen Institute for Humanistic Studies, New York, New York

HURWITZ, AL, Coordinator of Arts, Newton Public Schools, Newton, Massachusetts

H

297

I

IANNI, FRANCIS, Anthropologist and Director, Horace-Mann Lincoln Institute, Columbia University, New York, New York
INGRAM, SAM, State Commissioner of Education for Tennessee, Memphis, Tennessee
IREY, CHARLOTTE, President, National Dance Association, Washington, D.C.
IRVING, DONALD, Director, School of Art, Chicago Art Institute, Chicago, Illinois

J

JABBOUR, ALLAN, Director of Folk Arts Division, National Endowment for the Arts, Washington, D.C.
JACKSON, C. BERNARD, Director, Inner City Cultural Center, Los Angeles, California
JACOB, LILA, Dean of the Theatre School, Children's Theatre Company, Minneapolis, Minnesota
JACOBY, ARLENE, Junior High Teacher, West Hempstead, Long Island, New York
JENNINGS, COLEMAN, Associate Professor, Department of Drama, University of Texas, Austin, Texas
JOHNSON, CARL, Member, Memphis Board of Education, Memphis, Tennessee
JOHNSON, JAMES R., Dean, School of Fine Arts, University of Connecticut at Storrs, Storrs, Connecticut
JUSTICE, PETER, Program Director, Association of American Dance Companies, New York, New York

K

KAHN, GERALD, Statistician, National Center for Education Statistics, Washington, D.C.
KAMARCK, EDWARD, Editor, *Arts in Society*, University of Wisconsin, Madison, Wisconsin
KAWAMURA, LANI, Arts Coordinator, Minnesota State Arts Council, Minneapolis, Minnesota
KELLER, FLOYD, Director, Elementary and Secondary Education, Minnesota Department of Education, St. Paul, Minnesota
KERR, JOHN, Program Director, Education, National Endowment for the Arts, Washington, D.C.
KIERNAN, OWEN B., Executive Secretary, National Association of Secondary School Principals, Reston, Virginia
KING, BRUCE, Dancer, Choreographer, Educator, New York, New York
KINNE, FRANCES B., Chairman, International Council of Fine Arts Deans—1975, Jacksonville University, Jacksonville, Florida
KLAHR, MYRA, Director, New York State Poets-in-the-Schools Program, Chappaqua, New York
KLEYMAN, PAUL, Publicity Coordinator, Neighborhood Arts Program, San Francisco, California
KLIELER, DAVID, Professor of Film, Babson College, Wellesley, Massachusetts
KLIMO, JOHN, Director of Creative Arts Program, Rutgers University, New Brunswick, New Jersey
KLOTMAN, ROBERT, President, Music Educators National Conference, Reston, Virginia
KRATHWOHL, DAVID, Dean, School of Education, Syracuse University, Syracuse. New York
KRAWITZ, HERMAN, Chairman, Arts Administration Department, Yale University, New Haven, Connecticut
KRAY, ELIZABETH, Executive Director, Academy of American Poets, New York, New York
KRUEGER, MARK, Intern, Office of Gifted and Talented, U.S. Office of Education, Washington, D.C.
KURTEN, ALLELU, President, Puppeteers of America, Inc., Hyde Park, New York

L

LABERGE, MOLLY, Director, COMPAS Program, St. Paul, Minnesota
LANIER, RUTH ASAWA, Founder, Alvarado School Art Workshop, San Francisco, California
LARKEY, BETTY, Chairman, Community Arts Committee, Junior League, Memphis, Tennessee
LARRABEE, ERIC, Executive Director. New York State Council on the Arts, New York. New York
LAWHORN, JOHN, Music Consultant, Atlanta, Georgia
LEAR, NORMAN, Tandem Productions, Los Angeles, California
LEE, RON, Professor of Music Education, Syracuse University, Syracuse, New York
LEQUIRE, LOUISE, Art Teacher, Montgomery Bell Academy, Nashville, Tennessee
LEWIS, ANN, Chairperson, Alliance for Arts in Education, Minneapolis, Minnesota
LEWIS, ELMA, Director, Elma Lewis School of Fine Arts, Boston, Massachusetts
LEWIS, HILDA, Department of Art Education, San Francisco State University, San Francisco, California
LEWIS, RICHARD, Director, Touchstone Center for Children, New York, New York
LINDSEY, MARGARET, Professor of Education, Teachers College, Columbia University, New York, New York
LITTLE, ARAMINTA, Chairman, Department of Dance, School of the Arts, California State University, Fullerton, California
LIVERMORE, ARTHUR, Director of Education, American Association for the Advancement of Science, Washington, D.C.
LOEWENBERG, SUSAN, Artists in Prison, Inc., Los Angeles, California
LOPEZ, FRANK, Project Director, Plaza de la Raza, Los Angeles, California

LOVE, SAMUEL, Executive Director, National Association of Schools of Music, Reston, Virginia
LOWRY, W. McNEIL, former Vice President for the Humanities and the Arts, Ford Foundation, New York, New York

M

MADDEN, DOROTHY, Chairman of the Department of Dance, University of Maryland, College Park, Maryland
MADEJA, STANLEY, Director, Aesthetic Education Program, CEMREL, St. Louis, Missouri
MAHLMANN, JOHN, Executive Secretary, National Art Education Association, Reston, Virginia
MAHONEY, MARGARET, Vice President, Robert Wood Johnson Foundation, Princeton, New Jersey
MARLAND, SIDNEY, President, The College Entrance Examination Board, New York, New York
MARTIN, SISTER CATHERINE, Indiana Commission of the Arts, St. Mary-of-the-Woods College, St. Mary-of-the-Woods, Indiana
MARTIN, GERRY J., National Executive Director, Young Audiences, Inc., New York, New York
MARTIN, ZORA, Education Director, Anacostia Museum, Washington, D.C.
MARUS, LILLIAN, Executive Secretary, National Institute for Architectural Education, New York, New York
MATTER, MERCEDES, Dean, New York Studio School, New York, New York
MAVES, MARK, Assistant Director, Design and International Relations, American Institute of Architects, Washington, D.C.
McCASLIN, NELLIE, President of the Children's Theatre Association of America, New York University, New York, New York
McCLINTOCK, JUDITH, Music Department, Teachers College, Columbia University, New York, New York
McCRAY, MACK, Director of Community Services, Conservatory of Music, San Francisco, California
McGEARY, CLYDE, Senior Arts Advisor, State Department of Education, Harrisburg, Pennsylvania
McGRATH, KYRAN, Executive Director, American Association of Museums, Washington, D.C.
McKENNA, BERNARD H., Specialist, Instruction and Professional Development, National Education Association, Washington, D.C.
MICHALSKI, KIRSTEN, P.E.N. American Center, New York, New York
MILLS, FRED, Chairman, Department of Art, Illinois State University, Normal, Illinois
MIRABELLI, ANDRE, Project Director, National Committee for Cultural Resources, New York, New York
MONTEBELLO, PHILLIP, Vice Director of Curatorial and Educational Affairs, Metropolitan Museum of Art, New York, New York
MORRISON, JACK, Associate Director, Arts in Education Program, The JDR 3rd Fund, New York, New York

N

NATHAN, PEARL, Chairperson, Alliance for Arts Education, Providence, Rhode Island
NATHANSON, LUCILE, Department of Theatre and Dance, Nassau Community College, Long Island, New York
NELSON, DOREEN, Director, City Building Education Program, Los Angeles, California
NEW, LLOYD, Director, Institute of American Indian Art, Santa Fe, New Mexico
NEWBERG, JOAN, President, Alliance of California Arts Councils, Northridge, California
NEWSOM, BARBARA, Project Director, Council on Museums and Education in the Visual Arts, New York, New York
NEWTON, MICHAEL, President, Associated Council for the Arts, New York, New York
NOBLE, JOSEPH V., President, American Association of Museums, Washington, D.C.

O

O'GRADY, GERALD, Director, Educational Communications Center and Center for Media Study, State University of New York, College at Buffalo, New York

P

PALISCA, CLAUDE, Chairman, Department of Music, Yale University, New Haven, Connecticut
PEISER, JUDY, Director, Center for Southern Folklore, Memphis, Tennessee
PHARIS, WILLIAM L., Executive Director, National Association of Elementary School Principals, Rosslyn, Virginia
PIEROTTI, RAY, Assistant to the President, American Crafts Council, New York, New York
PITTMAN, BETTYE, Secondary Arts Supervisor, Memphis Public Schools, Memphis, Tennessee
PRESCOTT, KENNETH, Chairman, Art Department, University of Texas, Austin, Texas

RANDALL, TED, National Council on Education in the Ceramic Arts, Alfred University, Alfred, New York
RASNACK, PAUL, Director of Administration, San Francisco Conservatory of Music Community Service Program, San Francisco, California
RAVE, GEORGIA, Education Department, Manhattanville College, Purchase, New York
REALS, BOB, Arts and Humanities Specialist, New York State Department of Education, Albany, New York
REID, ANTHONY, Executive Director, American Theatre Association, Washington. D.C.
REISS, ALVIN, Arts Consultant and Editor, *Arts Management*, New York, New York
REMER, JANE, Program Associate, The JDR 3rd Fund, New York. New York
RICHARDSON, ARLEIGH, Director, National Humanities Faculty, Concord, Massachusetts
RINZLER, RALPH, Director of Folk Arts Program, Department of Performing Arts, Smithsonian Institution, Washington, D.C.
RIRIE, SHIRLEY, Dance Department, University of Utah, Salt Lake City, Utah
ROBERTS, VERA MOWRY, Department of Theatre Arts, Hunter College, New York, New York
ROGERS, FORBES W., Director, Alliance for Arts Education, Kennedy Center, Washington, D.C.
ROSENBLATT, ROGER, Director, Division of Education Programs, National Endowment for the Humanities, Washington, D.C.
ROSS, JERROLD, Head, Division of Arts and Arts Education, School of Education, Health, Nursing and Arts Professions, New York University, New York, New York
ROTHSCHILD, JUDITH, Painter, New York, New York

SAHASRABUDHA, PRUBA, Mineola School District, Long Island, New York
SALMON, PAUL, Executive Director, American Association of School Administrators, Washington, D.C.
SAPP, ALLAN, former Executive Director, American Council for the Arts in Education, New York, New York
SCHERPEREEL, RICHARD, Chairman, Art Department, Texas A & I University, Kingsville, Texas
SCHMIDT, LLOYD, Music Consultant, State Department of Education, Hartford, Connecticut
SCHRADER, STEVEN, Director, Teachers and Writers Collaborative, New York, New York
SCHRAG, KARL, Printmaker, New York, New York
SCHUBART, MARK, Director of Education, Lincoln Center, New York, New York
SCOTT-GIBSON, HERBERT, Black Theatre Alliance, New York, New York
SELEY, JASON, Sculptor and Professor, Cornell University, Ithaca, New York
SIMON, WILLIAM, President, Washington. D.C., Teachers Union, Local Number 6
SINGER, STEPHANIE, Education Program, National Endowment for the Arts, Washington, D.C.
SLATER, JOSEPH E., President, Aspen Institute for Humanistic Studies, New York, New York
SLOANE, JOSEPH, Trustee and past President, American Council for the Arts in Education; Director of Ackland Museum, University of North Carolina, Chapel Hill, North Carolina
SMITH, DENNIS, College of Education, Memphis State University, Memphis, Tennessee
SMITH, MARY, Chairman, Cultural and Ethnic Affairs Guild, Oakland Museum, Oakland, California
SMITH, WALLACE, Director of Urban Arts Program, Evanston Township High School, Evanston, Illinois
SNYDER, ALLEGRA FULLER, Chairman, Department of Dance, University of California at Los Angeles
SOURIAU, MANON, Executive Director, American Dance Guild, New York, New York
SPEIKER, CHARLES A., Associate Director, Association for Supervision and Curriculum Development, Washington, D.C.
STADTMAN, VERNE A., Associate Director and Editor, Carnegie Council on Policy Studies in Higher Education, Berkeley, California
STAKE, ROBERT, Center for Instructional Research and Curriculum Evaluation, University of Illinois, Urbana-Champaign, Illinois
STAPLES, DONALD, President, Society for Cinema Studies, New York University, New York, New York
STAUB, AUGUST W., Chairman, Department of Drama and Communication, University of New Orleans, New Orleans, Louisiana
STEARNS, BETTY, Public Relations/Administration, American Music Conference, Chicago, Illinois
STEVENS, RISE, President, Mannes School of Music, New York, New York
STILLINGS, FRANK, School of Fine Arts and Applied Arts, Central Michigan University, Mount Pleasant, Michigan
STILLION, JOHN, Arts Director, Los Angeles County Schools, Los Angeles, California
STOVALL, JEANELLE, Assistant to the Director, Performing Arts Training Center, Southern Illinois University, East St. Louis, Illinois
STRAUS, JOHN W., Chairman, International Council of Fine Arts Deans—1976, State University of New York, Purchase, New York

SUFT, DONALD, Dean, College of Fine Arts, University of South Florida, Tampa, Florida
SULLIVAN, JOHN, Director, Instruction and Professional Development, National Education Association, Washington, D.C.
SUTTON-SMITH, BRIAN, Chairman, Department of Developmental Psychology, Teachers College, Columbia University, New York, New York
SWANSON, ALICE, Director, Aesthetic Education Center, Memphis, Tennessee

TELLSTROM, THEODORE, Executive Director, Music Educators National Conference, Reston, Virginia
THOMAS, JAMES E., President, Ohio Music Education Association, Ashland, Ohio
THOMAS, MICHAEL TILSON, Music Director and Conductor, Buffalo Philharmonic Orchestra, Buffalo, New York
THOMSON, SCOTT, Associate Executive Director, National Association of Secondary School Principals, Evanston, Illinois
TOPAZ, MURIEL, Director, Lab and Notation, Dance Notation Bureau, New York, New York
TREISTER, KENNETH, Architect and Designer, Miami, Florida
TRUSTY, SHIRLEY, Supervisor, Cultural Resources, New Orleans Public Schools, New Orleans, Louisiana
TUMIN, MELVIN, Department of Sociology and Anthropology, Princeton University, Princeton, New Jersey
TURNBULL, WILLIAM, President, The Educational Testing Service, Princeton, New Jersey

UNSWORTH, JEANNE MORAN, Professor of Art Education, Loyola University, Chicago, Illinois

WAGNER, CHARLES A., Executive Secretary, The Poetry Society of America, New York, New York
WAGNER, JEARNINE, Director, Learning about Learning, San Antonio, Texas
WALDROP, GIDEON, Dean, The Juilliard School, New York, New York
WALTERS, WALTER H., Dean, College of Arts and Architecture, Pennsylvania State University, University Park, Pennsylvania
WARLICK, JOE, Acting Assistant Superintendent, Division of Supplementary Educational Services, Memphis Schools, Memphis, Tennessee
WATKINS, JUANITA, Member, Memphis Board of Education, Memphis, Tennessee
WATSON, BILL, TV Arts Project, New York, New York
WEBER, LILLIAN, Center for Open Education, City College of New York, New York, New York
WEIL, ROSE, Executive Secretary, College Art Association, New York, New York
WELCH, AUDREY, Art Coordinator, Glendale Unified School District, Glendale, California
WENNER, GENE B., Program Associate, Arts in Education Program, The JDR 3rd Fund, New York, New York
WILLIAMS, GALEN, President and Executive Secretary, Poets and Writers, Inc., New York, New York
WIMMER, SHIRLEY, Director of the Dance Program, College of Fine Arts, Ohio University, Athens, Ohio
WILSON, EDWARD, Department of Art, State University of New York, Binghamton, New York
WILSON, EDWIN, Director, Graduate Theatre Program, Hunter College, New York, New York
WINNER, BARBARA, Administrative Assistant, Neighborhood Arts Programs, San Francisco, California
WITHERS, MAIDA, Department of Human Kinetics and Leisure Studies, Division of Dance, George Washington University, Washington, D.C.
WOJTA, JUDITH O., President, State Assembly, National Art Education Association, Reston, Virginia
WOODS, JAMES, Program Director, Arts Neighborhood Development, Los Angeles, California
WRAY, JEANNE A., President, American Community Theatre Association, Washington, D.C.
WRIGHT, CHARLES DAVID, Poet, American Council for the Arts in Education, Boise, Idaho

YARBRO, CORNELIA, Department of Music Education, Syracuse University, Syracuse, New York
YESNER, SEYMOUR, Consultant, English and Humanities, Minneapolis Public Schools, Minneapolis, Minnesota

ADVISORY COMMITTEE

David Rockefeller, Jr., Chairman
Norris Houghton
Margaret B. Howard
Elizabeth McCormack
Jack Morrison
Wallace Smith
Harold Snedcof
Verne Stadtman

CONSULTANTS

Gerald Freund
Samuel Gould
August Heckscher

Administrative Secretary for Planning Stage, Nancy DeSoto
Staff Assistant for Report Preparation, Linda Goelz

MANUSCRIPT TYPISTS

Barbara Cassidy
Janet Hubbard
Gwen Shelton

The crisis and the hope

1. Martin Engel, "The Future of Aesthetic Education," *Art Education*, vol. 29, no. 3, March 1976, p. 7.

2. "Supplementary Fact Sheets, Challenge Grant Program for the Arts," *Preliminary Notification and Application Information: Challenge Grants*, pamphlet, National Endowment for the Arts, Oct. 14, 1976.

Roots and branches of learning and the arts

1. Alexis de Tocqueville, *Democracy in America*, trans. Henry Reeve, Arlington House, New Rochelle, N.Y., 1965, vol. I, p. 10.

2. Ibid., pp. 10–11.

3. Ibid., p. 14.

4. Richard Mather, *New England's First Fruits*, London, 1643.

5. Ibid., p. 14.

6. George L. Jackson, *Development of School Support in Colonial Massachusetts*, Teachers College Press, Columbia University, New York, 1909, p. 8.

7. Tocqueville, op. cit., 1965, vol. I, p. 15.

8. William Bradford, *History of Plymouth Plantation*, cited in Perry Miller and T. H. Johnson (eds.), *The Puritans: A Sourcebook of Their Writings*, Harper & Row, Publishers, Incorporated, New York, 1963, vol. I, p. 102.

9. Alexis de Tocqueville, *Democracy in America*, trans. Henry Reeve, revised by Francis Bowen, Phillips Bradley (ed.), Vintage Books, Random House, Inc., New York, 1945, vol. I, p. 45.

10. Cited in J. T. Howard and G. K. Bellows, *A Short History of Music in America*, Thomas Y. Crowell Company, New York, 1967, pp. 24–25.

11. *The South Carolina Gazette*, Nov. 5, 1744. Cited in J. H. Best and R. T. Sidwell (eds.), *The American Legacy of Learning*, J. B. Lippincott Company, Philadelphia, 1967, p. 59.

12. Howard and Bellows, op. cit., p. 33.

13. John Locke, "Of Ideas," *Essay concerning Human Understanding*, Gateway Editions, Henry Regnery Company, Chicago, 1956, book II, chap. I, pp. 19–20.

14. Edgar W. Knight, *Education in the United States*, 2d rev. ed., Ginn and Company, Boston, 1941, p. 150.

15. Cited in Stuart G. Noble, *A History of American Education*, Greenwood Press, Inc., Westport, Conn., 1970, 26–122 passim.

16. Ibid.
17. Ibid.
18. Cited in Richard Hofstadter (ed.), *American Higher Education: A Documentary History*, University of Chicago Press, Chicago, 1961, vol. I, p. 176.
19. Tocqueville, op. cit., 1965, vol. I, p. 243.
20. Ibid., vol. II, p. 49.
21. Ibid., pp. 35–36.
22. Ibid., p. 51.
23. Ibid., p. 52.
24. Cited in Noble, op. cit., p. 137.
25. Ibid., p. 142.
26. Knight, op. cit., p. 320.
27. Howard and Bellows, op. cit., p. 95.
28. Ibid., p. 165.
29. John Adams, *Letters of John Adams, Addressed to His Wife*, edited by his grandson, Charles Francis Adams, letter no. 178 (second letter, 1780), Charles C. Little and James Brown, Boston, 1841, vol. II, p. 68.
30. Arthur Knight, *The Liveliest Art*, Mentor Books, New American Library, Inc., New York, 1957, p. 12.
31. Clive Barnes, "The Arts in America: Optimism Tempered by Need," *New York Times*, Aug. 29, 1976, sec. 2, p. 16.
32. Howard and Bellows, op. cit., p. 346.
33. Marshall W. Stearns, *The Story of Jazz*, Oxford University Press, New York, 1970, p. 74.
34. John A. Lomax and Alan Lomax, *Folk Song U.S.A.*, Duell, Sloan & Pearce, Inc., New York, 1947, p. 334.
35. Stearns, op. cit., p. 123.
36. Ibid., p. xi.
37. Ibid., p. 282.
38. Larry Neal, cited in Norris Houghton, *The Exploding Stage: An Introduction to 20th Century Drama*, Weybright and Talley, New York, 1971, p. 198.

The arts: a better primer for our children

1. W. Vance Grant and C. George Lind, *Digest of Educational Statistics: 1974 Edition*, U.S. Department of Health, Education, and Welfare, National Center for Education Statistics, 1975, p. 1.
2. Judith Cummings, "Annual Survey Finds Fewer Adults are Grading Their Local Schools 'A for Excellence,'" *New York Times*, Dec. 17, 1975.
3. *Americans and the Arts*, National Research Council of the Arts, an affiliate of Louis Harris Associates, New York, 1974.
4. Iver Peterson, "The Newest Innovation: Back to Basics," *New York Times*, Jan. 15, 1975, p. 91.
5. Charles Silberman (ed.), *The Open Classroom Reader*, Random House, Inc., New York, 1973, pp. 749–750.
6. Fred R. Schwartz, *Structure and Potential in Art Education*, Waltham, Mass., Blaisdell Publishing Company, a division of Ginn and Company, 1970.
7. Beatrice Gross and Ronald Gross, "British Infant Schools: American Style," in Frank Krajewski and Gary Peltier (eds.), *Education: Where It's Been; Where It's At; Where It's Going*, Charles E. Merrill Books, Inc., Columbus, Ohio, 1973, p. 199.

8. *Seventh Annual Gallup Poll of the Public's Attitudes Toward Public Schools,* as cited by George Gallup, "How the Public Views the Schools," *Changing Education/ American Teacher,* January 1976, pp. 4–8.

9. "Come In and Take a Look!" unpublished information pamphlet from Public Schools, Oakland, Calif., n.d.

10. W. J. Joyce, R. G. Oana, and W. R. Houston (eds.), *Elementary Education in the Seventies: Implications for Theory and Practice,* Holt, Rinehart, and Winston, Inc., New York, 1970.

11. Information compiled and coordinated by our research staff.

12. Elwyn S. Richardson, *In the Early World: Discovering Art Through Crafts,* Pantheon Books, a division of Random House, Inc., New York, 1964.

13. Don L. Brigham, "Visual Art in Interdisciplinary Learning," in Al Hurwitz (ed.), *Programs of Promise: Art in the Schools,* Harcourt Brace Jovanovich, Inc., New York, 1972, p. 85.

14. Personal communication from Mike Dean, Head Teacher, Music and Multimedia, Magnet Arts School, Eugene, Oreg., to staff member, December 1976.

15. *Essentials: The Essentials of a Quality School Art Program,* a position statement by the National Art Education Association, Washington, D.C., n.d., p. 7.

16. "Guidelines in Music Education: Supportive Requirements," Music Educators National Conference, Washington, D.C., 1972.

17. New York State Education Department, Albany Bureau of Music Education, *Major New Movements in Elementary School Music Education; A report on a One-Day Statewide Demonstration Workshop,* Albany, N.Y., 1969.

18. "Guidelines for Children's Dance," *Journal of Health, Physical Education and Recreation,* vol. 42, no. 6, June 1971.

19. Dudley Ashton and Charlotte Irey (eds.), *Dance Facilities,* American Association for Health, Physical Education, and Recreation, a national affiliate of the National Education Association, Washington, D.C., 1972.

20. *Preparing the Elementary Specialist: A Report of the Task Force on Children's Dance and the Elementary School Physical Education Commission,* American Association for Health, Physical Education, and Recreation, a national affiliate of the National Education Association, Washington, D.C., 1973.

21. Alvina T. Burrows, Chairman, National Conference on Research in English, *Children's Writing: Research in Composition and Related Skills,* National Council of Teachers of English, Champaign, Ill., 1960–61.

22. Sara W. Lundsteen (ed.), National Conference on Research in English, *Help for the Teacher of Written Composition,* Educational Resources Information Center (ERIC) Clearinghouse on Reading and Communication Skills, Urbana, Ill., 1976.

23. Martin Russell, "IMPACT: A Process for Generating Positive Attitudes Towards Learning," unpublished information paper, Columbus, Ohio, May 30, 1975, p. 4.

24. The foregoing information was taken from Russell, ibid., p. 5, and "Arts IMPACT Evaluation," conducted by Department of Evaluation, Research and Planning, Robert J. Rodosky, City School District Evaluator, Columbus, Ohio, during school year 1973–74.

25. Susan Perona, "Some Random Thoughts on This Year's Grant in Movement Education," unpublished communication to Cultural Arts Consultant, Goleta Union School District, Goleta, Calif., March 1976.

26. *Newsletter Number 2, 1974,* The Center for City Building Educational Programs, Los Angeles.

27. Howard Conant, "An Evaluation of 1972–73 Guggenheim Museum Children's Program 'Learning to Read Through the Arts,'" New York University, School of Education, Center for Educational Research and Field Services, New York, unpublished, 1973.

28. Dr. Elaine Raichle, Art Supervisor, Irvington Public Schools, Irvington, N.J., in staff interview, April 1976.

29. Paul F. Brandwein et al., *Self Expression and Conduct: The Humanities*, Harcourt Brace Jovanovich, Inc., New York, 1974.

30. Jerome Hausman and Flora Hausman, *Visual Sources for Learning*, Sandak, Inc., Stamford, Conn., 1975.

Creative energy and the adolescent

1. B. Frank Brown, Chairman, The National Commission on the Reform of Secondary Education, *The Reform of Secondary Education: A Report to the Public and the Profession*, McGraw-Hill Book Company, New York, 1973.

2. John H. Martin, Chairman, National Panel on High Schools and Adolescent Education, *Report of the National Panel on High Schools and Adolescent Education*, U.S. Office of Education, 1974.

3. James C. Coleman, Chairman, Panel on Youth of the President's Science Advisory Committee, *Youth: Transition to Adulthood*, University of Chicago Press, Chicago, 1974.

4. Glenys G. Unruh and William M. Alexander, *Innovations in Secondary Education*, Holt, Rinehart and Winston, Inc., New York, 1974, p. 137.

5. *Report on a Study of Music Programs in U.S. Elementary and Secondary Schools—1972–1973*, American Music Conference and the Music Educators National Conference, Chicago, February 1974.

6. *The Tanglewood Symposium: Music in American Society*, sponsored by the Music Educators National Conference, Washington, D.C., 1967, p. 2.

7. Betty Stearns and Clara Degen (eds.), *The Music Revolution*, The American Music Conference, Chicago, 1974, pp. 17–22.

8. Ibid., pp. 61–64.

9. *Education Daily*, newsletter published by Capitol Publications, Inc., Washington, D. C., Jan. 12, 1976, p. 2.

10. Joseph L. Peluso, *A Survey of the Status of Theater in United States High Schools*, Final Report, Project #9-0103, U.S. Department of Health, Education, and Welfare, November 1970, pp. 29–38.

11. Shirley Ririe, "A Quality Program of Dance on the High School Level," unpublished paper written for | I | D | E | A | (Institute for Development of Educational Activities, Inc.), Los Angeles, n.d.

12. "Contract for Students of High School of Performing and Visual Arts," High School of Performing and Visual Arts, Houston, n.d.

13. Sr. Grace Ann Geibel, "Allied Arts and Humanities Programs in Selected Secondary Schools of New York State," unpublished M.A. thesis, Eastman School of Music, University of Rochester, Rochester, N.Y., 1966, p. 61.

14. "Guidelines for Secondary Schools," Working Paper in the Humanities for Minnesota Schools, compiled by the Humanities Task Force, Minnesota State Department of Education, St. Paul, Minn., 1973–1974.

15. Eric Mortensen, Consultant-Evaluator, *Interim Report: Improving Visual Perceptual Skills in Art Classes in High Schools*, New York City Board of Education #09-63604, March 1976, pp. 6–7.

16. Kathryn Bloom, "Can the Arts Survive in the Schools?" *Musical America*, April 1976.

1. Carnegie Commission on Higher Education, *The Purposes and the Performance of Higher Education in the United States: Approaching the Year 2000*, McGraw-Hill Book Company, New York, 1973, p. 15.

2. Claude V. Palisca, "Quality of Life and Music Education," *Australian Journal of Music Education*, vol. 16, p. 9, April 1975.

3. Arthur Podolsky and Carolyn R. Smith (eds.), *Education Directory: Colleges and Universities, 1975–76*, U.S. Government Printing Office, Washington D.C., p. 27.

4. *1976 American Artist Art School Directory*, Billboard Publications, Inc., New York, 1976, pp. D2–D29.

5. Henry Rosovsky, *New York Times*, Nov. 10, 1976, p. B4.

6. Henry Acres, chancellor of Educational Ventures, Inc., Allentown, Pennsylvania, in staff interview, December 9, 1976.

7. Richard Wengenroth, chairman of the Art Department, Baruch College, New York, and Lou Wengenroth, director of the GLCA Arts Program, New York, in staff interview, Dec. 13, 1976.

8. Russell Lynes, "The Artist as Uneconomic Man," *Saturday Review*, Feb. 28, 1970, pp. 25–26.

9. Cited in William M. Dawson (ed.), *The 1975–76 Concert Season: A Prediction*, Association of College and University Concert Arts Administrators, Madison, Wis., October 1975.

10. Myra Martin, Speech before American Social Science Association, 1892, Cited in Frederick Logan, *Growth of Art in American Schools*, Harper and Brothers, New York, 1955, p. 97.

11. W. McNeil Lowry, "The University and the Creative Arts," *Educational Theatre Journal*, vol. 14, no. 2, May 1962, p. 106.

12. Robert Brustein, "The Spirit of Excellence: Theatre and the University," *Nurturing the Arts: A Special 60th Anniversary Supplement, The New Republic*, Nov. 16, 1974, p. 14.

13. Ibid., p. 15.

Powers behind the curriculum: teachers, artists and administrators

1. Guy Hubbard and Mary J. Rouse, "Art-Meaning, Method, and Media: A Structured Art Program for Elementary Classrooms," in Hurwitz, op. cit., p. 15.

2. Personal communication from Joan Gaines, Director of Public Relations, Music Educators National Conference, to staff member, Mar. 2, 1976.

3. Personal communication from Beverly Jeanne Davis, Managing Editor of Publications, National Art Education Association, to staff member, Mar. 16, 1976.

4. W. Vance Grant and C. George Lind, *Digest of Educational Statistics: 1974 Edition*, National Center for Education Statistics, U.S. Department of Health, Education, and Welfare, 1975, pp. 1–3.

5. "Guidelines for Teacher Preparation," a position statement by the NAEA Committee on Professional Standards, National Art Education Association, Washington, D.C., 1970.

6. *Teacher Education in Music: Final Report*, Commission on Teacher Education, Music Educators National Conference, Washington, D.C., 1972.

7. Jerrold Ross, *The Development of an Innovative Arts and Arts Education Curriculum: A Report Prepared for the Rockefeller Foundation*, New York University, New York, August 1975, p. 22.

8. W. Todd Furniss, Director of the Office of Academic Affairs, American Council on Education, in staff interview, February 1976.

9. Calvin W. Taylor, "Developing Effectively Functioning People," *Education*, vol. 94, no. 2, pp. 99–110, November/December 1973, and "Increasing Creative Minds and Creative Mind Power Producers in the Creativity Movement," a paper prepared for the UNESCO Conference *Creativity in Education* held at Valencia University, Valencia, Spain, Nov. 19, 1976.

10. Micki Seltzer, "'Arts Impact' Impact, Test Score Leap at Eastgate School Examined," *Columbus Call and Post*, Aug. 24, 1974, p. 10B.

11. "Interim Report: Creation and Appreciation in the Arts," unpublished document of the Creation and Appreciation in the Arts Planning Committee of the National Humanities Faculty, Concord, Mass., n.d.

12. *Performing Tree, 1973–1976: Measuring Three Years of Growth*, Arts Development Associates, Inc., Minneapolis, June 1976.

13. Dean C. Corrigan, "Do We Have a Teacher Surplus?" *Journal of Teacher Education*, vol. 25, no. 3, pp. 196–197, 1974.

14. W. Robert Houston and Robert B. Howsam (eds.), *Competency Based Teacher Education: Progress, Problems and Prospects*, Science Research Associates, Palo Alto, Calif., 1972.

15. U.S., Congress, Senate, *Congressional Record*, 93rd Cong., 2nd sess., 1974, pp. H10849–H10850.

16. Ibid.

17. Personal communication from Ann Vermel, Executive Director, Rhode Island State Council on the Arts, to staff member, Sept. 28, 1976.

18. Western States Arts Foundation, *Study Summary: A Study of the Poetry and Visual Arts Components of the Artists-in-Schools Program*, Denver, Colo., Sept. 30, 1976, p. 14.

19. Elliot W. Eisner, "Is the Artist in the School Program Effective?" *Art Education*, vol. 27, no. 2, February 1974, pp. 19–23.

20. Western States Arts Foundation, op. cit., p. 1.

21. Daniel Powell, *John Hay Whitney Foundation: A Report on the First Twenty-five Years—The John Hay Fellows*, John Hay Whitney Foundation, New York, 1972, vol. 2. pp. 2–3.

22. Ibid., p. 59.

23. Ibid., p. 146.

24. *Arts Impact: Curriculum for Change*, a summary report prepared by the Arts IMPACT Evaluation Team, Pennsylvania State University, University Park, March 1973, p. 2.

25. Personal communication from Henry L. Pearlberg, Coordinator of Fine Arts, Neshaminy School District, Langhorne, Pennsylvania, to staff member, Nov. 26, 1975.

26. "Position Paper: Arts Advisory Curriculum Committee," Neshaminy School District, Langhorne, Penn., June 25, 1975.

27. Personal communication from Vince Lindstrom, Cultural Resource Coordinator, Fargo Public Schools, Fargo, N.D., to staff member, Aug. 19, 1975.

28. New England Miniconference, "Leadership in the Arts," National Art Education Association, Boston, Feb. 27–Mar. 1, 1975.

1. Edward L. Kamarck (ed.), "The Surge of Community Arts: A Prefatory Note," *Arts in Society*, vol. 12, no. 1, Spring–Summer 1975, pp. 6–9.

2. Priscilla Dunhill, *Study on Community Arts Organization*, New York State Council on the Arts, New York, 1971.

3. Elisabeth Stevens, "The Urban Museum Crisis," *The Washington Post*, July 2, 1972, p. F2.

4. Topper Carew, "Black Arts for Black Youth," *Saturday Review*, July 18, 1970, p. 46.

5. Hilton Kramer, "Curators Seek Wider Museum Roles," *New York Times*, June 25, 1975.

6. Warner Muensterberger, "Roots of Primitive Art," Charlotte M. Otten (ed.), *Anthropology and Art*, The Natural History Press, New York, 1971, p. 123.

7. Dennis White, "Economic and Technological Influence on Society, Leisure and Art," *Studies in Art Education*, vol. 16, no. 2, 1975, p. 18.

8. Ibid., p. 25.

9. Bennett Schiff, *Arts in Parks and Recreation Settings*, National Endowment for the Arts, Washington, D.C., 1973, pp. 18–19.

10. Max Kaplan, "The Arts and Recreation—Not-So-Strange Bedfellows," *Parks and Recreation*, vol. 9, June 1974, pp. 27, 91.

11. Edmund Carpenter, "Art and the Declassification and Reclassification of Knowledge," *Proposals for Art Education*, The Carnegie Corporation of New York, New York, 1970, p. 36.

12. John Michael Kohler Arts Center, brochure, Sheboygan, Wis., n.d.

13. Louis Harris, *Americans and the Arts*, National Research Center of the Arts, New York, 1974.

14. Personal communication to staff researcher from Shirley Genther, Director of Urban Gateways Program, Chicago.

15. Maryo Ewell and Peter Ewell, "Planning for Grassroots Arts Development: A Research Study of Nine Communities in Transition," *Arts in Society*, vol. 12, Spring–Summer 1975, p. 94.

16. Ibid.

17. "Arts Education for the General Public," *Reports from the Canadian Conference of the Arts* (Canadian Working Papers, Proceedings, and Recommendations of UNESCO Meeting of Experts) Ottawa, February 1970.

18. Don D. Bushnell, "Black Arts for Black Youth," *Saturday Review*, July 18, 1970, p. 43.

19. "Operation Rainbow," *The Fourth Street i*, New York, no. 2, 1969.

20. *The Status of the Arts in Michigan: Report of the Joint Legislative Committee on the Arts*, Senator Jack Faxon, Chairman, n.p., n.d., p. 29.

21. James P. Anderson, "Who Shall Teach Children Art?" *School Arts*, vol. 80, November 1969, p. 25.

22. Louis Harris, *Museums USA: A Survey Report*, National Research Center of the Arts and National Endowment for the Arts, Washington, D.C., 1975.

23. Children's Art Carnival, *Annual Report 1973–1974*, Director's Statement, New York, p. 4.

24. Barbara Y. Newsom, "On Understanding Art Museums," *Studies in Art Education*, vol. 16, no. 2, p. 54, 1975.

25. Junius Eddy, "Beyond 'Enrichment': Developing a Comprehensive School-Community Arts Curriculum," in Jerome J. Hausman (ed.), *Issues and Options in Art Education* (tentative title), McGraw-Hill, New York, forthcoming.

The promise and the problems of the media

1. Eliot Wigginton (ed.), *Foxfire*, Anchor Books, New York, 1973.
2. Center for Understanding Media/New School for Social Research, *Master of Arts in Media Studies* (information brochure), New York, 1975, p. 1.

Analyzing the present, mapping the future

1. Daniel W. Gilmore, "Plan of Action for Arts Education in the State of Michigan," *Michigan School Board Journal*, vol. 22, no. 4, p. 28, June 1975.
2. August Heckscher, in his role as Cultural Advisor to President Kennedy.
3. August Heckscher, *The Arts and the National Government*, a report to the President, May 28, 1963, p. 16.
4. Junius Eddy, "Perspectives on the Arts and General Education," an information paper for the Rockefeller Foundation, New York, January 1974, p. 13.
5. Ibid., p. 15.
6. PL 89-209, sec. 12, 13.
7. Eddy, op. cit., p. 10.
8. Junius Eddy, *A Review of Federal Programs Supporting the Arts in Education*, a report to the Ford Foundation, New York, May 1970.
9. Judith Murphy and Lonna Jones, *Research in Arts Education: A Federal Chapter*, to be published by the Office of Education, U.S. Department of Health, Education, and Welfare, with Arts/Worth (a project of the American Council for the Arts in Education), in early 1977.
10. National Endowment for the Arts, *National Endowment for the Arts Guide to Programs, 1976–1977*, Washington, D.C., August 1976, p. 21.
11. "Arts-in-Education Study Project," unpublished report of the National Endowment for the Arts, November 1976.
12. *Program Announcement 1974–1975*, National Endowment for the Humanities, p. 9.
13. Personal communication from Martin Engel, Arts and Humanities Advisor to the National Institute of Education, to staff member, December 8, 1976.
14. Education Amendments of 1974, PL 93-380, enacted Aug. 21, 1974, sec. 409.
15. Personal communication from Harold Arberg, Director of the Arts and Humanities Staff, Office of Education, U.S. Department of Health, Education, and Welfare, to staff member, May 1976.
16. Linda Coe, *Cultural Directory: Guide to Federal Funds and Services for Cultural Activities*, Associated Councils of the Arts, New York, 1975.
17. Rufus E. Miles, Jr., *A Cabinet Department of Education: Analysis and Proposal*, American Council on Education, Washington D.C., 1976, p. 2.
18. Ibid., p. 2.
19. Ibid., p. 3.
20. The following discussion of state government is based on extensive staff interviews in the three states studied.
21. This discussion is based on data provided by Cynthia Reade, Technical Assistance Coordinator, Associated Councils on the Arts, October 1976.
22. Robert J. McCartney, "A Minor Renaissance Is Turning City Hall into Center of Culture," *Wall Street Journal*, Mar. 15, 1976, p. 1.
23. Ibid., p. 1.

Selected bibliography

A

Abrahamson, Joan: *The Alvarado School-Community Art Program*, The Alvarado School Workshop, Inc., San Francisco, 1973.

Action Research Project: 1969–1972, Description of a joint project of the Docent Council of the Los Angeles County Museum of Art, the office of the Los Angeles County Superintendent of Schools, and four school districts, Los Angeles, Calif., 1973.

Aesthetic Education Program: Final Evaluation Report 1974–1975, Seattle University, Seattle, Wash., 1975.

Albers, Josef: *Search Versus Research*, Trinity College Press, Hartford, Conn., 1969.

Americans and the Arts, National Research Center of the Arts, an affiliate of Louis Harris and Associates, Inc., New York, 1974.

Anderson, F. P.: "Mainstreaming Art as well as Children," *Art Education*, vol. 28, no. 8, December 1975.

Anderson, Yvonne: *Teaching Film Animation to Children*, Van Nostrand Reinhold Company, New York, 1971.

Andrews, Michael F.: *Synaesthetic Education*, Syracuse University Press, Syracuse, N. Y., 1971.

Annual Report of the U.S. Commission of Education, U.S. Department of Health, Education, and Welfare, Washington, D.C., 1974.

Arnheim, Rudolf: *Art and Visual Perceptions*, University of California Press, Berkeley, 1954.

Arnold, Robert: "The State of Teacher Education: An Analysis of Selected Art Teacher Preparation Programs in the United States," *Art Education*, vol. 29, no. 2, February 1976.

Arnstein, Flora J.: *Children Write Poetry: A Creative Approach*, Dover Publications, Inc., New York, 1967.

Aronoff, Frances Webber: "No Age Is Too Early to Begin: Another Look at Young Children and Music Movement," *Music Educators Journal*, vol. 60, no. 7, March 1974.

Art and the Integrated Day, vol. 1, no. 1, G.A.M.E., Inc., New York, Spring 1975.

Art Education: Middle/Junior High School, The National Art Education Association, Washington, D.C., 1972.

Art Education: Senior High School, The National Art Education Association, Washington, D.C., 1972.

Art Is . . . , Sears-Roebuck Foundation, film, 1970. Available from: Sears-Roebuck Foundation, Audio-Visual Department, 303 East Ohio Street, Chicago, Ill. 60611.

"Art Services for Rural Schools," *Art Education*, vol. 23, no. 8, November 1970.

Artists-in-Schools, National Endowment for the Arts, film, 1975. Available from: National Endowment for the Arts, Washington, D.C.

Arts: An Alternative in Education, Expansion Arts, film, 1975. Available from: National Endowment for the Arts, Washington, D.C.

Arts and the Handicapped, Educational Facilities Laboratories, Inc., New York, 1975.

Arts and the People, National Research Center of the Arts, Inc., an affiliate of Louis Harris and Associates, Inc., New York, 1973.

Arts and the Schools: Patterns for Better Education, Report of the New York State Commission on Cultural Resources, 1972.

"Arts Education in California," special issue, *California School Boards*, vol. 34, no. 6, California School Board Association, Sacramento, Calif., June 1975.

Arts IMPACT: Curriculum for Change, Arts IMPACT Evaluation Team and the United States Office of Education, Washington, D.C., 1973.

The Arts in School, Terry Mack and Dan Mack, videotape, 1976. Available from: Teachers and Writers Collaborative, 186 West 4th Street, New York, N.Y. 10012.

The Arts in Secondary Education, Final Report of the Arts Curriculum Development Project, National Endowment for the Arts, Washington, D.C., 1970.

Ashton, Dudley, and Charlotte Irey (eds.): *Dance Facilities*, American Association for Health, Physical Education and Recreation, Washington, D.C., 1972.

Ashton-Warner, Sylvia: *Spearpoint: "Teacher" in America*, Vintage Books, Random House, Inc., New York, 1972.

Atkinson, J. Edward: *Black Dimensions in Contemporary American Art*, New American Library, Inc., New York, 1971.

B

Bailyn, Bernard: *Education in the Forming of American Society*, Vintage Books, Random House, Inc., New York, 1960.

Baker, David: "Trends in Secondary School Art: Emphasis . . . Middle and Junior High School," *Art Education*, vol. 29, no. 2, February 1976.

Ballard, Louis W.: "Put American Indian Music in the Classroom," *Music Educators Journal*, vol. 56, no. 7, March 1970.

Barkan, Manuel (ed.): *New Directions in Art Education*, Report of the International Symposium, Belgrade, Yugoslavia, National Art Education Association, Washington, D.C., 1967.

Barron, Frank: *Artists in the Making*, Seminar Press, New York, 1972.

Battcock, Gregory (ed.): *New Ideas in Art Education*, E. P. Dutton & Co., Inc., New York, 1973.

Bay, Ann: *Museum Programs for Young People*, The Smithsonian Institution, Washington, D.C., 1973.

Beechhold, Henry: *The Creative Classroom: Teaching without Textbooks*, Charles Scribner's Sons, New York, 1971.

Beittel, Kenneth: *The Effect of Self-reflective Training in Art on the Capacity for Creative Action*, Pennsylvania State University, University Park, 1964.

——— and Robert Burkhart: "Strategies of Spontaneous, Divergent and Academic Art Students," *Studies in Art Education*, vol. 5, no. 1, 1963.

Bell, Terrel H.: "The Principal's Chair: Pivotal Seat in Secondary Education," *NASSP Bulletin*, vol. 59, no. 391, May 1975.

Berlyne, D.: *The Psychology of Aesthetic Behavior*, Pennsylvania State University, University Park, 1968.

Better Schools through Better Partnerships: The Final Report and Recommendations of the Council of Chief State School Officers' National Field Task Force on the Improvement and Reform of American Education, U.S. Department of Health, Education, and Welfare, 1974.

Black Filmmakers Hall of Fame 1975, Oakland Museum, Cultural and Ethnic Affairs Guild, Oakland, Calif., 1975.

Bloom, Kathryn: *Arts Organizations and Their Services to Schools: Patrons or Partners?* The JDR 3rd Fund, Inc., New York, 1974.

Boorman, Joyce: *Dance and Language Experience for Children*, Longman Canada Ltd., 1973.

Brandstadter, J. Torche: "The Artist in Higher Education," *Art Journal*, vol. 29, no. 1, Fall 1969.

Brandwein, Paul F., et al.: *Self Expression and Conduct: The Humanities*, Harcourt Brace Jovanovich, Inc., New York, 1974.

Brittain, Lambert: "Art in Elementary Education Today," *Art Education*, vol. 29, no. 2, February 1976.

———: *Creativity and Art Education*, National Art Education Association, Washington, D.C., 1964.

Broudy, Harry S.: "Preparing Teachers of Aesthetic Education," *Teacher Education for Aesthetic Education: A Progress Report*, Central Midwestern Regional Educational Laboratory, Inc. (CEMREL), St. Louis, 1971.

Brown, B. Frank: "Changing Values in the 70's: A Study of American Youth," *NASSP Bulletin*, vol. 59, no. 381, May 1975.

Bruner, Jerome S.: *On Knowing: Essays for the Left Hand*, Harvard University Press, Cambridge, Mass., 1962.

Burgard, Ralph: *The Creative Community: Arts and Science Programs for New and Renewing Communities*, Associated Councils of the Arts, New York, n.d.

Burris-Meyer, Harold: *An Inquiry into the Educational Potential of Non-verbal Communication*, Florida Atlantic Arts Institute, Boca Raton, Fla., 1971.

Bushnell, Don C., and Topper Carew: "Black Arts for Black Youth," *Saturday Review*, July 18, 1970.

C

Californians and the Arts, National Research Center of the Arts, an affiliate of Louis Harris and Associates, Inc., New York, 1975.

Carpenter, Thomas H.: *Televised Music Instruction*, Music Educators National Conference, Washington, D.C., 1973.

Carroll, Jean, and Peter Lofthouse: *Creative Dance for Boys*, MacDonald & Evans, Ltd., London, 1969.

Catalogue of Federal Education Assistance Programs: An Indexed Guide to the Federal Government's Programs Offering Educational Benefits to the American People, U.S. Office of Education, 1974.

Cawelti, Gordon: *Vitalizing the High School*, Association for Supervision and Curriculum Development, Washington, D.C., 1974.

Children's Theatre of John Donahue, D. A. Pennebaker, film, 1971. Available from: Pennebaker, Inc., 56 West 45th Street, New York, N.Y. 10036.

313

Choate, Robert A. (ed.): *Documentary Report of the Tanglewood Symposium*, Music Educators National Conference, Washington, D.C., 1968.

Churchill, Angiola R.: *Art for Preadolescents*, McGraw-Hill Book Company, New York, 1971.

Coe, Linda (ed.): *Cultural Directory: Guide to Federal Funds and Services for Cultural Activities*, Associated Councils of the Arts, New York, 1975.

College Art Association of America (eds.): *The Visual Arts in Higher Education*, Yale University Press, New Haven, Conn., 1966.

College Bound Seniors, 1974–75, College Entrance Examination Board, New York, 1975.

Colwell, R., and C. Schwartz: "Aesthetic Education and the Performing Arts," *Journal of Aesthetic Education*, vol. 4, no. 2, April 1970.

A Compilation of Federal Education Laws, as Amended through December 31, 1974, U.S. Government Printing Office, 1975.

Comprehensive Arts Planning: October 1975, Ad Hoc Coalition of States for the Arts on Education, New York, 1975.

The Condition of Education: A Statistical Report on the Condition of American Education 1975, National Center for Education Statistics, Washington, D.C., 1975.

"Conflict, Craftsmen, and Professionals: A Sociological View of the Art Teacher," *Art Education*, vol. 23, no. 2, February 1970.

Conrad, George: *The Process of Art Education in the Elementary School*, Prentice-Hall, Inc., Englewood Cliffs, N.J., 1964.

Cotton, F. Jane: "Extending the Classroom by Community Experience," *NASSP Bulletin*, vol. 59, no. 391, May 1975.

Council for Research in Music Education, Special Issue, Bulletin No. 43, University of Illinois, Urbana, Summer 1975.

A Course Guide in the Theatre Arts at the Secondary School Level, rev. ed., American Theatre Association, Inc., Washington, D.C., 1975.

Cwi, David, and Albert Diehl: *In Search of a Regional Policy for the Arts: Phase I Report Prepared for the Joint Committee on Cultural Resources*, The Johns Hopkins Center for Metropolitan Planning and Research, Baltimore, 1975.

D

Dame, V. D.: "Art, Artists, and Environmental Awareness," *Art Education*, vol. 23, no. 7, October 1970.

Dancers in Schools, D. A. Pennebaker, film, 1971. Available from: National Endowment for the Arts Film Library, 600 Grand Avenue, Ridgefield, N.J. 07657.

Daniell, Rosemary: *Joy to the Word!* Georgia Council for the Arts, Atlanta, 1972–1973.

Daniels, William G.: "The Epworth Jubilee Community Arts Center of Knoxville, Tennessee: Community Arts in an Urban Appalachian Center," *Arts in Society*, vol. 12, Spring–Summer 1975.

Dennis, Lawrence E., and Renate M. Jacob (eds.): *The Arts in Higher Education*, Jossey-Bass, Inc., Publishers, San Francisco, 1968.

The Development of an Innovative Arts and Arts Education Curriculum, New York University, School of Education, Health, Nursing, and Arts Profession, New York, 1975.

Dewey, John: *Art as Experience*, Capricorn Books, G. P. Putnam's Sons, New York, 1958.

Dimondstein, Geraldine: *Exploring the Arts with Children*, The MacMillan Company, New York, 1974.

Dorethy, Rex E.: "Relevancy of College Art Education Programs," *Art Education*, vol. 25, no. 6, June 1972.

Dorn, C. M.: "Art Education without Walls," *Art Education*, vol. 22, no. 2, February 1969.

Doxiadis, Constantine A.: *Architecture in Transition*, Oxford University Press, New York, 1968.

E

Ecker, David W.: *Defining Behavioral Objectives for Aesthetic Education: Issues and Strategies for Their Resolution*, Central Midwestern Regional Educational Laboratory, Inc. (CEMREL), St. Ann, Mo., n.d.

———: "Evaluating the Art Curriculum: The Brookline Experience," *Art Education*, vol. 27, no. 2, February 1974.

"The Ecology of Education: The Arts," *The National Elementary School Principal*, vol. 55, no. 3, January/February, 1976.

Eddy, Junius: *A Review of Federal Programs Supporting the Arts in Education*, A Report to the Ford Foundation, New York, May 1970.

———: *A Review of Projects in the Arts Supported by ESEA's Title III*, A Report to the Ford Foundation, New York, August 1970.

Educational Change and Architectural Consequences, Educational Facilities Laboratories, Inc., New York, 1968.

Eisner, Elliot W.: *Educating Artistic Vision*, The Macmillan Company, New York, 1972.

———: "Is the Artist-in-the-School Program Effective?" *Art Education*, vol. 27, no. 23, February 1974.

——— and David Ecker: *Readings in Art Education*, Blaisdell Publishing Company, a division of Ginn and Company, Waltham, Mass., 1966.

Engel, Martin: "The Future of Aesthetic Education," Speech given at National Art Education Association, Miami, Apr. 7, 1975.

Englesman, Alan: "Improvisation in the English Classroom," *Secondary School Theatre Journal*, vol. 14, no. 2, Winter 1975.

Erikson, Erik H.: *Childhood and Society*, W. W. Norton & Company, Inc., New York, 1963.

————: "Youth, Fidelity and Diversity," Erik H. Erikson (ed.), *Youth Change and Challenge*, Basic Books, Inc., Publishers, New York, 1963.

The Essentials of a Quality School Art Program, A Position Statement by the National Art Education Association, Washington, D.C., 1970.

"Evaluation Guidelines for Multicultural/Multiracial Education," *National Study of School Evaluation*, Arlington, Pa., 1973.

Ewell, Maryo, and Peter Ewell: "Planning for Grassroots Arts Development: A Research Study of Nine Communities in Transition," *Arts in Society*, vol. 12, Spring–Summer, 1975.

The Exploratorium, Jon Boorstin, film, 1975. Available from: The Exploratorium, 3601 Lyons Street, San Francisco, Calif. 94123.

Extending the Dream, Report of the 1975 Artists-in-Schools National Conference, National Endowment for the Arts, Washington, D.C., 1975.

F

"Facing the Music in Urban Education," Special Issue, *Music Educators Journal*, January 1970.

Feldman, E.: *Becoming Human through Art: Aesthetic Experience in the Schools*, Prentice-Hall, Inc., Englewood Cliffs, N.J., 1970.

Financial Status of the Public Schools 1975, National Education Association, Reston, Va., 1975.

Financing Public Education: More Than One View, Special Paper, The National Association of Secondary School Principals, Washington, D.C., April 1972.

The First National Assessment of Musical Performance, National Assessment of Educational Progress: A Project of the Education Commission of the States, Denver, 1974.

Forman, Bernard: "Currents and Countercurrents in Art Education," *Art Education*, vol. 26, no. 9, December 1973.

Foshay, Arthur W.: "Toward a Humane Curriculum," Paper Prepared for the Lehigh Conference, Columbia University, Teachers College, New York, April 1974.

Foster, Betty J.: *Statistics of Public Elementary and Secondary Day Schools, Fall 1973*, National Center for Educational Statistics, Washington, D.C., 1974.

"Four Special High Schools for the Gifted Keep Stability amidst All the Changes," *New York Times*, July 10, 1975.

Fourth Street i, Mike Jacobson and Peter Kleinbard, videotape, 1973. Available from: National Commission for Youth Resources, 36 West 44th Street, New York, N.Y. 10036.

Fowler, Charles (ed.): *Youth Music in Education*, Music Educators National Conference, Washington, D.C., 1969.

Foxfire, Mike Jacobson and Peter Kleinbard, videotape, 1973. Available from: National Commission for Youth Resources, 36 West 44th Street, New York, N.Y. 10036.

Friam, Mary (ed.): *Performing Tree Guide to the Performing Arts*, The Junior League of Los Angeles, Inc., Los Angeles, 1974.

Furner, Beatrice: *Creative Writing through Creative Dramatics*, Annual Meeting of the National Council of Teachers of English, Urbana, Ill., 1971.

G

Gainer, Ruth Straus: "Painting Poetry," *Art Teacher*, Spring 1974.

Gair, Sondra: "Theater: A Total Art Education Experience for Children," *Art Education*, vol. 23, no. 8, November 1970.

Gallup, George: "How the Public Views the Schools," *Changing Education/American Teacher*, January 1976.

Galton, Francis: *Inquiries into Human Faculty and Its Development*, E. P. Dutton & Co., Inc., New York, 1911.

Gardner, Howard: *The Arts and Human Development: A Psychological Study of the Artistic Process*, John Wiley & Sons, Inc., New York, 1973.

Gary, Charles L., and Beth Landis: *The Comprehensive Music Program*, Music Educators National Conference, Washington, D.C., 1973.

Geerdes, Harold P.: *Planning and Equipping Educational Music Facilities*, Music Educators National Conference, Reston, Va., 1975.

Geibel, Sister Grace Ann: "Music in Humanities and Related Arts Programs in Selected American Secondary Schools," Ph.D. Thesis, University of Rochester, Eastman School of Music, Rochester, N.Y., 1974.

Gelvin, Miriam P.: "Arts Experiences in Early Childhood Education: Developing Perceptual Awareness through a Related Arts Approach," *Music Educators Journal*, vol. 60, no. 7, March 1974.

Gerbrandt, Gary L.: *An Idea Book for Acting Art and Writing Language*, National Council of Teachers of English, Urbana, Ill., 1974.

315

Gertler, Diane B., and Logan C. Ostendorf: *Summary of Offerings and Enrollments in Public Secondary Schools 1972–73*, National Center for Education Statistics, Washington, D.C., 1975.

Getzels, Jacob, and Philip Jackson: *Creativity and Intelligence*, John Wiley & Sons, Inc., New York, 1962.

Goldin, Amy: "The University Art School: Limbo for Alienated Youth," *Art in America*, vol. 61, no. 3, May 1973.

Goodlad, John: "Schools *Can* Make a Difference," *Educational Leadership*, vol. 33, November 1975.

Goodman, Nelson: *Languages of Art: An Approach to a Theory of Symbols*, The Bobbs-Merrill Company, Inc., New York, 1968.

Gowan, J. C., G. D. DeMoss, and E. P. Torrance: *Creativity: Its Educational Implications*, John Wiley & Sons, Inc., New York, 1974.

Graduation Requirements, The National Association of Secondary School Principals, Reston, Va., 1975.

Grant, Vance, and C. George Lind: *Digest of Educational Statistics: 1974 Edition*, National Center for Education Statistics, Washington, D.C., 1975.

Grayson, Lawrence P., Frank W. Norwood, and Harold E. Wigren: *Man-made Moons: Satellite Communications for Schools*, National Education Association, Washington, D.C., 1972.

Gross, Ronald, and Beatrice Gross: "British Infant Schools—American Style," in Frank Krejewski and Gary Peltier (eds.), *Education: Where It's Been; Where It's At; Where It's Going*, Charles E. Merrill Books, Inc., Columbus, Ohio, 1973.

Grove, Richard: *The Arts and the Gifted: Proceedings from the National Conference on Arts and Humanities/Gifted and Talented*, Reston, Va., The Council for Exceptional Children, 1975.

Guenther, Annette: "Open Education Puts the Arts in the Core of Curriculum," *New Ways*, Cambridge, Mass., September–October 1975.

Guide to Programs, National Endowment for the Arts, Washington, D.C., 1975.

Guidelines for Certification Media Specialists, extended version, Association for Educational Communications and Technology, Washington, D.C., 1972.

Guidelines: Curriculum Development for Aesthetic Education, Central Midwestern Regional Educational Laboratory, Inc. (CEMREL), St. Ann, Mo., 1970.

Guidelines for Teacher Preparation, National Art Education Association, Washington, D.C., 1970.

Guilford, J. P.: "The Structure of Intellect," *Psychological Bulletin*, vol. 53, 1965.

H

Hairston, Major T., and Murill F. Cooper: *Visual Imagery: A Means for Improving Self-Concept—Evaluation Report*, Board of Public Education, Wilmington, 1973.

Halprin, Lawrence: *The RSVP Cycles: Creative Processes in the Human Environment*, George Braziller, Inc., New York, 1969.

Hands-On Museums: Partners in Learning, A Report from Educational Facilities Laboratories, Inc., New York, 1975.

Hanks, Nancy: "The Arts in the Schools: A 200-Year-Old Struggle," *American Education*, vol. 11, no. 7, July 1975.

Hansen, Brian K.: "Aesthetic Education: An Instinctive Response," *Secondary School Theatre Journal*, vol. 14, no. 3, Spring 1975.

———: *A Curriculum Model for Theatre in Aesthetic Education*, Central Midwestern Regional Educational Laboratory, Inc. (CEMREL), St. Louis, Mo., 1972.

Hapgood, Marilyn (ed.): *Supporting the Learning Teacher*, Agathon Press, New York, 1975.

Hardiman, George W., and Theodore Zernich (eds.): *Review of Research in Visual Arts Education*, no. 4, Office of Continuing Education and Public Service, Urbana, Ill., Spring 1975.

Harrison, Margaret: "Theatre and Aesthetic Education," *Secondary School Theatre Journal*, vol. 14, no. 3, Spring 1975.

Harvey, Emily Dennis, and Bernard Friedberg: *A Museum for the People*, Arno Press, New York, 1971.

Hausman, Jerome J.: *The Museum and the Art Teacher*, The George Washington University and the National Gallery of Art, Washington, D.C., n.d.

——— and Sister Jeanne Ryan: "Degree Requirements for Art Faculty: Appointments, Promotion and Tenure," *Art Journal*, vol. 32, no. 2, Winter 1972.

Hawkins, Alma M.: *Creating through Dance*, Prentice-Hall, Inc., Englewood Cliffs, N.J., 1974.

Hedley, Carolyn: "Creative Reading Programs at Children's Art Carnival: Evaluation Report," New York, unpublished paper, 1975.

Heinig, Ruth, and Lydia Stilwell: *Creative Dramatics for the Classroom Teacher*, Prentice-Hall, Inc., Englewood Cliffs, N.J., 1974.

High Schools, Gordon Cawelti, Association for Supervision and Curriculum Development, audiotapes, 1975.

Hillson, Maurice (ed.): *Elementary Education*, The Free Press, New York, 1967.

Hoffa, Harlan: *An Analysis of Recent Research Conferences on Art Education*, report prepared for the Bureau of Research, U.S. Office of Education, 1970.

Hoffman, Donald H.: "A Total Arts Program Concept: Building Cooperation between Community and School," *Arts in Society*, vol. 12, Spring–Summer 1975.

Holbrook, Hollis: "Painting for Non-Majors," *Art Journal*, vol. 29, no. 4, Summer 1970.

Horsman, Joan: *The Arts and Education: A Partnership for Action*, The Canadian Conference of the Arts, Toronto, 1975.

Houston, W. Robert, and Robert B. Howsam (eds.): *Competency Based Teacher Education: Progress, Problems and Prospects*, Science Research Associates, Palo Alto, Calif., 1972.

How Does a Rainbow Feel? David Holden, film, 1975. Available from: Central Midwestern Regional Educational Laboratory, Inc. (CEMREL), 3120 59th Street, St. Louis, Mo. 63139.

Hubbard, Guy: "Trends in Secondary School Art," *Art Education*, vol. 29, no. 2, February 1976.

Hudson, Tom: "'Pure' and 'Applied' Art: The Need for the Right Balance in Education," *Studio International*, vol. 173, January 1967.

Huff, Robert A., and Marjorie O'Chandler (eds.): *A Taxonomy of Instructional Programs in Higher Education*, U.S. Department of Health, Education, and Welfare, 1970.

Hurwitz, Al (ed.): *Programs of Promise: Art in the Schools*, Harcourt Brace Jovanovich, Inc., New York, 1972.

Ianni, Francis A. J.: "The Arts as Agents for Social Change: An Anthropologist's View," Doris L. Barclay (ed.), *Art Education for the Disadvantaged Child*, National Art Education Association, Washington, D.C., 1969.

I Have Something to Tell You, New York State Poets-in-the-Schools, Inc., Chappaqua, N.Y., 1975.

Implications of the Teachers' Centre, Institute for Development of Educational Activities, Inc. (| I | D | E | A |), Dayton, Ohio, 1975.

"International Symposium on Music Today and Learning," *Music Educators Journal*, vol. 58, no. 7, March 1972.

I

Jacobs, Lewis: *The Rise of the American Film*, Teachers College Press, Columbia University, New York, 1968.

James, Charity: "The Child's Growth through Art," *American Journal of Art Therapy*, vol. 15, no. 1, October 1975.

Jensen, Olive Jacobson: "Ethnic/Folk Arts: A Curriculum Resource for the 1970's," *Art Teacher*, Winter 1975.

Johnson, Thomas J., and Robert J. Hess: *Tests in the Arts*, rev., Central Midwestern Regional Educational Laboratory, Inc. (CEMREL), St. Ann, Mo., 1971.

Jones, Richard M.: *Fantasy and Feeling in Education*, New York University Press, New York, 1970.

Journal of Health, Physical Education and Recreation, vol. 42, no. 6, June 1971.

Joyce, W. J., R. G. Dana, and W. R. Houston (eds.): *Elementary Education in the Seventies: Implications for Theory and Practice*, Holt, Rinehart and Winston, Inc., New York, 1970.

Judy, Stephen N., and Patrick L. Courts: *The Creative Word 6*, Random House, Inc., New York, 1974.

J

Kaplan, Max: "Educational Malnutrition Needs Vitamin A for Art," *Art Teacher*, vol. 4, no. 3, Fall 1974.

Kaufman, Irving: *Art and Education in Contemporary Culture*, The Macmillan Company, New York, 1973.

Kaufman, M.: "Teaching with Artists," *Elementary School Journal*, vol. 75, no. 6, March 1975.

Keith, Lowell, Paul Blake, and Sidney Tiedt: *Contemporary Curriculum in the Elementary School*, Harper & Row, Publishers, Incorporated, New York, 1968.

Keitz, R. A.: "Re-training of Teachers for Interdisciplinary Arts Teaching," *Viewpoints*, vol. 3, no. 1, Illinois State University, Center of Visual Arts, Normal, Ill., 1975.

Kellogg, Rhoda: *What Children Scribble and Why*, National Press, Palo Alto, Calif., 1955.

—— and Scott O'Dell: *The Psychology of Children's Art*, CRM, Inc., San Diego, 1967.

Kelly, H.: "Artists and Arts Education," *Art Education*, vol. 22, no. 4, April 1969.

Kennedy, Keith: *Film Making in Creative Teaching*, Watson-Guptill Publications, New York, 1972.

Kern, Evan J.: *Pace and the Arts: A Survey of Title III Projects—January 1966 to July 1967*, Central Midwestern Regional Laboratory, Inc. (CEMREL), St. Ann, Mo., 1968.

Kinard, John R.: "The Neighborhood Museum and the Inner City," unpublished paper available through the Anacostia Neighborhood Museum, Washington, D.C., n.d.

King, Bruce: "Movement and Learning: The Priority for Dance in Elementary Education," *Dance Magazine*, New York, October 1973.

Kingham, Jon Rye: "Individually Guided Education: A High School Change Program," *NASSP Bulletin*, vol. 58, no. 380, January 1973.

Kirby, Kent: "Art, Technology and the Liberal Arts College," *Art Journal*, vol. 29, no. 3, Spring 1970.

Kirshenbaum, Howard, Sidney B. Simon, and Roney W. Napier: *Wad-Ja' Get? The Grading Game in American Education*, Hart Publishing Company, New York, 1971.

Knox, Gerald M.: "Parent's Guide to What's Happening in Education," *Better Homes and Gardens*, March 1976.

Koch, Kenneth: *Wishes, Lies and Dreams: Teaching Children to Write Poetry*, Chelsea House Publishers, New York, 1970.

Kodály, Zoltán: *The Selected Writings of Zoltán Kodály*, ed. Ferenc Bónis, trans. 1964; reprint edition, Lili Halápy and Fred Macnicol, Boosey and Hawkes Music Publishers Limited, London, 1974.

Kornfeld, Paul: "The Institution of Community Art Programs by Art Departments in Higher Education," *NCAA Bulletin*, March 1975.

Korot, Beryl, and Ira Schneider (eds.): *Video and Kids*, Gordon and Breach, Science Publishers, Inc., New York, 1974.

Kuhn, Marylou: "Editorial—Where the Action Is: Upsurge in Arts in the Community," *Studies in Art Education*, 1975.

L

Lambert, Hazel M.: *Elementary Education*, Center for Applied Research, Inc., Washington, D.C., 1963.

Langer, Susanne: *Feeling and Form: A Theory of Art*, Charles Scribner's Sons, New York, 1953.

Learning Is an Adventure, City-as-School, New York, 1974–1975.

Learning Music as a Language, Summary Report, Title III, ESEA Project, Georgia Department of Education, Columbus, Ga., July 1970–June 1974.

Learning through Movement, Paul Barlin and Ann Barlin, Sycamore Elementary School, Claremont, Calif., film, 1966. Available from: SL Film Productions, 5126 Hartwick Street, Los Angeles, Calif. 90041.

Lee, Murray J.: *Elementary Education: Today and Tomorrow*, Allyn and Bacon, Inc., Boston, 1966.

Lehman, Phyllis: "Putting the Arts in the Union Hall," *The Cultural Post*, National Endowment for the Arts, Washington, D.C., July–August 1976.

Lewis, Michael: "Weave Music into the Fabric of City Life," *Music Educators Journal*, vol. 50, no. 8, April 1970.

Lidstone, John: *Art for the Mentally Retarded*, Queens College, New York, 1972.

Liebert, Robert M., John M. Neale, and Emily S. Davidson: *The Early Window*, Pergamon Press, New York, 1973.

Locke, John: "Of Ideas," *Essay concerning Human Understanding*, Gateway Press, Chicago, 1956.

Lomax, John A., and Alan Lomax: *Folk Song U.S.A.*, Duell, Sloan & Pearce, Inc., New York, 1947.

Lowenfeld, Victor, and W. Lambert Brittain: *Creative and Mental Growth*, The Macmillan Company, New York, 1975.

M

McCarty, Donald J., and Associates: *New Perspectives in Teacher Education*, Jossey-Bass, Inc., Publishers, San Francisco, 1973.

McCaslin, Nellie: *Theatre for Children in the United States: A History*, University of Oklahoma Press, Norman, 1971.

McCulley, Clyde E.: "Background of Art in Higher Education," *National Council of Art Administrators Report*, Washington, D.C., 1975.

McGeary, Clyde: "Pennsylvania Comprehensive Arts in Education," *New Ways*, vol. 1, no. 4, Educational Arts Association, Cambridge, Mass., May–June 1975.

Madeja, Stanley: *All the Arts for Every Child*, The JDR 3rd Fund, Inc., New York, 1973.

——, Nadine J. Meyers, Suzanne A. Dudley, and Donald Jack Davis: *The Artist in the School: A Report on the Artist-in-Residence Project*, Central Midwestern Regional Educational Laboratory, Inc. (CEMREL), St. Louis, 1970.

—— (ed.): *Exemplary Programs in Art Education*, National Art Education Association, Washington, D.C., 1969.

Mahoney, Margaret: *The Arts on Campus: The Necessity for Change*, New York Graphic Society, Ltd., Boston, 1970.

Mailer, Norman: *The Faith of Graffiti*, Praeger Publishers, Inc., New York, 1974.

Major New Movements in Elementary School Music Education: A Report on a One-Day Statewide Demonstration Workshop, New York State Education Department, Albany, 1969.

"Making Cultural Institutions More Responsive to Social Needs," *Arts in Society*, vol. 11, Spring–Summer 1974.

Making a Peer-Produced Book, Harold Burris-Meyer, film, 1970. Available from: Harold Burris-Meyer, Florida Atlantic University, Boca Raton, Fla. 33432.

Marcia, James E.: "Ego Identity Status: Relationship to Change in Self-Esteem, General Maladjustment and Authoritarianism," *Journal of Personality*, vol. 35, 1967.

Maslow, A. H.: "Music and Peak Experience," *Music Educators Journal*, vol. 54, no. 6, 1968.

——: *Toward a Psychology of Being*, The Van Nostrand Reinhold Company, Inc., Princeton, N.J., 1962.

Mason, Kathleen Criddle (ed.): *Dance Therapy*, American Association for Health, Physical Education and Recreation, Washington, D.C., 1974.

Materials on Creative Arts (Arts, Crafts, Dance, Drama and Music) for Persons with Handicapping Conditions, American Association for Health, Physical Education and Recreation, Washington, D.C., January 1975.

Mattil, Edward, et al.: "The Effects of a 'Depth' Vs. a 'Breadth' Method of Art Instruction at the Ninth Grade Level," *Studies in Art Education*, vol. 3, no. 1, 1966.

Mayhew, Lewis B.: "The Arts and Protest: A Possible Synthesis," *Music Educators Journal*, vol. 58, no. 9, 1972.

Mead, Margaret: "Museums in a Media-Saturated World," *Museum News*, vol. 49, no. 1, September 1970.

Mearns, Hughes: *Creative Power: The Education of Youth in the Creative Arts*, Dover Publications, Inc., New York, 1958.

Media Programs: District and School, American Library Association, Chicago; Association for Educational Communications and Technology, Washington, D.C.; 1975.

Melody, William: *Children's Television: The Economics of Exploitation*, Yale University Press, New Haven, Conn., 1973.

Michaels, Claire: "Study of a Five Week Program in Geriadrama," unpublished paper, New York, November 1975.

Mitler, Gene A.: "The Classroom Teacher: Missing Element in Efforts to Improve Elementary School Art Programs," *Art Education*, vol. 27, no. 1, January 1974.

Montgomery, Chandler: *Art for Teachers of Children*, Charles E. Merrill Books, Inc., Columbus, Ohio, 1973.

Morman, Jean Mary: *Wonder under Your Feet*, Harper & Row, Publishers, Incorporated, New York, 1973.

Morrison, Jack: "Challenge to the Artist-Teacher," *Arts in Society*, vol. 12, no. 3, Fall–Winter 1975.

———: *The Rise of the Arts on the American Campus*, McGraw-Hill Book Company, New York, 1973.

Motter, Charlotte: *Theatre in High School: Planning, Teaching, Directing*, Prentice-Hall, Inc., Englewood Cliffs, N.J., 1970.

Move! Ted Steeg Productions, Inc., film, 1972. Available from: National Endowment for the Arts Film Library, 600 Grand Avenue, Ridgefield, N.J. 07657.

Multiple Peppers, Vermont's Artists-in-Schools Program, 1974.

Murphy, Judith: *Community Arts and Community Survival*, The Eleventh Annual Conference of the American Council for the Arts in Education, Los Angeles, June 1972.

——— and Ronald Gross: *The Arts and the Poor: New Challenge for Educators*, U.S. Government Printing Office, 1968.

Murphy, Richard: *Imaginary Worlds: Notes on a New Curriculum*, Teachers and Writers Collaborative, New York, 1974.

Museums: Their New Audience, American Association of Museums, Washington, D.C., 1972.

Museums USA: A Survey Report, National Research Center of the Arts, an affiliate of Louis Harris and Associates, Inc., New York, 1975.

Music in the Air, Don Lenzer, film, 1972. Available from: National Endowment for the Arts Film Library , 600 Grand Avenue, Ridgefield, N.J. 07657.

"Music Education: Its Place in Secondary Schools," *NASSP Bulletin*, vol. 59, no. 393, October 1975.

Music's Generation, Music Educators National Conference, film, 1972. Available from: Music Educators National Conference, 1902 Association Drive, Reston, Va. 22091.

Muuss, Rolf E. (ed.): *Adolescent Behavior and Society: A Book of Readings*, Random House, Inc., New York, 1971.

"National Art Education Association Guidelines for Teacher Preparation," *Art Education*, vol. 26, no. 5, May 1973.

National Commission on the Reform of Secondary Education: *The Reform of Secondary Education: A Report to the Public and the Profession*, McGraw-Hill Book Company, New York, 1973.

National Institute of Education: Its History and Programs, Office of Public Information, Washington, D.C., 1974.

National Report on the Arts, National Committee for Cultural Resources, Washington, D.C., 1975.

Nelson, Doreen G.: *City Building Educational Program*, Los Angeles Center for City Building Educational Programs, 1975.

New Roles for Youth in the School and the Community, National Commission on Resources for Youth, New York, 1974.

Newton, Michael K., and Barbara B. Israel: *A Guide to Community Arts Agencies*, Associated Councils of the Arts, New York, 1974.

The New York Cultural Consumer, National Research Center of the Arts, an affiliate of Louis Harris and Associates, Inc., New York, 1976.

"New York Study Commission Finds City Schools in Turmoil," *American Teacher*, vol. 6, no. 6, February 1976.

Noble, Stuart G.: *A History of American Education*, Greenwood Press, Inc., Westport, Conn., 1970.

Nuell, Lon: *A Survey of Attitudes and Requirements concerning Art Education in the Fifty States as Indicated by the State Department of Education in Each State*, n.p., 1974–1975.

O

Observation: A Technique for Art Educators, National Art Education Association, Washington, D.C., 1971.

O'Grady, Dr. Gerald: "Integrating a Cinema Program into a Humanities Curriculum," speech given at The Harvard University Science Center Auditorium, Apr. 20, 1974.

————: "The Preparation of Teachers of Media," *Journal of Aesthetic Education*, vol. 3, no. 3, 1969.

Orem, R. C. (ed.): *A Montessori Handbook*, Capricorn Books, G. P. Putnam's Sons, New York, 1965.

Orendorff, H. S.: "College of the Creative Arts (A Proposal)," *Music Educators Journal*, vol. 55, no. 5, January 1969.

Otto, Herbert A., and Kenneth Griffiths: "A New Approach to Developing the Student's Strengths," *Social Casework*, vol. 45, no. 3, March 1965.

"Overcoming Cultural Racism," *Music Educators Journal*, vol. 58, no. 3, November 1971.

P

Palisca, Claude V.: "The Quality of Life and Music Education," *The Australian Journal of Music Education*, no. 16, April 1975.

Panel on Youth of the President's Science Advisory Committee: *Youth: Transition to Adulthood*, University of Chicago Press, Chicago, 1974.

Parnes, Sidney, and Harold Harding (eds.): *A Source Book for Creative Thinking*, Charles Scribner's Sons, New York, 1962.

Passow, A. Harry: *Secondary Education Reform: Retrospect and Prospect*, Teachers College Press, Columbia University, New York, 1976.

Peluso, Joseph L. (ed.): *A Survey of the Status of Theatre in United States High Schools*, Final Report, U.S. Department of Health, Education, and Welfare, November 1970.

Piaget, J.: *Play, Dreams, and Imitation in Childhood*, W. W. Norton & Company, Inc., New York, 1962.

Pines, Maya: "Head Head Start," *The New York Times Magazine*, Oct. 26, 1976.

The Place of the Arts in New Towns, A Report from Educational Facilities Laboratories, Inc., New York, 1973.

Place, Richard, Stephen Shapiro, and Richard Schneidenhelm: *Artists in the Classroom*, Connecticut Commission on the Arts, Hartford, 1973.

Platt, Joan M.: *Visual Literacy*, National Education Association, Washington, D.C., 1975.

Poetry-in-the-Schools, The Poetry Center, California State University at San Francisco, n.d.

Polsky, Richard M.: *Getting to Sesame Street: Origins of the Children's Television Workshop*, Praeger Publishers, Inc., New York, 1975.

Preparing the Elementary Specialist, A Report of the Task Force on Children's Dance and The Elementary School Physical Education Commission, American Association for Health, Physical Education, and Recreation, Washington, D.C., 1973.

Prevots, Naima Wallenrod (ed.): *Dance in the Public Schools: Developing Professional Standards, Certification and Curricula*, American Dance Guild, Inc., New York, n.d.

Pridgem, N. E. M., et al.: *Progress for Middle Grades Among the Educationally Disadvantaged through Photography*, International Reading Association Conference, Anaheim, Calif., 1970.

Proposals for Art Education, Gurdon Woods, Chairman, University of California at Santa Cruz, 1970.

R

Read, Herbert: *Education through Art*, Pantheon Books, a division of Random House, Inc., New York, 1958.

Reimer, Bennett: *A Philosophy of Music Education*, Prentice-Hall, Inc., Englewood Cliffs, N.J., 1970.

Report of the National Panel on High Schools and Adolescent Education, John H. Martin, Chairman, U.S. Office of Education, 1974.

The Report on the Phoenix Theatre School Project, Richard Kaplan, film, 1971. Available from: Public Relations, Phoenix House Foundation Inc., 203 West 84th Street, New York, N.Y. 10024.

Report on a Study of Music Programs in U.S. Elementary and Secondary Schools—1972–1973, American Music Conference and the Music Educators National Conference, Reston, Va., February 1974.

Research in Dance: Problems and Possibilities, Committee on Research in Dance, New York, 1967.

Richard, Nancy, and Stanley S. Madeja: *The Bee Hive: The Arts in Early Education*, Central Midwestern Regional Educational Laboratory, Inc. (CEMREL), St. Louis, 1974.

Richardson, Elwyn S.: *In the Early World: Discovering Art through Crafts*, Pantheon Books, a division of Random House, Inc, New York, 1969.

Ritch, Pamela: "The Visual Drama: Integrating People with Art," *Viewpoints*, vol. 3, no. 1, Illinois State University, Center of Visual Arts, Normal, Ill., 1975.

Ritchie, A. C.: *The Visual Arts in Higher Education*, The College Art Association, New York, 1966.

Robbins, Michael W. (ed.): *America's Museums: The Belmont Report*, American Association of Museums, Washington, D.C., 1968–1969.

The Role of the Fine Arts in Education, National Education Association, Washington, D.C., 1968.

The Role of Research in the Aesthetic Education Program, Bulletin of the Council for Research in Music Education, Washington, D.C., n.d.

Roman, Melvin: "The Arts as Agents for Social Change: A Psychologist's Viewpoint," Doris L. Barclay (ed.), *Art Education for the Disadvantaged Child*, National Art Educational Association, Washington, D.C., 1969.

Rosenblatt, Bernard S., and René Michel-Trapaga: "Through the Teacher to the Child: Aesthetic Education for Teachers," *Council for Music Education Bulletin*, vol. 3, no. 2, Summer 1975.

Rubin, Louis J.: *Facts and Feelings in the Classroom*, The Viking Press, Inc., New York, 1974.

Russell, John, and Suzi Gablik: *Pop Art Redefined*, Praeger Publishers, Inc., New York, 1969.

S

Saylor, J. Galen, and Joshua L. Smith (eds.): *Removing Barriers to Humaneness in the High School*, Association for Supervision and Curriculum Development, Washington, D.C., 1971.

Schiff, Bennett: *Artists in Schools*, National Endowment for the Arts, Washington, D.C., 1973.

————: *Arts in Parks and Recreation Settings*, National Endowment for the Arts, Washington, D.C., 1973.

Schneider, Allen A.: "Ten Critical Issues on Educational Reform," *Journal of Teacher Education*, vol. 26, no. 1, 1975.

Schnessel, S. M.: "Remarrying Art and Life: Artist-in-the-Schools Program, New Jersey," *American Education*, vol. 9, November 1973.

The School Music Program: Description and Standards, Music Educators National Conference, Reston, Va., 1974.

Schools and Museums, Report of the School-Museum Cooperative Education Project, State Department of Education, New York, 1968.

School Television Service WNET/Channel 13: *Manual for Teachers*, Intermediate (5–8), Secondary (9–12), Educational Broadcasting Corporation, two vols.; New York, 1975.

Schramm, Wilbur, Jack Lyle, and Edwin B. Parker: *Television in the Lives of Our Children*, Stanford University Press, Stanford, Calif., 1961.

Schwartz, Fred: *Structure and Potential in Art Education*, Blaisdell Publishing Company, a division of Ginn and Company, Waltham, Mass., 1970.

Schwartz, Julia, and Nancy J. Douglas: "Where Is Art Education in Early Childhood Education Today?" *Art Education*, vol. 23, no. 4, April–May 1975.

Schwebel, M., and J. Ralph (eds.): *Piaget in the Classroom*, Basic Books, Inc., Publishers, New York, 1973.

See-Touch-Feel, Donald Wrye, film, 1969. Available from: National Endowment for the Arts Film Library, 600 Grand Avenue, Ridgefield, N.J. 07657.

Seltzer, Micki: "Arts IMPACT: Test Score Leap at Eastgate School Examined," *Call and Post*, Columbus, Aug. 24, 1974.

A Seminar in Art Education for Research and Curriculum Development, Edward L. Mattil, project director, Pennsylvania State University, University Park, 1966.

A Seminar on the Role of the Arts in Meeting the Social and Educational Needs of the Disadvantaged, Final Report, U.S. Department of Health, Education, and Welfare, 1967.

Shields, A.: "The Future of Art Education," *Studies in Art Education*, vol. 12, no. 2, April 1970.

Shoemaker, John R.: "A Classroom on Wheels for the Circuit Riding Teacher," *Music Educators Journal*, vol. 56, no. 7, March 1970.

Sieber, Roy: "The Aesthetics of Traditional African Art," Carol F. Jopling (ed.), *Art and Aesthetics in Primitive Societies*, E. P. Dutton & Co., Inc., New York, 1971.

Siks, Geraldine Brain, and Hazel Dunnington (eds.): *Children's Theatre and Creative Dramatics*, University of Washington Press, Seattle, 1967.

Silberman, Charles (ed.): *The Open Classroom Reader*, Random House, Inc., New York, 1973.

Simon, Kenneth A., and Martin M. Frankel (eds.): *Projections of Educational Statistics to 1983–84*, 1974 Edition, U.S. Department of Health, Education, and Welfare, 1975.

Skinner, Robert G.: *Perceptions of Some Artists-in-Residence in Ohio Colleges and Universities*, dissertation, Ohio University, Athens, 1971.

Sloan Commission on Cable Communications: *On the Cable: The Television of Abundance*, McGraw-Hill Book Company, New York, 1971.

Smith, Dennis L.: "A Strategy for Change: The Memphis Aesthetic Education Program," *New Ways*, vol. 1, no. 4, Cambridge, Mass., May–June 1975.

Smith, George Alan, and Carol D. Smith: *The Arts and Their Needs in the State of Connecticut*, first report, prepared for the Connecticut Commission on the Arts and the Connecticut Foundation for the Arts, January 1975.

Smith, James A.: *Creative Teaching of the Creative Arts in the Elementary School*, Allyn and Bacon, Inc., Boston, 1967.

Smith, Nancy W. (ed.): *Focus on Dance IV: Dance as a Discipline*, American Association for Health, Physical Education, and Recreation, Washington, D.C., 1967.

Smith, Ralph A.: "The Arts, Cultural Services, and Career Education," *The Journal of Aesthetic Education*, Special Issue, vol. 7, no. 4, University of Illinois Press, Urbana, October 1973.

——— (ed.): *Aesthetic Education Today: Problems and Prospects*, The Ohio State University, Columbus, 1973.

Smith, Walter L.: "Governments' Responsibility for Improving Educational Outcomes," *Journal of Teacher Education*, vol. 26, no. 1, 1975.

Speaking of the Arts and Education, Elliott Eisner, McGraw-Hill Book Company, audiotapes, 1974.

Speidel, Judith D., and Margot T. Willett: "Art for Community's Sake," *Art Teacher*, vol. 5, no. 3, Fall 1975.

Spock, Michael: "Museums in Collaboration," *Museum News*, vol. 48, no. 8, April 1970.

Spodek, Bernard: "Preparing Music Teachers for Open Education," *Music Educators Journal*, vol. 6, no. 8, April 1974.

Spolin, Viola: *Improvisation for the Theatre*, Northwestern University Press, Evanston, Ill., 1963.

Stake, Robert (ed.): *Evaluating the Arts in Education*, Charles E. Merrill Books, Inc., Columbus, Ohio, 1975.

State Reports, State Alliance for Arts Education Committees, 1973–75, Alliance for Arts Education, Washington, D.C., 1975.

The Status of the Arts in Michigan: Report of the Joint Legislative Committee on the Arts, Senator Jack Faxon, Chairman, n.d.

Stearns, Betty, and Clara Degen (eds.): *The Music Revolution*, American Music Conference, Chicago, 1974.

Stearns, Marshall W.: *The Story of Jazz*, Oxford University Press, New York, 1970.

Stein, Judith: "Teaching: A Team Approach," *Art Teacher*, vol. 4, no. 1, Winter 1974.

Stevens, Joseph H., Jr., and Edith W. King: *Administering Early Childhood Education Programs*, Little, Brown and Company, Boston, 1976.

Stewart, David C. (ed.): *Film Study in Higher Education*, American Council on Education, Washington, D.C., 1966.

Stinnett, T. M.: *A Manual on Standards Affecting School Personnel in the United States—1974 Edition*, National Education Association, Washington, D.C., 1974.

Sunderland, Jacqueline: *Arts for the Aged*, National Council on the Aging, Washington, D.C., n.d.

Support for the Arts, A Survey of Possible Sources for State University of New York, Washington, D.C. Office, State University of New York, 1973.

Support for the Arts and the Humanities, U.S. Department of Health, Education, and Welfare, 1972.

Suzuki, Shinichi: *Nurtured by Love*, Exposition Press, New York, 1969.

T

Taylor, Anne: "The Cultural Roots of Art Education: A Report and Some Models," *Art Education*, vol. 28, no. 5, September 1975.

Taylor, Calvin W.: "Research Findings on Creative Characteristics," *Creativity and Art Education*, National Art Education Association, 1965.

Teacher Education in Music, Music Educators National Conference, Washington, D.C., 1972.

Teacher Education in the U.S.: The Responsibility Gap, University of Nebraska Press, Lincoln, 1976.

Teacher Supply and Demand: A Preliminary Report to the United States Office of Education, Rand Corporation, Washington, D.C., 1974.

Television and Children: Priorities for Research, Report of a Conference at Reston, Virginia, November 5–7, 1975, sponsored by the Ford Foundation, the John and Mary R. Markle Foundation, and the National Science Foundation.

Tellstrom, A. Theodore: *Music in American Education, Past and Present*, Holt, Rinehart and Winston, Inc., New York, 1971.

Tickton, Sidney G.: *To Improve Learning: An Evaluation of Instructional Technology*, R. R. Bowker Company, New York, 1970.

Torrance, E. Paul: *Encouraging Creativity in the Classroom*, Dodd, Mead & Company, Inc., New York, 1970.

——— and R. E. Meyers: *Creative Learning and Teaching*, Dodd, Mead & Company, Inc., New York, 1970.

Towards an Aesthetic Experience, Music Educators National Conference, Washington, D.C., 1970.

U

Unruh, Glenys G., and William M. Alexander: *Innovations in Secondary Education*, Holt, Rinehart and Winston, Inc., New York, 1974.

Van Tuyl, Marian (ed.): *Dance: A Projection for the Future*, The Developmental Conference on Dance, Impulse Publications, Inc., San Francisco, 1968.

Vitoria: "Elementary Art Education: The State of the Field," *Art Teacher*, vol. 5, no. 1, Winter 1975.

Wallach, M. A., and N. Kogan: *Modes of Thinking in Young Children*, Holt, Rinehart and Winston, Inc., New York, 1965.

Walters, Walter H.: *The Arts in Higher Education: Tensions and Transitions*, American Association for Higher Education, Chicago, March 1975.

Weber, George: *Uses and Abuses of Standardized Testing in the Schools*, Council for Basic Education, Washington, D.C., 1974.

Wenner, Gene C.: *Dance in the Schools: A New Movement in Education*, The JDR 3rd Fund, Inc., New York, 1974.

———: "Interdisciplinary Courses: Mythology and Methodology," *Art Education*, vol. 26, no. 6, September 1973.

Wiener, Jack, and John Lidstone: *Creative Movement for Children: A Dance Program for the Classroom*, Van Nostrand Reinhold Company, New York, 1969.

Wigginton, Eliot (ed.): *Foxfire 2*, Anchor Books, Doubleday & Company, Inc., Garden City, N.Y., 1973.

Wigren, Harold E.: *Using Instructional TV*, National Education Association, Washington, D.C., n.d.

Williams, Jeffrey W., and Sallie J. Worf: *Education Directory: 1973–74 Public School Systems*, National Center for Educational Statistics, Washington, D.C., 1974.

Wilson, O. J.: *Cultural Enrichment through Community Action*, Western Kentucky University, Bowling Green, 1970.

Wolff, Irving, *State Certification of Music Teachers*, Music Educators National Conference, Washington, D.C., 1972.

Woodruff, D.: "An Approach to Teacher Education," *Teacher Education for Aesthetic Education: A Progress Report*, Central Midwestern Regional Educational Laboratory, Inc. (CEMREL), St. Louis, 1972.

Wright, James: "Who Should Teach Art?" *Art Education*, vol. 28, no. 2, February 1975.

Wyatt, Leslie: *Observations on Graduate Enrollment in the Arts*, paper presented to the International Council of Fine Arts Deans, Denver, November 1975.

Ziegler, L. Harmon, M. Kent Jennings, and G. Wayne Peak: *Governing American Schools*, Duxbury Press, North Scituate, Mass., 1974.

Zimmer, Anne, and Bonnie Cherp Gilliom: *ITV: Promise into Practice*, Columbus Public Schools, Columbus, Ohio, 1972.

V

W

Index

AAE (*see* Alliance for Arts Education)
ACA (*see* Associated Councils of the Arts)
Accountability, 143, 145–147, 214
ACUCAA (Association of College and University Concert Arts Administrators), 128
Ad Hoc Coalition of States, 262
Administrators, 153, 158–159, 163–169
 aesthetic education for, 167, 254
 arts curriculum supervisors, 167, 168
 arts education conferences for, 234
 attitudes of, toward arts education, 163–164, 216
 fine arts coordinators, 167, 168
 principals, 163, 166, 169
 problems facing, 164
 role of: in arts education, 166–167
 in educational planning, 214
 superintendents, 163, 166, 169, 214
 teachers and, 164–166
 training of, 164–167
Adolescence:
 problems of, 90–95, 115, 139
 value of arts in, 90–95
Adult education, 140
Aesthetic education, 65, 71, 73, 87, 97, 112–113, 143, 151, 153, 164, 167
Aesthetic Education Learning Centers, 148, 150, 164
Aesthetic Education Programs, 148
 (*See also* Central Midwestern Regional Educational Laboratory)
Affective learning, 56–57, 65
African heritage (*see* Black arts)
Age of Reason, 24–27
Agencies:
 cultural (*see* Arts institutions; Cultural centers)
 federal (*see* Funding, federal)
 government (*see* Government)
 nongovernmental (*see* Arts councils)
 nonschool (*see* Nonschool agencies)
AIS (*see* Artists-in-Schools programs)
Alliance for Arts Education (AAE), 47, 214, 223–224, 237, 262
Alternative schools, 67–68, 80, 97, 98

American Association for Health, Physical Education, and Recreation, 74
American Council for the Arts in Education, 147
Applied sciences, 33, 38
Appreciation programs, nonschool, 175–177
Apprenticeship programs:
 higher education, 125–127, 133, 134
 nonschool, 175, 176, 180
 secondary school, 97, 105
Architecture, 22, 25, 37, 41, 44, 83–85
Art patrons, 36, 45, 185, 240
Artist-teachers, 22, 41, 140, 146, 155–162
 dilemma of, 160
 programs for, 155–160
Artistic process, 56, 201
Artistic symbols as vocabulary of art, 53, 56–57, 67
Artists:
 apprenticeships and, 126–127, 176
 as community resources, 105, 176, 222
 dilemma of, as teachers, 140, 160
 education of, 40–41, 123, 132–134
 (*See also* gifted students)
 higher education and, 160
 industry and, 184
 link between community and, 156–158, 160, 176
 in schools: recommendations for use of, 252–253
 resident, 156
 role of, 160, 161, 195, 252
 (*See also* Artists-in-Schools programs)
 society and, 161
 students and, 156–158, 161, 176, 222, 252
 teacher training for, 156, 159–161
 as teachers, 22, 41, 140, 146, 155–162, 222
 tenure and, 160
 in tribal communities, 179
 visiting, 156
Artists in residence, 64, 65, 68, 105, 106, 113, 156, 186
Artists-in-Schools programs, 47, 69, 75, 77, 78, 80, 82, 108, 155–160, 192, 207–208, 222, 232, 234, 235, 252, 262
 administration of, 158–159
 Dance Component, 75, 82, 108
 Film Component, 77

Artists-in-Schools programs (Cont.):
 goals of, 155
 Poetry Component, 78
 potential drawbacks of, 159–160
 reaction to, 155, 159
 recommendations for enlargement of, 252
 value of, 160
 Visual Arts Component, 221–222
 (See also National Endowment for the Arts)
Arts:
 American, emergence of, 37–38
 attitudes toward the, 185, 241
 as basic education, 6, 46, 53–56
 centers (see Arts centers)
 colonial, 22–24
 in the community, 172–194, 213, 239–242, 255–257,
 262
 (See also Community, arts programs)
 corporate support of the, 45
 curriculum (see Curriculum, arts)
 education (see Arts education)
 in education, 259–262
 programs (see Programs, arts education)
 role of, 212, 242
 status of, 63–68, 115–117, 120–134, 242
 value of, 212, 220–221
 (See also Arts education)
 evaluation in the, 146–147
 fear of the, 52–53, 140
 federal aid to the (see Funding, for the arts)
 funding for the (see Funding, for the arts)
 government and the, 243
 federal, 217–226, 239–242
 local, 236–242
 state, 227–236, 242
 industry and the, 184
 in the inner-city, 188–189
 institutions (see Arts institutions)
 labor and the, 234
 as learning aids, 113–114
 management courses, 134
 media and the, 204, 208–209
 (See also Media)
 in nonschool agencies, 97, 172–195
 organizations (see Arts centers; Arts institutions)
 participation vs. observation in the, 130
 polls on the, 54, 185, 241
 programs (see Programs, arts)
 recommendations for expanded approaches to the,
 249–250
 role of, 69–79, 248
 in adolescence, 94–95
 society and the, 27–29, 31, 42–43, 47, 154, 163, 181,
 187, 245
 status of the, 150, 163
 teachers (see Arts teachers; Teacher training)
 technology and the, 6, 199, 257–258
 twentieth-century developments in the, 37–47
 value of the, 56–59, 90–95, 212
Arts and Crafts Program (Department of the Army), 225

Arts in Education Program (The JDR 3rd Fund), 47, 64,
 112–113, 116, 152, 212
Arts in Education Program (U.S. Office of Education),
 223–224
Arts in Education Program, Jefferson County, Colo.
 (JEFFCO), 152, 166
Arts-in-education programs (see Programs, arts
 education)
Arts in Education Project (Rhode Island State Council
 on the Arts), 156
Arts and Humanities Program (U.S. Office of
 Education), 173, 219–221, 223
Arts in Industry Program, Sheboygan, Wis., 184
Arts centers, 124, 176, 178–179, 181, 189, 193–194
 (See also Arts institutions)
Arts councils (commissions), 175, 187, 195, 228
 local, 106, 240, 256
 nongovernmental, 240
 recommendations for establishing, 255
 role in arts program planning, 231–235
 state, 244, 256
Arts curriculum supervisors, 167, 168
Arts education:
 accountability in, 145–147, 214
 administrators, role in, 166–167
 budget cutbacks in, 216
 CBTE, effect on, 146
 child development and, 58–59
 in colleges (see Higher education)
 community programs (see Community, arts education
 programs)
 comprehensive approach to, 112–113, 168
 consortia, role in, 125–127
 contrast between elementary and secondary, 99–
 100
 curriculum development (see Curriculum, arts)
 effect on learning, 85–86, 113–114, 146–147, 191–
 192, 226
 effect on motivation, 6–7, 9, 71, 76, 80, 114
 elementary school, 51–87
 emphasis on technical skills, 101, 140, 180
 equipment: funding for, 220
 need for, 194–195
 evaluation in, 146–147
 faculty, 120
 (See also Arts teachers)
 funding for (see Funding, for arts education)
 for gifted students, 109–111, 132–134, 193, 254
 goals of, 123–124, 130, 160, 162, 212–213
 government and (see Government)
 graduate schools for, 132–134, 144
 grass-roots movement, 112, 224, 239–240
 in higher education, 120–134
 humanities and, 112–113, 165, 220–221, 223
 industrial revolution, effect on, 34
 interdisciplinary approaches to, 65–68, 80–87, 99,
 110–113, 131, 205
 obstacles to implementation of, 143
 role of individual arts in, 69–79
 in teacher training, 142–144, 150, 152–153

Arts education (*Cont.*):
 leadership in: need for, 253
 program recommendations for, 253–254
 major in, 122, 139
 media programs and (*see* Media, programs)
 need for, 3, 6, 11, 60
 nineteenth century, 28, 32–33
 in nonschool agencies, 96–97, 172–195
 (*See also* Arts institutions)
 in open classrooms, 60, 62
 performance vs. criticism in, 100–101, 130–131, 141,
 144, 146
 polls on, 53–55, 104
 pre-Revolutionary, 21, 27
 program planning (*see* Program planning)
 programs (*see* Programs, arts education)
 public opinion on, 54–56, 63, 163, 243
 recession, effect on, 46, 116, 229
 recommendations for improving, 249
 research in, 114, 146, 148, 153
 funding for, 221–223, 226
 need for, 124, 147, 195, 260
 recommendations for, 263
 response to, 52–56, 63, 82, 156, 163, 243
 (*See also* Polls; Surveys)
 role of, 248
 science and, 43, 57, 66–67, 218–219, 250
 secondary schools, 90–117
 statistics on, 104, 116, 120
 status of, 56, 63–68, 115–117, 165, 260
 support of: federal, 217–226, 243–244
 local, 220, 224, 234, 236, 239, 245
 state, 220, 224, 227–236, 244
 (*See also* Funding)
 surveys on, 63, 115–117, 121–122, 124–125
 teachers (*see* Arts teachers)
 television, role in (*see* Television)
 testing process in, 62, 114, 146–147, 230–232
 in ungraded schools, 60–62
 in universities (*see* Higher education)
 value of, 163, 216, 220–221
 (*See also* Education; Elementary school education;
 Higher education; Secondary school education)
Arts Events Program, Mineola, N.Y., 64
Arts institutions, 36, 124, 217, 239–242
 municipal, 241, 245
 neighborhood, 239–240, 255
 programming offered by, 242
 state-subsidized, 227
 (*See also* Arts centers)
Arts teachers:
 certification of, 142, 146, 252, 253
 classroom (*see* Arts teachers, generalists)
 elementary school, 139–141, 154, 203
 generalists, 138–140, 143, 144, 150, 154, 156,
 160
 in higher education, 140
 need for, 160
 roles of, 105, 113, 115, 140, 252
 secondary school, 139, 140, 142, 203

Arts teachers (*Cont.*):
 specialists, 55, 100, 138–144, 150, 156, 160
 training of (*see* Teacher training)
ASPIRE program, Burlington, Vt., 98
Associated Councils of the Arts (ACA), 45, 240, 262
Association of College and University Concert Arts
 Administrators (ACUCAA), 128
Association for Supervision and Curriculum
 Development, 115–116
Audiovisual education, 106
 (*See also* Media)

Back to basics movement, 46, 55–56
Basic education (*see* Arts)
Black arts:
 music, 39–40
 in the 1960s, 45
 theatre, 45
Board of Cooperative Educational Services (BOCES),
 Nassau County, N.Y., 111
Boards of education, role of, 144, 228, 230, 231, 239
BOCES (*see* Board of Cooperative Educational Services)
British schools:
 creative dramatics in, 69
 infant, 60
 primary, 65
Brown Commission, 96
Budgets for arts and education, pressures affecting, 123,
 125, 164, 216, 226, 228, 241
Business Committee for the Arts, 45

California Alliance for Arts Education, 154
Capitalism, 19, 34
Carnegie Commission on Higher Education, 121
CBEP (*see* Center for City Building Educational Programs)
CBTE (competency-based teacher education), 145–146
CEMREL, Inc. (*see* Central Midwestern Regional
 Educational Laboratory)
Center for City Building Educational Programs (CBEP),
 Los Angeles, 83–85
Center for Southern Folklore, 172
Central Midwestern Regional Educational Laboratory
 (CEMREL, Inc.), 46, 223
 Aesthetic Education Learning Centers, 148, 150, 164
 Aesthetic Education Programs, 86–87, 150, 152, 160
 Institute for Administrators, 164
CEP (*see* Cultural Enrichment Program)
Certification, 140, 142, 146, 252, 253
Child development:
 adolescence, 90–95
 early, 56–59, 87, 250
 importance of arts education programs to, 58–59
 value of arts to, 56–59
Children:
 function of art for, 58
 gifted, 109–111, 193, 254
 influence of environment on, 200
 influence of media on, 200, 209

Children (*Cont.*):
 measurable talents of, 146
 pressures on, 52
 reaction of, to arts education, 52, 156
 recommendations concerning arts education programs
 for, 250
Children's Art Carnival program (Museum of Modern
 Art, New York City), 190–191
Cinema, 38
 (*See also* Film)
Cities, 46, 55
 migration from, 241
Citizenship education, 97
City planning (*see* Urban planning)
Civil Service Commission, 226
Cognitive learning, 33–34, 56–57, 65
Coleman Report, 96
Collaborative teaching (*see* Team teaching)
Colleges:
 enlargement of arts faculties in, 124
 founding of, in America, 17, 20, 21
 preparatory programs for, 110, 111
 role of arts education in, 33, 127–134
 (*See also* Higher education)
Combination courses, 114, 143
 (*See also* Interdisciplinary approaches to arts education)
Communication courses, 106–107
 (*See also* Media)
Communism, 43
Community:
 arts education programs, 172–195, 213
 arts organizations, 255, 257
 arts programs, 160, 172–194, 212, 217, 239–242, 255–
 257, 262
 artists-in-residence projects, 186
 effect of, 156
 ethnic, 188–189, 242
 funding for, 175, 186, 217, 234, 239–241
 higher education and, 160, 258–259
 major movements in, 173–174
 nonschool, 175–194
 schools and, 186
 arts resources: local, 187
 recommendations for expanded use of, 255–257
 regional, 187
 role of, in arts education, 172–195, 212–213, 216
 school systems and, 186
 in smaller cities, 186–187
 in urban centers, 185–186
 arts specialists, 68
 colleges, teacher quality in, 122–123
 effect of exposure to arts on, 187
 the ethnic, 188–189, 255
 integration with arts education, 86, 96–98, 101–102,
 105, 110, 113, 152–153, 168, 186, 205–206
 museums, 177
 programs for re-education, 152–154
 relationship to arts institutions, 239–242
 role in teacher training, 142–144, 152, 168
 theatres, 69, 188

Compartmentalization of the arts, 99, 100
Competency-based teacher education (CBTE), 145–146
Comprehensive Program in the Arts, Pennsylvania, 66,
 150–152
Compulsory attendance, 99
Consortia:
 programs sponsored by, 125–127
 for teaching training, 143
Consumer rights, 46
Cooperative Institutional Research Program, 104
Coordinators of fine arts programs (*see* Administrators,
 fine arts coordinators)
Corporate support of the arts, 45, 184, 239, 262
Council on Museums and Education in the Visual Arts,
 172
Creative process, 8–9, 130, 248
 in children, 57–59
Creative writing, 78–79, 100, 104–105, 142
Creativity, 29–30, 34–35, 47
 in adolescents, 90–95
 in children, 40, 57–59
 in the elderly, 179, 180
Critics, training of, 100–101, 134, 141
CSA (*see* Model Cities/Chicago Committee on Urban
 Opportunity)
Cultural Arts Program, Goleta, Calif., 82
Cultural centers, 185–187, 190, 193–194
 (*See also* Arts institutions)
Cultural development:
 African influence on, 39–40
 economic influence on, 36, 42
 ethnic influence on, 189
 European influence on, 33, 39, 41
 nineteenth-century, 28–34
 pre-Revolutionary, 21–24
 role of universities in, 134
 scientific and technological influences on, 33–34, 38
 twentieth-century, 37–39, 42–47, 95–96, 241
Cultural Enrichment Program (CEP), North Carolina,
 228
Cultural Enrichment Program (CEP), Washington, 229,
 232, 234–235
Cultural identity programs, nonschool, 176, 178–179
Cultural origins:
 English, 22
 French, 16
 Indian, 16
 Puritan, 16–20
 Spanish, 16
 West African, 16, 39–40
Curriculum, 59, 132–133
 aesthetic education, 150
 arts, 148, 150
 changes in, 131, 153
 comprehensive approach to, 113
 development of: advisory committee for, 113
 in elementary education, 86–87
 funding for, 86
 in junior high schools, 115
 in middle schools, 115

Curriculum, arts (*Cont.*):
 elementary school, 55, 60, 63–87, 207
 graded, 141
 in higher education, 27, 258–259
 importance of, 82
 program planning, 69–79, 100–117, 151–153, 165, 194, 213
 role of teachers in, 115, 252
 recommendations for expansion of, 249–250, 258
 research in, 263
 restructuring of, 145
 role of artists in designing, 160, 193
 role of Artists-in-Schools programs in, 160
 secondary school, 97–117, 151, 157–158, 205–207
 supervisors, 167
 changes: in elementary education, 60–62, 87
 in liberal arts, 123
 in secondary school, 97–99, 102, 104–107, 112–113
 combination courses, 113–114
 as core, 62, 66–68
 development, 219, 221, 223, 230
 role of teachers in, 252
 elementary, 55, 59, 63–87, 207
 goals of, 113
 integration of arts into, 32, 33, 60, 156, 166–167, 186, 212, 214–216, 228, 231–232
 integration of media programs into, 205, 207, 209, 258
 interdisciplinary, 142–144
 planning, role of arts teachers in, 115, 252
 secondary, 74, 100–117, 151, 157–158, 205–207, 218–219
 specialists, 152
 status of arts in, 63–68, 163, 243
 for teacher training, 142–144
 (*See also individual disciplines*)

Dance, 37, 38, 41, 44, 74–75, 80–83, 100, 108–109, 141, 142, 149, 199
Day care centers, 140
Democracy:
 role of art in a, 27–29
 role of education in a, 26, 28
Department of the Army, 225
Department of Defense, 226
Department of Health, Education, and Welfare (HEW), 153, 223, 226, 243
Department of Housing and Urban Development (HUD), 189
Department of public instruction, 228–232
Departmentalization, 99, 205
Drama, 68, 69, 80–83, 141, 142
 (*See also* Theatre)

Economic development:
 depression, 41–42
 eighteenth-century, 22–23
 nineteenth-century, 27–28
 Puritan, 19–20

Economic development (*Cont.*):
 recession, 45–46, 116, 125, 154, 229
Economic forces, effect of: on the arts, 36, 123, 239–241
 on education, 36, 123, 125, 164, 216, 226
 on urban governments, 241–242
ECSU's (Educational Cooperative Service Units), 214
Education:
 accountability in, 143, 145–147, 214
 arts in (*see* Arts, in education; Arts education)
 back to basics movement, 6, 46, 53–56
 budget cutbacks in, 164, 226
 business (management) approach to, 143, 147
 change in: need for, 3, 9, 214
 process of, 214–215
 colonial, 18–19
 (*See also* Education, pre-Revolutionary)
 eighteenth-century, 31–32
 elementary school, 51–87
 film, use in, 151
 funding for (*see* Funding)
 goals of, 8–9, 160, 162, 212, 248
 higher, 120–134
 impact of American philanthropists on, 36
 integration of arts into, 60, 156, 166–167, 186, 212, 214–216, 223–224, 228, 231–232, 243
 1970s, 146
 1960s, 146
 nineteenth-century, 28
 pre-Revolutionary, 21, 24–27
 pressures affecting, 144–147
 public schools, 31–32, 109–111, 116, 141, 144–147
 recession, effect on, 46, 116
 research in, 45, 134
 science and, 43, 57, 66–67, 218–219, 250
 secondary school, 90–117
 society and, 26–29, 42–43, 154, 163, 245
 television and, 44–45
 twentieth-century, early, 40
 (*See also* Arts education; Elementary school education; Higher education; Secondary school education)
Educational Cooperative Service Units (ECSU's), 214
Educational Innovation and Support Program (U.S. Office of Education), 220, 225
Educational Research and Development Program (National Institute of Education), 225
Elementary and Secondary Education Act (ESEA), 219, 220
 Creative Reading Program, 191
 Title I, 85, 191, 219, 220
 Title III, 110–111, 114, 151–152, 219, 220
 Title IV, 220, 221
 Title VII, 186
Elementary school education, 51–87, 120, 219
 alternatives to traditional structure, 54–56, 60–62
 arts curriculum in, 55, 60, 63–87, 207
 arts programs in, 80–87, 114
 basic changes in, 60–62
 creative writing, 78–79
 dance, 74–75, 80–83
 drama, 68, 69, 80–83

Elementary school education (*Cont.*):
 environmental design, 83–85
 film, 76–77, 207
 language arts, 78–79, 85–86
 media programs, 76–77, 207
 music, 72–73, 80–83
 in open classrooms, 60–62, 65–66
 photography, 76–77, 207
 public response to, 53–56
 reading skills, development of, 80, 82, 85–86
 role of arts in, 69–79
 status of arts in, 63–68
 teacher training, 46–47, 64, 65, 69, 139–141, 220
 teachers (*see* Arts teachers; Teachers)
 in ungraded schools, 60–62
 urban planning program, 83–85
 verbal skills, development of, 80, 86
 video, 76–77, 207
 visual arts, 70–71, 80–83
 (*See also* Arts education; Education)
Emergency School Aid Act:
 Special Arts Projects, 222
 Title VII, 153, 193, 225
English curriculum, 104, 106–107
Enlightenment, the, 24–27
Enrollment:
 decline of, 46, 144, 147, 154, 214
 leveling off of, 125
 over-, 106
 rising, in the arts, 120–122, 124
Environment, 3–5, 9, 25, 200
 concern for, 46
 effect of the arts on, 132
 urban, elementary school studies in, 83–85
Environmental design, 44, 83–85, 101–102
 (*See also* Urban planning)
ESEA (*see* Elementary and Secondary Education Act)
Ethnic arts, 38–39, 142, 242, 255
Evaluation, 146–147
Evolution, 34

Farm Securities Administration, 173
Federal Council on the Arts and the Humanities, 225, 261
Federal Interagency Committee on Education (FICE), 225–226
Federal Theatre Project (WPA), 42
Fellows Program, John Hay, 165–166
Fellowships, 165–166
 (*See also* Grants)
FICE (Federal Interagency Committee on Education), 225–226
Film (filmmaking), 37–38, 44, 76–77, 100, 104, 106, 151, 198, 206, 207
 as an art form, 204
Folk art, 21, 39
Foundations, 29, 45, 150, 185, 195, 239, 262
Foxfire project, Rabun Gap–Nacoochee School in Georgia, 205

Free schools, 140
Frontier expansion, 29–31
Fulbright-Hays grants, 225
Funding:
 for the arts, 212, 243
 corporate, 45, 184, 239
 federal, 42, 43, 175, 179, 186, 217–226, 232, 239–242
 local, 175, 184, 185, 195, 239–242
 state, 175, 195, 217, 227, 234, 237, 239, 242
 for arts education, 175, 213, 243
 congressionally mandated programs for, 223–224
 corporate, 262
 federal, 47, 80, 86, 101–102, 114, 152, 155, 156, 186, 217, 232, 237, 243–244
 local, 80, 86, 102, 106, 152, 186, 195, 216, 217, 220, 224, 234–239, 244–245
 recommendations for, 259–262
 state, 156, 195, 216, 217, 220, 224, 227–229, 232, 234, 244
 by foundations, 195, 262
 private, 150, 175, 197, 216, 239, 240, 262
 public, 85
 through taxation, 238–239, 241, 242
 (*See also* Elementary and Secondary Education Act; National Endowment for the Arts)

Generalists (classroom teachers), 138–140, 143, 144, 150, 154, 156, 160
German university structure, 122
Gifted students, 101, 109–111, 132–134, 193, 254
GLCA (Great Lakes Colleges Association), 125–127
Government:
 agencies, 172, 195, 217, 243
 role of: in the arts: at federal level, 42–43, 45, 175, 217–226, 239–242
 at local level, 45, 236–243
 in the nineteenth century, 27–29
 recommendations for cooperative policy planning, 260–262
 at state level, 45, 227–236, 241
 in arts education, 217–226, 243
 in education, 28, 42–43, 120, 217–226
 (*See also* Funding)
Governors, role of, in arts education, 227, 228, 224
Graduate schools:
 for the arts, 132–134
 of education, 144
Grants, 179, 220, 225, 238, 240
Grass-roots arts education movement, 112, 224, 239
Great Depression, 41–42
Great Lakes Colleges Association (GLCA), 125–127

HEW (*see* Department of Health, Education, and Welfare)
High schools (*see* Secondary school education)

Higher education (colleges and universities), 120–134
 art specialists, 140
 arts appreciation and, 129–131
 arts boom in, 120–122
 arts management courses, 134
 arts programs: participation in, 121–122, 129–131
 for professional training, 46, 132–134
 student attitudes toward, 121
 student demands for, 122
 consortia: role in, 125–127
 teacher training and, 143
 effect of recession on, 125
 enrollment in, 124, 125
 faculty, role in, 120, 124
 goals of, 129
 government support for, 120
 graduate schools, 132–134, 144
 integration of arts into, 120, 123–124
 interdisciplinary arts courses, 131
 liberal arts programs, changes in, 123–125
 media programs, 206–207
 multi-arts vs. single discipline training in, 131
 museology, 134
 as patrons of the arts in, 127–128
 programs, 123
 recommendations for curriculum expansion in, 27, 258–259
 role of arts education in, 127–134
 role in arts research, 134
 role in teacher training, 134
 as sponsors of art events, 128–129
 status of arts in, 120–134
 teachers, arts, 140
 (See also Arts education; Education)
Historians, training of, 100, 101, 134, 141
HUD (Department of Housing and Urban Development), 189
Humanities courses, 100, 101, 112–113
 funding for, 220, 223

IMPACT (see Interdisciplinary Model Program in the Arts for Children and Teachers)
Independent study programs, 97, 105, 111, 132
Industrial revolution, 34–36
Industry, arts and, 184
In-school residency teams, 105
 (See also Artists in residence)
In-service teacher training, 143, 148, 150–154, 156, 207, 251
Institutions:
 arts (see Arts institutions)
 nonschool (see Nonschool agencies)
Interdisciplinary approaches to arts education, 65–68, 80, 87, 99, 110–113, 131, 205
 obstacles to, 143
 role of individual arts in, 69–79
 in teacher training, 142–144, 150, 152–153
Interdisciplinary Model Program in the Arts for Children and Teachers (IMPACT), Columbus, Ohio, 67, 75, 80–82, 146–147, 156, 166

International Council of Fine Arts Deans, 121
Internships, 97, 125–127, 143
 (See also Apprenticeships)
Interrelated approach to teaching (see Interdisciplinary approaches to arts education)
Inventors, 35–36, 38

JDR 3rd Fund, The, 29, 64, 148
 Arts in Education Program of, 47, 64, 112–113, 116, 152, 212
JEFFCO (Arts in Education Program, Jefferson County, Colo.), 152, 166
Junior high schools, 115

Kindergartens, 154

Labor, arts and, 234
Landscape painting, 29
Language arts, 78–79, 85–86, 206
Law Enforcement Assistance Administration, 179
Learning skills, 3, 9, 18, 53
Learning to Read Through the Arts Program, 85
Leisure-time programs, nonschool, 176, 180–182
Libraries, 225
Literature, 29, 41, 44

Materialism, 19, 27–28, 36, 42
Math skills, development of, 57, 82, 85, 114, 146–147, 154, 228
Media:
 as an art form, 209, 257
 in arts education, 198–199, 203–204, 207
 in competition with schools, 97
 degree in, 206–207, 209
 in elementary school curriculum, 76–77, 207
 programs, 76–77, 204–209, 257–258
 in secondary school curriculum, 106–107, 205–207
 student-directed programs, 205, 207
 in teacher education, 199–201, 203–204
Memphis Aesthetic Education Program, 150
Michigan Arts Council, 229, 234
Michigan Joint Legislative Committee on Arts, 188–189
Middle schools, 115
Mineola (N.Y.) Arts Project, 64
Minnesota Department of Education, 214
Minorities, 95, 201, 242
Model Cities/Chicago Committee on Urban Opportunity (CSA), 186
Model programs, 64, 80–82, 144, 213, 214, 224, 225
Multi-arts programs, 80, 142–143, 150
 (See also Interdisciplinary approaches to arts education)
Multidisciplinary programs (see Interdisciplinary approaches to arts education)
Museology, 134
Museums, 85, 172–174, 176–177, 179, 190, 192, 242
Music, 23–24, 32–33, 37, 39, 41
 black, 39–40

Music *(Cont.)*:
curriculum, 72–73, 80–83, 100, 102–104
majors in, 122
programs, 161
enrollment in, 121–122
relevance to other subjects, 103
teachers, 141, 142, 145
Music Educators National Conference, 72, 141, 142

National Art Education Association, 70, 141–142, 168
National Commission on the Reform of Secondary
Education (Brown Commission), 96
National Committee for Cultural Resources, 240
National Council on the Arts, 222
National Council of Teachers of English, 78
National Dance Association, 74
National Defense Education Act, 43
National Endowment for the Arts, 10, 101–102, 148,
172, 173, 175, 177, 186, 195, 212, 221, 225, 232,
240
Alternative Education program, 222
Artists-in-Schools programs (*see* Artists-in-Schools
programs)
Arts Administration program, 222
creation of, 220, 240, 244, 245
Education Program, 222, 225
Expansion Arts Program, 179
poets in schools program, 222
National Endowment for the Humanities, 220, 221, 223,
225
Division of Education programs, 223, 225
Education Projects, 223
National Humanities Faculty, 150
Creation and Appreciation in the Arts Planning
Committee, 150
National Institute of Education (NIE), 6, 148, 156, 223,
225
National Panel on High Schools and Adolescent
Education, 96
National Science Foundation, 219
Negro arts (*see* Black arts)
Neighborhood Arts Program, Akron, Ohio, 178
Neighborhood Arts Program, San Francisco, Calif., 195
New York State Council on the Arts, 227
NIE (*see* National Institute of Education)
Nonschool agencies, 96–97, 172–195, 254
appreciation programs, 175–177
apprenticeship programs, 175, 176
cooperative ventures involving, 192–195
cultural identity programs, 176, 178–179
financing of, 185
leisure-time programs, 176, 180–182
quality-of-life programs, 176, 182
teaching at, 189–190, 192
therapeutic programs, 176, 179–180, 182
North Carolina Arts Council, 233–234

Off-campus study, 125, 133
Office of Child Development, 226

Office of Education, U.S., 156, 192, 218–226
Ohio Arts Council, 156
Old age homes, 179, 180
Open City Project, New York City, 193
Open classrooms, 60–62, 65–66, 97, 203
Opening Doors Program, Oklahoma City, 192–193
Opera, 23, 24
Oral communication, 206

Packaged learning, 86–87, 106, 112–113, 148
Painting, 22, 29, 37, 41
PAM (Practical Arts, Art and Music), 115
Parents:
attitudes toward arts education, 52–53, 82, 115, 156,
163–164
involvement in arts IMPACT program, 146
participation in alternative school program planning,
68, 98
reaction to open education, 60–62
Parks, 182
Pennsylvania Aesthetic Education Program, 152
Performing arts:
buildings for the, 173–174
programs, 153–154, 156
schools for the, 46, 109–111, 193
technology and, 199
Performing Tree, Los Angeles, 153–154
Philanthropists, 36, 45, 185, 240
Photography, 37–38, 41, 76–77, 106, 198, 206, 207
as an art form, 204
Physical education, 11, 74, 100, 108–109
Pilot projects, 65, 82, 87, 113–114
funding for, 261
Poetry, 44, 78–79, 156–158, 222
Policy planning, 242–244
recommendations for, 260–262
(*See also* Program planning)
Polls, 53–55, 60–62, 104, 185, 241
(*See also* Surveys)
Population growth, 43, 46, 147, 239, 241
Portraiture, 22–23
Practical Arts, Art and Music (PAM), 115
Preschool education programs, 140, 154
Principals, 163, 166, 169
Printmaking, 206
Priorities:
educational, 55–56
nineteenth-century, 33
Puritan, 17–18, 120
Prisons, 179–180
Private schools:
art history courses in, 141
for the gifted, 109
Program planning, 212–217
arts councils (commissions), role in, 231–235
conferences on, for administrators, 235–236
department of public instruction, role in, 228–232
at federal level, 217–226, 243–244
funding for, 224
governors and, 227, 228

Program planning (*Cont.*):
 legislative role in, 228–230
 at local level, 213–214, 216–217, 224, 226, 236, 239–241
 models of, 213, 224
 need for, 212–213, 216
 recommendations for, 248–263
 at state level, 213–214, 216–217, 224, 226–236, 244
Programs:
 artist-teacher (*see* Artists, as teachers)
 Artists-in-Schools (*see* Artists-in-Schools programs)
 arts: for administrators, 254
 for child development, 250
 community (*see* Community, arts programs)
 for the disadvantaged, 257
 in education (*see* arts education, *below*)
 elementary school, 80–87, 114
 enrollment in, 121
 funding for (*see* Funding)
 for gifted children, 254
 in higher education, 46, 121–122, 129–134
 local, 226, 236, 239
 in media, 76–77, 204–209, 257–258
 research, 260, 263
 secondary school, 99–109, 113
 state, 226, 228–236
 arts education, 167–169, 224, 231, 260
 community (*see* Community, arts education programs)
 elementary school, 80–86, 114
 federal, 80–82, 86–87, 219–226
 graduate degree, 132–134, 144
 in higher education, 46, 123, 132–134
 for leadership development, 253–254
 in media, 76–77, 204–209, 257–258
 nationwide, 47, 150, 155, 166, 184
 nonschool, 96–97, 175–194, 254
 personalized, 99, 112
 planning of, 212–217, 224, 227, 230, 248–263
 at federal level, 243–244
 secondary school, 99–109, 113
 for teacher training, 8–9, 64, 65, 140, 144, 148, 150–154, 165, 186, 251, 258
 community (*see* Community, arts programs)
 funding for (*see* Funding)
 teacher-training (*see* Teacher training)
Progressive education, 40, 60–64, 96–97
Project Zero, Harvard University, 223
Promotion system, 122–123
Protestant Work Ethic, 19–20
Psychology, 34
 adolescent, 90, 94
 child, 14, 56
 role playing, 69, 81
Psychomotor learning, 57, 65
Public instruction, department of: role in arts program planning, 229–232
 role of superintendent in, 228
Public schools, 6, 10, 32
 elementary, 31–32

Public schools (*Cont.*):
 middle, 141
 outside pressures on, 144–147
 secondary, 31–32, 116, 141
 devoted to the arts, 109–111
 (*See also* Arts education; Education; Elementary school education; Secondary school education)
"Publish or perish" syndrome, 122
Puritanism, 16–18, 26, 120

Quality-of-life programs, nonschool, 176, 182

Radio, 42, 198, 206
 as an art form, 204
Reading Improvement Through the Arts (RITA), 114
Reading skills, development of, 80, 82, 85–86, 113–114, 146–147, 154, 191–193, 226, 228
Reading-Through-the-Arts (Title I), Irvington, N.J., 85
Recession, 45–46, 116, 125, 154, 229
Recreation centers, 181–182
Re-education programs, 148–154, 251
 incentives for, 148, 150, 152
 in science, 219
Religion:
 colonial education and, 18–19
 eighteenth-century education and, 31–32
 influence on economics, 19–20
Research in arts education, 86, 114, 146, 148, 153
 funding for, 221–223, 226
 need for, 124, 147, 195, 260
 recommendations for, 263
Resident artists, 156
Rhode Island State Council on the Arts, 156
RITA (Reading Improvement Through the Arts), 114
Rockefeller Foundation, 150
Role playing, 69, 81

School boards, 236–239, 244
Schools, 18, 31–32, 40, 53–55, 93–95, 144, 147–148, 154, 155, 163, 172, 186, 243
 (*See also* Alternative schools; British schools; Elementary school education; Enrollment; Graduate schools, Higher education; Pilot projects, Private schools; Public schools; Secondary school education)
Schools without walls, 97, 185
Science, 11, 33–36, 43, 57, 66–68, 70, 218–219, 250
Search for Education through the Arts, Related Content and the Humanities (SEARCH), 65
Secondary school education, 90–117, 120
 arts curriculum, 97–99, 100–117, 151, 157–158, 205–207
 comprehensive approach to, 113
 combination courses, 114
 compartmentalization of the arts in, 100
 compulsory attendance, reevaluation of, 99
 creative writing, 100, 104–105

Secondary school education (*Cont.*):
 credit requirements in, 98–99
 dance, 100, 108–109
 departmentalization, 99, 205
 devoted to the arts, 109–111
 effect of reforms in, on arts education, 99
 English, 104–107
 failures of, 90–95, 117
 fellowship programs for teachers in, 165–166
 film, 100, 104, 106, 151, 206
 humanities courses, 100, 101, 112–113
 integration of arts into, 112–113
 junior high schools, 115
 math, 114
 media programs, 106–107, 205–207
 middle schools, 115
 music, 100, 102–104
 nonschool programs affiliated with, 96–97
 oral communication, 206
 personalized programs, 99, 112
 photography, 206
 physical education, 74, 100, 108
 poetry, 157–158
 printmaking, 206
 programs, innovative, 97–99
 radio, 206
 reading skills, development of, 113–114
 recommendations for reform in, 95–97
 science, 218–219
 status of arts education in, 115–117
 student response to arts programs in, 104
 teacher training, 139, 140
 teachers (*see* Arts teachers; Teachers)
 television, 104, 105
 theatre, 100, 104–105
 visual arts, 100–102
 (*See also* Arts education; Education)
Senses, development of, through use of arts in education, 3, 25–27, 59, 66–68, 148, 200–201
Social studies, 66–68, 70, 83
Socialism, 34
Society:
 arts and, 27–29, 47, 154, 163, 181, 245
 changes in, 95–96
 education and, 26–29
 in a period of consciousness raising, 42–43
Southwestern Regional Laboratory (SWIRL), Los Alamitos, Calif., 86–87
Special Arts Project (U.S. Office of Education), 225
Special education, 109–111, 144, 154
Specialists, 55, 100, 138–144, 150, 156, 160
Sputnik, impact of, on American education, 11, 43, 219
Students:
 effect of arts on, 114
 gifted, 109–111, 193
 influence of artists on, 126–127, 155, 156, 161, 176, 193
 involvement in arts IMPACT program, 146
 participation in alternative school program planning, 98

Students (*Cont.*):
 reaction to arts programs, 104, 121–123
 teachers and, 154
Studio training, 131, 141
 for teachers, 144
Suburbs, 46
 migration to, 241
 social disorder in, 95
Superintendents, 163, 166, 169, 214
Surveys, 63, 115–117, 121–122, 124–125, 177, 190
 (*See also* Polls)
SWIRL (*see* Southwestern Regional Laboratory)
Symbols, artistic, as vocabulary of art, 6, 53, 56–57, 67

Tanglewood Symposium, 102
Teacher training:
 for administrators, 164–166
 at Aesthetic Education Learning Centers, 148, 150
 in architecture, 101
 for artists, 156, 159–161
 in the arts, 46–47, 86–87, 138–154, 220
 collaboration, 148, 150, 152–154
 competency-based, 145
 effect of, 146
 comprehensive arts education principles applied to, 168
 course-credit distribution in, 142
 in creative dramatics, 69
 in curriculum development, 64–65
 in dance, 109
 in environmental design, 101
 through fellowships, 165–166
 future of, 154
 graduate level, 144
 guidelines for, 141–142
 in the humanities, 150, 165
 in-service, 80, 101, 107, 143, 148, 150–154, 156, 207, 251
 institutions, 141, 146, 152
 interdisciplinary, 142–144, 150, 152–153
 in language arts, 78
 in media, 107, 199–201, 203–204, 206–207, 257–258
 in music, 73, 82
 new directions in, 142–144
 for nonschool programs, 140, 193
 pre-service, 143, 148
 programs, 8–9, 64, 65, 140–144, 148, 150–154, 165, 186, 251, 258
 recommendations for restructuring of, 251–252
 re-education programs, 148, 150–154
 role of higher education in, 134
 in science, 219
 for specialists, 139–144, 150, 156
 state requirements for, 141
 in summer institutions, 164–166
 workshops, 143, 148, 152–153, 186
Teachers:
 artists and, 159–160
 arts (*see* Arts teachers)

Teachers (*Cont.*):
 attitudes toward arts education, 99–100, 216
 certification of, 140
 classroom (*see* Arts teachers, generalists)
 and media in the classroom, 203
 re-education of, 148, 251–252
 (*See also* Teacher training)
 television and, 201
Team teaching, 60, 62, 101, 115, 131, 143
Technology, 6, 36, 38, 65, 199, 257–258
Television, 43, 44, 198
 as an art form, 198–199, 204, 209
 arts programming for, 203, 209
 in competition with schools, 97
 as cultural asset, 45
 fear of, in teachers, 201
 impact on values of children, 77, 209
 public, 207
 recommendations for use in arts programming, 257–258
 role in arts education, 107, 199, 203–204
 role in curriculum, 76–77, 104, 105, 107
 role in education, 44, 107, 199, 201–204, 207
Tenure policies, 122–123
 for artists, 160
Testing, 55, 56, 62, 68, 85, 114, 146–147, 192, 230–232
Textbooks, 78
 development of, by teachers, 62
 state commission on, 231
Theatre, 24, 37, 40, 45, 69, 100, 104–105, 199
Therapeutic programs:
 in dramatics, 69
 nonschool, 176, 179–180, 182

Ungraded (nongraded) schools, 60–62
Unified Arts Program, Brookline, Mass., 65, 167–168
Universities:
 expansion of art facilities at, 124, 174
 goal of, 129
 problems facing, 122–123
 role of, 134

Universities (*Cont.*):
 role of arts education in, 33, 127–134
 (*See also* Higher education)
University Repertory Theatre Association (URTA), 132
Urban Arts program, Minneapolis, Minn., 105, 195
Urban Gateways Program, 185–186
Urban planning, 44, 83–85, 101–102
URTA (University Repertory Theatre Association), 132

Verbal skills, development of, 3, 80, 86, 206
Video, 76–77, 207, 258
Visiting artists, 156
Visual arts, 46, 100, 221–222
 curriculum, 70–71, 80–83, 100–102, 141
 teachers, 141, 142
 technology and the, 199
Volunteer experts, involvement of: in alternative schools, 68, 98
 in arts education programs, 156
 in performing arts programs, 153–154
Voucher systems, 97

Washington Arts Commission, 234
Western States Arts Foundation, 159–160
Whitney, John Hay, Foundation, 165–166
Women, changing role of, 46, 97
Work-study programs, 97
Works Progress Administration (WPA), 42, 173
Workshops, 104, 186
 for administrators, 166
 after-school, 114
 artist-led, 65
 in-service, 82, 143
 for teachers, 148, 152–153
WPA (*see* Works Progress Administration)
Writing, creative, 78–79, 100, 104–105, 142

Young Audiences, 162
Young People's Film Festival, 207